Byzantine Art in the Making

Byzantine Art in the Making

*Main lines of stylistic development
in Mediterranean Art*

3rd – 7th Century

ERNST KITZINGER

Faber and Faber

3 Queen Square

LONDON

First published in Great Britain in 1977
by Faber and Faber Limited
3 Queen Square London WC1
Printed in Great Britain
Text by
Western Printing Services Ltd., Bristol
Plates by
Robert Stockwell Ltd., Southwark

ISBN *0 571 11154 8*

CONTENTS

to SUSAN

PREFACE

This book is based on a series of lectures I gave as Slade Professor of Fine Art at the University of Cambridge in the Michaelmas term of 1974. Some material has been added and rearrangements have been made at certain points. But the basic structure of the lecture series has been retained.

In this relatively restricted format I have tried to encompass five centuries in the history of Mediterranean art; centuries, moreover, with which modern scholarship has concerned itself extensively. Although an exhaustive bibliographical annotation was not feasible in the circumstances, sufficient references have been provided in the notes to direct the reader to specialized literature on the monuments and objects under discussion.

To convert the lectures into a book within a reasonable time would not have been possible without a grant from the National Endowment for the Humanities, which enabled me to spend the entire academic year 1974–5 on sabbatical leave. Much of the work was done at the Warburg Institute in London, for whose hospitality I am extremely grateful.

In preparing the book I have incurred numerous other debts of gratitude for help of many kinds. Sir Ernst Gombrich and Florentine Mütherich, two friends of long standing, were kind enough to read the lectures in manuscript. I trust that I can be allowed to acknowledge the benefit I have derived both from their encouragement and from their critiques without thereby implicating them in the book's short-comings. Colleagues and friends in many places have assisted me in the procurement of photographs for the illustrations. In this regard I owe special thanks to Janine Balty, Alice Banck, François Baratte, John Beckwith, Herbert Bloch, Beat Brenk, Alison Frantz, Danielle Gaborit, Theodor Kempf, Eugene Kleinbauer, Irving Lavin, Paul Lazaridis, Inabelle Levin, William Loerke, Arif Müfid Mansel, Per Jonas Nordhagen, Walter Schumacher, Maria Sotiriou, Marie Spiro, Lee Striker, Cornelius Vermeule, John Ward-Perkins, Kurt Weitzmann, William Wixom, Joanna Woods-Marsden and David Wright; as well as to the staff of Dumbarton Oaks in Washington, D.C., the Fototeca Unione in Rome and the photographic departments of the German Archaeological Institutes in Rome and Istanbul.

Two debts of a more general kind also call for acknowledgement. One is to the

Dumbarton Oaks Center for Byzantine Studies, where I spent the greater part of my professional life and where much of the work that has gone into the making of this book has matured. I owe a great deal both to the unique resources of that institution and to the manifold contacts it has afforded me over the years with scholars knowledgeable in a variety of germane fields. The other debt is to my students at Harvard University. Without the challenge of an organized course in which to present a complex and often not very approachable body of material, and without the students' reactions and critiques, I could not have attempted a synthesis such as the present. I am particularly grateful to William Tronzo, who helped me with a critical reading of the manuscript I had prepared for my lectures in the other Cambridge; and to Natasha Staller, who went through the final text with extraordinary care and discernment.

Finally, I must thank Mary Katherine Donaldson, my ever-faithful assistant whose tireless help, always cheerfully given, was indispensable at all stages of the work; my son Stephen Anthony, who has undertaken the task of design and production; and – last but not least – my wife, to whom I dedicate the book knowing that what it owes to her can never be adequately expressed.

Cambridge, Massachusetts August, 1976

INTRODUCTION

Titles often either understate or overstate the contents of books. In the present instance the title does both. 'Byzantine Art in the Making' is an appropriate designation for the central process within the period of art history to which this study is devoted. My actual subject is both larger and narrower.

The book is concerned with art in the Mediterranean world from the third through the seventh century. Roman art was still in its fullness in the third century; Constantine's new capital on the site of ancient Byzantium had not yet been founded; and although the city of Constantinople ultimately assumed undisputed leadership in the arts, this was a slow and gradual process. Even in the fifth and sixth centuries we shall encounter many important monuments that cannot properly be called Byzantine.

In this sense the scope of the book is broader than its title implies. On the other hand my coverage will not be comprehensive. It will extend only to the pictorial arts and will not include architecture. I shall be dealing, as the subtitle indicates, with stylistic developments only. And finally, in illustrating these developments, my procedure will be selective. It will be my purpose to trace, on the basis of a representative series of monuments, the main lines in the evolution of artistic forms during a particularly critical and complex period in the history of Western art.

The period is often referred to as Early Christian. This term, however, has connotations of the catacombs, of hesitant, tentative, perhaps even furtive beginnings. I find it inappropriate for works such as the mosaics of S.Vitale in Ravenna or the great encaustic icons of Mount Sinai. Although architecture is outside the scope of this book, in that field the suitability of the term for our period as a whole is even more uncertain. A building such as Justinian's church of St Sophia is not Early Christian.

Nor can monuments such as these properly be termed late antique. There has been a tendency to extend the concept of *Spätantike* to include not only the last centuries of Roman art but also succeeding developments at least to the period of Justinian if not, indeed, to the seventh or eighth century.[1] Admittedly this usage has its advantages. It puts proper emphasis on the continued strength of the Graeco-Roman tradition. But it overemphasizes the past at the expense of the future. Again, S.Vitale and St Sophia are not late antique.

There is, in fact, no simple term which adequately covers the entire period with which we are concerned, and it is obvious that in this problem of nomenclature there lies concealed a problem of identity. The period does not have the same kind of clear profile as other major phases in the history of Western art. [2] We cannot readily associate with it – as we can, for example, with Gothic or Baroque art – a distinctive set of forms in a distinctive combination. It is true that under close scrutiny any period in art history tends to lose some of its unity and cohesion. But we can still name many works of art that are quintessentially Gothic or quintessentially Baroque. For our period this is far more difficult. Nor is there a readily intelligible evolutionary curve in its artistic development. However differentiated the history of Gothic or Baroque art may have become, we can still speak with justice of Early, High and Late phases, of a style in the making, fully matured and finally in a state of hypertrophy foreshadowing its demise. No such life cycle can be discerned in the art of our period. Instead we are confronted with a coexistence or an abrupt and seemingly erratic succession of diverse and contrasting styles. Notorious cases of wide disagreement among scholars as to the dating of major monuments highlight this situation.

The period can be defined quite readily in terms of its boundaries. Historically, its beginning is marked by the first unmistakable signs of disintegration, the appearance of the first serious cracks in the structure of the Roman empire as a universal power; its end by the emergence of two great new powers with which the successors of Augustus and Constantine henceforth had to share possession of what had been the ancient world. With the Arab domains established on its southern flank and a Germanic empire in process of formation to the North, by the eighth century the old empire was finally and irrevocably reduced to regional status. Our time span is similarly set off in terms of art history. The third century witnessed the first crisis, the first major step in the disintegration of the classical tradition; the eighth century, the emergence of Islamic and North European art as separate entities and, simultaneously, the outbreak of the Iconoclastic Controversy which produced a major hiatus, at any rate for religious art, within the Byzantine empire itself. By then, however, firm foundations had already been laid for medieval art both in the East and in the West. To a very great extent Byzantine art of the post-Iconoclastic period resumed and built upon the traditions established before that great crisis; and the nascent art of the medieval West, while dependent on the contribution of the northern countries and the aesthetics of their 'barbarian' past, likewise drew heavily on these traditions.

In a very real sense, therefore, our period is one of transition – a bridge

between Antiquity and the Middle Ages – and therein, one might say, lies its true identity. 'Pre-medieval', in fact, might be a suitable term with which to encompass it.[3] Yet there is something intrinsically awkward about labelling five hundred years in the history of Western art simply as transitional. For the great monuments of the period – again I cite St Sophia and S.Vitale – it is hardly an adequate classification. And even if the term were applied to artistic achievements of such magnitude, what exactly is their place within this transition? There was, as I have indicated, no simple progression from a starting point to a goal.

In one sense – and it is an important one – the centuries which concern us do offer a rather clear picture of an organic development. I refer to the emergence and first full elaboration of art with a Christian content. An extraordinary process of growth lies between two definite, if negatively complexioned, landmarks – the taboo against religious images which obtained in the early Church until about A.D.200, and the new ban on such images in eighth-century Byzantium. From modest beginnings there arose a pictorial art of increasingly diverse content and scope and of ever more central and vital importance in public and private life. The very weightiness and centrality this imagery attained was what finally provoked the Iconoclastic reaction. Unquestionably this is a major aspect of Mediterranean art from the third to the eighth century. Indeed, in this sense the term Early Christian could well be applied to the period as a whole – provided that term were taken to denote not just a groping start but a fully rounded achievement. The process, though not our principal subject, will have a bearing on our discussion at many points.

But in matters of form and style, too, the period as a whole does have an internal development of its own. There is an intrinsic pattern, though it does not take the form either of a simple one-way progression from one style to another or of a life cycle of a single style through successive phases. To elucidate this pattern – a pursuit which is surely relevant to the problem of the period's unity and separate identity – will be the purpose of this book.

There was a time, earlier in this century, when scholars tried to establish an art-historical framework for our period in essentially geographic terms. The coexistence of different regional 'schools' with different artistic traditions and the interaction of these 'schools' were thought to go far in explaining the apparent lack of cohesion and unity in the overall picture. Charles Rufus Morey's antithesis of an 'Alexandrian' and an 'Asiatic' style is perhaps the best-known example of this approach.[4] Early in my own work, when sketching an art-historical synthesis of this period, I also made extensive use of the concept of regional styles as a means of correlating a mass of seemingly disjointed stylistic

phenomena.[5] The regional factor is undoubtedly important, and I do not intend to ignore it. To have done so is one of several basic points to be held against the one scholar who in the last twenty or thirty years has made a serious attempt to give a coherent account in stylistic terms of the history of art from the fourth to the seventh century. In an exceedingly audacious essay Andreas Rumpf has forced upon the disparate material a highly schematic pattern that does not allow for the variety of factors involved.[6] I do not think it is possible to isolate stylistic features – in the rendering of the human figure, for instance – that characterize works of a given date regardless of where they originated and regardless also of their subject matter and of the purpose for which they were made. Style changes occur at particular times, in particular places or regions and often in particular contexts which can sometimes be fairly narrowly circumscribed. Many of these impulses do, however, fall into broader patterns so that, over a longer period, one can speak of dominant stylistic trends. Over the years I have come to recognize more and more the existence and importance of such trends which follow one another in time and whose sequence and interaction constitute an intelligible and meaningful process. It is this sequence of trends – something far looser and more flexible than Rumpf's *Stilphasen* – which I propose to illustrate.

The process as I see it is a dialectical one. At certain times and in certain places bold stabs were made in the direction of new, unclassical forms, only to be followed by reactions, retrospective movements and revivals. In some contexts such developments – in either direction – took place slowly, hesitantly and by steps so small as to be almost imperceptible. In addition there were extraordinary attempts at synthesis, at reconciling conflicting aesthetic ideals. Out of this complex dialectic, medieval form emerged. My purpose will be to define the dominant trends as they succeeded one another. And, up to a point, I shall try to make sense of them in broader historical terms.

In some future analysis of twentieth-century intellectual history a footnote might well be devoted to a minor paradox. Many of the most significant advances made in the middle decades of this century in art-historical research – and this applies to all of its fields, but to late antique, Early Christian and Byzantine art more particularly – have been through iconographic and iconological approaches. That is to say, scholars have focused intensively and most fruitfully on the subject content of works of art, on the rationale behind the choice and grouping of themes and on their use in a given context or in relation to a particular patron, purpose or function. Yet this development in scholarship has coincided with a period of the most radical formalism in art itself. Art historians were concentrating on content and messages at a time when

painters and sculptors were eliminating subject matter altogether. I mention this rather odd disjunction merely to point out that no period more than our own has proclaimed in its art the meaningfulness of visual form as such. In our universities students flock to courses in which modern non-objective art is discussed and interpreted. Evidently they believe that it can tell them something about the period in which they live.

There is a general proposition involved here – namely, that the formal aspects of works of art hold important clues to an understanding of the period which produced them. This proposition I plan to take seriously. The concept of a stylistic trend with which I shall operate itself implies that a given set of forms becomes significant from a historical point of view. A form which 'catches on', as distinct from a purely ephemeral or accidental departure from an established norm, is liable to be meaningful to a group, a movement, an entire age. The difficulty lies in determining why.

There is, of course, an interrelationship between form and content. By stressing the importance of form *qua* form I do not imply any kind of dichotomy in this respect. In an attempt to interpret stylistic phenomena in historical terms, every aspect of a work of art must be taken into account: subject matter and the message it carries; the functional context; the patron's interest and intent; the use of established prototypes and formulae and their possible connotations. Sometimes there is a very definite and obvious relationship between one or another of these factors and the artistic form. At other times such interconnections are more indirect, subtle and elusive. But there are also instances where none of these approaches yields a satisfactory interpretation, and then one must have recourse to other kinds of data not provided by or gleaned from the work of art itself but from the social, intellectual or religious history of the period. And finally, there are cases where leads are lacking altogether and where the art historian can interpret style only intuitively or else must abandon the pursuit. No attempt will be made in this study to provide interpretations at all costs.

I have previously referred to the rise of Christian imagery and to the central role of that process within our period. The interpretative clues I have just mentioned will in many instances come from this sector. It is not feasible, however, to encompass the subject in all its fullness and complexity in the present framework. The early history of Christian imagery has its own dy-namics.[7] We must be content to glimpse it at those points where it is clearly of significance for the process of stylistic development which is our concern. We shall see that in the first phase the Christian contribution was negligible. The history of the first great crisis in Roman art in the third century can be written

practically without reference to Christian works. Thus in my first chapter
Christian monuments will figure only briefly and mainly on account of their
bearing on what was to come later. Early in the reign of Constantine, however,
at the time when Christianity gained official recognition, we shall encounter
Christian works of art with distinctive formal characteristics, unprecedented
and unparalleled in pagan art and apparently bound up with their religious
content and function. We shall see that the increase in Christian patronage and
the expansion and diversification of Christian subject matter which began with
Constantine certainly had a bearing on stylistic developments, although all
through the fourth century much of the initiative in matters of style still came
from other sectors. It was in the fifth century that art which was Christian both
in content and in functional purpose assumed undisputed leadership. To a
correspondingly larger degree this content and these purposes will thereafter
prove to be relevant to our understanding and interpretation of specifically
artistic achievements.

It will be clear from these introductory remarks that this study is not a hand-
book or in any sense a work of reference. Even within the limits implicit in
its particular approach no attempt will be made to cover uniformly the entire
artistic patrimony of the centuries concerned – fragmentary as that patrimony
is in any case. Certain places and certain media will receive more attention than
others. Illuminated manuscripts, for instance, will figure very little. While
reflecting the same basic trends as work in other media, they often pose special
problems for the stylistically oriented art historian, problems which are rooted
in the conditions of their manufacture and to which it would be difficult to do
justice in a book covering a large time span in a restricted space. In general
the text will be sparing both on descriptions and on the discussion of contro-
versial questions of chronology, although the literature cited in the notes will
enable the reader to inform himself on these matters. My aim is to trace a broad
picture of stylistic developments with the help of selected monuments, and the
selection will, I trust, prove to be sufficiently representative to give that picture
validity and meaning.

Ancient Art in Crisis

The stylistic developments with which we are concerned were set in motion by the collapse of the classical Greek canon of forms during the late Roman period. To gain an understanding of this breakdown must be our first task. The process, which for obvious reasons has held great fascination for twentieth-century observers, was as complex as it was momentous. For our purposes it must suffice to view it globally, focusing on certain key questions.

No monument embodies the demise of classical art more dramatically than the great triumphal arch in Rome dedicated to the Emperor Constantine by the Roman Senate in A.D.315 and commemorating Constantine's victory over his rival Maxentius in A.D.312 (fig. 1).[1] The sumptuous sculptural decoration of this structure comprises a large number of reliefs taken from imperial buildings of the second century, specifically from monuments honouring the Emperors Trajan, Hadrian and Marcus Aurelius. These reliefs appear here cheek by jowl with others expressly made for the arch, notably the long frieze band which encircles all four of its sides and which depicts in a succession of episodes the story of Constantine's victorious campaigns, essentially in the same way as the *res gestae* of Trajan and Marcus Aurelius had been illustrated (albeit with a far greater wealth of descriptive detail) on the spiral bands of their respective triumphal columns.

The contrast in style between the second- and the fourth-century reliefs on the arch is violent (figs. 2–4). The sculptor of a roundel of the period of Hadrian, representing that emperor's exploits as a lion hunter, was still rooted firmly in the tradition of late Hellenistic art. He creates an illusion of open, airy space in which figures move freely and with relaxed self-assurance. By contrast, the figures of the Constantinian reliefs are pressed, trapped, as it were, between two imaginary planes and so tightly packed within the frame as to lack all freedom of movement in any direction. While in the earlier work actions and gestures are restrained but organically generated by the body as a whole, in the later one they are jerky, overemphatic and uncoordinated with the rest of the body. (Suffice it to compare the manner in which the two sculptors represent the raising of an arm or the upturn of a head.) Accordingly, what holds the group together is no longer a rhythmic interplay of stances and movements

[7]

freely adopted by the individual figures, but an abstract geometric pattern imposed from outside and based on repetition of nearly identical units on either side of a central axis. Clearly, this pattern is designed with a view to a direct impact on the beholder. The earlier group is turned in onto itself. No one looks out towards us; the figures move and act in a self-contained, stable world. The scene of Constantine's distribution of largesse, on the other hand, which features as the grand finale of his triumphal progress, is spread out before us. Its unmistakable focus is the figure of the enthroned emperor who occupies the centre of the panel and who, though engaged in an action that involves the bystanders on either side, addresses himself first and foremost to the beholder and faces him in strict frontality. The group does not cohere intrinsically. The geometric pattern which holds it together makes sense only in relation to the spectator. Gone too is the classical canon of proportions. Heads are disproportionately large, trunks square, legs stubby. Nor is there consistency of scale. Differences in the physical size of figures drastically underline differences of rank and importance which the second-century artist had indicated by subtle compositional means within a seemingly casual grouping. Gone, finally, are elaboration of detail and differentiation of surface texture. Faces are cut rather than modelled, hair takes the form of a cap with some superficial stippling, drapery folds are summarily indicated by deeply drilled lines.

No doubt should arise concerning the legitimacy of the comparison between the two reliefs. They are fully commensurate in terms of their standing. We are not comparing a high-class work of art with a backwoods product. Both are official commissions honouring the ruler of the day. What is more, this is not a juxtaposition contrived by a twentieth-century art historian enjoying the freedom of Malraux's Museum Without Walls. These reliefs were placed side by side in the early fourth century under the eyes of the Roman Senate and the emperor himself.

This fact lends the Arch of Constantine special significance within the history of late Roman art. It compels us to face the question of awareness on the part of artists, patron and public vis-à-vis the radical reversal of aesthetic values reflected in its reliefs. The contrast between the contemporary work and the earlier pieces that were re-employed must have been obvious to all. Alas, no contemporary comment or explanation is on record. We are left to speculate, and I shall offer some thoughts on the subject in due course.

Attempts have been made at times to seek in accidental circumstances surrounding the creation of the arch the cause for the jarring juxtaposition of sculptures so utterly discrepant in style. There may have been a need to complete it in a hurry and this could explain the rifling of earlier imperial monu-

ments to provide part of the decoration.[2] An exodus of skilled craftsmen from Rome during the troubled years preceding Constantine's victory may account for the crudity of the reliefs expressly made for the monument.[3] But whatever special factors may have played a part in this particular instance, the primitivism of the friezes on Constantine's arch was more than just a local phenomenon during the period in question. A well-known group portrait in porphyry of four emperors of the Tetrarchy now affixed to the exterior of the church of S.Marco in Venice exhibits essentially similar formal characteristics (fig. 5).[4] Here again we find stubby proportions, angular movements, an ordering of parts through symmetry and repetition and a rendering of features and drapery folds through incisions rather than modelling. Ten or fifteen years earlier than the Arch of Constantine, this too is obviously a work of official art. Porphyry was a material reserved for imperial use. The only quarry which produced the stone was in Egypt, and the S.Marco group, which came to Venice as crusader loot from Constantinople,[5] undoubtedly was made in the Eastern parts of the empire. The style, then, was not confined to Rome. It had, in fact, wide currency in official high-class art during the Tetrarchy and the early Con-stantinian period and may be found in a variety of media. A portrait of Maxi-minus Daza (A.D.305–13) on a gold coin minted at Antioch (fig. 9)[6] or a detail from one of the sumptuous floor mosaics of the same period in the great villa complex at Piazza Armerina in Sicily (fig. 6)[7] will serve to illustrate the point. The hallmark of the style wherever it appears consists of an emphatic hardness, heaviness and angularity – in short, an almost complete rejection of the classical tradition.

It is possible to consider this phenomenon essentially as a decline. This was the view taken, for instance, by Bernard Berenson.[8] To treat a figure as a single block is easier than to articulate it. To achieve compositional unity through repetition or axial symmetry is simpler than to do so through an interplay of postures and of movements. Less effort is needed to engrave features on a face or folds on a drapery than to model such elements. There was clearly a loss of craftsmanship. But the causes of this can be manifold (as Berenson recognized), and they can be aesthetic as well as material. Traditional forms might be abandoned not simply because they were difficult to execute but because they had ceased to be meaningful or – to use a favourite word of our time – relevant. They could be abandoned also because they carried mental associations that were no longer desirable.

Another approach to the problem – and this has played a large part in scholarship – is in terms of outside influences. At the beginning of this century Josef Strzygowski, having become convinced of the crucial importance of the

countries of the Eastern Mediterranean littoral and their Asiatic and African
hinterlands in the process of transition from ancient to medieval art, coined
the phrase 'Hellas suffocating in the embrace of the Orient'.[9] The anti-classical
tendencies, the taste for the abstract and the two-dimensional, for hieratic
rigidity and geometric order, were thought of as re-emerging traditions of the
ancient Near East which gained ascendancy as the classical world went into
decline. Actually, in all the regions primarily concerned – the Anatolian high-
lands, the Syrian desert, Parthian Mesopotamia and Iran, Arabia and the valley
of the Nile – art had been quite thoroughly permeated with Greek forms.
What is important is not so much a survival and subsequent revival of ancient
regional traditions in contrast or opposition to the Graeco-Roman *koine* –
although such cases are known, for instance in Egypt – as the fact that, in the
hands of local craftsmen in these fringe areas of the classical world, the Graeco-
Roman *koine* itself had assumed a different accent. We may take as a character-
istic example a tomb relief from Palmyra (fig. 11)[10] which displays the vocabu-
lary of Roman statuary – the pose, the drapery, the facial type – but lacks the
overall quality of a living, self-governing organism which this vocabulary is
meant to convey. Instead, what mattered to the artist were a clear, simplified
pattern, a timeless existence, a hieratic solemnity. There is, as a matter of fact,
no great difference in principle between such hybrid art from the Eastern
borderlands and some of the art produced in the Western and Northern border
regions of the Roman world, regions such as the Rhineland (fig. 12)[11] or
Britain or the banks of the Danube. In those areas, too, the Graeco-Roman
repertory of forms was handled by artists who lacked comprehension of or
interest in the basic concepts and urges from which these forms had arisen. A
reassessment of classical values, then, had already taken place in the fringe areas
of the Roman world, West as well as East, and influences or stimuli from these
regions could well have become important for the late antique development in
Rome itself.

Nor is this all. During the centuries when classical taste ruled supreme in
imperial art, there was even in Italy a substratum of what has been variously
called popular or plebeian art.[12] Indeed, it can be – and has been – argued
that in imperial Rome Greek standards and values were never more than a
veneer overlying an indigenous Italic aesthetic which was wholly different and
which continued to assert itself in various ways throughout the centuries.
Accordingly, the late antique development in Rome can be – and has been –
viewed essentially as a massive re-emergence of this local plebeian tradition to
the virtual exclusion of all external influences. For example, in the first half of
the second century A.D., which was one of the most strongly classicizing periods

in Roman art, it was possible for a Roman worthy and his wife to have them-
selves commemorated in a funerary relief (fig. 10)[13] replete with features that
one normally thinks of as late antique: irrational spatial relationships; scale and
proportions determined by symbolic importance rather than laws of nature;
frontality; jerky and abrupt movements; hard, sharp-edged forms brought out
by deep undercutting. From this it certainly becomes clear that there were
forerunners in Rome itself of the stylistic revolution which we are considering.

The term 'sub-antique' may serve as a generic heading under which to bring
together the various artistic manifestations both at the fringe of the ancient
world and within the Roman empire, which these examples illustrate.[14]
Although each regional style has distinctive characteristics of its own, they all
have a great deal in common, not so much as a result of actual contacts or
connections – indeed, in many cases there clearly was no contact whatever –
but because they all arose in similar circumstances. In relation to the genesis of
late antique art particularly, it is important to be aware of these sub-antique
styles in their totality. I do not think that any one of them, to the exclusion of
all others, can be claimed as a chief source of the radically new elements
introduced into the mainstream of Roman art between the late second and the
early fourth century. At any rate, we are not as yet in a position to make
sufficiently fine distinctions. For instance, a tendency to present figures in an
en face view directly confronting the beholder – one of the characteristic and
important late antique innovations – was common in all areas of sub-antique
art. It is useful and illuminating here to draw a parallel between late antique
art and that of our own time by reminding ourselves of the wide range of
exotic and primitive styles which exerted an influence on the nascent art of the
twentieth century. At that critical point artists drew inspiration from a variety
of sources outside their own culture – from the art of Japan, Africa, Polynesia
and pre-Columbian America – as well as from primitive works immediately
around them (*images d'Epinal*, Rousseau le Douanier, children's drawings);
and some of the formal devices and principles in which they were interested they
could find in more than one of these sources.

A question, however, arises as to the nature of the influence in the period
which concerns us. Did Hellas in fact die embraced by the Orient, overwhelmed
by an influx of artists from the provinces, engulfed in an upsurge of plebeians,
as the case may be? In other words, was there some physical movement of
peoples or classes which more or less automatically brought to the fore a style
or styles that had previously been peripheral? Or can we make further use of the
late nineteenth-/early twentieth-century analogy by saying that at the core of
the development was an internal reorientation of Roman art itself? Were

leading or pioneering artists attracted by provincial or primitive styles? Did
they become aware of new possibilities of expression, new aesthetic stimuli
thus offered? And did they, therefore, absorb these elements on their own
terms?

Here we find ourselves face to face with a crucial problem in the interpre-
tation of the entire late antique development. To me it seems quite impossible
to account for this development simply through a physical dislocation of people.
Influence from the sphere of sub-antique art on the massive scale on which it
occurred implies a free and willing adoption of sub-antique forms. But adoption
by whom and for what reasons and purposes?

Let us return once more to the porphyry group of the Tetrarchs (fig. 5), of
which another version, smaller in scale and even more primitivistic in style,
exists, adorning the tops of two column shafts in the Vatican (fig. 8).[15] As a
rendering of human presences – to say nothing of imperial presences – these
figures are ludicrous. With their block-like, repetitive forms riveted together
by outsized arms they express one thing only, namely, the solidity of the com-
pact between the persons portrayed, their absolute unity and inseparability,
their unshakable amity and equilibrium. This, of course, was the theoretical
premise on which the Tetrarchic system of government rested. It is pro-
claimed here with a brutal visual directness which a rendering of the four
emperors in classical style could not possibly have achieved. Indeed, the
classical apparatus of form with its varied rhythms and its elaboration of
detail would have distracted from the basic point. In sub-antique art, on the
other hand, one finds stripped down to essentials the imaging of relationships
such as these groups were meant to proclaim. A small terracotta group repre-
senting a couple in loving embrace – one of a series of such objects which were
deposited as votive gifts in a Gallo-Roman temple at Trier – bears witness to
this (fig. 7).[16] It was a message of overriding urgency which in the portrayal of
the four emperors led to the total rejection of the classical canon. Perhaps we
can go further and say that the very radicality of the rejection implies that this
canon was presumed to be still in the beholder's mind. In other words, the
rendering of these figures may have a polemical aspect as well, which, given the
context, would have been politically motivated. The idea may have been to
link the rejected form to an era, an ideology, a social class that is itself implicitly
being rejected. And there would be the further implication that the powers of
the day have adopted the artistic language of another class hitherto submerged
or peripheral and wish to proclaim their sympathy and solidarity with that
class.

Twentieth-century experience has made us familiar with this kind of manipu-

lation of artistic styles for political ends. An element of this nature may well be present in this instance. It is fully in keeping with the character and purposes of a ruler such as Diocletian, whose concept and method of government were totalitarian in the sense that he claimed control over every department of life; whose background and power base were military and thus placed him in opposition to the senatorial class and the tradition of aristocratic refinement and phil-Hellenism associated with that class; and who consciously and explicitly espoused and proclaimed the sturdy values and ideals of the Roman past.[17]

It follows that sculptures such as the porphyry Tetrarchs are not the work of third-century forerunners of a Picasso or a Klee who on their own discovered the aesthetic potential of certain exotic or primitive art forms. These sculptures must have been executed by artists who actually came from the sub-antique sphere and were deliberately chosen because of their ability to communicate a particular message in a language that was extremely forceful and direct and which common men all over the empire could recognize as their own. Thus the patron emerges as an important factor – not, to be sure, in creating an artistic form, but in promoting it, in setting it up as a norm and charging it with new content. By making a choice of one style over another and using it for his own ends, the patron in effect influences the stylistic development. Such development, therefore, is not always solely of the artist's own making. As I have put it in an earlier essay, borrowing David Riesman's terms, it can at a given stage be 'other-directed' as well as 'inner-directed'; that is to say, it can be affected by persons outside the realm of art and in that case certainly must be fully conscious and deliberate.[18]

I have already touched on the question of consciousness in connection with the Arch of Constantine, pointing out that people at the time must have been aware of the stylistic contrast between the contemporary and the earlier reliefs. In this case we cannot assume that the employment of artists practising an emphatically popular style of sub-antique origin involved a protest against aristocratic, phil-Hellenic traditions, since so many works embodying precisely these traditions were also incorporated in the monument. It is conceivable, on the other hand, that an excessively primitivistic workshop was purposely selected in a spirit of compromise, or at least that such reasoning served to justify a choice that may, after all, have been dictated by circumstances. One thing is certain: here, too, the sub-antique style became the vehicle of a message which the traditional classical vocabulary could not have conveyed with anything like the same directness and palpability. Once more I refer to the ceremonial scenes with which the Constantinian frieze closes and in which the

primitive devices of axial symmetry, repetition, frontality and variable scale produce a simple, readily intelligible formula proclaiming with great force the concept of absolute rule and timeless superhuman authority (figs. 2, 4). Henceforth and throughout the Middle Ages this same basic formula was to be used many times not only in secular but also, and above all, in religious contexts to express this same idea.[19]

No doubt, then, the success of sub-antique forms in official art at the end of the third and the beginning of the fourth century was due in part to the fact that these forms provided a suitable means of expression for messages which important and influential patrons wished to communicate. To return to portraiture on coins, the hardness and simplified angularity characteristic of the imperial profile in many issues of this period minted in different parts of the empire cannot mean that artists capable of making dies in a 'better' style could no longer be found anywhere. It can only signify an official preference for the sub-antique manner with its ability to project an image of indomitable strength and toughness (fig. 9).

Important as the role of patrons and their conscious choices may be, however, this factor obviously cannot provide more than a partial explanation of a very complex phenomenon. The subversion of the classical canon was not a matter of a sudden assault by some powerful individuals during the Tetrarchy. It was a slow and gradual process which had begun more than a century earlier. The seeds of the late antique development were, in fact, sown in the late second century, in the era of the Antonines. The spiral band of the triumphal column of Marcus Aurelius, carved between A.D.180 and 193 in obvious emulation of the Column of Trajan made two generations earlier, affords excellent opportunities to observe this development in its incipient state.[20] For instance, the recurrent and more or less stereotyped motif of the emperor addressing his troops (figs. 13, 14) is here subtly transformed in such a way that the imperial person, rather than turning to his listeners, is in effect presented ceremonially to us, the beholders, anticipating in this sense the compositions on the Arch of Constantine. Raised to an upper register and entirely clear of the crowd gathered around him, Marcus Aurelius appears in an *en face* view and is flanked in near symmetry by two dignitaries and two groups of standards. Soldiers on the march, another recurrent motif in these war 'documentaries', are no longer shown in a variety of natural poses, but fall into a lockstep with postures, shields and spears creating a schematic, repetitive pattern.[21] We are faced here with relatively subtle and inconspicuous changes within what is clearly a continuous tradition, and it would seem unlikely that these changes were dictated by those who commissioned the work. On the contrary, we may

presume that these modifications were introduced by the artist himself in an act of freely copying the model imposed on him. There is, indeed, a good chance that they were arrived at intuitively and perhaps not altogether consciously. In other words, here, at a point much closer to the beginnings of the decisive and fateful style change that spelled the end of classical art, we must reckon with an artist's 'inner-directed' action, whatever the deeper motivation of that action may have been.

Certainly, in the instances I have cited, the sculptors of Marcus Aurelius' Column seem to promote, or at least to be groping towards, a new exaltation of the emperor on the one hand and a new standard of regimentation of his subjects on the other. But it is with the benefit of hindsight (namely in the perspective of subsequent official art and especially that of the Tetrarchy and of Constantine) that the significance of these early steps becomes apparent. It would be difficult to prove a programmatic intent here. In any case, the changes and innovations in Roman art during the last decades of the second century involved much more than a shift in political concepts. What took place was an assault on tradition on a much broader front.

A comparison of two sculptured sarcophagi of this period may help us to enlarge our view of the process under discussion (figs. 15, 16).[22] Both reliefs represent battles against barbarians. One was carved about A.D. 160–70, the other twenty or thirty years later. Crowded as the earlier relief is, it is still essentially a Hellenistic frieze in the tradition of the Pergamon Altar. Individual bodies are fully developed as organic entities; they strike dramatic poses which find an organic response in the pose of some adjoining figure. What looks like a melée consists, in fact, of a series of intricately interwoven duels. Deep shadows plough up the surface, but they coincide with the outlines of individual bodies and set off each one as an element in a fugue-like composition. In the later relief these contrasts of light and shadow no longer serve to define corporeal entities. They are so ubiquitous as to cut across all natural boundaries and themselves become a principal means of conveying a sense of chaotic, rapidly changing action. The whole surface consists of fragments of human figures, horses, weapons and other paraphernalia. Here, in principle, the Greek concept of a man-centred humanistic art is abandoned. The contrast of light and shadow, an element separate from and imposed upon the actors in the drama, becomes a major means of expression (as, incidentally, it does also on the Column of Marcus Aurelius). It has long been recognized that with the introduction of this 'optical' effect classical art is already at an end.[23] An element which is not generated by natural forms in their natural interplay but is abstracted from them and essentially independent of them becomes a vehicle

of an intense aesthetic and emotional appeal. Thus the way is open to the more radical abstraction that was to follow.

A certain disinterest in the sculptural elaboration of individual forms is a logical corollary. The rendering of anatomy, of drapery, of a face or a horse's mane is relatively summary, and much use is made of the drill to produce deep shadows that indicate rather than define such detail. No doubt this involves a loss of careful craftsmanship. But here, if anywhere, this appears as a jettisoning of ballast, a breaking through of new concerns. A close-up view of one of the vanquished barbarians is enough to bear this out (fig. 17). The simplified out-line uniting throat, chin and jaw in a single curve powerfully dramatizes the last desperate upward thrust of the doomed man's face, just as the few bold shadow lines that mark his drooping hair and the fold of his tunic spell the impending death-fall. Indisputably, simplification here serves to enhance expression.

Thus we are led to discern something of the inner forces behind the formal innovations of this period. This is a generation that revels in the representation of suffering. In the war scenes it is the defeated, the prisoners, the dying who seem most to engage the artist's attention – not in a spirit of compassion but because of the opportunity to represent great emotional stress. As the decades went by, these expressions became ever more extreme, as witness the heads of dying barbarians on the great mid-third-century battle sarcophagus in the Ludovisi collection (fig. 18).[24]

Scholars have spoken of an 'age of anxiety'.[25] The danger of an anachronistic diagnosis in terms of purely modern problems and experiences clearly lurks here. But one need only look at a representative series of third-century portraits to agree that we are indeed dealing with deeply troubled people. Or perhaps it would be more correct to say that it came to be considered appropriate in this period for the portrayal of any personage, however prominent or official, to convey a sense of anguish, though the expression may vary from worried concern to total absorption in a far-off vision, from defiant toughness to stoic resignation (figs. 19–22).[26]

The reasons, of course, are not far to seek. The Roman world was under-going a profound material and spiritual crisis. I need mention only the rapid succession and violent overthrow of rulers; the military catastrophes; the mounting taxation and inflation; the abandonment of traditional religion in favour of Oriental cults with their emphasis on the mysterious, the ecstatic and the irrational; and the emergence of new trends in philosophy that offered an escape from the realities of this world. To decide which of these factors are primary and which secondary – what is cause and what is effect – cannot be

our task. Their cumulative significance is not in doubt and, with contemporary portraits to guide us, we have no difficulty in recognizing in the massive assault on traditional aesthetic norms, in the mounting emotionalism and abstraction, a visual corollary to what was happening in other spheres of life.

Thus, in tracing the anti-classical development in late Roman art back to its earlier stages, we have arrived at a much broader, if less sharply focused, view of its scope and meaning. The messages are not as specific as those of the Tetrarchic and early Constantinian works with which we started; nor is there the same obvious correlation between messages and the visual devices conveying them. Also, in these earlier stages references to sub-antique style forms are less evident and tangible, and it would be hard to maintain that mental associations with the sub-antique sphere were being evoked deliberately. By the same token, it would be difficult to attribute an active role to the patron. Indeed, we cannot pinpoint with any accuracy the patronage behind many of the works in which the break with the classical past first becomes apparent.

But what we have lost in precision we have gained in depth. Going back in time, as we have done, we can no longer operate with the simple notion of a ruler manipulating artistic form to suit his purposes. The stylistic innovations that began in the late second century are rather in the nature of a broad irresistible stream engulfing everybody and everything and – so we have seen – springing from the whole human situation of the period, the hopes and fears, the preoccupations and sufferings of an entire society. We have penetrated to a far deeper level of contemporary life.

What emerges here is a dilemma which confronts the stylistically oriented art historian whenever he tries to go beyond the description, classification and interrelating of forms and undertakes to interpret their meaning in cultural terms. He can be specific in certain cases, particularly when the patron, his wishes and his programmes are tangibly involved. But such cases are like the tips of icebergs. They rest on a mass of widely diffused phenomena that can only be interpreted intuitively by invoking the mood of the age or, in other words, a Zeitgeist. The use of the term, it seems to me, is legitimate so long as we bear in mind that a Zeitgeist, in turn, is compounded of many elements, material and spiritual. In the present instance we are fortunate in knowing a great deal about the concerns which dominated people's lives, and the correlation between these concerns and the new stylistic forms which emerge is compelling. (At subsequent stages of our story the evidence will be far more meagre.) What is not susceptible to analysis in this remote and anonymous age is the actual linkage between the experiences of society as a whole and the workings of the aesthetic imagination. I have spoken of the innovations

introduced by artists at the end of the second century as essentially intuitive
and 'inner-directed'. By this I obviously do not mean that artists were not
affected by events, movements and ideas in the society around them. What I
do mean is that the translation of social experience into visual terms was their
own creative act.

I said at the outset that I would take a global view of the great stylistic upheaval
in late Roman art. The broad outlines of this process have, I hope, emerged,
but much of the detail has perforce been omitted. No account has been taken
of the ebb and flow of stylistic change from decade to decade. The assault on
the classical canon took different forms at different times, and there were
reactions, countermoves and retarding moments such as the 'Renaissance'
under the Emperor Gallienus (A.D.253–68).[27] Nor, in the present framework,
have I been able to do justice to regional differences. While the sculptors of
sarcophagi in Rome experimented with new formal devices that would heighten
the emotional impact of figures and scenes, their counterparts in Greece and
Asia Minor worked in a more conservative vein, producing reliefs that continued
to be based on the concept of the primacy, integrity and autonomy of the
individual human form (figs. 24, 25).[28] Finally – and this is of great importance
– a conservative and a progressive manner may appear side by side in the same
area, in the same workshop or even on the same monument. Certain subject
categories invited and encouraged the quest for the expressive or the abstract,
while others were felt to call for a more traditional treatment. The some-
what studied classicism I have just mentioned as being characteristic of Greek
and Asiatic sarcophagus reliefs is associated on these reliefs with mythological
figures and scenes. Now in Rome, too, a sculptor of the early third century
might persist in the loving elaboration of figures and, indeed, go out of his way
to achieve extremes of grace and surface polish when presenting a subject not
pertaining to the here and now. Thus on a Roman sarcophagus of this period
in New York (fig. 23)[29] the god Dionysus, his entourage of satyrs, maenads and
cupids and the four genii on either side personifying the four seasons are
rendered with an extraordinary if somewhat vacuous refinement and smooth-
ness. The delicate *sfumato* effect which envelops these figures seems to remove
them from our world altogether into a kind of never-never land.

Form, then, may be modulated depending on content. In a different way this
is illustrated by the Attic sarcophagus in the Capitoline Museum in Rome,
also of the first half of the third century, which bears on its front the story of
Achilles (fig. 25). The cool academic classicism which informs the mythological
scene (fig. 26) does not extend to the portrayal of the deceased who, with his

wife, is represented reclining on the lid of the tomb (fig. 27).[30] His is one of those mask-like, frozen, hard-edged faces which we found typical of third-century portraiture generally. Thus two different styles appear side by side on one and the same monument, one for contemporary mortal men, the other for figures from mythology. This is the phenomenon of the so-called 'modes' – the conventional use of different stylistic manners to denote different kinds of subject matter or different levels of existence. It is an extremely important factor which cuts across and to some extent negates the temporal succession of stylistic phases in Roman art. And, as we shall see, some of these conventions continue into subsequent centuries when such stylistic differentiation according to content will tend to be carried even further. This phenomenon, more than any other, adds to the complexity of the process we are studying.

But when all is said and done – and after making allowance for retarding elements, regional factors and the coexistence of different styles depending on subject content – the history of art in the period we have surveyed is still dominated by one central and crucial process, namely, the disintegration of the classical canon and the emergence of radically conceptual forms either abstracted from that canon or imposed upon it. It was the first and most decisive step on the road from classical to medieval art.

Finally, a few remarks must be added about Christian art, whose role in the third century was as yet marginal. Classical art transformed itself; it was not transformed by Christianity. There is only an indirect connection in the sense that the same material and spiritual crisis which underlies the aesthetic revolution of the period also caused a rapid expansion of the Christian religion, a development which in turn led to the rise of Christian art. But Christian art did not from the outset spearhead new forms.

There is no evidence of any art with a Christian content earlier than the year A.D.200.[31] In all likelihood this is not merely due to accidental losses. The surviving monuments of Christian pictorial art which can be attributed to the first half of the third century bear the marks of a true beginning.[32] Moreover, one can find in Christian literature of the period reflections of a changing attitude towards images and their role in religious life.[33]

That attitude was undoubtedly negative prior to this period. The root cause was not, as is often claimed, the Old Testament commandment against graven images but rather a state of mind which equated image-making with pagan cult practices and the entire pagan way of life. By the same token, the emergence in the third century of religiously meaningful images in Christian contexts was part of a process of coming to terms with that way of life. Naturally

Christians adopted artistic forms that were current in the society in which they lived.

Nowhere is this more apparent than in the early fresco decorations in the Roman catacombs. Wall painting, a medium we have not so far considered, had undergone a striking development in Rome during the late second and early third centuries. Simulated architecture, traditionally a favourite theme in painted mural decorations, had become increasingly attenuated and demateri-alized until only a network of thin lines remained, covering ceilings as well as walls. Within this ethereal web isolated figures float on large expanses of plain white ground. Roman domestic interiors of the first half of the third century were painted in this characteristic style which in its own way bears witness to the anti-classical tendencies of the period (fig. 28), and the same system of decoration appears in the earliest of the painted chambers in the Christian catacombs (fig. 29).[34]

Yet there is a difference. There are, of course, new subjects expressive of Christian concerns and based mainly on the Old and New Testaments.[35] But there is also a difference in the way these images were intended to function. This no doubt has to do with the fact that they constituted in effect an infringe-ment of a taboo. They point beyond themselves to a quite extraordinary degree. Biblical themes are represented for the most part in drastically abridged form, usually reduced to the minimum of figures and props necessary to call to mind a given text. It is not intended that the beholder should linger in contemplation of physical appearances. He is only meant to receive a signal. Furthermore, the texts to which the images refer are not invoked for their own sakes. There is no factual thread linking the various subjects together. What unites them is a common message which is of urgent concern to the beholder, a message of deliverance and security through divine intervention. Images are thus twice removed from an actual portrayal of sacred subject matter. They are ciphers conveying an idea. This method, which has been aptly described as 'signitive',[36] was not entirely new. It had previously been used in certain pagan contexts.[37] What was new was the intensity with which it was often applied in Christian contexts, the accumulation of 'signs' in a given space. The wall paintings in the catacombs are apt to be overcharged with content, for in this content lay the justification of the visual image.

Even this difference, however, tended to recede in the second half of the third century. There are Christian images of this period which were clearly meant to function more normally as representations in the classical sense and not merely as ciphers or pictographs. A remarkable group of small-scale marble sculptures of Eastern Mediterranean origin, acquired some years ago by the

Cleveland Museum of Art, is a particularly striking example (fig. 30).[38] Four of the pieces represent in sequence the sea adventure of Jonah, a 'deliverance' story familiar from the Roman catacombs. It is one subject which even in the earliest of the Roman paintings already appears elaborated to the extent of being shown as a story in successive stages. But here it is in the round – in the medium most closely identified with the idolatrous world of the pagans. The sculptor, steeped in the tradition of Hellenistic baroque, has dramatized the episode with a boldness and directness which almost foreshadow the art of Bernini; and to do this he has used the smooth, soft manner, the *sfumato* effects which, we have seen, were still favoured nostalgically in third-century pagan art for mythological and idyllic subjects. The Cleveland statuettes must have been intended for a well-to-do Christian who wanted an equivalent of a special kind of pretty decorative fountain sculpture fashionable among pagans at the time and featuring such subjects as Orpheus taming the animals with his music (fig. 31). The process of Christian assimilation to pagan usage has gone far here; and clearly it has not made for stylistic innovation – quite the contrary. Let us note incidentally that the same workshop in which the Jonah statuettes were carved also produced portraits of contemporary individuals which, while unmistakably related, show a more precise definition of forms (fig. 32). It is a good example of a style being modulated and attuned to different kinds of subjects.

The interest in representation for its own sake which the Cleveland marbles so clearly bespeak is evident also in certain Christian monuments of roughly the same period in Rome. Again the best examples are sculptures representing Jonah's ordeal and rescue, although the monuments in question bear no direct relationship, either iconographic or stylistic, to those Eastern statuettes. On the fronts of a number of sarcophagi made for affluent Christians in the late third century the story of the biblical prophet was spread out in sequence in much the same way as themes from mythology had been displayed on pagan tombs (fig. 33).[39] Indeed, stereotyped motifs that had served in the depiction of classical myths, pastoral idylls or the marine dream world inhabited by Nereids and Tritons, were drawn upon to pictorialize the Jonah story in loving detail. The most remarkable of these borrowings was the figure used to depict the prophet's rest under the gourd tree at the end of his ordeal. It is no other than Endymion, the beauteous shepherd boy whose awakening by Selene, the goddess of the moon, had long been a favourite subject of pagan sarcophagus reliefs (fig. 34). Christian interest and taste in this period clearly inclined to tradition rather than to the radical innovations which the third century had produced.

CHAPTER TWO

Regeneration

We ended our discussion of the great crisis in Roman art of the third century with a glimpse at Christian art of the period. It is with a category of Christian monuments that our survey of stylistic developments in the ensuing century can usefully begin.

There exists a class of marble sarcophagi preserved in numerous examples primarily in Rome, which in a purely visual sense strike a familiar note (figs. 35, 36). At first sight they might almost be taken for sections from one of the friezes of the Arch of Constantine (cf. fig. 4). Indeed, some of them seem to have been carved by the same workshop which produced those friezes. Others must have been made in closely related ateliers.[1] We recognize many of the most telling characteristics of the Constantinian work: the tight, isocephalous line-up of figures, the stubby proportions and angular movements, the crudely drilled lines denoting drapery folds. In some instances the similarity extends to minute detail such as the rendering of eyes or of beards (figs. 37, 38).

It is, however, a stylistic relationship only. Our sarcophagus reliefs turn out to be in a class of their own once their subject matter is taken into account. The tightly aligned figures of which these friezes are composed do not stand for anonymous crowds as do their equivalents on the arch. Nearly every one of them is a separate unit depicting a distinct event. At the most two or three together make up a scene. And these scenes, juxtaposed without separation and often in seemingly helter-skelter fashion, pertain to episodes in the Gospels and in the Old Testament and to apocryphal stories from the life of St Peter. For instance, on the sarcophagus illustrated in fig. 35 the five full-length figures on the right represent three different miracles performed by Christ. At the right end of the frieze he is shown raising Lazarus. Next he appears flanked by two apostles as he multiplies the loaves and fishes. Immediately to the left he appears again healing a blind man of diminutive size, while the bearded man in the background holding a finger to his mouth may stand – in drastically abridged form – for the scene in which an embarrassed St Peter is foretold that he will thrice deny Christ. There follows once more, to the left of a central orant figure flanked by apostles and intended to bear the portrait features of the deceased, the figure of Christ as he turns water into wine at Cana. Directly

adjoining him is one of the soldiers who take St Peter prisoner, while at the extreme left is the apocryphal scene of the apostle striking water from the wall of his prison for his thirsting guards. Two Old Testament scenes – the Fall and the Three Youths in the Fiery Furnace – are added on the short sides of the trough.

Such a way of representing a multiplicity of distinct events has no real precedent in ancient funerary sculpture. Normally when the subject matter of a Roman sarcophagus was narrative, the whole front of the trough was given over to a single myth recounted in epic breadth; and we have seen that in the late third century some Christians had begun to adopt this manner for their own tombs (fig. 33). One might find depicted on a pagan sarcophagus the Labours of Hercules or, in a rare instance, a series of scenes in the life of an official lined up in close formation.[2] But although this does mean an accumulation of many distinct events, the whole nevertheless forms a single sequence with an obvious narrative unity. In the case of our Christian 'frieze sarcophagi' there is no such obvious unity. What ties the scenes together is their implications. Most of them carry a single message – still, broadly speaking, the message of deliverance through divine intervention familiar from third-century catacomb art. Clearly the idea is to reiterate the point by exemplifying it with as many different episodes as possible. More than ever these images point beyond themselves. It is the 'signitive' method at its most extreme.[3]

The isocephalous frieze was an ideal vehicle for the purpose. It was like a line of writing which required the beholder's most active mental participation to enable him to decipher its content.[4] The monotonously erect figures of which it was basically composed allowed for only a minimum of visual enactment of the events concerned. To make the stories intelligible secondary figures and props were added on a much smaller scale; they provided the accents, so to speak. But, to continue the metaphor, there was no separation of words. It was left to the beholder to disentangle the scenes. At the same time space was saved for additional episodes. Never in the history of the sculptured sarcophagus had there been an attempt to say so much in so little space. It was the combination of isocephalous frieze and signitive method of narration which made this possible.

The frieze sarcophagus, despite its visual resemblance to the relief bands of the Arch of Constantine, is the first Christian artifact that is truly original and different in basic conception from anything that had ever been done in Graeco-Roman art. Produced serially, these tombs served for the burial of, presumably, middle-class Christians who died just before and in the first decades after their religion won official recognition. It can hardly be pure

coincidence that the almost frenetic piling up of content and messages which is
their distinctive characteristic occurred just at the time when Christianity was
at last being set free in the Roman world. The problem of the graven image
must have asserted itself with particular urgency at that moment. A way was
found to justify visual representation by more than ever charging it with messages.

I have focused on these sarcophagi at the outset of this chapter not so much
for their intrinsic interest – great as that interest is – but because, as already
indicated, they offer an excellent point of departure for our investigation of
ensuing developments. The frieze sarcophagus of the early Constantinian period
had a rich progeny. By following the production of Christian tombs in Roman
marble ateliers through the next several decades we can isolate and demonstrate
within a single geographically, technically and thematically coherent series of
artifacts a marked stylistic shift which will prove to be symptomatic of much
larger trends dominating fourth-century art as a whole. In the aggregate, as we
shall see, these trends amount to a massive reversal of the anti-classical tide
that had reached a high mark in the decades around A.D.300.

Three well-known sarcophagi will serve to illustrate a step-by-step trans-
formation within this particular category over a time span of about forty years.
Common to these three examples is a basic feature which again is without
precedent in the vast output of funerary reliefs in pagan Rome, namely, an
arrangement of the figure friezes on the trough in two superposed registers of
equal height. This device, which made it possible to pack the front of the tomb
with even more content, seems to have been invented specifically for Christian
purposes.[5] The so-called 'Dogmatic' sarcophagus, now in the Vatican and
carved perhaps in the third decade of the fourth century, is one of the earliest
to show this doubling of the frieze (fig. 41).[6] Within each register, scenes are
juxtaposed with the same unconcern for separating historically disparate events
that we noted earlier on the single friezes; for instance, in the lower zone, Daniel
in the Lions' Den is flanked by the Healing of the Blind Man and by the scene
in which Peter is foretold of his denial of Christ. At the same time there is a
marked stylistic change here. The actors in the various episodes do not jostle
one another quite so much. Each is separated from its neighbours by deep
shadows. And, what is particularly important, the crudely drilled lines which
on the earlier tombs had ploughed up all the sculpted surfaces and thus had
spun a web of shadows over the entire relief have disappeared. As a result the
figures stand out as so many solid blocks from which the sculptor has con-
structed a firm and tight composition marked by strong accents in the centre of
both registers, prominent framing bands and suitable props to close off each
frieze at either end. To the left are high-backed chairs serving as seats for God

the Father creating Adam and for the Virgin receiving the Magi. To the right are Lazarus' tomb and the wall from which St Peter produces drinking water. It is the assertion of each figure as a solid three-dimensional entity within this compactly organized framework which is of particular significance. We seem to be able to put our fingers around each one of them – so deeply are they undercut.

This is the direction in which the stylistic development will proceed, as shown by our second example – the sarcophagus of the 'Two Brothers' from S.Paolo fuori le mura (fig. 42).[7] If the two zones of the 'Dogmatic' sarcophagus seemed like shelves of a cupboard packed with solids, here spatial effects have become so strong that there is no longer a single coherent front plane. The medallion with the portraits of the deceased – now a decidedly concave form providing the busts with ample breathing space of their own – seems to float in front of the 'shelves'. The 'shelves' themselves have become so deep that they can accommodate figures and props that are fully in the round; and the figures use these 'shelves' as though they were miniature stages. For instance, in the Healing of the Blind (lower right) Christ turns on his own axis as he performs the miracle; and in the scene of Pilate Washing his Hands (upper right) the figures are arranged in a semicircle around a fully three-dimensional table that once supported the wash-basin.

Implied in this striking transformation is a fundamental change in the function and purpose of visual images on these tombs. If the figures on the early frieze sarcophagi were so many ciphers – shorthand pictographs intended to be read rapidly and to produce their effect cumulatively by recalling to the beholder's mind a multitude of meaningful stories and events – now the beholder is invited once more, as he was in the case of the more developed among third-century Christian images, to linger over each scene. Events are being re-enacted before his eyes. To do this, the artist again falls back on the enormously rich and immensely adaptable repertory of figure motifs that had been evolved in the Mediterranean world since classical times and more particularly in the Hellenistic period. The nude figure of Daniel in the Lions' Den had already been elaborated with some care on the 'Dogmatic' sarcophagus, whose sculptor in carving this figure must have had in mind Greek statues of ephebes; now it becomes a study in *contrapposto* in an almost Praxitelean sense. Similarly, the sister of Lazarus – in the earlier relief a mere accessory, a subsidiary sign spelling 'gratitude' – is now a full participant in the action (fig. 39). She is modelled (somewhat incongruously) after a figure from the repertory of pagan mythological sarcophagi, namely, Phaedra's nurse who sidles up to Hippolytus to bring him the fatal message from her enamoured mistress (fig. 40).[8]

One might interpret differently the stylistic change so clearly manifested in these reliefs. Rather than say that the sculptor uses the classical vocabulary to 'humanize' events and make them seem physically present, one could consider this effect a mere by-product of a renewed effort to create a Christian equivalent of the mythological imagery of pagan sepulchral art. In other words, the associative intent might be claimed to be paramount, just as it may have been previously in the case of those Christian paintings and sculptures of the third century in which biblical events had already appeared in decidedly Hellenistic garb. We lack the evidence to define with precision the artist's motivating force. What we can say is that the sarcophagi here under review truly reflect a stylistic development. We see a change taking place before our eyes over a period of a few decades. Nor is this only a matter of form. Hand in hand with the stylistic change goes a marked thematic expansion, a dilution of the single-minded message of personal salvation to which nearly all the subjects of Christian funerary art had hitherto been keyed. Cyclical narration spread during this period. A scene like Pilate Washing his Hands – here presented in elaborate detail – had had no place in the traditional repertory of themes. Now it serves as an epitome of events relating to the death of Christ, while on another, probably slightly earlier, sarcophagus it forms part of an incipient Passion cycle (fig. 44).[9] Sacred history is being factually re-enacted before the beholder's eyes rather than being merely recalled to his mind for the purpose of conveying an urgent personal message.

The third example in my series is the famous sarcophagus of Junius Bassus, city prefect of Rome, who died in A.D.359 (figs. 43, 46, 47).[10] In this, the best-known of all Early Christian sarcophagi, the frieze form is abandoned. Each episode is given its own niche (or, in the case of the Pilate scene, two niches) within an elaborate and ornate columnar framework. The result is a multitude of miniature stages, and the amount of space and depth in each varies according to the demands imposed by the setting and the disposition of the figures. Certainly the sarcophagus is rooted in the workshop tradition of the preceding decades. The arrangement in two registers alone testifies to this, and so does much of the iconography. There is here, however, a far more definite reattachment to aesthetic ideals of the Graeco-Roman past than we encountered in our earlier examples. In reintroducing a columnar framework – a feature familiar from some types of pagan sarcophagi of earlier centuries – our sculptor was anticipated by the carvers of other Christian tomb reliefs a decade or two before, witness the sarcophagus with Passion scenes already referred to (fig. 44). But we need only compare close-up views of the heads of Pilate from the two sarcophagi to become aware of quite distinctive new elements in the style of

the Junius Bassus reliefs (figs. 45, 46). Forms have become extremely soft. There is a smooth transition from feature to feature and an alabaster-like finish to the whole surface. At the same time the face has become more animated. It has a gentle, lyrical quality, while the other still shows much of the hardness and angularity of early fourth-century reliefs. This lyrical, slightly sweet manner is characteristic of all the figures on the Bassus tomb – even of the Roman soldiers who lead St Peter to his martyrdom (fig. 47). There can be no doubt that the master who introduced this new element to the Roman atelier in which the sarcophagus was carved must have come from the Greek East. To be specific, there are close stylistic analogies between figures on these reliefs and the Cleveland portrait busts which were found together with the series of statuettes depicting the Jonah story. Making allowance for the difference in scale and subject matter, one may compare the head of St Peter with the male heads in Cleveland, and these same busts also show a rendering of draperies analogous to that of the soldier on the right (figs. 32, 47, 48).

This is not the first instance in which a classicizing manner in the art of Rome can be traced to the Greek world. Certainly the Eastern Mediterranean had reserves of Hellenism which the West lacked. We shall come upon this phenomenon again and again. But in the present context two points should be borne in mind. In the first place, the Eastern sculptures which I am citing for comparison are about three generations older than the Bassus tomb. There is no evidence to suggest – and some reason to doubt – that even in Eastern marble ateliers the same polished and soft manner was practised at this level of refinement through the Tetrarchic and Constantinian periods. Thus our hypothetical immigrant master from the East might well himself have been the product of a revival movement, a movement parallel to that which we have seen taking place in Rome. In the second place, the introduction of a soft, lyrical style in the Bassus sarcophagus merely reinforces this latter movement in Rome itself, a movement which had been building up within a single clearly definable workshop tradition for the preceding thirty or forty years. Foreign influence alone cannot account for this entire stylistic development, which we have indeed found to be a corollary to major changes in the function and content of images on these sarcophagi.

The process of regeneration which we have traced on Christian tomb reliefs was, as we shall see, the keynote, the common denominator of fourth-century style developments in general. By going into a certain amount of detail in regard to this one group I hope, on the one hand, to have demonstrated that organic, step-by-step style developments can and do occur, and, on the other hand, to have avoided the danger of describing such developments in too broad

and general terms. Our series of sarcophagi bears witness to a specific evolu-
tionary process in the realm of form which calls for specific explanations. As I
have indicated, in this instance explanations are as yet only partially forth-
coming. However, one additional factor may be cited. At the beginning of our
series of sarcophagi we were faced with a phenomenon of mass production,
presumably for a middle-class clientele. At the end stands an individual and
extremely elaborate tomb commissioned by or for a high official who was a
member of a prominent and wealthy family.[11] This is surely significant. The
aesthetic ideals embodied in the Bassus sarcophagus are those of the highest
stratum of Roman society. Taking a cue from this observation, one might
describe the entire development which I have outlined as a gradual appropri-
ation of a popular type of Christian tomb by upper-class patrons whose
standards asserted themselves increasingly both in the content and in the style
of these monuments. The development could be seen as parallel to and con-
tingent upon the increasing rate of conversion of upper-class people to Christi-
anity in the late and post-Constantinian period. But I find it hard to believe
that so gradual a transformation could have been initiated and guided solely
by patrons. To use again a term which served us in our description of style
developments in the third century, the progressive changes evident in so many
aspects of the imagery of these sarcophagi cannot have been wholly 'other-
directed'.[12] Let us also remember that in the early years of Constantine's
reign the 'aristocratic' form ideals had not been able to prevail even in work
commissioned by the conservative Roman Senate, as the friezes on the triumphal
arch of A.D.315 palpably demonstrate.

There is, then, a rising curve, a regenerative process powered, at least to
some extent, by forces within the artists' own sphere and gathering momentum
as the century progresses. We shall see this confirmed when we turn to other
categories of artistic production of the period after A.D.350. But before doing so,
we must return very briefly to the early decades of the century. For the overall
picture of stylistic currents and cross-currents in those decades is more complex
than I have made it appear so far. In laying stress on the anti-classical tendencies
in the art of the Tetrarchy and in the early Constantinian period, I have failed
to do justice to a number of initiatives in different media and different places
which foreshadow the regeneration to come and which it has become customary
to subsume under the heading of Constantinian classicism.[13] Each one of these
initiatives needs to be explained on its own merits before any conclusions can
be reached regarding their roots, their possible interrelationships or their
bearing on subsequent developments. The subject is too large to be dealt with
in detail here, and I shall have to limit myself to citing a few examples.

Even the work on the Arch of Constantine, an enterprise so largely dominated by craftsmen who were untouched by or unsympathetic to classical standards of form, entailed the activity of at least one sculptor of a different outlook. I refer to the master who recarved the imperial heads on the reused Hadrianic medallions in line with their new destination (fig. 49).[14] His soft, delicate rendering of the face of Constantine with its sensitive mouth and its boyish, carefully groomed haircut reminiscent of Augustus' is a far cry from the dominant style of the workshop. There is a related phenomenon in imperial portraiture on coins. Early portraits of Constantine on coins issued in the West (fig. 50) are remarkably classical in form and spirit, and subsequently this style spread to Eastern mints also.[15] Finally, to cite an example from the realm of painting, the magnificent fragments of frescoed ceilings which have been recovered in the excavation of the imperial palace at Trier and which can be attributed to the period *c.* A.D. 315–25 also betray a decidedly classicizing spirit (figs. 51, 52).[16] Whatever their antecedents may have been, they are certainly in striking contrast to the ethereal type of wall decoration which had been current in Rome in the preceding century (fig. 28). An elaborate system of simulated coffers here serves as a frame for full-bodied figures of bejewelled ladies and nude cupids. Constantinian court art, then, is not without its 'Renaissance' phenomena; and undoubtedly these prepared the ground for the broad regenerative development which followed.

Turning now to the further progress of that development in the second half of the fourth century, I shall first draw attention to a category of objects which, like the Trier paintings, reflect the secular tastes of the wealthy upper class, namely, silver vessels with repoussé or engraved reliefs, of which an extraordinarily large number have survived from that period. Several hoards of such objects, such as the Treasure from the Esquiline in the British Museum and that from Traprain Law in the National Museum in Edinburgh, were unearthed a long time ago.[17] Others, like those from Mildenhall (also in the British Museum) and Kaiseraugst (the ancient Rauracum) not far from Basle, have only come to light in recent decades.[18] Rich in representations of subjects from Greek mythology and especially in those pertaining to Dionysus and his retinue of land- or sea-borne revellers, these silver objects were natural vehicles of classical form. Indeed, in this type of object a more or less pure classical style might be assumed to have been perpetuated almost automatically through the generations. There is, however, no evidence of a strong continuity in the manufacture of such silver work during the late third and the early decades of the fourth century. It is true that the strikingly great incidence of finds dating

from the second half of the fourth century may not reflect increased production
so much as more frequent burial (and hence preservation into modern times)
due to the greatly increased threats of barbarian incursions in all parts of the
Roman world. It is also true that a hoard buried at that time may well contain
objects that are considerably older. But so far as research has elucidated this
problem – and it should be emphasized that a great deal remains to be done in
this area – it has not identified either for the period of the Tetrarchs or for that
of Constantine full equivalents of works such as the Mildenhall Maenad Plate
or the Achilles Plate from Kaiseraugst (figs. 53–5). The point is worth em-
phasizing. It does seem that the demand for such work increased after the
middle of the century. And this demand was not purely frivolous. The attempt
to relate the Kaiseraugst find to Julian the Apostate, who we know made
repeated use of the Castellum of Rauracum during his Gaulish campaign
(A.D.359–60), has aroused grave objections on chronological and other
grounds.[19] But the increased production of such works in this general period
may well be significant and connected with that reassertion of the pagan religion
and the pagan way of life of which Julian was the most famous and most
conspicuous exponent. For instance, the relief on a silver tray (or *lanx*) from
Corbridge (fig. 56), which features Apollo and Artemis, has been plausibly
connected with the cult of these divinities on the island of Delos, and it has
been suggested that the object commemorates Julian's visit there in A.D.363.[20]

It is true that, retrospective as these silver reliefs are in both content and
style, the third-century breakdown of classical form has nevertheless left its
mark on them. None of the figures on the Corbridge *lanx* – man, woman or
beast – bears close scrutiny by the standards of the classical canon of pro-
portions or simply of anatomical verisimilitude, to say nothing of background
features (the aedicula, the tree) or the spindly and highly schematic vine rinceau
on the border. The whole representation is strangely anaemic. The figures on
the Kaiseraugst Achilles Plate are more spirited, but they too have their flaws –
what, for instance, happens to Deidameia's right arm as she tries to hold back
Achilles in the group on the left in the central medallion (fig. 54)? – and both
in their positioning and in their movements they lack a convincing three-
dimensional development. In analysing works such as these, one becomes aware
of how all-pervasive the third-century crisis had been and how basically
irreversible were the trends which it had set in motion. But there can be no
doubt that those who executed these silver reliefs – and those who commissioned
them – were trying to hold fast to ancient tradition if not, indeed, to turn back
the clock. Here, then, is an artistic vogue which, thanks to its subject matter as
well as to the prodigal use of expensive material, can fairly confidently be

attributed to a known element in the social and cultural history of the fourth
century, namely, a wealthy and conservative elite which for a time resisted the
onrush of Christianity.[21] It was especially in the Western part of the empire
during this period that land-owning families were able to accumulate extra-
ordinary wealth and power, and the great hoards of fourth-century silver plate
have, in fact, all been found in the West. But the manufacture of these easily
transportable objects was empire-wide – the Kaiseraugst Achilles Plate, for
instance, bears an inscription showing that it was made in Thessaloniki – and
art historians have so far been unable to distinguish regional workshops or
schools. Thus, definable as this particular impulse towards regeneration is in
historical terms, we are not as yet in a position to measure its overall im-
portance for the history of art in the second half of the fourth century. More
specifically, we cannot yet gauge its precise bearing on two more broadly
based movements belonging to the last decades of the century, to which I
shall now turn. Centred in the Greek East and in the Latin West respectively
both of these movements are sometimes subsumed under the heading of a
'Theodosian Renaissance'.[22]

Theodosius the Great, after Constantine the ablest and strongest of the emperors
of the fourth century, ascended the throne in A.D.379 with the Eastern half of
the empire as his domain. It is in works associated with his reign (which lasted
until A.D.395) that we can first define a distinctive style centred at the new
capital of Constantinople. Objects characteristically 'Theodosian' have come
down to us in a variety of media and they display a considerable range of subject
matter. One senses that some strong artistic personality or personalities who set
the tone and aesthetic standards were active at the centre of political power,
stamping the monuments of this era with an unmistakable imprint.

A good example is provided by a famous silver plate in Madrid, an object of
imperial largesse commemorating the tenth anniversary of Theodosius'
accession and undoubtedly made in an Eastern Mediterranean atelier (figs.
57–9).[23] Delicately wrought in low relief, it represents the emperor solemnly
enthroned before a ceremonial palace architecture (a *fastigium*) as he hands a
diploma of appointment to a high official depicted in much smaller size.
Theodosius is flanked by his two co-emperors and bodyguards, while from the
lower segment of the plate a recumbent female figure personifying the earth
gazes up, recognizing in the enthroned monarch her lord and master. The gifts
of her abundance are being offered to him playfully by three little nude putti
surrounding her.

Since, as we have seen, silversmithing was a particularly flourishing craft

from the middle of the fourth century on, the Madrid Plate gives us a good chance to define the Theodosian style in relation to immediately antecedent forms. It is best for this purpose to focus on the figure of *Terra* (fig. 59), since it belongs to the genus of idealized mythological images so prominent on fourth-century silver vessels generally. A kinship with figures such as those on the Corbridge *lanx* (fig. 56) is easily recognizable. Nude bodies have the same soft, rubbery quality; limbs are similarly unarticulated and, again, the anatomical construction does not bear close scrutiny. *Terra*'s left shoulder and arm, for instance, seem dislocated, and one wonders whether her bent near leg is her left or her right. But there is no direct continuity with the *lanx* or with any other known work of the preceding decades. The Madrid *Terra* is a far more pretentious representation, a figure in a contrived, artificial pose put on display self-consciously and theatrically. Each drapery fold is carefully modelled to suggest the part of the anatomy it conceals, and the hem lines, though rather artificially curled, evoke memories of Attic art of the fifth century B.C. There is an element of studied classicism here which indeed justifies the use of the term 'Renaissance'. But this is only one aspect of the style. There is at the same time an insistence on clear, continuous and simplified outline, on neatness and regularity. Flat as the relief is, the figure's silhouette stands out in long, straight or gently curving lines. The facial features merge into a smooth, elongated oval, and the line of the forehead with its surrounding wreath is echoed in the cornucopia to the left, just as the outline of the figure's intervening arm and hand is rhythmically correlated with that of the leaping putto immediately to the right. Classicist form is oddly paired with linear abstract order.

In the main part of the relief, the geometric element is much more in evidence. It may seem paradoxical to find schematism and abstraction carried farthest in the representation of the reality of Theodosius' court, while mythical *Terra* and her surrounding putti, whose presence clearly is meant to impart to the scene cosmic and timeless significance, have an air – however contrived – of playful casualness. The answer, of course, is that it was precisely in regard to the reality of the imperial person and its exercise of authority – as exemplified by the ceremony depicted – that timelessness and absolute stability most needed to be emphasized. The devices employed to this end – strict symmetry of composition, clarity and simplicity of line, repetition of wholly or nearly identical forms with circular and oval shapes predominating – leap to the eye.

Despite the difference of scale and material, it is not difficult to recognize the same essential qualities in the reliefs on the four sides of the cubic stone base which supports the Egyptian obelisk erected by Theodosius in the midst of the hippodrome of Constantinople and which stands in its original location to

this day (fig. 60).[24] Executed a few years after the Madrid Plate and placed within a stone's throw of the imperial palace, the reliefs are proof that the Theodosian style was indeed practised – and very possibly created – in the capital. Like the silver relief, they depict solemn ceremonial appearances of the emperor and his entourage, and there is in them the same stylistic dualism (fig. 61): symmetry and geometric order are paired with careful, delicate modelling and loving elaboration of detail. Drapery folds form soft, flowing curves which enliven the surfaces of figures subtly modelled in very low relief. But nothing is allowed to interfere with the neatness of outlines repeated with monotonous regularity. The beholder is confronted with row after row of emphatically oval heads placed on drooping, rounded shoulders to form a continuous array of smooth, sinuous contours. Physiognomies too, while individualized to some extent, are not allowed to disturb the regularity of the ensemble. The artist operates with a limited number of facial types, all distinctive of this period. The most characteristic is a smooth, boyish face, already familiar to us from the Madrid Plate, with a single neat curve outlining cheek and chin, and a low forehead sharply delineated against a closely fitting cap of hair (figs. 58, 74). Combining a measure of 'Hellenic' idealization with a strange kind of blandness, these faces betray both the aspirations and the limitations of the 'Theodosian Renaissance'. The most perfect embodiment of that era's aesthetic and human ideal is a life-size portrait in the round from Aphrodisias (fig. 62).[25] It is a face of the same type and in all probability represents Valentinian II, Theodosius' co-emperor in the West (A.D.375–92).

The court style of Theodosius I should be clearly recognized for what it was, namely, a new departure rather than the outcome of a gradual step-by-step development. The Madrid Plate – so we have seen – is not simply a sequel to earlier fourth-century silver work. Similarly, the reliefs of the obelisk base or the Aphrodisias portrait have no evident antecedents in their own century;[26] although it would be difficult to name one specific model from earlier times which the artist could have had in mind, his ideal of the human countenance – calm, serene and formally perfect – is clearly inspired by and suggestive of classical precedent. The most palpable proof that there was indeed under Theodosius a conscious revival of forms associated with distant 'golden ages' is provided by the great triumphal column which was erected on the emperor's new forum in the capital and of which only pathetic fragments now remain.[27] Adorned with a spiralling relief band which depicted in great detail Theodosius' military campaigns, this monument was obviously modelled on, and meant to rival, the Columns of Trajan and Marcus Aurelius in Old Rome. No such work had been created in the intervening two hundred years. Perhaps one can

go a step further and suggest that this entire artistic effort with its classicizing overtones has to do with the fact that Theodosius was a 'new' man unrelated to the Constantinian house, determined to establish his own dynasty and hence a traditionalist in matters of style.[28]

This can only be a suggestion. Too little is known about the circumstances in which these works were created. We reach much safer ground when we turn to a Western development concurrent with the 'Theodosian Renaissance' in the East.

Among all the initiatives towards regeneration in the art of the fourth century, it is this Western development which is most clearly related to specific historical circumstances. Its primary exponents are objects commissioned during the final decades of the century by members of the old senatorial families in Rome, who in those years were making their last heroic effort at a pagan revival.[29] A famous ivory diptych (fig. 63)[30] with two officiating priestesses – the left half in the Musée de Cluny in Paris, the right half in the Victoria and Albert Museum – is the most eloquent artistic witness to this amply documented *Kulturkampf*[31] which was carried out on many fronts – political, religious and intellectual. Inscribed with the names of the Nicomachi and the Symmachi, two of the families most prominently involved in this struggle, these panels proclaim their patronage *expressis verbis*. They depict in solemn and accurate detail rites, attributes and settings appropriate respectively to Ceres and Cybele and to Bacchus and Jupiter, and are clearly intended as professions of unswerving devotion to the ancient gods. But what is most important in our context is the fact that the past is here being resuscitated also by purely formal means. The carver of these ivories must have studied classical Greek sculptures and their Roman replicas. Indeed, he must have deliberately set out to create an equivalent of such works. The setting, the composition and the figure and drapery motifs can be matched to a remarkable degree on the so-called 'Amalthea' relief formerly in the Lateran, one of several replicas of what must have been a well-known Greek original depicting an as yet not satisfactorily identified mythological scene (fig. 64).[32] Already the earlier work, which is a typical product of the Greek revival under Hadrian, has a chilly, academic quality. In our ivory this quality is enhanced. What distinguishes these carvings from a work such as the Corbridge *lanx* is that their classicism is so studied and conscious. They are exercises in nostalgia undertaken in the service of a very specific cause.

More than one atelier of ivory carvers must have worked for this powerful and enormously wealthy clientele. For instance, a diptych in Liverpool (fig.

65)[33] portraying figures – or, to put it more correctly, statues – of Asclepius and his daughter Hygieia (health personified) is clearly a work of the same period and the same retrospective spirit, but shows stylistic nuances different from those of the two priestesses. The modelling is softer, the figures are more ponderous, and as they stand on projecting pedestals they produce a more decidedly three-dimensional effect with space all around them.[34] Yet another variant of the style is exemplified by a silver plate from Parabiago in Milan (fig. 66), representing the triumph of Cybele and Attis, a work which must also owe its existence to the same group of last-ditch defenders of the old faith. So strikingly retrospective is its manner that the first study devoted to it attributed it to the second century A.D.[35]

In the history of late antique and medieval art there are few instances of a stylistic vogue so patently associated with an identifiable cause. The classicism of these works is insistent, not to say aggressive. It is not merely a by-product resulting more or less automatically from the depiction of pagan mythological themes. On the contrary, it is consciously elaborated and emphasized, so as to lend greater force – add another dimension, so to speak – to the message which these themes were intended to convey. The persons or groups responsible for the subject matter can be identified. May we not assume that these same patrons also instigated and promoted its formal corollary? Our earlier antithesis of 'inner-directed' and 'other-directed' stylistic developments is clearly relevant here. The academic classicism of these late fourth-century Italian works is as good an example as one can find of a largely 'other-directed' style.[36]

This revival was to have a profound impact on the whole development in the West, as I hope to show. For the moment I shall confine myself to one of the most immediate ramifications of the movement, namely, its influence in the sphere of official art. The period which witnessed the manufacture of those nostalgically retrospective ivory reliefs was also the period when the annually appointed consuls and other high dignitaries adopted the practice of distributing among their friends and peers ivory diptychs to commemorate their assumption of office. It is another instance of the ostentatious consumption and display of expensive materials which we found became rampant among the wealthy and powerful during the latter half of the fourth century. Given this patronage, it is not surprising to find that some of these official diptychs were made in the same (or closely related) ateliers that produced those with pagan religious themes, and there can be no doubt that the aesthetic ideals which informed the latter also helped to shape the style of the former.

The diptych of Probianus, *vicarius* of the city of Rome, is a case in point

(fig. 67).[37] At first sight it appears to have little in common with the pagan group. Its two halves present nearly identical compositions showing the principal figure immobilized in a strictly *en face* view on the central axis, with attendants of smaller scale flanking him, and acclaiming officials of yet another scale in a separate zone below. Once again abstract principles of symmetry, frontality, and differentiation by scale and registers serve to express power and authority. But the scene is enframed by a delicately wrought palmette ornament virtually identical with that on the borders of the diptych of the two priest-esses (fig. 63). This is a tell-tale detail indicating a close relationship between the two works as regards both place and time of manufacture. It is true that the carver of Probianus' diptych, while taking over the classical ornament of the Nicomachi relief, did not similarly emulate the latter's 'wet drapery' style. The heavy official costumes worn by all his figures did not favour this particular revival element. It is true also that his figures are squatter in proportion and lack the harmoniously balanced poses of the priestesses. But their organic and well-articulated build, their strong bodily presences, their easy, natural move-ments and the soft, sinuous flow of their garments betray the hand of an artist determined to apply to the official imagery of the period traditional Graeco-Roman standards for the rendering of the human form.

What is significant above all is the artist's evident concern to place his figures in a plausible spatial ambient. To do this within the elongated format of the diptych he has even jeopardized its compositional unity by closing off the lower zone in a complete frame of its own. While thus incongruously dividing the acclaiming figures from the object of their acclamation, he has gained for the principal group a naturally proportioned panel which an architectural setting, designed in perspective, turns into a plausible view of an interior. Though far too small in scale for the figures inhabiting it, it is a remarkably life-like, even intimate, setting foreshadowing the box-like chambers of fifteenth-century painting. No exact antecedent for such a use of architectural perspective has yet been found in ancient art, but the elements are clearly those developed in Roman painting in the first century A.D.[38] Not to compete with this effect in the lower zone and yet to provide a spatial setting for the figures in that zone also, the artist has given them – again somewhat incon-gruously – a strip of outdoor terrain to stand on. The incongruity of this locale is enhanced by the ornate table he has placed between the figures, though in its foreshortened view the table also gives the composition a further spatial accent.

Other official ivories created during this period do not show the kind of tangible link with a workshop involved in the pagan revival that we find in

Probianus' diptych, but are nevertheless imbued with the spirit of that revival. Probus, a member of the great family of the Anicii, became consul in A.D.406, more than a decade after the pagan reaction had collapsed as a political movement. His diptych at Aosta (fig. 70)[39] portrays on both its leaves his sovereign, the West Roman emperor Honorius, in the classical guise of the cuirassed *imperator* familiar from Roman statuary. Indeed, one wonders whether the diptych was meant to represent not the actual person of the emperor but his statue, paralleling in this respect the Asclepius diptych in Liverpool (fig. 65), which it recalls also in its composition. But there is at the same time a definite suggestion of a locale as the massive, powerfully modelled figure moves forward from the plane of the relief.

The tall, narrow format of these diptychs lent itself well to this kind of statuesque presentation. The panel here assumed the role of a niche or a gateway with strongly spatial implications. Multifigured reliefs, on the other hand, posed a more difficult problem, witness the diptych of Probianus. Two other official diptychs (or rather, single surviving leaves of diptychs) of this period – one in Brescia, the other in Liverpool – are interesting in their attempt to inject into complex figure compositions a modicum of spatial illusion (figs. 68, 69).[40] They introduce a subject that was to be represented many times throughout the period during which these diptychs were in vogue, namely, a consul or other high dignitary presiding over circus or amphitheatre games of which he was the donor. The Brescia leaf is inscribed with the name of the Lampadii and its lost companion leaf bore that of the Rufii.[41] Once again we are in the sphere of the Roman senatorial nobility. With his smooth, carefully rounded face and his regular features, the dignitary, here shown seated in his loge between two lesser officials, recalls the portrayals both of Probianus on the Berlin diptych and of Honorius on that in Aosta, although a certain hardening of line may indicate yet another atelier or possibly a slightly later date. But what is especially noteworthy is the artist's success in suggesting actual physical relationships in space within the awkward format of the panel and despite his evident concern to make the donor of the games the centre and focus of the whole composition. He has not made use of a perspective architectural setting in the manner of the Probianus relief, but he has also avoided splitting the scene into two separate halves. Although he has combined an eye-level view of the official party sitting in its box behind an ornate parapet with a bird's-eye view of the chariot race in progress below, visually the two parts form a unit. There is, indeed, a suggestion that the box overhangs the arena.

The panel in Liverpool is clearly related. Here the event in the arena is a stag hunt whose episodes are arranged in a frankly abstract manner in five

superposed registers. There are, in fact, other ivory reliefs of the same general
period composed entirely in terms of such abstract two-dimensional designs.
In particular, the composition of the circus scene in the Liverpool panel
closely recalls that of a diptych with *venatio* scenes in Leningrad, which cannot
with certainty be identified as an official diptych (since it lacks a representation
of a presiding dignitary) and which displays on both its halves identical groups
of men and animals neatly laid out in a vertical pattern (fig. 71).[42] The carver
of the Liverpool panel must have been familiar with this type of composition.
But he transmuted it, 'bent' it, as it were, to inject it with a measure of spatial
plausibility. Half-open doors at the edges of the arena, with attendants emerging
from them, are strongly suggestive of depth. As for the official spectators, who
here, as in the diptych of the Lampadii, occupy the top part of the panel,
they recede into what may be realistically considered as background. They are
much smaller in scale than their counterparts on the Brescia relief; credibility
is not strained by making the principal figure larger than the two companions;
and, especially noteworthy, the lower edge of their box is slightly but effectively
overlapped by the curved rim of the arena. This interest in natural spatial
relationships goes together with a particularly soft and delicate manner of
modelling and, once again, the use of a classical *kymation* as a frame ornament.
Clearly the aesthetic ideals propagated by the patrons of the pagan revival have
helped to shape such works.

That movement thus stands revealed in some of its wider repercussions. As
I have said, scholars have at times lumped together the art to which it gave rise
with the products of Constantinopolitan court art of the same period, including
both under the heading 'Theodosian Renaissance'. From an ideological point
of view this is misleading since the Western development is bound up with an
active and militant opposition to Theodosius' anti-pagan policies. Nor is there
much evidence of actual contacts between the Eastern and Western workshops
concerned. Occasionally – in the facial type of the emperor on the diptych of
Probus or in the extraordinary softness and delicacy of carving of the *venatio*
relief in Liverpool – one may suspect a direct influence of East Roman court
art. But on the whole the Western works we have discussed do not exhibit the
specific style features we found to be characteristic of that art. At their core lies
a separate initiative, distinct in patronage and intent, in subject and form.

There is, however, another factor common to the two movements, and it is an
important one. Both carried over into the production of Christian imagery as
well.

We have encountered the typical physiognomies of persons and dignitaries

at Theodosius' court. Artists at Constantinople in the 380s and 390s A.D., when called upon to depict scenes from the Gospels, cast their image of Christ in the same mould. On a fragmentary marble relief at Dumbarton Oaks representing the Healing of the Blind Man (fig. 72), Christ unmistakably bears the same characteristic facial features (cf. figs. 73, 74). Nor is the influence of court art upon this work confined to the countenance of the Saviour. The entire event assumes the character of a court ceremony, with the afflicted man appearing in the role of a suppliant, the apostle accompanying Christ in that of a standard-bearer (the cross being the insignia of Christ's power), and Christ himself as the ruler performing his act of grace with sovereign ease.[43]

Infiltration of elements from imperial art into Christian contexts was a process which had been going on continuously throughout the fourth century. A major factor, particularly in the iconographic development of Christian art during that period, it reflects powerful and important ideological trends intimately connected with the Christianization of the state.[44] The process reached a climax in the Theodosian period. What we find in this period – and the Dumbarton Oaks relief exemplifies this very well – is a complete recasting of Christian subjects in terms of contemporary court art, undoubtedly at the hands of artists who actually worked for the court. As a result – and this is the aspect which specifically concerns us – Christian art in and around Constantinople became deeply imbued with the spirit and the forms of the 'Theodosian Renaissance'. Suffice it to cite one other monument which quintessentially embodies traditional values of formal purity and perfection thus powerfully injected into Christian imagery, namely, a small marble sarcophagus found in Constantinople some fifty years ago and generally thought to have been made for a prince of the Theodosian house (fig. 75).[45]

To observe the Western counterpart of this Christian classicism, we turn once more to small reliefs in ivory. A famous panel in the Bavarian National Museum in Munich depicts in similarly pure, clean forms and carefully elaborated detail the Marys' Visit to the Tomb and Christ's Ascension (fig. 76).[46] This remarkable work is not, however, simply an offshoot of Constantinopolitan court art. The direct antecedents of the figures of the Holy Women who here approach with measured step and restrained pathos the Lord's sepulchre are figures such as the priestesses on the ivory diptych of the Nicomachi and Symmachi (fig. 63). The whole elegiac atmosphere of this relief, with the hushed action taking place around an artfully wrought tempietto in some sacred grove, is inspired by those products of nostalgic paganism. The approximation would be closer still had not the innate Christian urge to pack the image with content resulted in a second and more dramatic scene being put

into what should ideally have remained open and clear background space. This insertion negates the unity of scale and prevents the mood of idyllic calm which the setting engenders from being developed fully. But the ancestry of the work is unmistakable. The Holy Women's Visit to the Tomb is imbued with a spirit reminiscent of a Greek tomb relief. Once again we are led to ask what role this associative element played in the mind of the artist and in that of his patron. Was it the subject which prompted (or, at any rate, facilitated) the use of such emphatically pagan forms? Or was it, on the contrary, a desire to create a Christian equivalent to classical imagery in an elegiac mood which determined the choice of subject? This we cannot know. But there is, indeed, a second ivory relief of similar date and origin which depicts the same event (fig. 77),[47] and this panel bears evidence of having actually been carved in the same atelier which produced the diptych with the priestesses. Surrounding the door of Christ's tomb there appears once more the characteristic palmette ornament which we found on the frame of that diptych and also on that of the diptych of Probianus, the Roman official; as in the case of the latter work, the scene has been bisected quite irrationally so as to create two approximately square panel pictures, each with its own separate setting. It is evident that one and the same workshop served impartially the causes of pagan reaction, image-conscious officialdom and, we may now add, Christian devotion; in all three contexts it was apt to use the same formal and ornamental devices.

There is rich irony in the thought that it was the Nicomachi, Symmachi and other like-minded patrons who thus helped to bring about a massive transfer of pure classical forms into Christian art. They had fostered these forms – and the values underlying them – as part of their defence of the pagan religion and the old way of life. In effect they helped to set a new course for the art of their adversaries. The obvious explanation is that there was a large and important element on the Christian side eager to take up the challenge. By the late fourth century much of the Christian patronage of art in Rome and other Italian centres came from persons belonging to the same social stratum and nurturing the same aesthetic values as the die-hard defenders of the old faith. The great silver casket from the Esquiline Treasure in the British Museum may serve to illustrate the point. A bridal gift for Projecta – a member of another prominent and wealthy Roman family – it displays on its lid a very classical Venus on a seashell surrounded by Tritons and Nereids, while the accompanying inscription expresses a pious Christian sentiment (fig. 79).[48] When persons of such background and social rank commissioned work that was Christian not only in verbal expression but in subject matter as well, they naturally saw to it that the same artistic standards were maintained. The best way to ensure this was

to employ the very same artists who were working for their peers in the opposite camp.

What we see happening here in the realm of the visual arts has an exact parallel in literature. It is sufficient to cite the name of St Ambrose, the great Bishop of Milan, who was also a scion of a prominent family. Although in theory he rejected artfulness in writing, the stylistic quality of his own literary production was of great concern to him. His models were classical writers such as Cicero, Livy, Tacitus, Sallust and Virgil, a roster which includes some of the very same authors whose texts his pagan opponents strove to keep alive and incorrupt by a systematic enterprise of editing and commenting.[49] It is exactly the same relationship as that between the pagan and Christian ivory diptychs of the period.

However, the parallel between art and literature goes further. It is a well-known fact that the literary and philological activities sponsored by the last defenders of paganism proved enormously important not only for contemporary Christian writing but also for passing on good texts of the classics to the Western Middle Ages.[50] In the same way, the pagan revival in art fostered by the Symmachi and their like-minded friends not only rubbed off on Christian work of the same age but also set standards and models of a classically oriented Christian art for centuries to come. In particular the Carolingian and to some extent also the Ottonian Renaissance were to draw on works of this period for inspiration and emulation. For instance, a Carolingian ivory in Liverpool reproduces with remarkable fidelity the scene of the Holy Women's Visit to the Tomb from the Munich ivory (figs. 76, 78).[51] A rich element of humanism was thus injected into the mainstream of medieval art. There are few examples in history that illustrate so dramatically what far-reaching effects a struggle for a lost cause may have. Foredoomed though it was, the last-ditch stand of the defenders of paganism in Italy probably had an even greater overall impact on medieval civilization than the 'Renaissance' sponsored by the court of Theo-dosius in the East.

To conclude this discussion of how Christian art in the West reflects the retrospective attitude of the late fourth century, I shall turn finally to a work of monumental art, namely, the mosaic in the Church of S.Pudenziana in Rome (fig. 80), probably of the period of Pope Innocent I (A.D.402–17). The earliest of the great Christian apse compositions to have survived (albeit as a ruin only), the mosaic can serve well both to substantiate and to broaden our view of the dominant stylistic trends of the period, formed so far on the basis of works of the minor arts.[52]

Mosaic is a medium which by this time had risen to special prominence and

which was to play a key role for many centuries to come. To rehearse its earlier history even in outline would take us too far afield. It is enough to say that the emergence of glass mosaic as a principal form of decoration for walls and vaults was an outcome of an aesthetic revolution in architecture which was essentially a counterpart to the great upheaval in the pictorial arts discussed in the previous chapter, although it had begun as far back as the early imperial period. By the fourth century it had long since become the wall's primary role to delimit and define a hollow interior space rather than to function as an articulated bodily entity in its own right.[53] Thus three-dimensional membering and modelling of surfaces gave way increasingly to sheathing with polychrome and highly polished materials. The third and fourth centuries were a period of experimentation with different kinds of pictorial decoration that would leave the envelope of the interior space smooth and inviolate; be completely at one with it physically and aesthetically; and at the same time enhance its effect by the glitter and the richness of the materials employed. From these experiments mosaic emerged victorious being much the most supple and flexible of incrustation media.

In S.Pudenziana it was used in an illusionistic spirit reminiscent of Roman wall decorations of a much earlier period. A magnificent architectural vista, now sadly curtailed at either side, opens out before the beholder and serves as a dramatic setting for Christ enthroned in imperial splendour amidst his apostles. The two groups of disciples, truncated below and drastically restored (particularly on the right), can no longer be fully visualized in their compositional relationship either to the central figure or to the setting. What is clear is that although the apostles overlap one another – thus implying some recession into depth – they actually form (or formed) a solid front, with the ascending lines of their heads leading up to the majestic figure of Christ in the central axis.[54] But while the protagonists are (or were) thus displayed in an essentially two-dimensional triangular pattern, there is – an effect which can still be fully perceived today – a succession of receding planes behind them. Two female figures – generally interpreted as personifications of the Church of the Jews and the Church of the Gentiles – stand behind the seated apostles and by their position create a suggestion of an interval of open space separating the solemn assembly from the semicircular portico enclosing them. The portico in turn serves as a screen behind which we see the roofs and upper parts of distant buildings against a magnificent evening sky, from whose multi-coloured clouds the four winged beings of the Apocalypse emerge. The hill of Golgotha with its huge jewelled cross rising immediately behind the portico forms yet another, intermediate, plane.

One must not overstate the amount of realism that has been achieved in the depiction of space. There is no 'aerial perspective', no suggestion of haze enveloping the more distant figures and objects. Nor is there consistency of scale. The distant cross and the even more distant apparitions in heaven, being enormously large, dwarf the foreground group and seem to tower above it rather than recede behind it. The whole surface is cluttered and crowded. Nevertheless, the fact remains that the artist has provided his figures with a coherent spatial setting and that he has produced a highly dramatic effect by a succession of planes staged in depth. Spatial illusion gains further from the fact that the conch in which the mosaic is placed is not the usual quarter-sphere but a largely vertical expanse of wall curving forward only near the top.[55] As a result, the main group of figures is physically in an upright position and there is a smooth transition from the beholder's space to the space they inhabit, a space which with its curved architectural scenery echoes and underscores the real curvature of the apse. The sanctuary seems to be opening out, affording a vision of Christ's heavenly court.

The devices used by the artist are those developed in late Hellenistic and early imperial art. Vistas of the tops of distant buildings, their lower halves concealed by screen walls, are familiar background scenery in reliefs of that period and a key element in the so-called Second Pompeian Style of wall painting.[56] Elaborate architectural backdrops of various kinds were frequently used in official art of the first and second centuries A.D. to enhance the solemnity of imperial appearances.[57] Often these settings denote specific locales; and the same may be true of the scenery of the mosaic of S.Pudenziana, whose designer may have incorporated features of contemporary Jerusalem in the view of the heavenly city in which Christ holds council.[58] But in the art of the third and fourth centuries such topographic references had become more and more sparse and incoherent, and so far as assemblies of Christ and his apostles are concerned – a theme frequently depicted in catacomb paintings of the fourth century – there is no previous example which shows this scene placed against so elaborate a backdrop. Clearly our designer was harking back to the art of a much earlier age. Even in Hellenistic and early imperial art, however, his creation has no precise antecedent.[59] Like the designer of the exactly contemporary diptych of Probianus, but on a far more grandiose scale, he has operated freely with the spatial devices of that earlier period to create for a figure of authority a setting that makes the triumphant presence highly dramatic and palpably real.

The diptych of Probianus, so we have seen, has a tangible connection with the pagan revival in Rome. It was carved in a workshop which served that cause.

For our mosaic there is no such concrete link, and it would be rash to claim that it was made under the direct influence of that movement. Its Roman affiliation is not in doubt.[60] But we must remember that in Rome, as elsewhere, there had been other revival efforts in the course of the fourth century. The art of the pagan reaction is merely the culmination, the quintessential expression of much broader trends; while it had clear and demonstrable repercussions also in Christian art, in the case of a work such as the S.Pudenziana mosaic one can speak only in general terms of a response to the challenge that had been posed, a taking up of stimuli that had been received.[61]

In our survey of the art of the fourth century we have found a number of distinct impulses and initiatives in different places and at different times. Many were linked to some particular clientele and often they were concentrated in particular crafts. Undoubtedly, however, these impulses influenced one another and to some extent were sparked by or gained momentum from each other. It is surely remarkable that in different ways they all involve a return to classical formal standards. A more thorough investigation of fourth-century art would not substantially change this picture. There is a chain reaction, a snowballing effect. To unravel at this distance the precise interplay of forces which produced this effect is impossible, but its reality is undeniable. The whole is larger than the sum of its parts. If abstraction and anticlassicism were the keynote of the art of the third century, regeneration was the keynote of the art of the fourth. It was, let it be recalled once more, a period in which the classical heritage reasserted itself with equal force in the world of thought and letters, not only in the writings of professional pagans like Libanius and Julian, Symmachus and Macrobius, but also in those of Gregory, Bishop of Nyssa, and Ambrose, Bishop of Milan.

Fifth-Century Conflicts – 1

The fourth century confronted us with a variety of distinct artistic initiatives and impulses in different places and different media. This is even more true of the fifth. One of the striking characteristics of Mediterranean art of this century is a greatly intensified regional diversification. It was a natural corollary of strongly centrifugal processes in the political, cultural and religious spheres. With the empire divided between the two sons of Theodosius I, its Eastern and Western halves had been set irrevocably on separate courses. The West sustained the shocks of successive Germanic invasions and its entire political fabric was disrupted in the process. The East, while maintaining its essential political unity, developed deep religious cleavages over the question of the divine and the human nature in Christ, cleavages which brought to the fore particularist tendencies in countries such as Egypt and Syria.

The artistic heritage of the period, fragmentary as it is, concretely reflects this diversity. In Italy, for instance, distinct developments can be traced in Ravenna – successively the refuge of the Western imperial court and the seat of the Germanic kings of Italy – and in Rome, where the military and political upheavals left only the papacy intact as an effective power. In the East a number of countries evolved during this period regional idioms of their own, the most characteristic being the so-called Coptic style in Egypt. Diversity is accentuated further by the fact that many of the developments seem to be once again conditioned by particular crafts or associated with particular categories of objects.

At first sight the variety is indeed bewildering, and in attempting to give a unified account of the fifth century as a whole the art historian runs an exceptionally grave risk of oversimplifying matters. The very fact of fragmentation must be counted among the primary characteristics of the period. Yet as one surveys the different regions and the different crafts, common traits, or at any rate common symptoms, do emerge. Everywhere in one way or another the classical tradition which had so strongly reasserted itself in the course of the fourth century was subjected to new challenges. It was confronted with opposing tendencies of various kinds that brought about subtle and slow modifications in some instances, drastic and radical changes in others. This element

of conflict runs through all the new artistic departures of the century. In the aggregate they amount to a second major step in the transformation of the Graeco-Roman heritage, comparable to and perhaps to some extent inspired by that which had taken place in the third.[1] The very diversity of fifth-century developments makes this common basic tendency strikingly real and apparent. But it also raises in singularly acute form the problem of how such period trends should be explained and interpreted.

Our approach must of necessity be particularly selective when dealing with this period. Let us turn first to ivory reliefs which lend themselves well for an initial glimpse of the new stylistic departures of the fifth century.

The practice of celebrating the assumption of high office with the distribution of elaborately carved diptychs continued throughout this period and, indeed, well into the sixth century. Among surviving examples a fair number relate to known personages and thus provide us with secure chronological guideposts. It is instructive to compare the diptych of Boethius (fig. 81),[2] consul in A.D.487 (and father of a famous son, the author of *De Consolatione Philosophiae*), with examples of the period around the year A.D.400 which we have seen previously. Once again we are in the sphere of the high Roman aristocracy, and in having himself represented as a statuesque figure against an architectural frame Boethius adhered to an old-established type (cf. fig. 70). But the contrast in rendering is startling. On one leaf the consul is shown standing, on the other seated as a donor of games. Neither figure functions in space. Rather, it appears to be affixed to its architectural foil with the head oddly pressed into the entablature. The figure's bulk shuts off any glimpse of a third dimension behind it, and it hardly acts as an autonomous organism. The standing consul's arms and legs hang limply; the seated consul's right hand juts out jerkily and awkwardly – the upper arm seems missing altogether – as he gives the signal for the games with his *mappa*. There is no consistency of proportions just as there is no harmony or rhythm of movement or posture. An enormously large head rests on an underdeveloped bust. Classical standards are firmly rejected also in the manner of carving, which is almost aggressively hard and angular, especially in the rendering of folds reminiscent of the so-called chip carving techniques in sub-antique and Germanic art. With its square jaw, heavy bulk and big staring eyes, the portrait of Boethius seems to take us back to the days of the Tetrarchy. Like those earlier portraits it gives the appearance of having been designed deliberately to project an image of brutal strength.

It should not be inferred, however, that members of the Roman nobility were now – in the years following the final collapse of the Western empire in A.D.476 – suddenly and purposefully turning against the ideal of a refined

academic classicism propagated by their forefathers three generations earlier. The loss of that ideal was a gradual process which can be followed in a series of diptychs made for high officials in the West in the intervening period. One can observe how figures lose their firm stance on a plausible base so that increasingly it is the background which provides them with material support. Suggestions of space around and behind them are correspondingly diminished or eliminated entirely. Proportions become ponderous, attitudes stiff and wooden, faces mask-like with big lifeless eyes staring into the void. Rounded relief gives way more and more to sharp incisions and hard schematic lines. While not every official diptych of the period between *c.* A.D.420 and 480 bears witness to every aspect of this development, there is unmistakably an overall progression in the sense indicated (fig. 82).[3]

A corresponding stylistic change can be observed in ivories depicting Christian subjects. The artist who carved a series of scenes from Christ's Passion on four small panels now in the British Museum (fig. 83)[4] – originally in all probability parts of a casket – clearly was rooted in the tradition which in the years around A.D.400 had produced those Christian reliefs of markedly classicizing character discussed in the preceding chapter. Indeed, the time lag vis-à-vis the Munich plaque with the Holy Women and the Ascension (fig. 76) may not be great, and the London pieces must have been made in much the same geographic ambient. Facial types, drapery style, attitudes and gestures are similar, and something of the gentle lyrical mood so characteristic of the Munich ivory also persists. But the figures have become much heavier and as their bulk has increased they have, as it were, consumed and gathered into themselves the space that had enveloped their counterparts in the earlier work. As a result, compositions have become extremely tight and, despite the very high relief, essentially two-dimensional. I would attribute to a slightly later date a group of small reliefs with Gospel scenes divided between the museums of West Berlin and the Louvre (fig. 84).[5] While less crowded, these carvings show a loss of feeling for or interest in the human figure as a smoothly functioning, three-dimensional entity. Not only is the relief here much flatter, but actions and movements tend to be projected on the background plane against which the figures are quite sharply silhouetted. Concern with narrative expressiveness had already operated to the detriment of grace and elegance in the case of some figures in the British Museum panels. On the panels in Berlin and Paris movements are generally jerky and rather mechanical; all action is plain and direct and nothing of lyricism remains. A course was set for a radical stylistic transformation that becomes fully apparent later in the century in the Gospel scenes carved on a pair of book covers in Milan Cathedral (fig. 85).[6]

These scenes combine the crowding of figures in the London panels with the drastic and lively depiction of action on the panels in Berlin and Paris, but now in a generally flat relief. Cursorily drawn, the figures do not project with any force even though many of them overlap their frames. Indeed, it is the framing system of squares, circles and oblongs which predominates. The carvings make a pattern, a foil for the cloisonné metalwork of the Lamb and the cross mounted as principal features in the central panels of the two covers.

All the ivories cited so far were made in the West and presumably in Italy. We cannot with certainty identify the centre or centres that produced them – Rome, Milan and Ravenna all have their claims and their advocates in specific instances[7] – but there is a strong coherence and consistency in the stylistic development to which they bear witness.

Turning to the Eastern Mediterranean, we do not find a similarly coherent sequence of ivory carvings of the fifth century, either official or Christian. Yet a corresponding, though quite distinct, development must have taken place there also. For such a development is presupposed by a remarkable group of diptychs made for Constantinopolitan dignitaries just after the end of the century.

At first sight it is hard to realize that the diptychs of Areobindus,[8] consul in A.D.506, and of Anastasius (figs. 86, 113),[9] consul in A.D.517, perpetuate the old theme of the circus games presided over by the official who has donated them (cf. figs. 68, 69). The curved edge of the arena is still shown, the proceedings within are lively enough, and we even see groups of spectators crowded behind the barrier. But the relationship between this scene and the donor, now an enormously enlarged, full-length figure majestically enthroned in splendid isolation on an elaborate seat, is conceptual only. The beholder is not given the slightest hint as to how the two parts of the composition might relate to one another in real space. The scene in the arena is relegated to a kind of predella. There are, it is true, much earlier precedents for this device. Thus on the base of Theodosius' obelisk (fig. 60) the events of the hippodrome are depicted in small scale in the bottom zone, with a correspondingly lopsided emphasis on the august person (or persons) presiding in the kathisma above. One may cite the precedent of Theodosian court art also for the strictly *en face*, full-length image of the enthroned potentate (see fig. 57). But granted that such antecedents played their part in shaping the composition of these diptychs, the difference is still enormous. Overloaded with paraphernalia and symbols of triumph and majesty – elaborately carved thrones supported by heraldic lions and adorned with victories and imperial portraits; heavily emblematic sceptres; garland-bearing putti – the relief forms a tight pattern closing off the third dimension

entirely. The principal figure with its spherical face, its staring, circular eyes and its stiff and richly ornamented official costume which sheathes the body like armour, itself becomes an emblem and an integral part of this pattern. Compared with the gentle modulations of Theodosian art, the carving, particularly in Anastasius' diptychs, has a harder, more metallic quality.

Clearly the style of these reliefs presupposes a development corresponding to that which we have observed in the West. One finds in the East a similar hardening of forms, elimination of space and depth, creation of a surface pattern coextensive with and supported by the material surface of the panel, and a stiffening and schematization of figures and faces. Compared with their Italian contemporaries the Eastern diptychs display much greater precision, discipline and polish. The consul's physique is presented without undue distortion or imbalance of proportion, devices that helped to make the figure of Boethius the forceful portrayal that it is. But there is in the Eastern diptychs the same – or, indeed, an even greater – concern with a direct and palpable display of power, witness the almost obsessive accumulation of emblems and symbols around the consul's person. By locking his figure and his action firmly into an overall pattern the majesty of his office is given a precise visual expression. The image is made timeless and immutable. The consul's hand is not just raised momentarily to signal the opening of the games but seems to be frozen in this action permanently in token of an absolute and unremitting authority. Content and form appear to be tangibly and specifically correlated.

Might this not be a clue of larger relevance to the drastic stylistic innovations we have observed, a lead that could help us to interpret these innovations in terms of the motivating forces and pressures behind them? It will be best to leave this question in abeyance until we have seen more of the art of the fifth century.

To broaden our view of stylistic developments in this period, I shall turn to mosaics, now the major pictorial medium. It is on the lavishly encrusted walls and vaults of the churches of Ravenna and Rome, Milan and Thessaloniki that the greatest examples of fifth-century image-making survive. But before entering on a discussion of these celebrated monuments (or, at any rate, a selection of them), I want briefly to call attention to their more lowly cousins on pavements. I have said that wall mosaic did not fully come into its own until the fourth century. Floor mosaic, on the other hand, was a much more traditional medium; it was practised extensively in Hellenistic times and had become a ubiquitous form of decoration throughout the Roman world by as early as

the first century A.D.[10] Since, in the nature of things, it has had a much better chance of survival (and retrieval through excavation), it permits – within the confines of what is admittedly often a craft rather than an art – a close study of formal developments on a regional basis. Focusing on the Eastern Mediterranean in the fifth century, I want to single out one episode in the history of floor decoration – the emergence of what may be called figure carpets. For in certain respects this phenomenon is not unrelated to developments we have seen in ivory carvings, and it will prove illuminating for the study of wall mosaics to which I shall turn subsequently.

The process in question can be observed most clearly at Antioch on the Orontes thanks to the large number of mosaics which came to light in the extensive excavations carried out on the site of that great Syrian metropolis in the 1930s.[11] The excavation of the nearby city of Apamea, also undertaken in the 1930s and resumed in recent years, promises to provide a welcome supplement to the Antiochene corpus once the pavements, which here too have been found in sizeable numbers, have been fully published and studied.[12] At both sites, and in many places elsewhere in the Near East, a new kind of floor decoration came into vogue in the fifth century. Figure compositions were taken apart, so to speak, and each element was set singly and with even spacing on neutral ground to form a pattern potentially extensible *ad infinitum*. The individual form may – and usually does – retain its three-dimensionality, and both man and beast may be shown in lively action. But their setting is disjointed. Instead of a landscape background, one finds isolated shrubs, trees and parts of terrain interspersed between the figures, and all motifs, regardless of their natural relationship, are more or less equidistant from one another. A splendid floor with hunting scenes, now in the Art Museum at Worcester, Massachusetts, is an outstanding example (fig. 90).[13]

Within the history of Antiochene floor decoration these figure carpets, showing a unified theme spread over large surfaces of varied shape, were an innovation. Traditionally, the normal way of depicting figure subjects – and complex scenes especially – on floors was in the form of *emblemata*, that is to say, simulated panel paintings with figures and objects shown in their natural relationship in settings that suggest depth. Such panels when placed on the floor evidently were meant to make one forget the solidity of the surface they occupied, much in the same way as a simulated vista painted on the wall of a Pompeian house may suggest an open window. But since the surface which is being dissolved is the very ground on which the beholder stands, the effect on him can be startling. Indeed, a deliberate attempt to tease him often seems to be involved. For example, on the floor of a third-century dining-room at

Antioch (figs. 87, 88)[14] an *emblema* is placed in the recess of a simulated niche which further reinforces the *trompe-l'oeil* effect. While the rest of the surface is covered with a geometric repeat pattern that is essentially two-dimensional and congruous with the floor *qua* floor, the *emblema* drastically interrupts this comfortable view. By contrast, on our fifth-century floor the figure composition is coextensive with the entire surface, and that surface, far from being dissembled, has itself become the matrix and carrier of everything that is depicted. The result is a unified design functionally appropriate also in the sense that it offers upright views of figures to the beholder regardless of where he stands or from which side he approaches. When Antiochene designers of earlier periods had composed floors that were meant to be viewed from more than one direction, they had normally done so by placing on them several *emblemata* with different orientations. A mosaic from a villa of the early fourth century (fig. 89)[15] is particularly instructive. While anticipating our fifth-century example in subject matter (through its hunting theme) and also to some extent compositionally (both artists used diagonal dividers, which they borrowed from ceiling decorations, to organize their designs), the earlier floor in effect offers the viewer four separate panel pictures or *emblemata*, each facing in a different direction. Within the Antioch mosaic corpus the figure carpet with its flowing continuity and its extraordinary adaptability to areas of any shape or size stands out as an innovation of the fifth century.

Nor was the phenomenon confined to Antioch. It was, as I have said, a characteristic development in floor decoration of this period all over the Near East. I shall illustrate one other example, roughly contemporary with the hunting floor in Worcester but situated in another region and different in its subject content as well as in its context, which is religious rather than secular. The wings of the transept of a basilica at Tabgha on the shore of the Sea of Galilee, which marks the site of the miracle of the Loaves and Fishes, are adorned with a pair of floor mosaics (fig. 92) depicting – it is not clear with what motivation in reference to the church – the scenery of the Nile.[16] But there is no coherent view or panorama. The component elements – aquatic birds and plants and various buildings, including a nilometer – are taken completely apart and scattered over the pavement. Although they all face in one direction – there are no diagonal dividers introducing different angles as in the Worcester floor – they form an even spread which potentially could be continued endlessly in every direction.

The sources of this new development have been much debated in recent years.[17] The problem can be mentioned here only in passing. A key fact is that the principles of floor design which are embodied in these fifth-century mosaics

have a long history in the Western Mediterranean world. Not that the custom of adorning the floor with compositions in the form of panel pictures was not popular also in the West. *Emblemata* abound in pavement mosaics in Italy, in North Africa, in Gaul, in Spain and in Britain. But the tradition was not as deeply rooted as it was in the Greek East.[18] In Italy the figure carpet emerged as an alternative compositional device as early as the second century in the so-called silhouette mosaics, which show black figures loosely distributed over expanses – often very large expanses – of white ground. In the third and fourth centuries similar principles can be seen coming to the fore in the polychrome pavement decorations of North Africa, products of a prolific and extremely inventive regional school whose influence abroad is evidenced by the spectacular mosaics of the great villa complex at Piazza Armerina in Sicily (fig. 6). In this context it is also interesting to recall certain ivory diptychs of the fourth and early fifth centuries, now mostly considered Western, which present figures distributed evenly over a neutral ground (fig. 71).[19] As well as being in some instances thematically related to the Antioch figure carpets, the diptychs in question are based on essentially the same compositional principles; they, too, involve an acceptance of the material surface as a matrix for an even spread of figure motifs. A case can therefore be made for the proposition that influence from the West played some role in introducing these principles of composition to floor mosaics in the East.

It is in pavements of purely ornamental design that one can see the idea of radical surface acceptance first clearly asserting itself at Antioch. As early as A.D.387, in the north arm of the great martyrium church of Kaoussie, we find a very large floor area, which traditionally would be broken up into a sequence of panels, treated as a unit with a single pattern extending over the entire surface (fig. 91).[20] In effect, what happened at Antioch (and elsewhere in the Greek East) in the fifth century was that this carpet concept was applied to figure compositions and ousted the *emblema*. While the latter had deep roots in the region's Hellenistic past, the former was essentially foreign to the Greek tradition. A dramatic conflict between hardy conservatism and radical innovation is being played out before our eyes within a single medium and in a single important centre in the Eastern Mediterranean world.

This glimpse at the art of the floor mosaicist will stand us in good stead as we turn to mural mosaic, a medium which from here on, and in all subsequent chapters, must receive much of our attention. By far the greater number of decorations in that medium surviving from our period are in the Latin West. But in discussing these Western works I hope to throw some light on mural

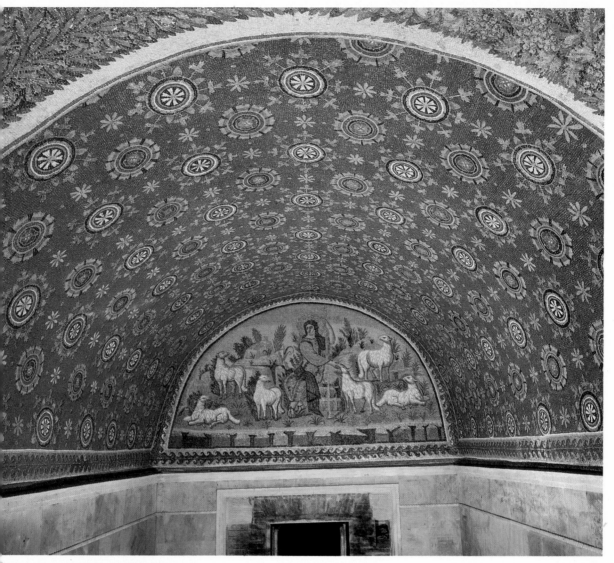

1. Mausoleum of Galla Placidia, Ravenna
North arm with Good Shepherd lunette

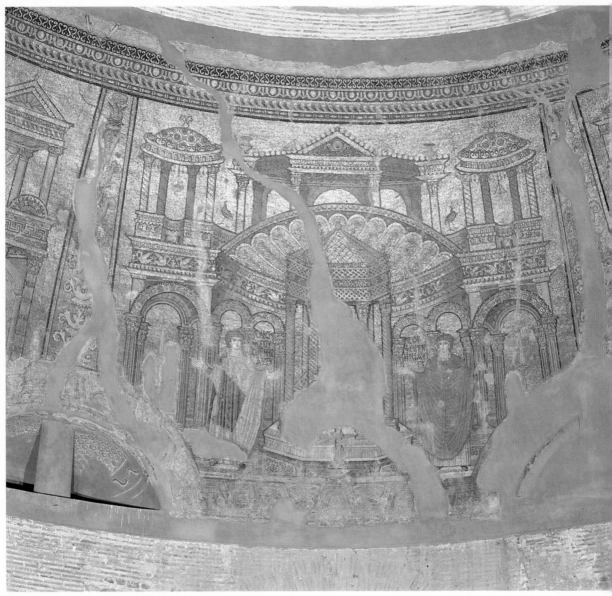

II. Church of St George, Thessaloniki
Detail of dome mosaic with Sts Onesiphorus and Porphyrius

mosaic in the Greek East as well, and I shall introduce extant Eastern monuments at appropriate points.

Leaving for the next chapter the one major ensemble of the fifth century that has survived in Rome, I propose to concentrate primarily on Ravenna. It is at Ravenna only that a consecutive series of fifth- and early sixth-century buildings with mosaic decorations can still be seen today. But these decorations, far from being products of a closed regional school, reflect much broader developments. Ravenna was a city without an important cultural or artistic tradition which suddenly, at the beginning of the fifth century, had thrust upon it the role of a capital. We know nothing about the origin and schooling of the generations of mosaicists who worked there for a succession of powerful patrons both lay and ecclesiastic. It is one of the basic uncertainties in the history of fifth- and sixth-century art. The mosaics themselves, however, suggest a variety of foreign affiliations and relationships, as we shall have occasion to see. On the other hand, continuity is by no means lacking in the Ravenna production. There are some quite obvious links between successive works. Thus by focusing on Ravenna I shall be able to trace an inner development of some consistency and at the same time sketch out a broader picture of which that development is a part.

We enter first the so-called Mausoleum of Galla Placidia (figs. 93ff.),[21] built as an annex chapel of the Basilica of the Holy Cross, which no longer exists in its original form. The basilica is said to have been erected by Galla Placidia, a daughter of Theodosius I and empress in the West from A.D.424 to 450; and although the chapel was almost certainly not her burial chamber, there is good reason to believe that it was built and decorated during her reign.[22] It is the earliest interior anywhere to have preserved its mural mosaics intact.

In approaching this exquisite ensemble our observations on floor mosaics will at once prove helpful and relevant. For basic to the entire design is a clear distinction and interplay between the two-dimensional and the three-dimensional, between surface acceptance and surface denial such as we found was characteristic of pavement decorations adhering to the *emblema* tradition.

There is indeed one element in the Ravenna interior which can only be described as a true *emblema*. I refer to the famous representation of the Good Shepherd in the lunette over the entrance door (fig. 94). Despite its heavily symbolic message – the figure's royal garb, halo and cross sceptre make it evident at first glance that this is no ordinary guardian of sheep – the picture preserves much of the character of a bucolic scene in the Hellenistic tradition. The rocky landscape, it is true, is made up of conventional motifs. But it is not just a backdrop. The shepherd really appears to be seated *in* it and responds

to the spaciousness of the setting with a complicated torsion of arms and legs. Although in the placing of the six sheep heraldic symmetry is only barely avoided, the mosaic as a whole, with its rather low horizon and its trees and rocks outlined against a light blue 'sky', convincingly suggests an airy space receding into indefinite distance. The impression is powerfully reinforced by the threshold or step of cleft rocks in the foreground, an old device of late Hellenistic and Roman panel painters[23] which emphatically places the scene beyond the frame and at the same time strengthens the illusion of a horizontal floor beneath the figure.

In its successful simulation of a plausible locale, the picture calls to mind the apse mosaic of S.Pudenziana (fig. 80) and other works of the turn of the century (cf. fig. 67). Made about a generation later, the Ravenna mosaic still bespeaks a strong interest in creating an illusion of space receding into depth, and once again the artist achieves his purpose with the help of devices borrowed from a much earlier age. Undeniably this is a work still in the 'Renaissance' spirit of the late fourth century. But there is no tangible relationship with S.Pudenziana. The stylistic rendering of our shepherd has nothing in common with that of the few figures in the Roman mosaic which have preserved their original appearance; and it is a far cry from the grandiose vista opening out in that earlier apse to the intimacy of this pastoral idyll, so clearly suggestive of an easel painting. As in the pavements with *emblemata* (figs. 87, 88), the illusion of being afforded a view well beyond the solid surface is reinforced by the fact that in the area surrounding the panel the surface is vigorously affirmed. What is admittedly a trick photograph showing the mosaic in its setting brings out the point (pl.I). Taken with a wide angle lens, it allows a full view both of the Shepherd lunette and of the lovely star pattern on blue ground that covers the adjoining barrel vault over the entrance arm of the cruciform chapel. The pattern is purely two-dimensional – it is, in fact, borrowed from textiles and more specifically from woven silks of exotic origin[24] – and the effect is that of a sumptuous tent cover with a view into open space at the end. By the very contrast of its rendering the vault helps to dissolve for the viewer's eye the materiality of the lunette.

The interplay of surface-denying and surface-accepting elements pervades the entire ensemble, and it does so with a degree of sophistication that goes well beyond anything known in pavements. Correlated throughout with the component parts of the architecture, it systematically and rhythmically sets off these parts against one another and powerfully underlines the structural organization of the interior. In particular, the contrast between two-dimensional and three-dimensional forms is used to set off covers or roofings

of individual compartments against their vertical enclosure walls. To a greater or lesser degree the former are affirmed in their reality while the latter are dissembled. The openness of the vista effected by the Good Shepherd mosaic is not matched by the composition in the lunette of the opposite cross arm depicting St Lawrence (figs. 93, 95). A window in the centre of the panel interferes with a unified illusion of depth. Nevertheless, the two objects with which St Lawrence shares the space – an open bookcase with the four Gospels displayed on its shelves and the grate of his martyrdom, both shown in strong foreshortening – create decidedly three-dimensional accents. These objects (which together with the saint himself make up a sort of rebus spelling out his role of martyr both in the sense of witness and of victim) give the impression of being displayed on some open stage. St Lawrence, book in hand and shouldering a cross, is hurriedly entering from the right to fulfil his mission. His image, like that of the Shepherd, is situational and perceived as lying beyond the frame, while overhead the same star pattern is spread out as in the barrel vault opposite.

The lunettes in the other two cross arms (fig. 97) are not opened up in the same way. Occupied by identical compositions of two stags on either side of a pool of water – recitations, as it were, from the famous verses of Psalm 42 – they are clearly subordinate to the Good Shepherd and St Lawrence mosaics, which they help to set off by their more heraldic design. Depth here is screened out by the tracery of the rinceau patterns in which the stags are entwined. While thus leading the eye on to the decorations of the adjoining barrel vaults, the stag lunettes are, however, still in decided contrast to the mosaics in these vaults. The animals, placed on green strips of terrain against blue ground, are fully modelled, and so is the foliage surrounding them. By contrast the equally rich rinceau patterns which adorn the barrel vaults – and even the four figures of apostles or prophets worked into these patterns – are rendered entirely as gold silhouettes, fully at one with the surfaces which bear them.

Once more, and most effectively, three-dimensional form is played off against an essentially two-dimensional design on the walls and ceiling of the upper zone (fig. 98). Here, in the central square, pairs of apostles stand in the four lunettes acclaiming the cross which appears in the centre of the star-spangled vault above them. Visually these figures correspond to those in the lunettes of the lower zone rather than to the silhouette figures in the barrel vaults just mentioned (even though iconographically they may relate to the latter). And, like the Good Shepherd and St Lawrence, they have a real stage on which to move and act (fig. 97). From a dark blue ground there mysteriously emerge strange pedestals for each pair to stand on. Rendered in shades of

green, these platforms suggest meadows; but at the same time they are emphatic block shapes receding into depth, while above the apostles' heads shell motifs in strong foreshortening similarly help to define for the figures a plausible stage. By contrast the celestial vision in the vault above them – cross, stars, and, in the corners, apocalyptic symbols – is once again rendered as a monochrome gold pattern on blue ground.

There is thus a remarkable consistency in this decoration. Walls are dissembled to a greater or lesser degree while ceilings are aesthetically accepted as ceilings, even when they signify the starry sky. If we extended our analysis to the decoration of the framing arches that constitute the armature for both these elements, we would find that here the same rationality does not prevail. Some of the seemingly or actually load-bearing members are decorated with strongly three-dimensional motifs which in effect dissolve their physical substance. The twisted ribbon ornament on the arches supporting the central vault is particularly interesting in this respect. Here classical rules of structural logic seem to be deliberately perverted. But the rhythm of the basic design is classical (or, more precisely, Hellenistic) and, one may suspect, specifically indebted to a tradition that belonged to the Eastern Mediterranean world. It is in the painted decoration of a second-century tomb chamber at Palmyra that we find a lunette similarly set off against the adjoining barrel vault in terms of surface denial versus surface acceptance (fig. 96).[25] In this context let us also recall once more our observations on floor mosaics, for we found that the *emblema* concept – so crucial to the design of the Ravenna decoration – had been adhered to in that medium far longer and far more tenaciously in the Greek East than in the Latin West. In any case, whatever its precise geographic roots, the art of the chapel of Galla Placidia harks back to the Hellenistic past.

At this point, before continuing with the Ravenna series, it is well to turn to the Eastern Mediterranean region itself and consider the one major mosaic decoration of the fifth century which has survived, if only in a fragmentary condition, in that area. I refer to the mosaics that were placed in the dome of the great rotunda of the imperial palace at Thessaloniki when that structure, later dedicated to St George, was first converted into a church, probably in the decades just before A.D.450 (pl.II; figs. 99–101).[26] Although the Thessalonikan work has no direct relationship at all to that in the chapel of Galla Placidia, it exhibits a similarly conservative spirit, as will be seen presently. It will also provide a perspective for some of the other Ravenna interiors yet to be discussed.

The scale here is vast – the clear diameter of the dome is approximately 24 m. – and, judging by what remains, the quality of the mosaic work was

superb. To visualize the composition in its entirety requires an effort of the imagination, but it was clearly of a sumptuousness unequalled in mosaic decorations of the period and unsurpassed at any time. The basic theme was not entirely dissimilar to that which forms the core of Galla Placidia's decoration. Again a heavenly apparition at the summit was being received by a group of acclaiming figures in the zone below. But it was Christ himself who appeared in the centre of the Thessalonikan dome, and he was standing in an elaborately framed medallion carried by four flying angels (fig. 100). Of the figures receiving him, only some of the feet and the lower hems of some white garments remain. It was a large chorus – there must have been at least twenty-four figures standing in varying poses on light green ground – but we do not know who they were. What chiefly remains is the third and lowest zone – a magnificent golden band almost 8 m. wide, framed by a simulated entablature above and a simulated console frieze below and divided into eight panels of which seven are more or less preserved. Each of these panels is occupied by fanciful architectural scenery reminiscent of stage sets with either two or three figures of saints standing in front of it in an orant pose (pl.II). Because the identity of the figures in the second zone is lost, the overall theme of the composition remains in doubt. It has been persuasively argued, however, that the subject was Christ's Second Coming.[27]

There are precedents going back as far as the Hellenistic period for the decoration of a dome or dome-like vault or ceiling being devised as a sequence of concentric rings or bands; it is particularly noteworthy that the interpretation of the outer or lowest band as a kind of wainscoting or dado supported and crowned by simulated friezes and cornices is likewise of Hellenistic origin.[28] It is quite clear – and extremely important – that in the Thessalonikan dome the lowest band was indeed meant to suggest such a wainscoting. The architectural backdrops in each panel, for all their perspective renderings, do not really negate this effect. To depict these dream buildings so largely in gold on a golden background was a stroke of genius. They thus appear diaphanous, insubstantial and of a truly otherworldly richness appropriate to their role as 'the celestial palaces of Christ's athletes'.[29] At the same time they leave the surface they adorn basically intact and still able plausibly to support and be supported by the structural members that frame them. The saints themselves, all shown *en face* and with their bodies concealed behind large, solid expanses of plain cloaks, add to, rather than detract from, the wall-like effect of the entire zone.

Above the entablature, however, there was a change of scene and pace. A continuous ground, whose light green colour implies natural open terrain,

provided a stage for figures which, judging by the position of their feet, dis-
played a certain amount of movement. At least some of them must have been
turning in space; and, unlike the static and frontally placed martyrs below,
they must as a group have been in active contact with the great apparition of
the triumphant Christ being borne aloft in the summit of the dome. What
remains of the background in the area immediately surrounding the central
medallion is gold once more, and we do not know at what level and by what
means the change from the natural terrain colour to the golden ground was
effected.[30] But the zone as a whole was clearly in some contrast to the lower one.
While the latter had connotations of an enclosure wall, the former must have
suggested open space, affording a view of heaven itself. To be sure, this was not
illusionism in the sense of later European art. It is a far cry from here to
Mantegna's painted 'dome' at Mantua or the *trompe l'oeil* effects of baroque
ceilings in which 'real' sky is seen opening above a simulated architecture that
literally continues the actual architecture of the wall below. But unquestionably
the design of this dome decoration was rooted in a tradition going back to the
first century B.C., whereby the upper zone of a wall was made to suggest open
space above a closed zone of simulated wainscoting.[31] To the extent to which
this concept was realized here, the dome was made to appear as something
other than itself. The integrity of its material surface was visually dissembled
as, in their own different ways, the apse of S.Pudenziana and the lunettes of
the chapel of Galla Placidia had had their material solidity dissembled. In the
rendering of the heads of some of the saints (fig. 101) the forces of geometric
abstraction which throughout the Mediterranean area became increasingly
dominant in the course of the fifth century clearly assert themselves. But in its
basic concept the decoration of the Thessalonikan dome is still on the side of
Hellenistic make-believe.

Returning to Ravenna, we enter next the so-called Baptistery of the Orthodox
(pl.III; figs. 102, 103), an octagonal structure built as a baptistery for the
Cathedral towards the end of the fourth century and adorned with mosaics by
Bishop Neon not long after the middle of the fifth.[32] Neon's decoration was part
of a thorough remodelling of the baptistery whereby its original wooden roof
was replaced by a dome. The scale here is very much smaller than that of the
Thessalonikan dome; but to view Neon's lavish decoration with the latter in
mind is highly instructive.

No doubt the design of the Ravennate dome mosaic is also based on the
concept of two wide concentric bands around a central medallion in the apex,
with the outer or lower band presenting a relatively solid 'façade' and the
inner or upper band opening out into a distant airy space. Here, too, floral

candelabra divide the outer band into eight compartments; and here, too, these compartments are filled with fanciful architectural scenery, although the buildings are single-storeyed and do not serve as backdrops for human figures. The inner band shows dark blue 'sky' above a continuous strip of terrain comparable to that which appears in a corresponding position in the Thessalonikan dome; and here again, this open landscape serves as a stage for figures in lively movement – in this instance crown-bearing apostles in two files led by Peter and Paul respectively. But unlike the wreath of active figures in Thessaloniki, which may be presumed to have been in physical and emotional rapport with the heavenly apparition in the centre, this circular procession of apostles, for all its dynamic effect, is self-contained and without an evident goal or objective. The scene of Christ's Baptism in the central medallion, while appropriate enough for the location, is quite separate.

Thus the composition lacks the dramatic unity which the Thessalonikan dome mosaic undoubtedly possessed. By the same token, the visual effect of a vista opening out above a closed architectural band, while definitely present also at Ravenna, is far from being clear and unambiguous. Although the eight architectural views which make up the outer band of the baptistery dome suggest unearthly and celestial mansions as do their counterparts in Thessaloniki, compared with those gold-on-gold fantasies they give an impression of much greater solidity. On the diagonal axes the interiors of four sanctuaries are depicted, each with an altar-table displaying one of the four Gospels. The buildings on the principal axes, on the other hand, which serve as settings for jewelled thrones bearing the imperial insignia of Christ's universal rule, take the form of open garden pavilions and behind these we glimpse dark blue sky. Thus in these latter compartments at least the contrast with the inner zone is in effect negated. It is negated further by the fact that the partitioning with floral candelabra here extends to the inner zone as well. Since the procession of apostles necessitated twelve of these floral devices, their axes could not be made to coincide with those of the candelabra in the lower zone, axes which in turn were determined by the octagonal shape of the building. But despite this disjunction, it is evident that a totally different scheme of dome decoration has intervened here, a scheme based on radial partitions rather than concentric bands. This scheme has its own (predominantly Western) tradition, represented, for instance, by the lost mosaic decoration of the mid-fourth century in the dome of S.Costanza in Rome.[33] The influence of this radial design also accounts for the fact that the floral candelabra which divide the eight architectural views of the outer band here extend below that band. They rise from the spandrels beneath and thus connect with the system of vertical supports

which articulates the walls of the building. In effect, then, the dome mosaic of the Orthodox Baptistery is the result of a conflation of two quite distinct schemes. [34]

Either scheme was capable of producing an effect of spatial illusion. We have seen how the outer or lower one of two concentric bands, especially when rendered architecturally, could serve as a kind of *repoussoir* for a spatially more open composition in the inner or upper band. Similarly, the spaces between the spokes of a radial composition could be treated in such a way as to provide an illusion of depth. The floral rendering of the spokes could, in fact, make it appear that the dome was a kind of open bower or pergola with the representations in the interstices receding into the distance. Such, indeed, must have been the effect in the dome of S.Costanza. But in the dome of the Orthodox Baptistery, where the two schemes are combined, the spatial implications of both are severely impaired. There is no unified pergola effect because a concentric circle intervenes and the floral supports are discontinuous. On the other hand, the contrast between the outer and the inner band is neutralized to some extent because solid three-dimensional forms and dark blue sky create unduly strong spatial effects in the lower zone, while the golden framework of foliate supports (with a canopy of white draperies conspicuously suspended between them) accentuate foreground rather than depth in the upper zone. Elements of the specific spatial illusions implicit in both basic schemes are clearly present. But they are in conflict, and what finally predominates is the complicated surface pattern resulting from their superposition. The pattern receives strong reinforcement from the rendering of the apostles in the 'free' zone. It is true that they move and turn, but each figure is fitted neatly into a compartment of uniform size and shape (pl.III). Heads are kept relatively small and lower contours expand to conform to these wedgeshaped frames. And, significantly, the apostles introduce no colour accents different from those of their framework, their tunics and mantles being gold and white in an alternating rhythm.

Thus it is a two-dimensional effect, a rich and agitated pattern which prevails over the elements that imply depth and spatial illusion. The equilibrium which had existed in the chapel of Galla Placidia is gone. There is tension and conflict here between the forces of surface denial and surface acceptance, a conflict no less significant for being traceable to the simultaneous employment of two essentially incompatible concepts of dome decoration.

Some fifty years later, in the dome mosaic of Ravenna's Arian Baptistery (fig. 104), [35] the conflict appears resolved. Built by King Theoderic for his Arian Goths, this second baptistery is clearly modelled on the earlier one. But

in its mosaics the principle of surface acceptance has carried the day. The iconographic programme is reduced to the scene of Christ's Baptism in the central medallion and the encircling ring of apostles, which now has a focus of its own in a jewelled throne surmounted by a jewelled cross. The third zone has been omitted. But there is a basic stylistic change quite aside from this reduction. The designer has made a clear decision in favour of the concentric scheme of dome decoration. By replacing the floral candelabra between the apostles with free-standing palm trees he has done away with the suggestion of a radiating pergola, and by substituting gold for the dark blue sky in the zone of the apostles he has largely eliminated the spatial implications of the earlier design. It is true that he has retained a strip of green terrain for the apostles and the palm trees to stand on, just as he has retained the river scenery in Christ's Baptism. The feature that dominates overall, however, is the gold ground which both zones share. In effect the entire hemisphere of the dome is seen as a single surface subdivided only by a flat ornamental band which separates the outer ring from the central medallion.

Against this neutral foil the apostles stand almost motionless. The lively rhythm of the earlier procession – generated by the figures themselves and powerfully reinforced by the alternation in the colour scheme of tunics and mantles and, above all, by the strong undulating pattern of the draperies overhead – is gone. What remains is twelve staccato accents in white. The rendering of the figures is not uniform. Peter and Paul, flanking the throne, and the apostle standing next to Paul are distinguished from the rest by the bolder modelling, warmer colouring and more alert expressions of their faces. There evidently was a break in the work after the central medallion, the throne and the first three apostles had been completed. Another team took over to complete the ring. But by comparison with their counterparts in the Orthodox Baptistery, all the apostles are much harder and stiffer. The folds of their draperies are schematic and angular and all forms seem frozen.

The profound stylistic change which this decoration manifests vis-à-vis its model is symptomatic of a broad development in the second half of the fifth century. Leaving Ravenna for a moment, we find at Milan a small mosaic dome of this period whose designer went even further in accepting and accentuating the hemispheric surface as a basis and carrier of his composition, allowing it to make its effect as pure abstract form. Known, interestingly enough, as St Victor in the Golden Sky, the building in question is a memorial chapel for a local saint adjoining the Basilica of St Ambrose.[36] Its dome (fig. 105) is an expanse of gold unrelieved and unarticulated except for the central medallion containing the martyr's bust portrait. Gold here has fully come into its own as the ideal

background medium, a role it was to maintain throughout the Middle Ages. While emphatically proclaiming the unity and integrity of the architectural shell, it at the same time dematerializes that shell, suffusing it with light. The saint, Christ's witness, dwells in solitary glory in the midst of a luminous sphere which is not of this world. To a remarkable degree, and on a miniature scale, the composition foreshadows the great dome mosaics of medieval Byzantine churches, in which a bust of Christ himself, the Pantokrator, will similarly appear, gazing down upon us from the summit of a golden heaven.

At Ravenna one of the major artistic efforts of the reign of Theoderic was the adornment with mosaics of his palace church, later rechristened S.Apollinare Nuovo (pl.IV; figs. 106–8).[37] The decoration bears witness to the same basic development that is so clearly manifest in the two domes just discussed. The entire wall surfaces of the basilican nave, above the cornices that crown the supporting colonnades, are evenly covered with mosaic, there is no articulation through profiles or mouldings, and gold dominates throughout. A flat ribbon bearing a meander ornament runs the entire length of each wall beneath the sills of the clerestory windows, setting off the lower zone of the decoration as a single, plain broad band. The stately processions of male and female martyrs which now fill the greater part of these bands on the right and left wall respectively, and which are so marvellously in tune with the even flow of the surfaces they occupy, are not part of the original design. They were put there by Archbishop Agnellus (appointed A.D.556) some twenty years after the Ostrogothic regime had given way to that of Byzantium, and took the place of long and solemn corteges of Theoderic's court, which must have been in this position. The views of the king's palace (fig. 107) and of the port city of Classe (pl.IV) from which the two court processions set out, as well as the representations of Christ (fig. 106) and the Virgin (each enthroned and flanked by angels) which were their respective goals, have survived, since they were retained in the Byzantine remodelling. Thus the original processions must be visualized as having been contained within the same monumental and static framing motifs as the present ones. Altogether, the aesthetic effect of Theoderic's corteges may not have been very different from that of the defiles of saints which have replaced them. Theoderic's figures, too, had a continuous gold background; and their movement may have been as restrained as that of the procession of apostles in his baptistery (fig. 104).

The upper zone, above the meander ribbon, is dominated by thirty-two tall, statuesque figures of haloed men in white placed singly against a gold background in the spaces between the windows and, three in a row, in the large windowless surfaces at either end of each wall which again provide a strong

framing element. The figures carry books or scrolls and are thought to represent prophets and heralds of Christ both from the Old and from the New Testament. To create a setting for them, Theoderic's designer has harked back once again to an earlier decoration at Ravenna. Each figure has a green shaded pedestal to stand on and a shell-shaped canopy overhead as do the apostles in the Mausoleum of Galla Placidia (fig. 97). But the motif has been so drastically transformed that at first sight the relationship is not at all apparent. The pedestals lack substance and hover uncertainly on the gold background. As for the shells, they do not curve back with any force and thus fail to scoop out any overhead space. Indeed, the designer has gone out of his way to sever any connection between them and the figures for which they were meant to provide canopies. He has inserted a slender horizontal band, bearing a simple ornament and accentuated by a thin white line, which firmly relegates the shell motif to a separate and narrow sub-zone at the top of the wall. Nothing could be more characteristic of this artist's aesthetic preferences. He introduces a potentially space-creating element only to cancel its effect. The horizontal band is intersected by vertical bands of the same design so that a tall oblong panel is marked out as a frame for each of the statuesque figures beneath, as well as a much smaller frame for each shell motif above. Thus, in effect, it is a slender grid or lattice, lacking structural force and substance, which in conjunction with the plain contours of the profileless windows organizes the vast wall surfaces of the clerestory zone.

Alone among all the representations on these walls the shell 'canopies' are not placed against a background of gold. Rendered in gold themselves, they stand out from a dark blue foil reminiscent of the night sky of the Galla Placidia mosaics. But this blue ground has become part of a surface pattern. For it alternates with the gold background of the intervening panels which are given over to a sequence of scenes from the Gospels.

These scenes, of which those on the left relate to Christ's ministry and those on the right to his Passion and Resurrection, are justly famous. Not only are they the earliest extant examples of a cyclical representation of Gospel events on the walls of a church, but the manner of representation – stark and spare in its concentration on essentials of figures and settings – is powerful indeed. The fact that the scenes are relegated to those small inconspicuous panels at the top of the two walls, where they appear dwarfed by the shell motifs separating them, is all the more remarkable. The normal and obvious location for a sequential depiction of stories in a basilican nave was in the large expanses of wall spaces between colonnades and windows (compare, for instance, the fifth-century cycle of Old Testament scenes in S.Maria Maggiore in Rome, to be

discussed in the next chapter). At S.Apollinare Nuovo, as we have seen, that
prime space was given over to a display of court ceremonial ending up before
solemn representations of Christ and the Virgin with their angelic guards.
Presumably the fact that this was a palace church is not irrelevant here. But it
is not only by its peripheral placing that the narrative element is played down.
The rendering of the Gospel scenes (fig. 108) is such that there is little induce-
ment to 'read' them as a continuous story. Action is reduced to a minimum;
figures face the beholder; and scenes are individually centred, the actors being
arranged in such a way as to form closed, self-contained compositions. Quite
frequently outright symmetry is achieved, and when buildings or landscape
settings appear they also help to create a static pattern within the panel. Im-
mobility, then, and solemn display are all-pervasive characteristics of this
decoration.

Turning finally to the third mosaic-adorned interior of Theoderic's period to
have survived in Ravenna – a small chapel in the Archbishop's Palace (figs.
109–11)[38] – we find it to be an exponent of the same basic trend. The imagery
here consists exclusively of single figures. The decoration is no longer quite
complete, but there can be no question that it ever comprised any narrative
elements. Medallions with busts of Christ, the twelve apostles and male and
female saints are placed against a gold background on the soffits of four arches
supporting the vault over the square central space. A medallion with the
monogram of Christ in the apex of the vault is carried by four caryatid angels
placed on the diagonal axes, while in the spandrels between the angels the four
beings of the Apocalypse appear, again on a plain gold ground.

Simple, timeless portrayal and frozen action are as characteristic of all these
ensembles as is the silhouetting of figures against large expanses of neutral
foil.[39] It is tempting to connect the two phenomena and to see in the latter an
aesthetic expression of the former. Indeed, might there not be some clue here to
the whole trend towards acceptance (as against dissembling) of the given
surface which we have found to be basic to fifth-century style developments in
general? Could one not see in this entire development a quest, a steady groping
for an image freed from all earthly contexts, immutably fixed and eternally
valid? I shall return to this question in the course of our further exploration of
fifth-century monuments in the next chapter.

Meanwhile the Ravennate series of mosaic decorations which we have passed
in review certainly can be said to possess both inner cohesion and wider
affiliations. I have previously remarked on the lack of evidence concerning the
origin and background of the successive generations of artists who worked on
these decorations. In the various enterprises of the period of Theoderic different

ateliers undoubtedly must have been active side by side. But it is also evident
that artists took note of each other's work, witness the instances of citations
and borrowings of themes and motifs from antecedent monuments which we
have encountered. We are not dealing with a succession of totally independent
initiatives. Indeed, one might almost speak of a kind of dialogue, a sequence of
action and reaction in the Ravenna series.

At the same time, however, this dialectical process, while to some extent
locally conditioned, is in line with developments we have previously observed
elsewhere and in the Greek East in particular. Contacts with the Greek world
are, in fact, evident throughout the series, beginning with the mosaics of
Galla Placidia and continuing with those of the Orthodox Baptistery (whose
partial affinity with the decoration of the Thessalonikan rotunda indicates a
Greek connection) and the works of the period of Theoderic. Regarding this
latter group, I shall single out the atelier which produced the medallions with
busts of apostles and saints in the Archbishop's Chapel, and which perhaps was
also active in the lower zones at S.Apollinare Nuovo. The busts of apostles
(fig. 110) may be compared with a similar series which has survived from a
mosaic decoration of roughly the same date in the apse of the small Church of
Panagia Kanakaria at Lythrankomi in Cyprus (fig. 112).[40] It is true that the
Cypriot heads are softer and somewhat more summary in manner of execution
as well as more relaxed in expression. They have neither the linear precision
nor the spiritual intensity of their Ravenna counterparts. More of a Hellenistic
tradition survives in this Eastern work.[41] But the Cypriot mosaic, whose central
feature – now sadly fragmentary – was an enthroned Virgin rigidly enframed
in a mandorla and flanked by two angels in an *en face* view, was certainly a work
of the same general character as the Ravenna mosaics of Theoderic's time.
Nor are the geometric precision and hypnotic power of these Ravennate
images altogether without equivalents in the East. In this respect the heads of
some of the saints in the Archbishop's Chapel make an interesting com-
parison with that of the Consul Anastasius on his ivory diptych (figs. 111, 113).
There can be no doubt that the Ravenna series reflects fifth-century develop-
ments in the Byzantine world.

We shall continue our discussion of the momentously important stylistic
innovations of that century in the next chapter.

Fifth-Century Conflicts – 2

The city of Rome has a famous counterpart to Ravenna's great series of fifth-century mosaics – the decoration devised and executed during the 430s for the Basilica of S.Maria Maggiore.[1] Based on quite different premises – historically, ideologically and also stylistically – these Roman mosaics will help us to add both breadth and depth to the picture drawn so far of artistic movements in the fifth century.

What has survived of this extensive programme is only a torso. The original apse was destroyed in the thirteenth century when a transept was added to the nave. The fifth-century apse directly adjoined the triumphal arch, which therefore is really an apsidal arch (fig. 115). Its tiers of mosaics with scenes from Christ's infancy must be visualized as framing what was undoubtedly an important and sumptuous composition in the conch itself.[2] The mosaics of the entrance wall, which comprised a long inscription of Pope Sixtus III (A.D.432–40) dedicating the church to the Mother of God, had largely disappeared by the time of the remodelling of the church in the late sixteenth and early seventeenth centuries. That remodelling, which gave the interior more or less its present appearance (fig. 114), also brought changes to the longitudinal walls of the nave but spared the greater part of the mosaic panels with scenes from the Old Testament which occupy the spaces beneath the windows. Drawings made of the nave walls before they were transformed show, however, that the changes introduced by the architects of the late Renaissance were not as drastic as might have been supposed. The rich articulation of those walls was not a sixteenth-century innovation. There always were pilasters between the windows which gave relief to the large surfaces and provided them with a firm architectural framework (fig. 116). Within its allotted bay, each mosaic panel had its own pedimented aedicula. A strongly classicizing element has rightly been discerned in the design of these walls,[3] witness also the fact that they are placed on entablatures and not on arcades such as one commonly finds by this time in the naves of basilicas. The architectural membering does not, however, extend to the apsidal arch (figs. 115, 127, 128) whose huge surface – devoid of all framing and articulation – is displayed as a single, two-dimensional expanse, subdivided only in a geometric sense by the horizontal bands of its mosaic

decoration. The design here involves an acceptance of the basic planimetry of the wall in its entirety, while in the nave the plain surface is dissembled. Classicism, then, does not reign unchallenged, and this is borne out by a study of the mosaics themselves.

The nave panels (figs. 117, 119, 129, 131, 132) depict, often in great detail, a series of episodes mainly from the Books of Genesis, Exodus, and Joshua. On the left-hand wall, beginning at the point next to the apse, are scenes pertaining to Abraham, Isaac and Jacob, on the right-hand wall, again beginning at the sanctuary, the stories of Moses and Joshua. Altogether, twenty-seven panels have survived more or less intact (out of an original forty-two), and most of them show two episodes superimposed. It is much the fullest example of cyclical narration in monumental art to have come down to us from the centuries with which we are concerned.

Any evaluation of the style of these mosaics must take as its point of departure their relationship to book illustration. This in turn makes it necessary to revert once more to the activities of artists who served Rome's reactionary pagan aristocracy at the end of the fourth century. The philological and editorial enterprises fostered by these aristocrats in their concern for the preservation of classical literature must have entailed also the production of illustrated *de luxe* editions. At least one illuminated codex has been plausibly related to this Roman milieu, namely, the famous Vatican Codex of Virgil's *Georgics* and *Aeneid* (figs. 118, 120).[4] And, as has long been recognized, there is a close stylistic relationship between some of the miniatures in this manuscript and certain mosaics in the nave of S.Maria Maggiore.

The illustrations in the Vatican Virgil manuscript are framed panel pictures. Many offer views of landscapes and some even of interiors. Although figures, buildings and other stage requisites all tend to be placed in the foreground or superposed in registers, and although there is often a lack of consistency in the scale of different parts of the pictures, the actors nevertheless appear enveloped in their settings and to perform within them. Many of the outdoor scenes in particular are remarkable for their success in creating an illusion of open space. Grey ground imperceptibly shades over into zones of pink, purple or blue, suggesting a view of hazy distances. In terms of the criterion of denial as against acceptance of the material surface, it is clearly the former principle which prevails. The illuminator opens up a 'window' on the parchment page, just as we have previously seen 'windows' opened up by mosaicists on floors and walls and by ivory carvers on the leaves of diptychs. It is the *emblema* concept once again. Indeed, we see here applied to the illustration of a codex compositional and pictorial devices that had been current in monumental painting

during the early imperial period (fig. 121).[5] Whatever the sources and models were on which the painter of the Virgil manuscript drew – and this is at present very much an open question[6] – there is no doubt that these miniatures have a strongly retrospective cast, in keeping with the entire revival and preservation movement of which they are a product.

A connection between these illustrations of ancient Rome's greatest epic and the Old Testament cycle of S.Maria Maggiore may be assumed with all the more confidence because there is evidence of biblical manuscripts illustrated in the same style, if not, indeed, in the same atelier, as the Vatican Virgil. Such an extension of, or response to, the pagan revival effort of the period around A.D.400 in the realm of Christian imagery is not surprising in view of what we have previously seen in other media, especially ivory carving. The evidence for the illustration of biblical texts by artists related in training and outlook to those who worked on the Vatican Virgil comes from a few precious leaves with scenes from the Book of Kings discovered at Quedlinburg in the last century and now in the State Library of Berlin (fig. 122).[7] They testify to the existence of a biblical codex in the Old Latin version (the so-called *Itala*), richly adorned with 'panel pictures' similar to those in the Vatican codex. Evidently this book was commissioned by a patron who belonged to the same social stratum as the sponsors of *de luxe* editions of the classics and who shared many of the same cultural values. The Quedlinburg miniatures have in common with those of the Vatican manuscript the delicately shaded atmospheric backgrounds, the disposition of the figures within these settings, and even some of the figure types and motifs.

Clearly, the Old Testament cycle of S.Maria Maggiore owes much to the stylistic tradition which produced these two manuscripts. In a number of panels, particularly in the Moses and Joshua sequence, similar compositional schemes, similar atmospheric settings and some of the same figure types reappear (figs. 117, 119). If the miniatures of the Virgil and *Itala* codices were composed in a manner originally associated with mural paintings, many of the mosaic panels in turn seem like enlarged miniatures. It is true that the arrangement of distinct scenes in two coequal registers which most of the panels show has no full counterpart in either of the two manuscripts, but this device is used quite frequently in another illustrated *de luxe* edition of a classical text (though one that is slightly later in date and presumably of Eastern Mediterranean rather than Roman origin), namely, the *Iliad* Codex in the Ambrosian Library at Milan (fig. 123).[8] One feature entirely peculiar to the mosaics is the use made of gold. The illuminators of the Vatican Virgil and of the *Itala* employed fine lines of gold as highlights. In many of the Old Testament scenes

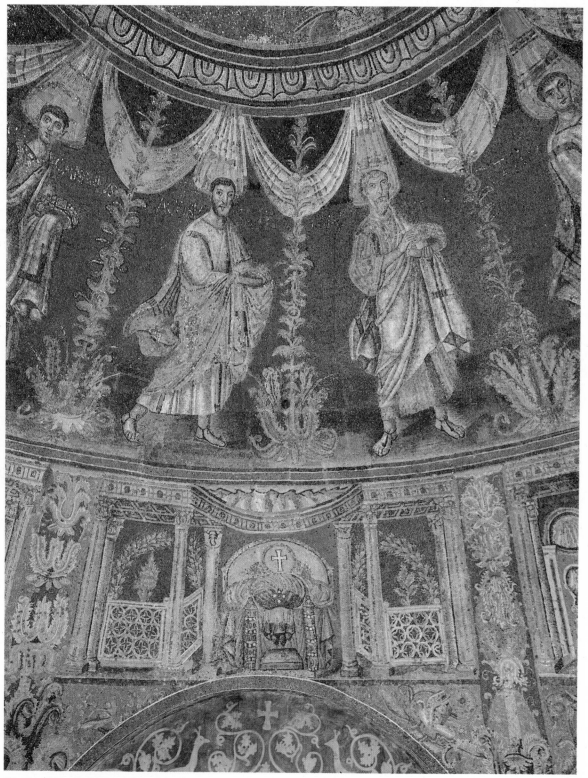

III. Orthodox Baptistery, Ravenna
Detail of dome mosaic with Sts James and Matthew

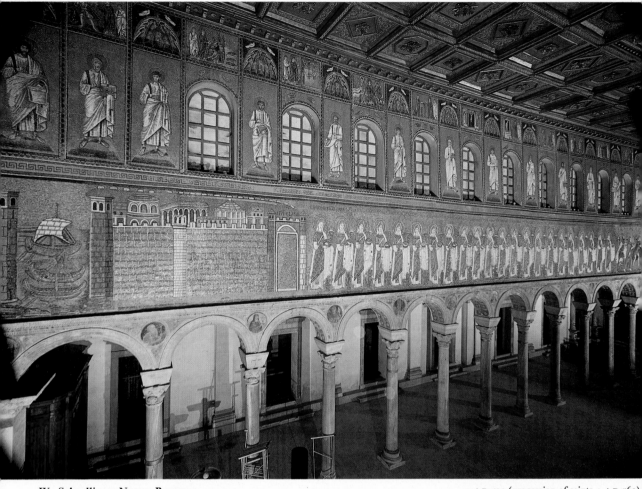

IV. S.Apollinare Nuovo, Ravenna
North wall

c. A.D.500 (procession of saints *c.* A.D.560)
page 62

in S.Maria Maggiore, on the other hand, fairly large expanses of gold appear as an intermediate background zone. The injection of this totally 'unreal' element into those vague and hazy settings is, of course, highly significant in view of the enormous role gold was shortly to assume as the foil *par excellence* for sacred persons and scenes on the walls of churches. But in many of the scenes at S.Maria Maggiore it is still very much part of an airy space – a luminous zone in the middle distance which takes over from the ground on which the figures stand and often merges on the far side into hills or clouds.[9] The figures themselves, agile in pose, summary in rendering and indefinite in contour, live and breathe in these spaces as do those in the Virgil and *Itala* miniatures.

It is interesting here to recall for a moment the mosaics of the chapel of Galla Placidia in Ravenna and to note that those of S.Maria Maggiore are their exact contemporaries. In the Ravennate decoration, too, wall surfaces dissolve as the mosaicist opens up views of distant spaces. But in S.Maria Maggiore the effect is achieved by entirely different means, and there can be no doubt that many of the devices which were used here came from the retrospectively oriented book illuminations of the period. As for the architectural organization of the walls, it provides a suitably classicizing framework for such pictures.

Quite different characteristics come to the fore in the scenes from Christ's infancy on the arch (figs. 127, 128). Figures are larger in relation to the total surface of a given scene. They are much more ponderous and block-like and they tend to face the beholder squarely. The whole pace of the narrative is much slower and more solemn. Figures also tend to close ranks, shutting off views into the distance. No longer do they inhabit a spacious setting. The background has become a backdrop in which gold predominates and often takes on the nature of a solid band with a sharply defined upper edge.

It used to be thought that these differences betoken a time interval. While the arch mosaics are of the period of Sixtus III, whose name is monumentally recorded in the dedicatory inscription in the centre of the top zone, the Old Testament panels were thought to have been made for an earlier building and to have been re-employed.[10] But this view is untenable. Not only is it hard to reconcile with the unity of concept which underlies the entire iconographic programme (this is a point to which I shall return), it is untenable also on stylistic grounds. If, instead of the broad categories of spatial concepts, settings and compositional arrangements with which we have operated so far, we use finer – more 'Morellian' – criteria relating to technique and craftsmanship we find many close ties between nave and arch mosaics.[11] For instance, the same characteristic device for depicting facial features occurs in both. Eyes are apt

to be rendered by a juxtaposition of a single dark cube, denoting the pupil, with one or more white cubes, while a straight, dark horizontal placed directly above indicates the brow (figs. 124, 125). Mosaicists who worked on the arch no less than those who worked in the nave used this bold impressionist device which produces the effect of a piercing glance and is a major factor in endowing faces and even entire figures with intense animation.

Such close-up scrutiny of workmanship discloses at the same time strong variations *within* each of the two groups; witness, for instance, the mothers in the Massacre of the Innocents (fig. 126) in the third register of the left side of the arch as against the elders in front of the temple in the first register on the right (fig. 125). The obvious conclusion is that a considerable number of different hands must have been employed, as would naturally have been the case in so large and complex an enterprise. But there are too many technical and stylistic bonds between mosaics in the nave and on the arch not to consider these different hands as members of a single team working simultaneously.[12]

If, then, the discrepancy in basic conception which nevertheless exists between nave and arch mosaics cannot be explained by attributing the two parts of the decoration to different periods or different teams, one may be tempted to account for it by assuming that models of very different appearance were used for the Old Testament and New Testament scenes respectively. Here the relationship of the nave mosaics to book illumination would seem to provide helpful evidence. Have we not seen that many of the Old Testament panels look like enlargements of miniatures such as those in the Vatican Virgil or the Quedlinburg *Itala*? Does not this latter book provide tangible evidence that Bible manuscripts illustrated with pictures in the style of our mosaics did in fact exist at the time? And does not the history of art know other instances of biblical cycles on church walls being copied quite literally from illuminated codices, the best-known case being that of the Genesis scenes in S.Marco in Venice, which reproduce with remarkable fidelity miniatures in a famous Bible codex of the fifth or sixth century that once belonged to Sir Robert Cotton?[13] Assuming that similar use was made of illustrations of an Old Testament manuscript in devising the nave mosaics of S.Maria Maggiore, the specific characteristics which differentiate these mosaics from those on the arch might well be accounted for.

This is, in fact, the unspoken – and at times explicit – assumption underlying much of the discussion of the S.Maria Maggiore Old Testament cycle in scholarly literature. But the assumption is untenable. It has long been observed that a number of the Old Testament scenes bear a close relationship to the arch mosaics not only in details of workmanship but in their overall appearance as

well.[14] The Separation of Abraham and Lot is an example (fig. 129; cf. fig. 130). The two protagonists are block-like figures squarely facing the beholder, filling a large part of the surface and in effect shutting off the view into the distance. The other elements of the composition – secondary figures and buildings – are joined to the two principal figures to form with them an extra-ordinarily expressive but essentially abstract pattern which, with its two more or less coequal halves and its central cleft, conveys unforgettably the substance of the event depicted. Now it is a striking fact that both on the left and on the right side of the nave – that is to say, both in the Genesis and in the Exodus scenes – it is in the mosaics closest to the sanctuary that this monumental style comes to the fore. It follows that the scenes cannot be outright copies of a cycle of book illustrations, for they were clearly designed with a view to their location in the building.[15] As one approaches the sanctuary, the pace of the narrative slows. There is a *ritardando*, as it were, or, to use another musical term, a change of key. A more solemn, more ceremonial note is introduced, and this note is then sustained throughout the cycle of Christological scenes on the arch.

Once again we encounter here the phenomenon of 'modes', a conscious choice made by artists between different manners in the light of the content, meaning or purpose of a given representation or group of representations.[16] There can be no doubt that this factor played a major role in the design of the mosaics of S.Maria Maggiore. To some extent form is correlated here with location, and, as we shall see, location in turn has to do with function and mean-ing.

How, then, are we to visualize the creation of these mosaics? Designed with a view to their place in the building, they cannot have been copied mechanically from a codex such as the Quedlinburg *Itala*. That manuscript does, however, provide us with an important clue. Beneath the badly eroded pigments of its miniatures, verbal instructions to the painter, or – in some instances – very rough disposition sketches, have come to light.[17] This can only mean that the miniatures themselves were not copied from another codex but were designed *ad hoc*. Evidently a painter of the period could be expected to be able to trans-late such verbal instructions into images with the help of a standard vocabulary. Similarly, our mosaicists must have operated with stock formulae. Their Joshua (fig. 119), for instance, is the same figure of an officer which in the manuscripts did duty for Saul or Aeneas.[18] The mosaicists may also have worked on the basis of verbal instructions and disposition sketches only. *Sinopie* or outline drawings have been found on the wall itself beneath some of the scenes on the arch, and it is interesting to note that they do not always correspond

exactly to what was executed.[19] If small-scale preparatory paintings were used at all they must have been made *ad hoc*.

The undeniable resemblance of so many of the scenes to illustrations in the manuscripts of Virgil and the *Itala* (and, to a lesser extent, the *Iliad*) was not, therefore, an automatic inheritance from book illumination. I would go further and say that it too was a matter of deliberate choice. It too was a 'mode' purposefully cultivated. The biblical picture stories on the wall were meant to evoke the pages of a lavishly illustrated epic. In terms of legibility it was hardly an ideal format. At the great height at which they are placed, the mosaics which most resemble miniatures are difficult to read. One is led to conclude that the mental associations with the pages of a manuscript of Virgil or Homer which these scenes in their cyclical sequence could be expected to evoke in a fifth-century beholder were considered more important than his ability to follow each event in detail.

That the epic mode was introduced here with an associational intent seems all the more likely because it is in line with other references to the pagan past which have long been recognized in the S.Maria Maggiore mosaics.[20] One of the most interesting of these references occurs in the scene on the arch of the Presentation of the Christ Child in the Temple (fig. 128). Unmistakably the façade in front of which the event takes place is that of Rome's own Temple of the goddess *Roma*, so that Jerusalem merges with Rome and Simeon appears to be receiving the Child on behalf of the world's ancient capital.[21] But 'Roman' and 'imperial' connotations are strongly in evidence also in the nave, where they merge or overlap with those elements which evoke the great epics. Thus, while a number of the battle scenes in the Exodus and Joshua cycles are composed on lines familiar from the Milan *Iliad*, Joshua's defeat of the Amorite kings clearly recalls the composition of the great Roman battle sarcophagi of the third century.[22] The Marriage of Moses (fig. 131) takes the form of a Roman couple's *dextrarum iunctio* (with Moses wearing the costume of a high Roman official). Abraham's encounter with Melchizedek is modelled after an imperial *adventus* (figs. 132, 133).

There is, then, in this entire decoration an emphatic, demonstrative and surely deliberate appropriation or assimilation of the pagan past. The evocation of an illustrated epic in the nave mosaics is part of this. The forces which motivated this appropriation cannot be in doubt. While the major fourth-century basilicas in Rome were imperial foundations, S.Maria Maggiore is the first great church erected by the popes. Its founding reflects a situation in the fifth century when – with the seat of empire long removed, the pagan aristocracy finally defeated, and the venerable city sacked by Alaric – the bishop of Rome,

the only effective authority left in the city, asserted his claim as the true and rightful heir of the Caesars.[23] Rome, the see of St Peter, was to be the centre of a new universal realm, the Church of Christ, ruled on his behalf by the occupants of the Apostle's Chair. The greatest and most eloquent proponent of this doctrine of papal power was Leo I, the immediate successor of Sixtus III. But Sixtus had already put forward the Roman bishop's claim to universality when he placed in huge letters at the focal point of his magnificent basilica the terse dedication: 'Xystus episcopus plebi dei'. 'God's people', in the new dispensation, is all of Christendom.

The insistent use both in the architecture and in the mosaics of forms and motifs associated with the pagan past must be seen in this light. It is not simply a carry-over from the late fourth-century 'Renaissance'. It is a counter-move, a conscious and programmatic appropriation of the past. It is as though the Church were addressing the defeated resisters – and perhaps, in a way, smoothing the path for them – by saying: Your temple has become the Lord's Temple, and the heroic deeds of bygone days in which you may glory and which will sustain you in the present are those performed at the Lord's command and with the Lord's help. These are the true epics, the true *res gestae*.

Yet the narrative does not proceed straight – certainly not on the arch, and not even in the nave. Epic story-telling is fitted into and subordinated to an overall programme of great complexity. As the nave is an anteroom to the sanctuary, so the Old Testament scenes in the former are preparatory to the Lord's actual epiphany portrayed in the latter. Progressing from the entrance to the altar, the faithful experience in space God's providential plan for the salvation of mankind as it has unfolded in time. But the story is pointed. It does not begin with Creation, as it will do in the Old Testament cycle painted only a decade or so later in the nave of S.Paolo fuori le mura;[24] it concentrates on a few great figures who under the Old Law were the recipients of God's promise to his Chosen People and the instruments of the fulfilment of that promise. And while much of the narration takes the form of a blow-by-blow account involving a great deal of circumstantial detail, there are also some interesting departures from 'historical' chronology.[25] The Melchizedek scene (fig. 132), showing the priest king of Salem offering bread and wine, is taken out of the correct sequence (I see no reason to assume that this is a mistake made in the sixteenth-century restoration) and placed monumentally as the very first panel immediately next to the sanctuary and the altar, in obvious reference to the Eucharist. And the Separation of Abraham and Lot (fig. 129) – the third scene in the same sequence – includes as a pendant to Lot's young daughters the boy Isaac (not yet born at the time) to

lend dramatic emphasis to God's promise to his people. For as he was to say to
Abraham: 'In Isaac shall thy seed be called' (Genesis 21:12).

It is hardly coincidental that these departures from 'history' occur in the area
where the narrative slows up, its tenor becomes solemn and ceremonial and its
formal representation more stylized and patterned. On the arch, where these
characteristics prevail throughout, the rearrangements of history are correspond-
ingly more numerous and more drastic. I shall not enter into the old controversy
as to whether or not the iconography of the arch mosaics was inspired by (or at
least reflects) the decisions of the Council of Ephesus in A.D.431, which, in re-
futing the teachings of Nestorius, proclaimed the Virgin to be the Mother of
God.[26] Given the coincidence of dates and the princely splendour with which
Mary is presented in the mosaics (fig. 127), I find it hard to believe that there is
no connection with the Council of Ephesus at all. But it is only one theme among
others. The imagery of the arch is replete with unconventional renderings of
established subjects, enigmatic – and from the point of view of simple narration
clearly superfluous – figures and details, and strange transpositions in the
chronological order of events. As a result, it invites endless speculation by
iconographers and iconologists. Even the subject matter of some of the scenes
depicted is controversial. The key theme is without doubt the triumphal advent
of Christ as universal ruler. So much is clear from the choice and arrangement of
episodes on the arch as well as from the context created for them by the mosaics
in the nave.[27] But there are subsidiary themes in this intricately coded and
richly orchestrated ensemble. The Marian theme is one of them (after all, the
church was dedicated to the Virgin), the 'Roman' theme another. With a
multiplicity of dogmas, messages and allusions woven into the narrative, the
formal language becomes correspondingly weighty, pointed and emphatic. As
eternal, immutable verities are directly proclaimed, action freezes, the real world
recedes, and an abstract, static pattern is imposed on figures and compositions.

I have discussed the mosaics of S.Maria Maggiore at some length because we
see here being played out within a single monument some of the major stylistic
conflicts we have previously observed in fifth-century art. We see these conflicts
coming to the fore in the confines of what is undoubtedly a single unified project
accomplished within a limited time span – probably no more than a decade. And
more clearly than elsewhere can the differences in formal language be related to
different and competing ideological concerns and purposes. Both the classicizing,
retrospective style and the abstract – or, as it has also been called, 'transcen-
dental' – style[28] correspond to ideas and intents that are at least broadly identi-
fiable.

We do not know where the team of mosaicists came from. The question is as

moot here as we previously found it to be in the case of the great fifth-century enterprises at Ravenna. There is little connection with what we know of earlier wall mosaics in Rome.[29] It is possible, therefore, that the team employed by Sixtus III included a sizeable foreign element; and, although the S.Maria Maggiore mosaics are in no way related to those commissioned during the same period by Galla Placidia in Ravenna, it is arguable that in the Roman enterprise too artists from the Greek East were at work. There appear to be some interesting parallels both for the poses and for the rendering of certain figures in floor mosaics at Antioch and Apamea (compare figs. 134 and 136 with figs. 135 and 137 respectively).[30] But wherever the artists hailed from and whatever their training may have been, they were not entirely free agents. Although we have encountered stylistic nuances which are due to different hands working side by side, we have also found a basic stylistic dichotomy which cuts across such groupings. This dichotomy, so we have seen, has to do with the content and location of different parts of the programme and must therefore flow from a master plan generated locally. It was imposed on the executant artists by a guiding mind which saw the imagery as a whole, in relation to the building and its functions and to the ideas that had created it.[31] Who this individual was we shall never know. But to the extent that formats, motifs and modes of presentation were here chosen deliberately as visual equivalents and expressions of what was ultimately an ideological programme, they confront us once again with the possibility of an 'other-directed' element in the shaping of stylistic forms.

It was to the abstract manner of the arch and of the nave panels nearest the arch that the future belonged. To realize this we need only recall the Ravennate mosaics of the period of Theoderic discussed in the previous chapter. No actual contact between the mosaic workshops of Ravenna and those of Rome has ever been conclusively demonstrated. But S.Maria Maggiore does show the abstract mode of the Ravenna mosaics of the period around A.D.500 *in statu nascendi*, and here already the striving after this mode is bound up with subjects that have to do with ceremony, with power, and with the proclamation of eternal verities. A true 'language of authority' does indeed emerge as a great and central concern of fifth-century pictorial art. The official ivories of the late fifth and early sixth centuries which combine a fully perfected, abstract, hard and static style with a vastly increased quantitative emphasis on the ruler figure are another manifestation of this (fig. 86). To a preponderant interest in the timeless and ceremonial in subject matter corresponds a full triumph of formal abstraction.

We have reached a point where we seem to be in a position to grasp some of the root causes and motivating forces that produced stylistic change in the fifth

century, and it might be best to leave it at that. We have discussed major monuments commissioned by, and reflecting the ideas and aspirations of, leading powers of the day – imperial officialdom, the papacy, the Ostrogothic kingdom in Italy. But in thus giving focus to our period portrait we have also narrowed our field of vision. We must not lose sight of artistic impulses and initiatives which came to the fore during the fifth century in less exalted spheres and less programmatic contexts and which similarly entailed new assaults on classical traditions and new explorations in the realm of abstract form. The emergence of the figure carpet in the floor mosaics of Antioch is a case in point.[32] Certainly acceptance – as opposed to dissembling – of the physical matrix as carrier and integrating element of a composition was a fundamental trend in the art of this period; and with this went a loss of natural and organic relationships – or, to put it another way, an assertion of purely conceptual relationships – on a very broad front.

To assure a balanced picture of stylistic developments in the fifth century and to guard against a one-sided interpretation of these developments I shall, in conclusion, turn to a branch of artistic activity which we have not previously taken into consideration – ornamental sculpture in stone. The category will serve my purpose well. In the field of decorative sculpture for buildings the period was exceptionally creative and innovative; and since little or no subject content is involved, these innovations reveal with great purity basic aesthetic interests and attitudes. There is the additional fact that much of the most interesting material comes from the Aegean region, so that we are able to focus more definitely than in our discussion of other branches of fifth-century art on the Byzantine heartland and on Constantinople itself.

In order to make the material manageable for the present discourse, I propose to limit myself to one kind of ornamental sculpture only, namely, capitals. They offer the best means to illustrate succinctly both the variety of new forms in this branch of art and certain unifying style trends. They are also the best-explored category, thanks largely to the pioneering work of Rudolf Kautzsch.[33]

Some of the innovations in the design of fifth-century capitals, such as the so-called 'Theodosian' type, the type with animal protomes, and that with windswept foliage, entailed revivals – on the basis of more or less tenuous survivals – of earlier Roman forms.[34] Others are entirely new. I shall concentrate primarily on what happened during this period to the traditional and conventional Corinthian capital, a process which Kautzsch analysed with great thoroughness. Through the fourth century the Corinthian capital maintained essentially its classical shape and appearance, as a comparison of a Cypriot capital of that period (fig. 139) with a second-century example from Pergamon (fig. 138) shows;

that is to say, the transition from circle at bottom to square at top is effected by means of the abacus, the square member placed on top of a cup-shaped core, the so-called bell.[35] The essence of the Corinthian capital is that it invests the purely static relationship between these two core members with a semblance of organic growth. It almost conceals the bell, making it disappear behind wreaths of acanthus foliage staged in depth and thus turning it into a foliate calyx. From behind the innermost row of these leaves, volutes grow as if pushed up by an innate live force, and the abacus, swerving out in response to their movement, appears to rest lightly on these springy supports. It is true that in our fourth-century example these elements and relationships no longer seem quite so natural. The acanthus leaves are more schematic, they lack true modelling, and the tips of their lateral lobes, which are deeply undercut, touch those of the adjoining leaves so that the interstices between them recede into deep shadows and form patterns of their own. On top, at the corners, the volutes which converge from adjoining sides coalesce into a single undefined mass, and the flowers that had adorned the centre of each side of the abacus (having grown on thin elegant stalks from behind the acanthus foliage) have become amorphous protuberances of the abacus itself.

These changes, however, though significant in view of what was to come, are minor compared with those wrought in the course of the fifth century. The capitals of S.Apollinare Nuovo, which take us to the very end of the century or, more probably, to the first decades of the sixth, and which on the evidence of their masons' marks were carved in or near Constantinople, can serve well to exemplify these changes (fig. 141).[36] The acanthus leaves are reduced in number and simplified in outline. The abstract pattern of diamonds, trapezoids and ovals formed by their interstices has become almost their coequal as a design element. What is most significant is the transformation of the upper zone. The volutes have atrophied. Instead of rising from the foliage, their stems are joined together on each side in a catenary curve, a form suggesting suspension and thus the very opposite of their former supportive function. In any case, the volutes are only superficially indicated on the rather amorphous plastic mass that fills the entire space enclosed by the foliate wreaths. No longer bell-shaped, this core mass itself emerges as the true load-bearing element; and it is within this core that the transition from circle to square is effected. Thus the function of the capital is no longer translated into organic terms. Indeed, the overall shape has ceased to be that of an expanding calyx. It has contracted, become a block. The boss on the abacus has also been enormously enlarged as though it were an outgrowth of a yet denser mass pushing out from inside this block. On the other hand, the almost *à jour* treatment of the leaves, suggesting as it does a shadow

zone of indefinite depth behind the foliage, rather irrationally calls into question the solidity of the core, otherwise so emphatically asserted.

This radical transformation of the Corinthian capital, turning it from an organic and rational design element into an abstract and irrational one, was a slow but relentless process which took place with remarkable consistency in many different areas during the fifth century. Exemplified here by a single comparison, it was studied and analysed by Kautzsch in a variety of regional manifestations.[37] But it was the Aegean region that during this period led in inventive and innovative designs. The transformation of the foliate capital into an abstract block shape here received a powerful impetus from the concurrent development of another closely associated member, namely, the impost. First introduced in the late fourth century, the impost was by origin a structural device.[38] Its purpose was to help effect the transition from the top of the capital to the footing of the arch above, and it still appears as a frankly technical and auxiliary element in many instances of columnar architecture as late as A.D.500 or even later. S.Apollinare Nuovo itself provides an example (fig. 141). The imposts here are plain, truncated and inverted pyramids, adorned only with a cross on the side facing the nave. Elsewhere, however, the impost had long since begun to sprout a foliate ornamentation of its own, at first only on its front and in a subsidiary role as a frame for the cross (fig. 142), but soon spreading and at the same time eating into the substance of the block through the kind of under-cutting and resultant deep shadows which we have encountered on capitals (fig. 143). By the second half of the fifth century one finds imposts whose entire surface is covered with a lacelike pattern of finely serrated acanthus foliage against a background of deep shadows, a decoration conceived entirely in terms of the plain solid of the block yet radically calling into question its very solidity (fig. 144).[39] Here the goal to which we saw the designs of Corinthian capitals progress slowly and gropingly was in effect already realized. And the impost carried the capital with it in its triumphant evolution. This is most clearly in evidence in its relation to the Ionic capital, on which at first one finds it perched rather stiffly and demurely (fig. 145), while subsequently it overpowered the Ionic element and invested it with its own increasingly luxuriant ornament. The so-called Ionic impost capital which resulted from this merger was one of the many original creations of the fifth century and became a vehicle for a great deal of imaginative play (figs. 146, 147).[40] But in due course imposts were to triumph over – and, in a sense, absorb – capitals of other types as well, including the Corinthian. The result was an entirely new form, the so-called impost capital, which streamlined completely the transition from circle to square, bringing this transition fully out into the open and effecting it smoothly within

the block-shaped body itself. The impost capital was the climax of the entire development here under review.[41] Outstanding among early examples are the capitals in the lower storey of the Church of Sts Sergius and Bacchus, Justinian's first ecclesiastical foundation in Constantinople (fig. 148).[42] They are particularly interesting because they represent a variant clearly indebted to Corinthian antecedents, witness the curvatures of the abacus by which the shape of the entire body is here determined (cf., for example, fig. 139). In other instances – including examples that are certainly pre-Justinianic – the 'squaring of the circle' was accomplished in terms of the purest and most abstract stereometry.[43] Aesthetically, then, the capitals of S.Apollinare Nuovo (fig. 141), which come close to a pure block shape but still carry separate plain imposts, were already outdated in their time.

The development in ornamental sculpture which I have illustrated with these few examples shows extraordinary consistency. Resulting in momentous change and entirely new forms, it has an almost irresistible inner logic. It thus raises profound and disturbing questions of historical determinism. Consider a run-of-the-mill Corinthian capital in Jerusalem (fig. 140) which was certainly made before A.D.400,[44] but which, by comparison with our Cypriot example of that period (fig. 139), is less expansive in outline and shows the volutes losing some of their springiness and the core mass emerging above and below them. Was the carver of this capital already groping towards the block shape of the pure impost capital? If so, what was it that impelled him to make this as yet almost imperceptible change? And what, if any, connection is there between his innovation and the style changes we have previously observed in other media?

We must certainly accept a change such as this as wholly 'inner-directed', a pure manifestation of the sculptor's own aesthetic preference and intent. There is no content here, no point to be made, no message to be conveyed. No patron can have demanded, let alone generated this innovation. Indeed, I would maintain that the whole evolution of sculptural ornament which I have outlined was essentially autonomous and took place entirely within the aesthetic sphere. It was a kind of chain reaction among artists with each successive step being predicated on the preceding one. And whatever the motivation was in a specific instance, there is no doubt that the process as a whole has meaning. It has as much 'meaning' as the dissolution of organic and natural relationships in a cubist painting and has comparably profound implications, implications which have to do with man's perception of and attitude towards the physical world and the forces governing it.

At the same time, however, it also presents parallels with what we have seen happening in other media. The progressive rejection of classical forms; the

increased abstraction; the bringing out (as against the dissembling) of basic forms and structural matrices; and the simultaneous dematerialization of these matrices – all these emerge as fundamental style trends common to fifth-century art as a whole. In this sense our impost block with its lacelike skin (fig. 144) is, in fact, an exact stylistic equivalent of the little golden dome of S.Vittore in Milan (fig. 105).[45] We must, I think, conclude that these broad trends, at different stages of their evolution, also played a part in shaping works as diverse as the mosaic decorations of S.Maria Maggiore and of S.Apollinare Nuovo. To a greater or lesser degree their style too was willed by the artist and was therefore 'inner-directed'. But the artist's intent and outlook was in turn shaped by forces in the spiritual and intellectual, social and political realm of which these highly articulate works can give us at least an inkling.

Perhaps it will be best, at the close of our inquiry into this complex period, to look once again at the face of an individual. We found the concerns and predicaments of the third century reflected in the countenances of men of the period. A justly famous portrait head from Ephesus (fig. 149)[46] – surely one of the most eloquent visual statements about a particular human being in all post-classical art – will render this same service for the fifth century. Its forms are rooted in the art of the Theodosian period. But these forms have been radically made over and redefined to convey with great power the consuming intensity of one man's awareness of the supernatural world.

CHAPTER FIVE

The Justinianic Synthesis

Some of the discussions in the last two chapters have already taken us well past the year A.D.500. We have considered ivory diptychs made for consuls in the early years of the sixth century. We have surveyed the mosaic decorations created at Ravenna in the time of Theoderic, whose rule lasted until A.D.526. In architectural sculpture we have traced a development which carried through to the time of Justinian. Obviously the historical process was continuous. The turn of the century does not constitute a landmark.

A new era, often acclaimed as the First Golden Age of Byzantine art, did, however, begin with the advent of Justinian in A.D.527. The great monuments of the ensuing quarter-century bear a character all their own. Yet the bold new departures of this period depended heavily on accumulated experiences of the past. In this sense the art of the early Justinianic age, to which this chapter will be devoted, constituted not so much an innovation as a fulfilment and a consummation. For a brief time seemingly conflicting forces and traditions were balanced out in a state of controlled tension. Like other such climactic efforts in the history of art, the synthesis was not sustained for long.

A change of style in this period is borne in sharply on the visitor to Ravenna, who, coming from S.Apollinare Nuovo or any of the other mosaic-adorned interiors of the period of Theoderic, enters the Church of S.Vitale. The famous mosaics in the chancel of this church embody the golden moment of Justinianic art as does no other extant work in a pictorial medium. They will be given pride of place in our discussion. Although they should and will be viewed in the light of their local antecedents, they will prove to be highly representative of the art of their time.

The Church of S.Vitale[1] was founded by Ecclesius, Catholic bishop of Ravenna under Theoderic, probably shortly after the Arian king's death. Construction, however, may not have got under way until after the conquest of the city by the Byzantines in A.D.540. As for the mosaics, they are entirely a work of the decade following that event. In the famous imperial panels, Bishop Maximian, who was appointed to the see in A.D.546 and who consecrated the church in A.D.547 or 548, is prominently portrayed. On the other hand, the Empress Theodora, who died in A.D.548, seems to be depicted as still living.

[81]

The iconographic programme of these mosaics is intricate. But there is a central theme clearly relating to the eucharistic rite for which they provided the setting. The Agnus Dei – the sacrificial Lamb – placed in the centre of the vault and directly over the altar is literally the keystone of the entire composition (fig. 153); biblical prototypes of offering and sacrifice are prominently displayed on the two side walls (pl.V; figs. 154, 155); and in the apse Justinian and Theodora appear with their retinue offering precious liturgical vessels as donations for the church (figs. 151, 152, 158). The liturgical reference, therefore, is central to the entire ensemble. But we are also shown a kind of conspectus, assembled in a unified space, of God's plan for the redemption of man. It is a conspectus to be experienced in a single view rather than in progressive motion as in S.Maria Maggiore, and it does not take the form of an epic narrative as it did in the Roman basilica, but rather of a selective portrayal of those who have succeeded one another in time as principal heralds and agents of the divine plan: prophets, apostles, evangelists and saints. Moses is depicted three times in different actions in the spaces adjoining the sacrifice scenes, and these spaces are shared by Isaiah and Jeremiah (pl.V; fig. 154); the four evangelists are fitted in the zone above (pl.V; figs. 154, 157); medallion busts of apostles and saints appear in the soffit of the entrance arch (fig. 153) ;and the celestial vision of the Apocalyptic Lamb overhead carries the unfolding of God's redemptive action to the end of time. The whole is presided over by the majestic figure of Christ seated in a paradisical landscape in the conch of the apse. Flanked by angels, he receives a model of the church from Bishop Ecclesius while handing a martyr's crown to its titular saint (fig. 156).

Thus images that are thematically static – single figures and slow ritual actions – predominate here as they did in the mosaics of Theoderic's court church. Yet the visual effect could hardly be more different. Severe geometry is replaced by luxuriant life. Even figures in isolation tend to be in action, gesticulating and turning. Many have outdoor settings. Whatever spaces remain are filled with rich vegetation. And the dominant colour is not gold but a verdant bluish green.

The S.Vitale decoration seems to take us back to a period much earlier than the age of Theoderic. Nor is this only a matter of more natural and lively motifs. With these elements the artist composes real pictures, self-contained compositional units strongly reminiscent of the traditional *emblema*. We see figures and groups of figures in a clearly delimited environment and in communication with that environment. A return to the past seems to be involved also in the overall structuring of the surfaces. That structure is firm and consistent, and it is carried through on the basis of a clear distinction of framing

and framed parts. It is true that on the lateral walls of the chancel such a distinction was pre-established by the architect. Both in the lower and in the upper storey he provided the mosaicist with recessed surfaces (open arcades surmounted by lunettes) set in a wide frame (pl.V; fig. 154). But one wonders whether in creating this articulation the architect did not already have the mosaic decoration in mind. Be this as it may, the designer of the mosaics takes up the cue and follows it consistently even in the apse and the vault where, with but little aid from the architecture, he still makes heavy and emphatic frames the basic organizing element (figs. 150, 153).

Real and palpable as this return to the concept of picture and frame is, however, we do not find at S.Vitale what had been a corollary of this concept a century earlier in the decoration of the Mausoleum of Galla Placidia, namely, a rhythmic interplay of three-dimensional and two-dimensional surfaces (pl.I; figs. 93, 98). At S.Vitale the frames too are vehicles of *emblemata*, most conspicuously on the two lateral walls. The distinction so clearly established with one hand is taken away with the other. In part this might be said to be dictated by iconography. Not only the sacrifice scenes in the lunettes of the lower storey but also the Moses scenes in the broad framing spaces adjoining them called for an indication of locale. It was natural to provide a landscape setting for Moses pasturing Jethro's flock, loosening his sandals before the Burning Bush and receiving the law on Mount Sinai, as well as for Abel and Melchizedek making their offerings and for Abraham feasting the three angels and preparing to sacrifice Isaac. But the portrayals of the four evangelists with their symbols in the upper zones of what we have found to be framing surfaces likewise take the form of scenic *emblemata*, and in this case the iconographic motivation for such a device is far less evident and certainly less compelling. Here the desire to counteract the distinction between framing and framed parts of the wall system seems to be a primary factor.

The panels with the evangelists (fig. 157) are particularly interesting. As *emblemata* showing their subjects seated in rocky landscapes in the company of symbolic animals, they invite comparison with the classic instance of an *emblema* among the Ravenna mosaics, the Good Shepherd lunette in the Mausoleum of Galla Placidia (fig. 94). One might go further and suggest that the artist who designed these panels drew his inspiration from that earlier work. But what is chiefly illuminating in this comparison is the difference it reveals. No longer are the landscapes spacious settings receding into a distance. They are more in the nature of backdrops or curtains placed behind the figures. If in the earlier composition the horizon was remarkably low, here it is extraordinarily high. The rocky threshold with its cliffs, which in the earlier mosaic so effectively helped to make

the space within the picture recede from the frame, is still present. But it is surmounted by tier upon tier of similar formations, all more or less equidistant from the beholder. Thus the rocky scenery is more like a wall mysteriously disappearing into nowhere below the lower frame and rising almost vertically. The symbolic animals at the very top are at no greater distance from us than the figures beneath and really play the role of headpieces or pictorial titles as they will often do subsequently on the pages of early medieval manuscripts depicting the authors of the Gospels. The evangelists themselves seem to be affixed to rather than supported by their settings. Shadows, reminiscent of an *en creux* relief, accompany some of their outlines and provide the figures with a kind of shallow niche, thus anchoring them more securely to the precipitous mountain sides on which they are placed. Actually, on closer inspection, one begins to have doubts as to the solidity and cohesiveness of these rocky walls. The cliffs and outcrops are interspersed with what might be considered hillocks, and some of these formations are so soft and fuzzy in outline as also to suggest clouds. Indeed, in two of the panels there appear at the top, behind the symbols, narrow sections of cloudy sky with which some of these 'hillocks' seem to merge. Such fusion of ground and sky is an old device of late antique impressionism which we have previously encountered in the mosaics of S.Maria Maggiore (figs. 117, 119). At S.Vitale it serves to call into question the material identity, the rational build-up of the landscapes and makes them appear even more like semi-abstract backdrops.

One might suppose that in designing the mosaics for these particular sections of the chancel walls the artist was conscious that he was dealing with what was structurally a frame and was therefore anxious to avoid the impression of a truly receding space such as the Galla Placidia mosaic offers. But when we turn to the pictures within the frames, that is, the lunettes with the sacrifice scenes, we find that the principles on which they are composed are not essentially different. In particular the landscape setting for the two Abraham scenes when examined closely turns out likewise to be semi-abstract (fig. 155). It is, in fact, a quite remarkable mélange, part meadow, part mountain, and part sky. Mounds and cliffs briefly appear and disappear again. How solid really are the outcroppings on the right, bending as they do with the curvature of the frame and the crouching figure of Isaac, for which they form the background? Is the striking form just to the right of the seated angels earth or sky? As for the scattered plants and trees, they do not really grow from the ground and scarcely add to its plausibility. This is true even of the great oak of Mamre near the centre of the panel, a pivotal element both iconographically and compositionally. The angels at their table are oddly interlaced with the trunk of the tree so that doubts arise in the

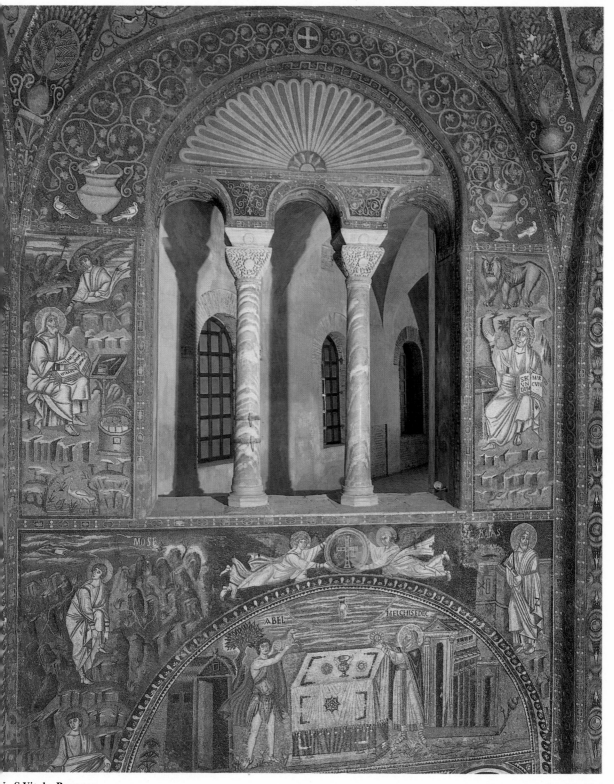

V. S.Vitale, Ravenna
South wall of chancel

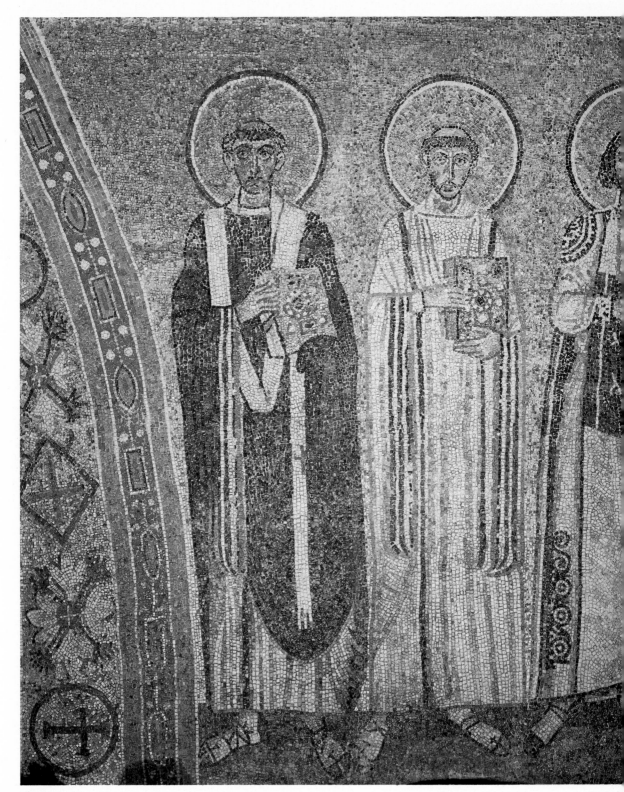

VI. Two saints
Mosaic on apse wall of Chapel of S.Venanzio, Lateran Baptistery, Rome

beholder's mind as to how much bodily substance any part of this entire con-
figuration really has. Seated on an orange-coloured bench, the angels overlap
the oak's trunk; yet they seem to be not in front of but behind it, since the legs
of the table that is placed before them appear to rest on the ground behind the
tree. None of this, then, bears rational analysis. Existence of real persons and
objects in real space is only approximated: in effect, like the evangelists, they
are attached to a backdrop.

What the artist has created here may appropriately be termed a pseudo-
emblema. It is a framed panel picture with seemingly unified and space-creating
scenery and with figures in seemingly natural relationships inhabiting this
scenery. In actual fact there is no recession into depth. The *emblema* is not a
'window' as it had been in the past. As for the frame within which it is set, it
in turn has become a vehicle of similarly pseudo-real views. In both cases the
surface remains basically intact. We found that the acceptance of the surface in
its totality, the frank display of the abstract matrix, was an essential formal
principle which came to the fore in the course of the preceding century. The
step is not reversed here. Nowhere is the surface really broken through. Its
integrity is merely disguised by the introduction of two other – more traditional –
factors: one is a structuring in terms of framing and framed parts; the other,
an abundance of 'nature' elements. The latter, however, are spread over *all* the
surfaces, thus making for uniformity. The overriding impression these walls
create is indeed that of a *horror vacui*. There is movement and luxuriant growth
everywhere. But it is only a veneer. Beneath it the wall is solid and intact.

The Justinianic pictorial style can thus be seen to be indeed a kind of balanc-
ing act which attempts to reconcile the irreconcilable. It involves a reattach-
ment to past ideals of natural and organic relationships without abandoning the
new abstractness firmly established in the course of the preceding one hundred
years. In passing it may be noted that similar principles also govern Justinianic
architecture. *Mutatis mutandis* one finds the same paradoxes as in our mosaics
embodied in the design of St Sophia.[2]

In the apse of S.Vitale it is the composition in the conch which functions as
an *emblema*, while the rest of the decoration constitutes an elaborate framework
(figs. 150, 156).[3] The view of the paradisical garden in which Christ holds court
is set back from a heavy ornamental band, filled with a pattern of cornucopiae,
which arches around the opening of the conch; and although the arrangement
of the figures is formal and symmetric, the landscape in which they are placed
makes a plausible spatial setting. Yet once again this impression does not remain
unchallenged. The blue sphere signifying heaven on which Christ is seated is
fitted into a segment cut out, as it were, from the green ground, and thus the

materiality of the terrain is radically called into question. At a crucial point the landscape setting turns out to have a consistency no greater than paper.

Still, in relation to the whole, the scene does have the character of an *emblema* surmounting two tiers of wainscoting.[4] The lowest zone is an actual skirting of *opus sectile* articulated by a pilaster architecture which carries an entablature. The mosaic decoration begins above the latter's projecting cornice. But the first mosaic zone, on the level of the windows, is in effect another wainscoting. Simulated pilasters are placed between the windows. They stand on the axes of those in the *opus sectile* zone and on them rests the narrow band that is the actual border of the scene in the conch. On the sides this border rests on the two panels with the imperial processions which, extending as they do to the very front edge of the apse, are an integral part of this second support zone (figs. 151, 152). Indeed, the cornucopia band that enframes the paradise picture from the front, though contained within the latter's ornamental border, in effect also rests on these panels, and their supporting function is made explicit by the fact that the system of simulated pilasters carries through into their domain. Although, with characteristic ambiguity, the lateral pilasters are half-absorbed into the architectural scenery of the processions, they clearly relate to those in the centre, and they again stand on the axes of the *opus sectile* pilasters below. Justinian in his purple robe might himself be said to take the place of a missing pilaster (fig. 151).[5]

The picture-frame concept, then, is very definitely present in the apse as well. In fact, here too it constitutes the organizing principle. But again the frame has its own 'pictures'. The two imperial scenes are self-contained tableaux, each with its own setting, though only Theodora's is elaborated in some detail. With their tightly packed compositions, their severe lines and their precise delineation of every detail, the two panels differ so strikingly from all the other mosaics in the chancel that they have at times been thought to be of a different date, afterthoughts added by Maximian to a decoration already largely completed when he assumed office. But to consider this difference of styles as a matter of dates (or even of 'hands') is to disregard quite fundamental aspects of this art. It is a case not unlike that of the mosaics of S.Maria Maggiore in Rome discussed in the preceding chapter.[6] There can be no doubt that at S.Vitale too the difference was introduced intentionally and purposefully, although here it was done with an eye on the compositional context which I have just analysed, as well as for thematic reasons. With little space given to settings, the imperial processions in their tight alignment present a solid front – a wall, almost. This befits the function of these panels as part of a 'wainscoting' zone while at the same time expressing the fact that the figures here belong to a different world,

distinct both from the heavenly paradise above and from the biblical ambient of the scenes on the adjoining lateral walls. In this sense it is once again a matter of 'modes', a deliberate change of key, with the most pronounced geometry, order and abstractness reserved for the world of the earthly ruler.

Thus the formal rendering of the imperial scenes ingeniously serves the needs both of their subject content and of their role in the compositional structure. Their differentiation vis-à-vis the *emblema* in the conch is, however, only a relative one. On closer examination, the imperial panels turn out to be not quite so static and rigid as they seem at first. Theodora's procession moves decidedly towards the centre of the apse, and Justinian and his suite too are in motion. In fact, the seeming simplicity of this panel with its isocephalic array of rigidly erect figures is wholly deceptive (fig. 158).[7] One need only attempt to plot on a 'ground plan' the position of all the figures in relation to each other and to the frame to become aware of two factors which, while mutually incompatible from a realistic point of view, are both in conflict with the impression of a simple line-up parallel to the picture plane.

For one thing, the entire retinue is staggered in depth behind the emperor. His figure in effect is at the head of a V-shaped column which, in terms of its three-dimensional implications, projects far out from the wall and well into the 'real' space of the sanctuary; at the same time the formation is placed diagonally in relation to the frame. At the left end the imperial bodyguard is overlapped by the frame, while at the right end hand and foot of the censer-bearing cleric cut across the framing pilaster. Both these devices entail a modicum of spatial illusion, and this is reinforced by the fact, noted earlier, that the pilasters themselves are in a sense part of the real architecture of the apse. Thus Justinian and his suite become a real presence in a way no other element in the entire S. Vitale ensemble does. Their diagonal alignment helps to underscore the impression that they are indeed a moving procession – an impression created primarily by the sideways action of arms proffering gifts or utensils and subtly aided by the fact that Justinian's position is slightly off centre. But the placing of the emperor at the apex of a 'V' reinforces the contrary effect of a static and symmetric composition of which he is the axis.

This latter effect is clearly meant to dominate, but it is cunningly challenged by those factors which imply movement in space. It is challenged in another way as well. Maximian, standing next to the emperor, is overlapped by the latter in the area of his right arm and must therefore be assumed to be in a second plane behind his sovereign. Yet he is taller than Justinian and actually appears to be standing in front of him. (He is also the only person singled out by a name inscription.) The emperor is made to share his prominence with the bishop.

Together the two figures in their dark robes form, as it were, the central part of a triptych whose wings are constituted by two pairs of courtiers and clerics clad in white. It is a picture within the picture, set off from the bodyguard on the left which has its own quite distinct colour accents; and it makes an unmistakable point, a point decidedly at variance with the idea of Justinian's sole and absolute power which is conveyed by the composition as a whole.

This panel, therefore, for all its apparent simplicity, is as intricately constructed and as highly charged as a Bach fugue. Nowhere is the 'reconciliation of the irreconcilable' carried through with such consummate artistry as here. Nowhere are the resulting tensions as effective and dramatic. But at the same time they are carefully controlled and calibrated so as not to impair the function assigned to the panel in the overall design. The picture very definitely remains part of the framing and supporting zone for the great celestial vision above.

Clearly the designer of the S.Vitale mosaics was a great master, one of the great artists of the first Christian millennium. We do not know where he came from. Undoubtedly he must have studied the earlier Ravennate decorations. But the roots of the stylistic innovations he introduced lie elsewhere. In its most essential aspects, the art of S.Vitale is not explicable in local terms. It becomes historically intelligible only in the light of certain antecedent developments in the Greek East. The master designer must have hailed from that area or at any rate have been in close touch with what was happening there.

To demonstrate this, it is best to turn once more to floor mosaics. They alone among works in the pictorial media are preserved in sufficient density in all parts of the Mediterranean world to permit comparative judgements as to trends and developments in different regions. Obviously it means a descent to a lower level – literally and artistically. But the descent will prove as illuminating as it did earlier in our study of fifth-century art.

A very few examples must suffice to bring out the key points.[8] We saw how in the pavement mosaics at Antioch the principle of surface acceptance had gained ground since the late fourth century, first in the form of unified geometric carpets (fig. 91) and then in the form of what I have called figure carpets (fig. 90). Now in the realm of purely ornamental floors a further striking change gradually took place both at Antioch and elsewhere in the Greek East as the fifth century progressed. Although carpets composed entirely of geometric motifs continued to be made, there was an increasing tendency to inject organic elements – animal and vegetable – into the designs. If a typical nave mosaic in a church of about A.D.400 offered a seemingly infinite expanse of repetitive geometric motifs, by the year A.D.500 a typical nave floor anywhere in the Greek world shows a variety of birds, animals and plants incorporated into

such patterns. These motifs in turn tend to be quite repetitive, so that the overall character remains that of an endlessly expansible carpet. A floor in the narthex of a basilica excavated at Delphi, probably of the period *c.* A.D.500, provides a good example of this style (fig. 161).[9] By this time, however, many designers of floor decorations all over the Near East had substituted floral for geometric motifs in constructing the framework itself (fig. 162).[10] These floral motifs are severely stylized, but they do carry suggestions of organic growth which the geometric carpets had excluded entirely; and when, as presently happened, these floral grids were also enriched with organic filler motifs, a totally new kind of carpet was in effect created – still geometric in its basic structure, but teeming with life. The 'Striding Lion' floor from Antioch, a work of the advanced fifth or, more probably, the early sixth century, is a good example (fig. 163).[11] The next logical step is the replacement of the floral grid by an actual growing organism, a rinceau issuing either from stems in the four corners or from a single stem at the base. A floor found outside the Damascus Gate in Jerusalem is a splendid example (fig. 164).[12] The involutions of the rinceau are kept so uniform as to create what is still an abstract pattern to be filled at will with animals, birds and other motifs. Yet it is an organism, coherent, unified and continuous, with a single live force flowing through it; and it provides a natural habitat for the creatures it encloses.

It should be emphasized that 'inhabited' rinceaux as field patterns for floors had existed at a much earlier period in Italy, North Africa and elsewhere in the West.[13] But in the East, and particularly in Syria and Palestine where such floors became commonplace in the sixth century,[14] they constituted at that time a new vogue, a vogue prepared by and growing out of the process of floralization of carpet designs which I have outlined. Although I have perforce simplified and schematized this development its existence is undeniable and, as will be seen readily, it has a bearing on the revolutionary change that we have observed at S.Vitale.

The 'Striding Lion' floor at Antioch (fig. 163) is interesting also in another respect. The handsome beast after which it is named is superimposed on the grid pattern and provides it with an emphatic focus and centre. The birds and quadrupeds which fill the grid face in four different directions; from whichever side a beholder approaches he will see a group of them in an upright position. In this sense the mosaic is multidirectional and endlessly expansible in true carpet fashion. But the lion creates a principal viewpoint, and there is a heavy outer frame to enclose him and to keep the flowing pattern within bounds. Increasingly during the late fifth and early sixth centuries such focal motifs were placed at or near the centre of repeat patterns, and increasingly also framing bands were

broadened, elaborated and multiplied.[15] There is thus a clear tendency in these floor designs to counteract the even spread and potential endlessness of carpet-type compositions; to make them finite and centralized; and to structure them in terms of primary and secondary components. In fact, the grid pattern of this mosaic is in a sense a foil for an image of a lion in an ample frame. There is here, in other words, a latent tendency to return to the *emblema* concept. But this change is accomplished within what remains very definitely a carpet-type design.

It is not surprising in the light of this development to find that certain mosaic floors made in Greek lands in the first half of the sixth century present once more real 'pictures', that is, panels of limited size offering views of natural objects in more or less natural relationships. A floor of *c*. A.D.525–50 in the Church of St Demetrius in Nikopolis in Epirus may serve as an example (fig. 165).[16] It shows a landscape with trees standing on (or, to be quite precise, hovering slightly above) a strip of ground, along with plants and some pecking birds, while other birds are in the air. Though obviously stylized and highly formalized, this is a view of a piece of the 'real' world in the tradition of the famous garden prospects painted in the Augustan age on the walls of the Villa at Prima Porta.[17] The picture is enclosed within no less than five framing bands beginning with a bead-and-reel border and a running spiral, which are classical framing motifs for *emblemata*. The principal frame is a broad strip of simulated water inhabited by fish and fishermen and in turn enclosed between two narrow ornamental bands. The mosaic, which covers the floor of one wing of the transept of the church, is intended to be far more than a mere ornament. It has a lengthy inscription in Homeric hexameters which invests it with an extremely interesting cosmographic symbolism: the tree landscape, so we are told, stands for the earth, the aquatic band around it for the encircling ocean. The injection of explicitly cosmological themes into the decoration of church floors was a characteristic and significant development in the Justinianic age.[18] Our concern here, how-ever, is the composition of the Nikopolis floor, which it is interesting to compare with that of an earlier landscape mosaic in a corresponding location in the Church of the Multiplying of the Loaves and Fishes at Tabgha (fig. 92).[19] The artist at Nikopolis regrouped the elements which in the earlier work had been taken apart, re-established their real relationships and firmly enclosed the re-sulting view in a multiple frame. But the view has no depth. The panel picture, unlike the true *emblema* of Roman times, respects the integrity of the floor. The matrix remains basically intact as it does in the Palestinian example. What the sixth-century artist has created is a pseudo-*emblema*.

In using this term again I am not implying any direct connection between the

atelier of S.Vitale and the Greek workshops which created floor mosaics such as the one at Nikopolis. What I do suggest is that basically similar formal principles and ideals are involved in both cases. There is in both a desire to re-establish a natural view of things, to show their organic interrelationships and confine them within clear and reasonable limits; to tame infinity as it were, but without abandoning the premise of a potentially limitless foil that cannot be fully assimilated and mastered in terms of earthly experience. The special importance of the pavement mosaics lies in the fact that in them we can discern an evolutionary process leading up to this extraordinary reconciliation of opposites. Moreover, they show this process to be very definitely concentrated in the Greek sphere. There are occasional offshoots of the pseudo-organic style of pavement decoration in the Latin world.[20] But the West did not participate actively and consistently in creating it. The emergence of the style must be interpreted as a reassertion in the Greek East of traditions deeply rooted in that area's Hellenistic past. There is in these Eastern floor mosaics of the pre-Justinianic and early Justinianic period much groping towards forms compatible with that past. The latent (and finally not so latent) reassertion of the *embl·ma* concept is especially interesting in this respect. The end result is a floor such as that at Nikopolis, which can hardly be explained without assuming an actual revival, a conscious going-back to much earlier forms. This entire process is undoubtedly relevant to the art of S.Vitale. Without detracting from the achievement of the great master who created that magnificent decoration, the Eastern pavements help to put that achievement in context.

Before leaving S.Vitale a few words should be added about the mosaic of the ceiling with its celestial vision of the Agnus Dei (fig. 167). Four diagonal bands, richly adorned with flowers, fruit and birds support a central wreath in which the Lamb appears against a starry sky. The bands reflect and emphasize the shape and structural function of the groin vault which bears the mosaic. The wreath is supported additionally by four caryatid angels standing on blue spheres. The motif of the angels had appeared at Ravenna a few decades earlier on the ceiling of the small chapel in the Archbishop's Palace (fig. 109), and it is very evident that the S.Vitale master studied the local work that had preceded his own. Indeed, in this case he might be said to be quoting from it. But he has completely transformed the motif by reducing its relative size and embedding it in a sumptuous floral decor. In doing this he drew on other sources. Systems of bands, florally interpreted, as a support for a central element of a vault decoration are traditional, and by the fifth century had reached a degree of stylization such as we find here. In the vault mosaic of the Chapel of St John the Evangelist built by Pope Hilarus (A.D.461–8) as an annex to the Lateran Baptistery a

scheme of this kind serves as a framework for a central Agnus Dei (fig. 166).[21]
Rinceaux as an all-over design in vaults also have a long history; intended to
suggest a bower or pergola, they too had become formalized. In a small fifth-
century chapel at Capua (fig. 168) we find them fitted into each of the four
spandrels of a groin vault as they are in S.Vitale.[22] It was by combining the firm
structure of the garland bands with the spandrel rinceaux and by making of both
a setting for the caryatid angels that the S.Vitale master achieved his extra-
ordinarily rich effect. Once again there is a clear distinction between framing and
framed parts. Structural differentiation is carried further by confining the gold
background to the two spandrels in the longitudinal axis, while in the two
transversal spandrels the colour scheme is reversed (the background being green
and the rinceaux gold). But having thus differentiated the component elements,
the designer unites them all by the ubiquity and luxuriance of the floral theme.
Each element in itself is traditional. The combination is wholly new. More
clearly than elsewhere we can see the master's achievement as a synthesis – not
only in the sense that he unites what had previously been separate, but also in
the remarkable balance he achieves between abstract order and organic life.

At the same time, the convergence with the evolution we have observed in
Eastern floor mosaics becomes very evident here. We need not necessarily
assume that the designer looked at floors. But there was an inherent relation-
ship of long standing between floor and ceiling designs.[23] Hence at S.Vitale it is
to the ceiling that the development we have observed in floor mosaics is more
particularly relevant. But the whole decoration is a unit informed throughout by
the same stylistic principles. The evidence of the pavement mosaics enables us
to postulate a seedbed in the Greek East which generated these principles and
brought them to maturity. This evidence is all the more valuable because in the
East no wall mosaic has survived which fully embodies the essential charac-
teristics of the early Justinianic style.

There is one major work in Rome which exhibits a variant of the style. A monu-
mental apse mosaic (fig. 169) survives in fairly good condition in the Church of
SS. Cosma e Damiano on the Via Sacra, a foundation of Pope Felix IV (A.D. 526–
30).[24] The central figure is Christ, as in the apse of S.Vitale, and again there is a
ceremonial presentation scene in a landscape setting. But the action is far more
dramatic. Christ – a majestic bearded figure in golden robes, reminiscent of the
great ruler and teacher presiding over the assembled apostles in the apse of
S.Pudenziana (fig. 80) – stands aloft in a magnificent expanse of dark blue sky
on which his path is marked by multicoloured clouds. He strikes a pose long
associated with the monarch's triumphant *adventus*,[25] and he is being acclaimed

by the princes of the apostles who, standing beneath on the flowery bank of a paradisical River Jordan (thus inscribed), present to him the two titular saints. The latter step forward offering their crowns of martyrdom, and their action is echoed by the figures of St Theodore on the far right, also offering his crown, and the papal founder on the far left (a seventeenth-century restoration entirely), offering a model of the church. The whole is placed in a framework of apocalyptic motifs.[26]

Although many elements in this composition derive from a specifically Roman tradition of apse decoration,[27] there is no doubt that in its formal aspects the mosaic reflects broad trends of its period. Since most of the Roman antecedents are lost, it is hazardous to assert either that a strong element of drama has been newly injected into what in the prototypal works had been a solemn, static array of holy figures or, on the contrary, that dramatic action has been firmly contained within a static system. But certainly we see here – in an important monument created at the very beginning of the Justinianic era – a remarkable balance being achieved between these opposing factors. They are held in a state of tension which is the key to the mosaic's powerful effect. Christ's *parousia* is sudden and overwhelming. Yet he is also the apex of a solid and rigidly symmetric triangular construction. The scene takes place on a plausible, if shallow, stage, with grassy ground, water, cloud-bank and sky forming so many planes one behind the other; and the figures, which are voluminous, indeed ponderous, are organic entities using this space freely and expansively (fig. 170). Yet the beholder cannot for a moment lose sight of the geometric and purely two-dimensional pattern of which every element in the composition is a part.

These principles pervade every detail, above all the extraordinarily impressive heads (fig. 160). A firm linear framework, an inheritance from the preceding decades, underlies their construction (cf. figs. 110–13). But each component part of a face – forehead, nose, cheeks, beard, hair crown – is now strongly modelled; and they all seem to press forward against the framework without ever rupturing it at any point. A great force, concentrated most irresistibly in the huge, wide-open eyes, pushes from within, and subtle asymmetries enhance the effect of intense animation. But the glance remains immutably fixed in timeless authority.

Precisely these terms apply also to a head such as that of Justinian in the imperial mosaic at S.Vitale (fig. 159). Here, too, all features are contained within a clear geometric frame – in this case a parabolic shape of which the flattened band of the jewelled crown forms an integral part – but they are strongly modelled and again there are subtle asymmetries to offset the regularity of the

design. Here, too, the result is a portrayal of overwhelming power, imperturbably timeless yet entirely real, individual and alive. The kinship between the Roman and the Ravennate work becomes most readily apparent in this comparison. The mosaic of SS.Cosma e Damiano, executed some twenty years before the mosaics of S.Vitale, shows that the essential principles of the Justinianic synthesis were then already operative.

It is, however, in the minor arts and more particularly in ivory carvings that the salient characteristics of the S.Vitale mosaics have, among extant works, their closest equivalents. Since the ivories in question are undoubtedly from the Greek East, they help to confirm the key role which that region played in generating and promoting these characteristics. A discussion of two of these objects will round out our exploration of the art of the early Justinianic era. Viewed in the context of their own craft, they will highlight further the vitality and creative power of that era as well as the remarkable consistency of its aesthetic aims.

By far the most sumptuous product of the ivory carver's art to have survived from the entire period with which this book is concerned is the decoration of Bishop Maximian's episcopal chair (figs. 171–5).[28] This, of course, takes us back to Ravenna once more and, indeed, to a man prominently associated with the S.Vitale mosaics. Together, the mosaics and the Chair, which bears on the front the Bishop's monogram artfully worked into its ornamentation, might, in fact, be taken as exponents of a local variant of Justinianic art, reflecting the taste of a particular patron or group of patrons. Most scholars, however, are agreed that the Chair is not of local Ravennate manufacture. Numerous other ivory reliefs are known which, on the evidence of their stylistic character, must have been carved in the same atelier as those adorning the Chair, or at any rate in closely related shops. There is a continuing debate as to whether this 'school' was located in Egypt or, as I believe, in Constantinople.[29] But it was certainly in the Greek East, and while the Chair may have been made to Maximian's specifications it also exemplifies that school's much larger production.

Front, sides and both faces of the back are covered with figure representations. On the front are standing figures of the four evangelists and, in the centre, John the Baptist holding the Lamb of God; on the two sides is a series of scenes depicting the story of Joseph; the back showed in twenty-four oblong fields events from the life of Christ, but a number of these panels are now missing. On all sides are framing bands richly carved with vine rinceaux.

The framework particularly calls for comment. Four upright posts, square in section and adorned with vines, form the principal supports on which the Chair rests. (There was, however, originally, concealed beneath the seat, a system of

reinforcements in wood which has not survived.) Both on the front and on the sides the four posts are interconnected by broad horizontal bands which form with them a kind of armature within which other panels are contained. This distinction between framing and framed elements is basic to the whole composition. It rests on the fact that the broad bands with vine rinceaux on the front and three of the five Joseph panels on each side are entirely flush with the corner posts and are conceived by the eye as continuous with them, while the panels within this framework have their own heavy mouldings and, thanks to the shadows these mouldings create, appear quite deeply recessed. On the sides (figs. 171, 173), this alternation of framing and framed panels is readily perceptible, and the rhythm is accentuated by the fact that the latter are much wider than the former. But the series of vertical figure panels on the front (fig. 172) also shows the same differentiation. Here, too, broader panels recessed within mouldings alternate with narrow ones that are flush with the rinceau bands, with the result that two of the five panels with standing figures really belong with the armature and, aesthetically speaking, constitute additional upright supports firming up the structural framework of the Chair.

However, like the master who created the S.Vitale mosaics, the designer of the Chair also seems bent on negating the compositional structure he himself has so clearly created. The cycle of Joseph scenes is a single narrative covering all five of the tiered panels on each side, framing as well as framed ones.[30] Similarly, the holy figures in front – clearly a unit, a sort of *sacra conversazione* – cover all five of the vertical panels. And since, with the sole exception of Maximian's monogram, there is also a superabundance of organic motifs in the superbly carved ornamental bands above and below these panels, the overall impression of luxuriant life – of a *horror vacui* that seeks to cover all parts of the available surface with vibrant living forms – is even stronger here than in S.Vitale. Thus, both iconographically and aesthetically, the artist has to a considerable extent levelled the distinction between picture and frame. But in another sense again he has not. He has re-emphasized it perversely by a paradoxical treatment of the relief. It is in the framing parts – which provide the armature and which we would therefore expect to be the most solid – that figures and ornaments are most deeply undercut. As a result, these framing members – the three narrow Joseph panels, the two narrow evangelist panels, and the vine rinceaux above and below – have deeper shadows, less substance and more of an *à jour* effect than the reliefs within the frames. Irrationality is carried even further here than at S.Vitale.

Much else would have to be taken into account in a full stylistic analysis of the Chair. There are stylistic differences between individual parts that are due

not to the differentiation of structural roles but to different hands and the
use of different 'modes' for the different kinds of subjects. Yet the unity of the
design and of the overall character is undeniable. I shall draw attention to only
one other unifying feature, namely, a preference for *contrapposto* stances which
all the figure reliefs share, though this characteristic stands out most clearly in
the Joseph scenes (figs. 173, 175). Many figures in these scenes show an em-
phatic differentiation between free leg and engaged leg. Heads and shoulders
tend to bend in rhythmic correlation to the movement of the free leg, so that
entire bodies become swaying 'S' curves. Often the action portrayed provides
little or no motivation for these *contrapposto* rhythms which are, of course, an
inheritance from Graeco-Roman art, but which here become a kind of man-
nerism. The swaying motion they engender tends to be echoed throughout an
entire panel and repeated in adjoining panels. As a result, not only individual
scenes but also sequences of reliefs are knit together by an undulating movement.
This movement affects the Christological scenes as well (fig. 174) and even – by
dint of an alternating rhythm – two of the five great statuesque figures in front
(fig. 172). At S.Vitale, too, we found the movements and actions of figures to be
one of the factors contributing to the unity of the whole. But in the mosaics
movements are not so spe ifically correlated as they are here, and the *con-
trapposto* device does not occur there at all. In a sense, therefore, the ivories are
more classicizing and at the same time even more strongly and organically
integrated than the mosaics.

The other ivory to be discussed is the so-called Barberini Diptych in the
Louvre (fig. 176).[31] Second only to Maximian's Chair in fame and interest, it
leads us into the sphere of secular imperial art and shows imagery in that sphere
shaped by the characteristic aesthetic preferences of the early Justinianic period.

The diptych is of the 'five-part' type, a type which came into vogue in the
fifth century and was used for exceptionally sumptuous book bindings (cf.
fig. 85) as well as for exceptionally sumptuous objects of official largesse. In the
latter capacity the type may have been reserved exclusively for imperial
patrons.[32] One of the five panels of the Louvre piece is missing and the second
half of the diptych is entirely lost. The central panel of the extant leaf depicts
the emperor mounted on a richly caparisoned horse and attended by an acclaim-
ing barbarian, a flying Victory and a recumbent *Terra*. A high-ranking military
officer approaches from the left, offering 'Victory' in the form of a small statue,
and no doubt there was originally a corresponding figure on the right. Homage
is also being paid by representatives of various exotic nations depicted in small
scale in the lower horizontal strip. Led by yet another Victory they bring
appropriate gifts and tributes, including wild animals. But the ruler triumphs

by the grace of God and on God's behalf, as witness the bust of Christ, borne by flying angels, in the top panel.

Scholars are not universally agreed on the dating of this work. There is, however, a specific stylistic relationship to the reliefs of Maximian's Chair. Indeed, the tribute-bearing barbarians are closely related to figures in the latter's Joseph scenes (fig. 175). Faces (particularly eyes) are cut in similar fashion and bodies move in the same characteristic swaying action. The Barberini Diptych must have been made in the same period and perhaps even in the same atelier as the Chair. It follows that the emperor whose success it extols must be Justinian.[33]

Five-part diptychs are framed pictures by definition. The central panel – here, as often, rendered in very high relief – dominates; the other four form its frame. What is remarkable in this instance is the amount of lively activity with which the central relief is packed. Most often in such diptychs that panel is occupied by a completely static image – a motionless figure of a ruler in rigid *en face* view or, in the case of religious pieces, an appropriate emblem (fig. 85) or an enthroned Christ or Virgin. A portrayal of the emperor in solemn repose would have been a natural subject in this case. He would have appeared simply as the ever-imperturbable recipient of the acts of homage and tribute by which he is surrounded, the immovable centre upon which all movement converges. Instead the scene here is crowded with momentary action so swift and intense that the panel can barely contain it. The emperor has arrived on his charger this instant, his mantle still flying in the wind. It almost appears as though he had just passed through a low city gate which had caused him to tilt his head. He pulls in the reins and makes a rapid half-turn as he rams his spear into the ground to use it as a support in dismounting. Earth herself renders a groom's service and puts a helping hand under his foot, while the cheering barbarian obsequiously brings up the rear and Victory flies in to crown him. In all Roman imperial art there is no more spirited portrayal of an imperial *adventus*.[34] It is not on a sedentary presence that the figures in the framing panels converge. Action is met by action, and all parts are knit together in indissoluble unity. Movements of figures in different panels respond to each other as they do on Maximian's Chair. The result is again a swaying rhythm pervading the whole and counteracting the distinction between picture and frame, a distinction which is none the less unmistakable. The only figure in repose is Christ in his celestial *clipeus* in the top panel. But taken in its entirety that panel, too, represents action – note how the angel on the left bearing the *clipeus* takes up the movement of the emperor's head – and this action must surely be understood as being closely parallel to that in the centre. The celestial vision cannot be

meant to be stationary. Christ makes his appearance in heaven at the moment in which the emperor stages his triumphal *adventus* on earth. It is a graphic depiction of the harmony between heavenly and earthly rule, a concept basic to Byzantine political thought from the outset but proclaimed by Justinian's artist with unprecedented clarity and vigour.

The Barberini Diptych makes a fitting conclusion to our exploration of the art of the early Justinianic era. Particularly when viewed against the background of the official diptychs of the preceding generation (fig. 86), it palpably epitomizes the aesthetic achievement of this period. Once again there arises the question as to what the achievement means and whether it can be related in some way to a broader historical and cultural context.

There is no ready answer to this question, and I shall confine myself to two suggestions. One concerns the revival of forms and motifs associated with the Graeco-Roman past.[35] This was certainly an important factor in the stylistic make-up of the works we have studied; and it has quite tangible parallels in other areas, more particularly in Justinian's legislative work. His goal was, after all, a *renovatio* of the Roman empire.[36] Given the consciousness of this effort, a retrospective or even an antiquarian bent in the realm of art is readily understandable. In many instances the trend might indeed be promoted by the wishes and purposes of patrons and donors and therefore be 'other-directed'.

My second point is more elusive. It has to do with the quest for wholeness, for indissoluble unity – and a kind of structured and organic unity – which emerged as a fundamental trait of the art of the period. This is a more instinctive trend, implicit to some extent in antecedent developments and, I submit, largely 'inner-directed'. It has, however, an equivalent in the subject matter of works such as the Barberini Diptych or the chancel decoration of S.Vitale. The latter with its unified conspectus of divine *oikonomia* and its harnessing of that conspectus to the liturgy foreshadows the great systems of Byzantine church decoration in the centuries after Iconoclasm.[37] At S.Vitale we are as yet far from the uncluttered clarity, calm and simplicity of Daphni. The artists of Justinian's time conceived of wholeness and unity in terms of physical continuity and physical interconnections. They presented divine order in the guise of natural order. But it was a world order which they were building, an all-embracing view embodying past, present and future; earth and heaven; the visible and also the invisible. This was a concept which their stylistic devices helped to make concrete and with which these devices were fully in tune.

Polarization and Another Synthesis – 1

The aesthetic ideal of the early Justinianic period was short-lived. By its very nature it hardly could have been maintained for long. Aiming as it did at a total reconciliation of abstract forms and relationships with natural and organic ones, it presented challenges which only the most brilliant and sophisticated artists of the period were able to meet fully. By the year A.D.550 the impetus that had produced the great works of synthesis of the period – St Sophia, S.Vitale, Maximian's Chair – seems to have spent itself.

The ensuing period until the outbreak of Iconoclasm in Byzantium – a time span of close to two centuries – has a far less clearly defined profile than any of the preceding ones. It is a period of convulsive change, marked by the break-up of Justinian's empire, the intrusion of Slavs – and, above all, of Arabs – into the Mediterranean world, and the slow transformation of Byzantium into a regional power based on Asia Minor. In art history, too, the period constitutes a major turning point. But its specific achievements and its peculiar importance are only beginning to be fully recognized.

A marked stylistic shift in the later years of Justinian's reign is manifested by the sanctuary mosaics in the church of the fortress monastery at Mount Sinai, built by that emperor between A.D.548 and 565.[1] The principal subject, in the conch of the apse, is the Transfiguration, set in a frame of medallions containing portraits of apostles, prophets and two donors (fig. 177). There can be little doubt that the mosaics are contemporary with the building.[2]

The Transfiguration has a special relevance to the site, involving as it does Moses, the 'cult hero' of Mount Sinai, and showing him in dramatic association with Christ. The subject lends itself for display in an apse since the scene has a somewhat ceremonial character. Indeed, the Sinai mosaic invites comparison with the ceremonial representations in the apses of SS.Cosma e Damiano in Rome and S.Vitale in Ravenna. But the contrast is striking. Both in the Roman and in the Ravennate mosaics figures form a plausible group on a plausible landscape stage. At Sinai they are placed singly and without overlaps against the plain gold ground. The terrain at their feet is very much reduced and gold is insistently displayed as an abstract foil, much as it had been in the mosaic decorations of the pre-Justinianic era. To be sure, at S.Vitale the illusion of

[99]

solid terrain supporting the figures is tenuous and, as we have seen, it breaks
down in the central area.[3] But in the Sinai mosaic the indication of locale is
altogether confined to a sequence of narrow bands – dark green, light green and
yellow. Interestingly varied in width but sharply delineated throughout, these
bands convey only the vaguest and most general suggestion of a sunlit meadow.
Of the two conflicting elements in the S.Vitale landscape, it is the notion of a
dematerialized 'baseboard' which prevails. The figures are not really supported
by the terrain. One might just barely conceive of the two prophets as standing
on it. The recumbent Peter is in front of it, while the two kneeling apostles,
though strongly three-dimensional in themselves, are oddly poised on its razor-
thin upper edge (fig. 179).

The utter reduction of the landscape elements in this mosaic is doubly re-
markable when one considers that the subject called for the depiction of a
mountain. It has been suggested that the mountain scenery – which is hardly
ever absent in subsequent Byzantine representations of the Transfiguration –
was omitted in order to transpose the event into heaven and equate it with
Christ's Second Coming.[4] But the scenes at SS.Cosma e Damiano and S.Vitale
are also celestial, and that locale is indicated by multicoloured clouds. In the
Sinai mosaic the neutrality of the ground and the starkness with which the
actors – including Christ in his magnificent blue mandorla – are set off against it
must be seen as a stylistic trait. As such, it is of a piece with other features of the
design: its essential symmetry; the simplified rendering of forms; the absence
of strong colour accents within the figure group; the huge lettering of the name
inscriptions. All these make for an abstract and unified pattern, for which the
neutral ground is an appropriate foil. It is true that the figures retain much of
the corporeality characteristic of those of the preceding period. Indeed, in the
kneeling apostles bulk is emphasized almost to excess. Also, to the right of the
head of Elijah (fig. 180) there remains, in an oddly residual form, one of those
deep shadows which in S.Vitale were used to hollow out a niche or cavity for a
figure from its landscape backdrop (fig. 157). In the absence of such a backdrop,
the device hardly makes sense. But such features only confirm that a genuine
stylistic change is here in the making.

The Sinai designer still surrounds his scene with a strong and heavy frame.
But with the suggestion of a view into an open landscape so greatly reduced, the
contrast of picture and frame, which at S.Vitale was basic to the entire composi-
tion, is largely lost. The frame with its serried rows of medallions is set off
against the scene within only by presenting an even denser and tighter pattern;
between frame and 'picture' the designer has inserted another band bearing the
dedicatory inscription, and he has made this band more nearly part of the

II. The Maccabees First half of seventh century
Fresco in S.Maria Antiqua, Rome *page 113*

VIII. St Peter
Icon in Monastery
of St Catherine,
Mount Sinai

Here attribu
to *c*. A.D.700
page 120

'picture' than part of the frame. Evidently there is no longer a desire to create a clear distinction and a true functional tension between the two components.

It should perhaps be emphasized that the differences between the Sinai mosaic on the one hand, and the mosaics of SS.Cosma e Damiano and S.Vitale on the other, are not primarily a matter of quality. To be sure, in execution the Sinai mosaic is uneven. Although in the best passages the quality is very high, there are particularly among the busts of prophets and apostles – and also among the figures on the wall above the conch – some whose rendering must be described as provincial. Yet an increased abstraction is evident even in passages of indisputably high artistic merit; witness, for instance, the predominance of straight lines in the system of highlights and shadows on Christ's white raiment (fig. 178).

The Sinai mosaic has been attributed to an atelier from Constantinople.[5] Obviously artists must have been brought to this remote outpost from elsewhere, and the fact that the monastery was an imperial foundation makes it historically plausible that they came from the capital. The principal elements of the style of the S.Vitale mosaics likewise were Greek, as we have seen,[6] and it is entirely possible that they, too, derived from metropolitan Byzantium specifically. If both theses are correct, the difference between the two mosaic decorations cannot be explained in regional terms any more adequately than in terms of quality. When details from the two ensembles are put side by side, it can be seen readily that they are, in fact, fruits from the same tree (figs. 180–3).

We must reckon, then, with a rather fundamental change in Byzantine art itself around the year A.D.550. The exuberance, the crowding of organic forms, the emphasis on things growing, living and moving are gone. A chill has descended and has left the scene bare and figures frozen in their positions.

At Ravenna the change is reflected in the apse decoration of S.Apollinare in Classe, a church consecrated by Bishop Maximian in A.D.549, only two years after the dedication of S.Vitale (figs. 184–6).[7] Like the earlier Ravennate decoration – and like that on Sinai – the Classe mosaic is highly complex in subject matter. In this respect it is perhaps the most intricately constructed of all Justinianic programmes. An apotheosis of St Apollinaris – a confessor (if not, indeed, a martyr) who was thought to have been Ravenna's first bishop and whose tomb was enshrined in the church – is combined with the Transfiguration theme, but a Transfiguration strangely represented in a semi-allegorical, semi-symbolic manner, and here clearly to be perceived as an eschatological, or, at any rate, a timeless event.[8] There certainly is no falling off either in ideological intensity or intellectual subtlety on the part of those who commissioned this

decoration and devised its iconography. Similarly, the standard of artistic quality is not in doubt; indeed, it is sustained more consistently than in the Sinai decoration. The magnificent mosaics of S.Vitale, only recently completed and only a few miles away, were bound to exert an impact on the work and they obviously did. In particular the S.Vitale master's treatment of the window zone and the idea of making the mosaics of that zone a 'wainscoting', a semi-architectural framework for a landscape view in the conch, influenced the designer at Classe. But this is neither a case of the same workshop trying to repeat its own triumph nor of some local followers trying to imitate it. In either of those cases one would be likely to find a far more literal, more slavish adherence to S.Vitale in details. What this decoration bespeaks is a turning away – surely on the part of a new team – from an ideal that has had its day. The comparison may seem a little far-fetched, but it is helpful here to think of the first mannerists in the Italian Cinquecento – Pontormo, Bronzino, Rosso – following upon the climactic period of the High Renaissance. Though unthinkable without that climax, they decisively veered away from its goals; and here again, quality is not the issue.

An analysis of the compositional principles underlying the design of the Classe apse mosaic is complicated by the fact that changes were made in the window zone in later times.[9] It is evident, however, that this register, when compared with the corresponding one at S.Vitale, is conceived far more as a figure zone in its own right. Its structural and supportive function is far less clear. Rather than being subordinated to the composition in the conch, it is more nearly its coequal. As for the conch mosaic, the landscape here has not been reduced to a mere strip at the bottom as on the Sinai mosaic, but, on the contrary, has greatly expanded in area and importance. It is a paradisical garden, appropriate as a setting both for the glorified saint standing in its midst and for the Transfiguration immediately above; the latter, as I have said, being presented here as an eschatological theophany. What concerns us particularly is the rendering of this garden landscape as a decidedly vertical backdrop. There is no longer any pretence, as there was in S.Vitale (figs. 155–7), that things cohere organically; that trees and plants grow at random in grassy meadows; that rocks are outcroppings of these meadows; and that in the distance the rocks may blend into clouds and clouds into sky. All these elements are there, but each one is isolated and sharply delineated, and they are tidily lined up in rows, tapestry-fashion (fig. 184). It is a method reminiscent of the one we have encountered previously in floor mosaics of the fifth century. There, too, landscapes were taken apart and their component elements spread out with a complete avoidance of overlaps (fig. 92). The appearance here of a

comparable method is significant. Clearly in this apse composition, with its green and gold zones balanced and sharply set off against one another and with no indication of depth in either of them, the two-dimensional surface is strongly reasserted. The huge blue disc in the centre, bearing amidst its ninety-nine stars a jewel-studded cross, has, it is true, suggestions of an *opeion*, a view of the night sky opening out in the apex of a dome. But placed as it is on the boundary between the two zones and forming a single vertical axis with the figure of the saint just below it, it, too, is very much part – indeed, the dominant part – of a surface pattern.

In sum, it is my contention that the Sinai and Classe mosaics are evidence of a major stylistic shift around the year A.D.550 and not simply chance survivals of the work of some undefined regional 'schools' that had practised their respective manners all along. Obviously the two decorations are very different one from the other. But they have in common a rejection of basic principles underlying the style of S.Vitale – this is particularly evident at Classe – and a bold reassertion of abstract principles of design that had been in vogue around A.D.500. The S.Vitale phase in this perspective seems like an interlude. The synthesis soon came apart. Its abstract component alone triumphed.

I feel the more confident in this interpretation because, moving forward to works of the ensuing period, one finds that the trend which these mosaics of the last ten or fifteen years of Justinian's reign indicate did indeed become increasingly accentuated as time went on. This can be seen in many places: in Ravenna itself, in Rome, in Thessaloniki.[10] Without tarrying at these intermediate stages, we proceed to the Church of S.Agnese fuori le mura in Rome, whose apse (fig. 187) was adorned with mosaics under Pope Honorius I (A.D.625–38).[11] Here abstraction has reached a new peak. Three single figures rise like so many vertical pillars on a vast expanse of gold ground, which they serve to divide with strict symmetry. Each is quite self-contained, even though the two lateral ones are donors subordinated to the saint in the centre in what is still a ceremonial presentation scene. All three are dressed in purple, so that colouristically, too, they create a unified pattern. The rest of the surface is likewise organized entirely on geometric principles. The dedicatory inscription, here definitely included within the principal scene (if 'scene' is the word), forms a bottom zone and is surmounted by a green band in two tones indicating terrain but, as in Sinai, devoid of all suggestion of depth. Above the main zone the sky is similarly composed of concentric bands. As for the figures, not only are they totally subordinated to the surface pattern in their positions and their attitudes; there is little in their rendering to suggest tangible and autonomous bodily presences. This is particularly true of the central figure of St Agnes.[12] In

outline, proportion and rendering of features, she presents a degree of abstraction and dematerialization exceeding anything we have yet seen in the course of our journey through the late and post-antique centuries. With her elongated body, diminutive head and chalk-white face, she appears like a phantom. If the third and the fifth centuries saw drastic departures from the classical ideal of the human form, here we are confronted with a third major step. The two-dimensional, the linear and the geometric are consistently proclaimed as positive principles of design.

S.Agnese is a memorial church for a highly venerated martyr. It enshrines her tomb, as the basilica in Classe enshrines the tomb of the saint who was revered as Ravenna's first bishop. The practice of placing commemorative portraits on tombs – and on shrines of martyrs particularly – had been adopted by Christians long before this time.[13] It was an exceedingly important step. More than any other category of images the portrait involves representation for representation's sake. It is the very opposite of 'signitive' art.[14] To conjure up a physical presence is its chief *raison d'être*. In the apse mosaics of Classe and of S.Agnese we see such portraits assume a new and central importance. In both churches a great statuesque figure of the titular saint is prominently placed and not only dominates the pictorial decoration of which it is a part but is made a focal point for the entire sanctuary. At Classe the saint raises his hands in prayer, his role as intercessor with the deity being one of the many layers of meaning of this composition. St Agnes stands in complete repose in the centre of the apse of her church. The only 'narrative' elements are the two flames by her feet alluding to her martyrdom.

One associates such still and lonely figures – gaunt and remote, timeless and supremely authoritative – with Byzantine art in its mature state in the centuries after Iconoclasm.[15] But it was in the age before Iconoclasm, during the long stretch of time between Justinian and the outbreak of the conflict in A.D.726, that this important artistic concept was first fully realized. Nor was it confined to the portrayals of martyrs in the apses of their shrines. The image of the Virgin, too, was thus offered to the spectator's gaze – and to his worship – in a focal position and in solemn isolation as it was to be so often in later times. In this connection the apse mosaic of the Church of the Dormition at Nicaea, destroyed in 1922 but fortunately recorded in good photographs before World War I (fig. 188), is a document of great significance.[16] Unquestionably the figure of the Virgin which was to be seen in the apse was a work of the period *after* Iconoclasm. It was executed in the second half of the ninth century to take the place of a large cross – discernible in outline within the sutures in the gold background – that evidently had been the sole decoration of the apse during the

period when the cross was the only 'image' permitted in a church. However, we owe to the late Paul Underwood's careful scrutiny of the photographs of the mosaic the irrefutable proof that the cross in turn was preceded by an earlier representation and that this earlier representation can only have been an image of the Virgin.[17] In other words, what was done in the ninth century was to restore the status quo that had existed before A.D.726. While in the details of its rendering the Nicaea Virgin displayed ninth-century characteristics, in terms of its position and its thematic context it was a document of pre-Iconoclastic art. That context, incidentally, and the whole programme of the pre-Iconoclastic decoration were once again multilayered and saturated with dogmatic and liturgical meanings. Though not datable with precision, in a broad sense this decoration was a contemporary of the mosaic of S.Agnese and testi-fies to the fact that during the period in question the lonely statuesque apse figure did not remain confined to martyria. Here it is in a normal church in the very heartland of Byzantium.

Such representations do indeed mark a great forward leap. They should be seen in the light of a changing functional role of the religious image in the period after Justinian.[18] The late sixth and seventh centuries saw the rise of a new kind of piety expressing itself in a vastly increased use of images in worship and in devotional practices; and the Byzantine government – in a period of un-precedented stresses and catastrophes – took a lead in fostering such practices. In order to proclaim the authority of Christ, the Virgin and the saints over human affairs it increasingly introduced their images into a variety of contexts. (Eighth-century Iconoclasm, in turn, was an official reaction in Byzantium to a development which the imperial government had done much to bring about.) It was in this situation that the holy figure in statuesque isolation assumed a central position in the church. The ground had been prepared in the preceding centuries by the use of commemorative portraits on the one hand, and by ceremonial representations with their majestic central figures of the Deity on the other (figs. 80, 156, 169, 177). Now these central figures were put before the worshipper in stark isolation as a statue of a god or goddess had been in a Greek temple.

Another characteristic manifestation of the new religious atmosphere was the votive panel. Whether painted on wood as a portable icon, or permanently installed on a church wall, such panels are not part of a systematic overall decoration embodying fundamental doctrine, but spring from the devotional needs of an individual or of a group. They tended to be placed in relatively low and readily accessible locations and thus responded to a desire for personal rapport with the saint. The *ex voto* mosaics in the Church of St Demetrius in

Thessaloniki exemplify this practice. They were sadly decimated in the fire of 1917, and the dating of a number of them is conjectural. But one major group, on the piers flanking the entrance to the chancel, certainly was put up about the middle of the seventh century (figs. 189, 190).[19] It shows the city's patron saint in the company of various dignitaries, on whose shoulders he places a protective arm, and two companion saints, one of them similarly protecting two children. Here again, as in the Roman mosaic of S.Agnese, we see the triumph of geometry and abstraction. The style is not identical, but there are the same gaunt proportions, the small heads on elongated bodies, the emphatic verticals, the firm subordination of the figures to an overall planimetry (which here takes the form of an actual architectural frame). In Rome, these Thessalonikan figures have their nearest equivalent in the mosaics of the Chapel of S.Venanzio in the Lateran, more particularly in the saints flanking the apse (pl.VI).[20] Even more phantom-like than St Agnes, these figures were commissioned some ten or fifteen years later by Pope Theodore (A.D.642–9), one of the many Greek popes of the period.

About twenty years ago I put forward the suggestion that there is an inner connection between this striving after abstraction which, steadily on the rise since the mid-sixth century, reaches a peak in these works of the mid-seventh, and the changing function of the religious image which these same monuments bespeak.[21] In other words, not only location and context, but the very rendering of these images may have to do with their increasingly central role in Christian worship. The case does not rest solely on circumstantial evidence. The Iconoclastic controversy which ensued in the eighth and ninth centuries produced a large amount of literature on the subject of holy images. From it we learn a great deal not only about the actual role of such images and about the uses (and abuses) to which they were put during the period in question, but also what they stood for in people's minds. A key element in the defence of holy images as it was evolved in the course of the seventh century, and more systematically during Iconoclasm, was the claim that the image stood in a transcendental relationship to the holy person it represents.[22] No longer was it merely an educational tool, a means of instruction for the illiterate or edification for the simple-minded, as earlier writers had claimed. It was a reflection of its prototype, a link with the invisible and the supernatural, a vehicle of transmission for divine forces. In a seventh-century account of miracles worked by an image of St Simeon the Younger we read that 'the Holy Ghost which dwelt in the saint overshadowed his image.'[23] Bearing this in mind while looking at actual representations of saints of that period, one is indeed tempted to see some connection. Are not the thinness and transparency of these figures fully in keeping with their

being conceived as receptacles for the Holy Ghost and as channels of communication with the Deity?

General psychological considerations also support this interpretation of the abstract style. The hobby horse of Sir Ernst Gombrich's *Meditations* is relevant here. 'The greater the wish to ride' – so we have been shown – 'the fewer may be the features that will do for a horse.'[24] By the same token, when the desire to pray, the urgency to communicate with Christ and his saints are great enough, there is no need to elaborate the physical features of the holy persons. In fact, too much realism can be an impediment. In Gibbon's *Decline and Fall* there is a story of a Greek priest who rejected some pictures by Titian because the 'figures stand quite out from the canvas'. He found them 'as bad as a group of statues'.[25]

So there is a good deal of evidence to support my interpretation; and I continue to believe that in order to understand the extremes of abstraction and dematerialization reached in seventh-century art, the changing role and function of the religious image need to be taken into account. However, I have never considered the correlation to be a simple and straightforward one. It needs to be qualified in a number of ways, particularly in the light of certain other examples of iconic and devotional art yet to be discussed. But first let us broaden our view of the period by turning to some rather remarkable works produced in other spheres totally outside the realm of devotional art.

One of the major break-throughs in the study of Byzantine art was the discovery made by Russian scholars early in this century of the true chronological position of a series of silver vessels with classical mythological reliefs in repoussé, many of which have been found on Russian soil.[26] A number of the vessels in question bear hallmarks indicating that they were assayed, and their silver content guaranteed, by Byzantine imperial officials in the sixth and seventh centuries. It used to be assumed that the vessels themselves – with their representations of gods and heroes, of cupids and Nereids, of satyrs and maenads – were centuries old at the time. But careful examination revealed that the hallmarks were punched in when the vessels were in a semi-finished state, and that the reliefs were not fully worked out until after these stamps of approval had been applied. Art historians were thus confronted with the indisputable fact that from the period of the Emperor Anastasius (A.D.491–518) to that of Constans II (A.D.641–68) Byzantine craftsmen produced work sufficiently classical to have passed for being of the time of Hadrian or Marcus Aurelius. The two plates illustrated in figs. 191 and 192 – one showing Meleager and Atalante as hunters, the other Silenus and a maenad dancing – are characteristic examples.[27] Both bear hall-

marks of the earlier part of the reign of Heraclius (A.D.610–41). Their reliefs, therefore, are nearly contemporary with the mosaics of St Demetrius and S.Venanzio – a useful reminder of how problematic the notion of 'one period, one style' can be.

We saw silver reliefs of the same kind in our review of the fourth century. The Silenus plate, for instance, calls to mind a plate with a similar representation in the Mildenhall Treasure (fig. 53). Indeed, the earlier relief seems to provide a historical perspective in which our seventh-century piece becomes intelligible. Evidently what we are dealing with is a branch of private and decidedly secular luxury art quite distinct from the church art that we have considered so far. While the latter developed towards ever greater solemnity and abstraction, there was still a market for imagings of the joyous, sensuous life that had always been associated with Dionysus and others of the ancient gods. Byzantium had never disowned the myths of antiquity. They were part of its cultural heritage. Literature as well as art is full of references to them. So it would not be difficult to imagine a group of workshops in the metalworkers' quarter at Constantinople where generation after generation through the fifth, the sixth and into the seventh century the traditional representations of whirling maenads and chubby Silenuses were turned out in the traditional style, while elsewhere in the city painters and mosaicists came ever closer to finding fully adequate forms for representing Christ and his saints as the transcendent and eternal powers that truly govern the lives of men.

Our seventh-century dish could well be a product of just the kind of work-shop tradition that I have suggested. When compared with its fourth-century antecedent, it shows symptoms of a certain fatigue. Forms seem to be worn out by routine repetition. There is much slurring and simplifying, for instance, in the folds of the maenad's costume. Its flying ends stand out stiffly as though they were starched. The proportions of her trunk in relation to her legs do not bear close scrutiny. Her hair is oddly bunched on the side rather than on the back of her head. When Leonid Matsulevich, in an epoch-making book, first put before a larger scholarly public the case for the late date of these vessels, he systematically analysed the tell-tale signs in the style of their reliefs which, quite aside from the evidence of the hallmarks, show that they are not products of true Classical Antiquity. They are works of what he called *Byzantine Antiquity*.[28]

A correct understanding and a just evaluation of this phenomenon are important in relation to the whole congeries of stylistic developments with which we are concerned in this book. On the one hand there is the notion just expounded, namely, that a style involving – despite all the losses – a wealth of

classical and organic forms was perpetuated more or less automatically by generation after generation of specialized craftsmen who met a continuing demand for silverware with mythological subjects. The style survived because the subjects called for this kind of treatment; and while in relation to the overall picture of stylistic developments this craft tradition may be only a side-line, the survival of Hellenism which it entailed could have wide ramifications. On the other hand, however, there is also the possibility that an object such as our Silenus plate constitutes a revival. A seventh-century craftsman may have gone back to much earlier work of the kind represented by the Mildenhall plate and tried to imitate it.

The question of revival as against survival presented itself even in relation to the mythological silver reliefs of the fourth century.[29] We found these silver objects to be natural vehicles of Hellenistic forms that were even then in grave jeopardy in other branches of artistic activity. The objects seemed to cluster in the latter half of the century, and there was reason to believe that this may not be just an accident of preservation. It was not readily apparent that the production had continued in a steady flow through the Tetrarchic and Constantinian periods. When we pursue this line of investigation through the fifth, sixth and seventh centuries, we find that the same pattern persists. There are clusters of mythological silver concentrated in certain periods with quite large gaps in between. The fifth century is an almost total void. Probably a statistical survey would show that altogether the amount of extant silver vessels from that century is smaller than that from the second half of the fourth. Accidental circumstances may well play a part here. Still, we do have fifth-century silver work that is either unadorned or bears other kinds of decoration (Christian, 'official', or purely ornamental), and the fact that mythological silver has not survived in a corresponding ratio is striking.[30] From the end of the fifth century on, when the system of regular hallmarking begins, we are on safer ground in establishing chronological distinctions. Two clusters can be identified for this period. One, not surprisingly, belongs to the reign of Justinian, an era notable for its interest in the Graeco-Roman past.[31] This Justinianic group comprises pieces such as the well-known plate with a shepherd in the Hermitage (fig. 193) or the fragment of a huge, heavy dish at Dumbarton Oaks (fig. 194).[32] The latter had as its principal figure a very corpulent Silenus who, despite his somnolence, was clearly a predecessor of the jolly dancer on the seventh-century dish in Leningrad. The second cluster is precisely in the period of Heraclius and his successor Constans II.[33] There is no lack of silver from the half-century intervening between Justinian and Heraclius. But most of these pieces are liturgical or neutral.[34] Obviously, further finds might change the picture. But it does begin

to look as though the production of silver with classical subjects classically executed was not steady through the centuries which concern us. It seems to be governed by a pattern of ebb and flow.

I am using the metaphor of advancing and receding tides advisedly. My contention is that the flow never stopped entirely between the fourth and the seventh century even though at times it was apparently much reduced. An enlarged close-up view of the figure of Meleager on the Hermitage plate bears out the point (fig. 196). It does not suggest a hand setting out to copy self-consciously and deliberately a model from a remote past. On the contrary, it suggests a hand practising an accustomed technique with complete ease and assurance. It testifies to a current – or, at any rate, an undercurrent – of what I like to call 'perennial Hellenism' in Byzantine art,[35] although the statistics do seem to show that the current had been receding in the decades before this plate was made and had only recently begun to rise again.

This, however, is still not the complete picture to be gained from the silver work of the period. It is instructive to compare with the close-up view of Meleager a likewise enlarged view of the head of another young hero from another exactly contemporary relief. Fig. 195 reproduces the head of David from a great dish now in New York depicting David's combat with Goliath, the centrepiece in a famous set of nine plates with the story of David that was discovered in the early years of this century in Cyprus.[36] This set, so its hallmarks show, also belongs to the first half of the reign of Heraclius. In spirit the two youths – one pagan, the other biblical – are not too far apart. There is in both an afterglow of Hellenic radiance and grace. But clearly the workmanship in the case of the David is quite different – far more elaborate and less free and easy. Curls of hair are individually modelled and engraved. Facial features, too – eyes, eyebrows, lips – are far more precisely defined, as is the head as a whole. This precision and elaboration of detail pervades all the work on the David plates (figs. 197, 198). Limbs, armour and draperies are carefully modelled within insistently drawn outlines. Not since the fourth century – the days of the Mildenhall Treasure and the great missorium in Madrid – have hems been so minutely and artfully curled (fig. 59). While the mythological plates of the time of Heraclius can be understood as products of a tradition never completely broken through the centuries, here we are faced with an effort to leap back across the centuries and recapture forms from a distant past. The David plates are full of references to works of the fourth and fifth centuries, and more particularly to works of the Theodosian period. The similarity between the scene of the young David appearing before King Saul (fig. 198) and that of Theodosius holding court (fig. 57) is only the most immediately obvious of these relationships.

It is not likely that even if chance discoveries should add to our present knowledge of late antique and early Byzantine silver, these two reliefs will ever prove to have been linked by a steady production of similar pieces. The art historian, faced with this evidence, is compelled to make room for yet another classical revival. As yet this Heraclian revival has barely found its way into the textbooks. But specialized scholarship has for some time recognized the phenomenon, which has a counterpart also in literature, more particularly in the epics of George the Pisidian, Heraclius' court poet.[37] The whole classicizing episode is intimately tied to the imperial court. The Cyprus plates bear this out both through the context in which they were found and through their iconography. The set must have belonged to a high official who had close connections with the court in Constantinople[38] – and there are reasons to believe that concealed in this cyclical celebration of the career of the young Hebrew king is a celebration of the career of Heraclius himself, the youthful warrior who had come to power by overthrowing the terrible Phocas.[39] In effect, Heraclius was a usurper, and the elaborate and academic classicism in his court art should be seen in the light of this fact. The taste of upstart rulers often gravitates in this direction. Theodosius himself, on whom Heraclius fastened as a model, may provide an example, as I mentioned earlier.[40] The David plates again confront us with the phenomenon of a revival based on surviving classical trends, a revival so explicit and so contrived that it must have been conscious and purposeful. Inspired by persons at Heraclius' imperial court, as there is every reason to believe it was, it is yet another example of an 'other-directed' stylistic innovation.

We seem to have gone some way towards explaining the glaring dichotomy which has revealed itself as our view of late sixth- and seventh-century art has unfolded. The art of these silver plates, at any rate, is a hothouse plant artificially nurtured and consciously forced. As such it could well have coexisted with those gaunt and disembodied figures of saints we saw earlier in the apses and on the walls of churches of the same period. The latter were products of a broad and relentless development which we were able to trace from the late Justinianic period on. It was a development which seemed to be essentially of the artists' own making, even though it can be linked to profound spiritual and religious processes taking place during this period. Here, on the other hand, we have a group of objects brought into being by imperial command and purposely emulating the style of another age. It is true that the Cyprus plates are religious in subject matter. The extolling of the monarch in biblical guise rather than in the direct manner of the Madrid Plate is in itself an interesting sign of the times.[41] But functionally this is secular art. Altogether, then, the classical and

the abstract style trends belong to different spheres, and one can well see how
they could have existed side by side within metropolitan Byzantine art.

Another monument patently associated with the imperial court in Constanti-
nople seems to be part of the same picture. The magnificent floor mosaic dis-
covered in the 1930s during the excavation of a huge peristyle in the heart of the
imperial palace is very much a work of secular art, displaying as it does a vast
array of hunting, pastoral and other rustic motifs (figs. 199, 200).[42] In terms of
its composition the pavement is an outstanding example of a figure carpet, a
type of floor design we saw evolve at Antioch and elsewhere in the fifth century
(fig. 90). But in execution the figures are much more lifelike and three-
dimensional, much more strongly permeated with Hellenic traditions than
those on the comparable pavements in the Syrian metropolis. At the time of its
discovery, and for some time after, the palace mosaic was thought to be con-
temporary with the Antiochian figure carpets, its qualitative superiority and its
insistent Hellenism being accounted for by the imperial milieu. But subsequent
investigations produced solid evidence that this pavement cannot be earlier
than the Justinianic period; and it may well be of the seventh century or even as
late as A.D.700.[43] Once again, as in the case of the mythological silver reliefs, one
is tempted to speak of perennial Hellenism, of a tradition never entirely broken
within a specialized craft, although on the other hand here, too, an element of
revival may well be involved. The work is too isolated to permit us to differen-
tiate with any clarity between these two factors. But the mosaic is certainly a
counterpart to the silver work we have seen, and as such it further encourages
us to interpret the dichotomy which has emerged between abstraction on the
one hand and Hellenism on the other as having to do with subject content and
functional purposes.

It would be convenient if we could halt our inquiry into late sixth- and
seventh-century art at this point. But there is yet another aspect to this com-
plex picture. The period produced works which are clearly religious and de-
votional in function but decidedly Hellenistic in style. Polarization goes further
than I have yet indicated. It not only pits imperial and profane silverware and
floor mosaics against cult images and icons, but also manifests itself within
iconic art itself. I shall turn to this phenomenon, its implications and its con-
sequences, in the next and final chapter.

Polarization and Another Synthesis – 2

It was the discovery in the year 1900 of the Church of S.Maria Antiqua on the Roman Forum which first revealed the existence of a strongly Hellenistic current in religious painting of the seventh and early eighth centuries.[1] The church was installed, probably in the first half of the sixth century, in a building of the early imperial period and was abandoned in the ninth. It harbours a wealth of murals of various dates (some on superposed layers of plaster), including a large number of panels put up individually or in groups to serve special devotional needs such as the cult of particular saints. A bold impressionist style reminiscent of Pompeian frescoes is conspicuous in many of these paintings and appears at its most pronounced in certain works of the first half of the seventh century; that is to say, of precisely the period in which the abstract style reached a peak in the pier mosaics of St Demetrius in Thessaloniki and in the apse mosaics of S.Agnese and S.Venanzio in Rome, as discussed in the preceding chapter. By focusing on this phenomenon we shall be led to an enlarged and more balanced view of stylistic developments in the seventh century as a whole. Indeed, the Hellenistic current in religious painting will prove to be of crucial importance for a correct evaluation of the art of that century and a key element in making the period the critical turning point it was.

Among the frescoes of S.Maria Antiqua none exhibits a more accomplished impressionist manner than a panel on one of the nave piers depicting Solomone, the Mother of the Maccabees, with her seven sons and Eleazar, their tutor, who in the early Middle Ages enjoyed veneration as martyrs (pl.VII; figs.204, 205).[2] The picture, which in all probability was painted in the decades just prior to A.D.650, is not without firm linear coordinates. While Eleazar and the seven sons are loosely grouped in relaxed poses, the mother, standing erect and purely *en face*, forms a strong vertical axis (somewhat to right of centre). The blue sky in the background is schematically divided into two zones whose boundary forms a sharp horizontal accent and exactly bisects Solomone's halo. But the main background area, below the sky, is hazily rendered in shades of grey and brown, and since it also forms the ground on which the figures stand, it could be seen as a vast plain stretching behind them to a far horizon. In any case, the figures appear to be enveloped in air and atmosphere which dissolve their

outlines. Bodies, draperies and particularly faces are indicated solely by means of contrasting hues. Deep shadows and sharp highlights suggest rather than delineate forms. The brushwork is executed with a verve and an ease which one associates with Graeco-Roman painting in its most developed phase in the first century A.D. Who were the masters who in the seventh century were capable of employing such a technique?

That they came from the Greek East there can be no doubt. Rome had not produced such painting for centuries. A break within the Roman development is brought home most dramatically at S.Maria Antiqua itself on the so-called Palimpsest Wall, an area to the right of the apse where remains of figures from several superposed decorations are preserved in a seemingly chaotic medley (fig. 201).[3] Among these fragments are two isolated remnants of an Annunciation scene – part of the face of the Virgin and much of the upper half of the angel (fig. 202) – which are among the most outstanding exponents of the Hellenistic style in the church. Yet this painting, which in due course was covered over by the decoration of Pope John VII (A.D.705–7), superseded an earlier one of the sixth century – a Virgin in Byzantine court costume flanked by angels – which shows hardness and abstraction carried to an advanced stage. Very clearly the Hellenistic style appears here as a new and intrusive element datable to the seventh century.[4] However, granted that during this period S.Maria Antiqua (and many other Roman churches) were in effect Greek enclaves, the impressionism of paintings such as the Maccabees and the Annunciation fragments just mentioned requires explanation in Greek terms, too. We can no longer operate, as Charles Rufus Morey and his disciples did in the 1920s and 1930s, with the concept of an Alexandrian school.[5] Alexandria and Egypt generally have produced no evidence of a survival of an impressionist style at so late a date. We have seen better indications of strong Hellenistic trends – at least in the secular sphere – in Constantinople itself.

The silver plates in particular, whose study revealed a pattern of development compounded of survival and a revival of ancient forms, can provide important guidance. A painting such as the Maccabees suggests, even more strongly than some of the mythological figures on the plates, a hand practising an accustomed style with complete ease. These boldly sketched figures imply a living tradition, not a self-conscious effort to emulate models from a remote past. A comparison between heads in the fresco and the head of Meleager in the Leningrad plate is suggestive in this sense (figs. 196, 205). May we infer that in painting, too, the continuity was never entirely broken through the centuries, though it may have been almost submerged at times and then come to the fore again? The example of the silver shows that there need not have been a broad stream through

successive generations. And perhaps we can go further and say that in painting, too, it was the secular category – idyllic genre, mythology and other subjects in which the Hellenistic style was, so to speak, endemic – that was the principal vehicle of this perennial Hellenism; and that, particularly in periods when the tide was rising, impulses and stimuli were transmitted from it to the religious sphere. A somewhat analogous process had taken place once before in the fourth and early fifth centuries, and there were to be other such transfers from the secular into the religious category in later stages of Byzantine art, especially the period of the 'Macedonian Renaissance'.[6] The coincidence in time between the cluster of mythological silver reliefs under Heraclius and the most Hellenistic of the frescoes in S.Maria Antiqua is certainly suggestive.

A recent find in Istanbul, as yet published only in preliminary form, provides welcome corroborative evidence. In the course of a systematic investigation of the church of unknown name which later became the Mosque of Kalenderhane, a fragmentary mosaic panel has come to light, depicting in an ornate frame the Virgin as she presents the Christ Child to the aged Simeon (fig. 206).[7] The mosaic belongs to an early stage in the history of the building, but the context for which it was created is still unclear. What is certain is that it was an isolated panel in a low position – in this respect it is comparable to the votive images in S.Maria Antiqua and in Thessaloniki – and that it is a work of the pre-Iconoclastic period. It escaped destruction during Iconoclasm because a wall had been built in front of it, apparently by the time the conflict erupted. Thus it constitutes our first and so far only example of a mosaic with a Christian figure subject of pre-Iconoclastic date in the Byzantine capital, and stylistically it is not without relationship to the paintings of Hellenistic character in S.Maria Antiqua. Simeon the priest in particular, a powerful, strongly three-dimensional figure rendered entirely in terms of light and dark passages sharply and abruptly juxtaposed, invites comparison with some of the Maccabees in the Roman fresco. The Constantinopolitan mosaic may be attributed with confidence to the seventh century and proves beyond doubt that in this period religious art in the capital was deeply affected by the Hellenistic current.

We may assume, then, a kind of contagion. In the early decades of the seventh century a resurgence of Hellenism took place in Byzantine secular art on the basis of a surviving tradition, and as a result there was a burgeoning of this tradition also in some of the iconic art of the period. It is certainly remarkable that this resurgence and this contagion should have taken place during the very decades in which abstraction reached its peak and that both movements should be traceable to metropolitan Byzantium. But perhaps the resultant stylistic dichotomy in religious art is not as fundamental as it may appear at first

sight. Simeon, in the Constantinopolitan mosaic, for all his apparent cor-
poreality and his lively, expressive movement, is yet strangely immaterial and
weightless. His feet are not placed on the ground but overlap the frame so that
he appears to be levitating in space in front of the panel. In their own way the
Maccabees in the Roman fresco are similarly insubstantial. Solomone – with
her diminutive head, elongated body and sketchily adumbrated features – is as
evanescent and transparent as any saint in the abstract style. Her sons are more
sturdily proportioned, but their forms, too, dissolve, suffused as they are by
light and air. Impressionism is a two-edged tool. It creates the illusion of bodily
presences, but it also transfigures these presences. If the aim is an image 'over-
shadowed by the Holy Ghost',[8] impressionism no less than linearism and
abstraction can serve that end.

Another panel at S.Maria Antiqua which bears this out is, like the mosaic in
Istanbul, a depiction of an event from the Gospels. In a position corresponding
to the 'icon' of the Maccabees, on the opposite side of the nave, is a fragmentary
scene of the Annunciation (fig. 208).[9] Later superseded by a fresco of the same
subject, it is undoubtedly of much the same date as its pendant. The angel in
this painting is slim and graceful, and although the brushwork is crude com-
pared to that of the Maccabees, the figure is as bold an example of impres-
sionism as the early Middle Ages have left us. It should be noted that the
depiction of angels gave artists particular scope for displaying virtuosity in this
style. Throughout the early medieval period, in fact – and our fresco is a good
example – angels tend to be relatively airy and insubstantial even when other
figures are firmly and solidly delineated. They are, after all, *asomatoi*, beings
without bodies; and the fact that they were frequently singled out for im-
pressionist treatment supports my contention that this style can be a means of
emphasizing a spiritual order of being. At the same time this special treatment
of angels exemplifies the phenomenon of the 'modes', namely, the almost con-
ventional use of a particular stylistic manner in connection with a particular
subject or type of representation.[10]

Hellenistic illusionism, then, is not incompatible with spirituality and other-
worldliness. But, I repeat, it is a two-edged tool, and for an understanding of
the role the style played in religious art of the seventh century it is important to
be aware of this ambivalence.

Nowhere are its shifting potentialities more apparent than in the frescoes of
S.Maria Antiqua. An 'icon' of St Anne with the Child Mary in her arms was
painted there about the same time as the panel with the Maccabees (figs. 203,
207).[11] The picture, which is on eye-level, must have enjoyed special veneration
because it was spared subsequently when the entire chancel was repainted

under Pope John VII early in the eighth century. Indeed, it was incorporated into that decoration. The figure, a close relative of the Mother of the Maccabees in stance, attire and facial type, is, like the latter, the work of a painter who had full command of the impressionist technique. The system of long, deeply grooved shadows and thin, sharp highlights in the mantle is identical and here as there suggests a garment of glossy and rather stiff silk densely creased. But if in the case of Solomone the overall effect was one of transparence and evanescence, here the same pictorial devices produce firm, tangible surfaces. This saint is a solid bodily presence. The head has not only increased in relative size but has also acquired weight and substance. Whereas Solomone's facial features were only hazily sketched on an indeterminate darkish ground, here they are firmly drawn and the flesh is carefully and naturalistically modelled by means of slow and gradual transitions from red-brown to light pink.

Much the same devices were used by the outstanding master who painted the Annunciation scene on the Palimpsest Wall (figs. 201, 202). The scanty remains of the angel and the Virgin exhibit characteristics similar to those of St Anne, though in a particularly subtle rendering. By contrast, the 'icon' of St Barbara (fig. 214),[12] which directly adjoins the panel of the Maccabees on the same nave pier, is the work of a less accomplished artist who somewhat slavishly imitated the adjacent figure of Solomone. But here again the head has been made larger and more solid and the face is fleshy and fully rounded.

The inherent ambivalence of the impressionist style is well brought home by these murals. To illustrate the point further I shall turn to an important painting from a different area and in a different medium. One of the rare wooden panel pictures of early date which the systematic exploration of the treasures of the Sinai Monastery has brought to light is an image of the Virgin and Child flanked by two saints in court costume and, in the background, two angels (figs. 210–12, 215).[13] Here is a true icon in the narrow sense of the word, a portable votive image, and it was done by a master skilled in the use of impressionist techniques. But what is remarkable is the variety of effects he was able to achieve by this means. The heads of the two angels are boldly foreshortened as they gaze upward to the Hand of God which appears at the top of the panel and to the ray of light descending from it upon the Virgin. Dressed in white, these angels are truly creatures of light and air, fleeting, transitory apparitions. They are examples of an extraordinarily pure survival of a Hellenistic tradition – the head of Achilles in a fresco from Herculaneum (fig. 213)[14] makes an interesting comparison – and confirm once again that the representation of angels afforded special scope to that tradition. The Virgin and the Child, however, though evidently painted by the same hand, have far more substance and weight. The

chubby Child, dressed in a rich golden robe and shown comfortably seated on his mother's lap with his legs strongly foreshortened, is an outstanding piece of painting. The head of the Virgin in its fleshy fullness has some similarities with that of St Barbara in S.Maria Antiqua (figs. 211, 214). Admittedly, the latter is a cruder piece of work, but the affinity does suggest that the Sinai icon is of much the same date. Some scholars, it is true, have attributed it to the sixth century, but no concrete evidence has been produced to support so early a date.[15] Finally, in the two saints and more especially in the marvellous figure of the bearded St Theodore on the left (fig. 215), matter is entirely subordinated to spirit. The slim, ascetic face glows as if consumed by an inner fire. With his huge dark eyes firmly fixed upon us, the saint exerts an almost hypnotic power. His tall, thin body sheathed in a mantle that has the quality of glass but suggests little of the anatomy, also seems drained of substance. It neither requires nor creates space around itself. I know of no such figure in sixth-century art. Disembodied and columnar, the two saints recall figures such as those in the *ex voto* mosaics on the piers of the Church of St Demetrius in Thessaloniki (figs. 189, 190), a comparison which reinforces my contention that the Sinai icon is, indeed, a work of the first half of the seventh century.

We thus end up comparing figures from a painting clearly rooted in Hellenistic impressionism with figures from a monument previously cited among the exponents of abstraction during this period. It is the phenomenon of the 'modes' which explains the apparent paradox. The Sinai icon provides an outstanding example of an artist modulating his style within one and the same context to suit different subjects, to set off from one another different orders of being and to express different functions. His angels are airy and weightless. His Virgin, and especially the Child, are incarnate in the literal sense of that word. In his depiction of saints – those hallowed persons who are the faithful's conduits to the Deity – he has employed many of the devices of the abstract style.

It was the emphasis on the incarnate body which in the long run was to prevail. In the murals of S.Maria Antiqua, where in the first half of the seventh century Hellenistic impressionism had appeared in such purity and strength, we can observe that style's continued hold on religious painting during the latter half of the century and beyond; and we can see that increasingly its practitioners put emphasis on volume and fleshly reality as the painters of the St Anne and St Barbara panels had done earlier. For reasons unknown, the Annunciation scene in the nave (fig. 208) was covered over after about two generations with another fresco of the same subject, a painting quite similar in iconography but very different in style (fig. 209).[16] The impressionist technique, so boldly used in the earlier work, is still clearly in evidence, but it has become a means of

modelling solid, massive forms. It is particularly interesting to find the figure of an angel made a vehicle of what might almost be taken for an artist's silent critique of a predecessor's work. This is one angelic figure which is anything but incorporeal. The modal convention for angels has had its character and meaning completely transformed by an overriding interest in monumentality and weight.

I have already referred to the comprehensive redecoration of the chancel of S.Maria Antiqua, which took place in the years A.D.705–7 under Pope John VII.[17] Probably it was then that the earlier Annunciation scene was replaced.[18] In any case, the same taste for large, massive figures as in the later version is very much in evidence in John VII's decoration. A series of well-preserved busts of apostles in medallions on the side walls of the chancel best exemplifies this (figs. 216, 217). Impressionist verve is not lost in these paintings, as witness the sharp, broken highlights juxtaposed with dark shadows on the mantle of Andrew or the equally bold rendering of the dishevelled hair that had long since become an established feature of that apostle's physiognomy. But the painterly detail is clearly contained and circumscribed by heavy lines that provide a firm and ample structure for the entire head. Far from making for evanescence and transparency, the strong highlights, shadows and colour accents serve to bring out the solidity of each component part of that structure. Thus the figures become commanding bodily presences. Though comfortably placed in natural three-quarter views within their circular frames, they still have their huge, dark eyes firmly and squarely fixed on the beholder.

There is an affinity here with the art of the early Justinianic age. Nowhere in the intervening period had natural and organic forms been fused so completely with firm geometric construction; and nowhere had there been, as a result, figures of such authority, weight and power. The head of St Peter, from the apse mosaic of the Church of SS.Cosma e Damiano – previously illustrated as an example of the great 'Justinianic synthesis' in Rome itself (fig. 160) – makes a suggestive comparison with the head of St Andrew in S.Maria Antiqua. In the nearly two centuries that separate these two works there had been much hieratic solemnity; there had also been a good deal of Hellenism, sometimes in exuberant forms. But there had not been any real fusion combining essential elements of both in a single unified conception.

It is not likely that this fusion took place without actual inspiration from Justinianic art. I believed at one time that this was a local Roman phenomenon. But subsequently evidence began to accumulate which suggests that the work commissioned by John VII (who was the son of a high Byzantine official in Rome) reflects a development within the mainstream of Byzantine art. The

proposition has engendered a certain amount of controversy. But it is becoming increasingly apparent that in the Greek East as well as in Rome the decades around A.D.700 do indeed constitute a distinctive phase.[19]

In part the debate on this question has hinged on another of the early icons preserved on Mount Sinai, a portrait of St Peter (pl.VIII).[20] It is a work of exceptionally high quality which invites comparison with the portrayal of the same apostle in the mosaic of SS.Cosma e Damiano (fig. 160). In my opinion, however, the icon is not actually of the period of Justinian but rather, like the busts of the apostles in S.Maria Antiqua, an instance of an artist of the period c. A.D.700 reverting to a Justinianic ideal of lifelike monumentality. To be sure, in a comparison with the Roman busts the Sinai portrayal stands out both by the intense, if aristocratically restrained, humanity of the saint's countenance and by the extraordinary refinement of its pictorial technique. But it is precisely the technique which seems to me incompatible with a sixth-century date. I do not know in that period any parallel for the devices here used to represent drapery. Heavy, dark shadow strokes are accompanied by thin, sharp highlights, producing the same effect of a stiff, silky material with deep notch-like folds that we encountered in the work of Greek painters in S.Maria Antiqua (pl.VII; figs. 203, 207). The delicate hatching with fine highlights that appears both in Peter's mantle and in his hair is also familiar from the Roman murals. Unless or until evidence is produced that this specific brand of impressionism existed in the sixth century it is necessary to remain sceptical vis-à-vis so early a dating. Nor, on the other hand, is there a close relationship with the Virgin icon from Sinai which we considered before. The use made here of impressionist devices to create a figure of great volume, power and solemnity can be most plausibly explained in terms of a Justinianic revival subsequent to the period in which that icon was made.

Fairly recently another icon from Sinai has been introduced into this discussion. By a careful removal of later overpaint, a bust portrait of Christ, similar in dimensions and composition to the panel with St Peter, has been revealed as a work of much the same style (fig. 221).[21] Certainly, the technical detail in the painting of the two faces is similar,[22] and it seems likely that the two panels are roughly contemporary. In other words, I believe that the Christ portrait must also be of the period around A.D.700. Both reflect a new solidity, tangibility and monumentality achieved at that time on the basis – and to a considerable extent with the means – of Hellenistic impressionism. As we have seen, that style had developed in this direction for some time. Here the trend is brought to full fruition, with the art of the Justinianic era serving as a model and a catalyst. Paintings such as these were, in my opinion, the last great achievements of

Byzantine religious art before Iconoclasm. This is quintessentially what an icon was at the time the crisis erupted.

There is one class of precisely dated monuments which helps to reinforce and flesh out this view of late seventh-century developments, namely, coins. The design of coin dies was, of course, an activity very definitely concentrated in Constantinople itself. The late seventh and early eighth centuries were a period of intense and varied activity in this field, resulting in what has been called 'one of the culminating points in Byzantine numismatic art'.[23] The movement began with a reform under Constantine IV (A.D.668–85) which involved a return to types and designs not used since the reign of Justinian. Indeed, in coinage a conscious Justinianic revival is indisputable. Thus Constantine, who named his son after Justinian, reintroduced a martial portrait bust with helmet, cuirass, spear and shield that clearly harks back to issues of his great sixth-century predecessor (figs. 219, 220). At first the imitation is iconographic only. In its rendering the bust retains the schematic linearism that had increasingly characterized coin portraits over the preceding one hundred years.[24] But in the coins from the early 680s one observes a stylistic regeneration as well. Faces and features are carefully modelled (note the eyes) and the three-quarter view of the Justinianic prototype is successfully reproduced. This regeneration continues under Justinian II and comes to the fore particularly in that monarch's most momentous innovation, namely, the bust of Christ which he was the first to put on the obverse of coins in lieu of the emperor's own portrait (fig. 218). That image as it appears on issues of Justinian II's first reign (A.D.685–95)[25] is a highly competent small-scale replica of a fully modelled figure in painting or relief. Indeed, it is quite obviously based on the same prototype as the Sinai icon (fig. 221); and while this relationship does not conclusively settle the question of the latter's date, it certainly adds plausibility to the contention that the icon is a work of this same period. In any case, the entire development in late seventh-century Byzantine coinage is very much in line with the major trend we have traced in painting.

In trying to understand this trend and evaluate its significance, some further consideration of these images of Christ can be of help. Their ultimate source of inspiration has been sought in Pheidias' Olympian Zeus, of which a head in the Boston Museum of Fine Arts is generally agreed to be a good replica (fig. 222).[26] Whether or not one accepts this specific derivation, in a broader sense it is undeniably correct: the type is that of a Greek father god. A presence both authoritative and benign, Christ is here visualized, as were the gods of classical Greece, in terms of an idealized humanity. This provides us with an important clue to the entire phenomenon of the resurgence of Hellenism and the direction

that style took in religious art of the seventh century. Fundamentally, what is involved is more than stylistic devices and pictorial techniques. Artists adopted and grappled with them to fashion with their help a new image of the celestial world. The holy figures they conjured up are tangible and human enough to be real, yet so generalized as to be beyond day-to-day experience.

This achievement of the seventh century proved to be a lasting one. The 'Jovian' image of Christ, so powerfully and authoritatively proclaimed and propagated on the coins of Justinian II, became the Byzantine image of the All-ruler *par excellence*. After the end of Iconoclasm it was reintroduced by the imperial mint, in direct and conscious imitation of the coinage of Justinian II.[27] It was in this same guise that Christ was to appear at that time, majestically enthroned, in the mosaic over the main door of St Sophia (fig. 223).[28] Thereafter the type was to be repeated again and again throughout the Byzantine Middle Ages.

The true significance of seventh-century Hellenism can best be perceived in this larger perspective. The period that began with the last decade or so of the reign of Justinian I had brought, in the first instance, a thrust towards abstraction more radical and extreme than any that had occurred earlier. At no previous time had the alienation from classical form and classical ideals been so great as in the late sixth and first half of the seventh century. But at this critical stage – and it is this which makes it a major turning point in the history of art – the classical tradition strongly reasserted itself in Byzantium. It did so not merely in marginal branches of artistic activity but in the central sphere of religious art, to result in the end in an image of the Deity in which the divine and the human, the solemn and the personal are superbly and lastingly blended. Both Byzantium after Iconoclasm and the Northern European countries just then beginning to move to centre stage were the heirs and beneficiaries of the tempered humanism which the seventh century ultimately achieved.

EPILOGUE

It is well to conclude this journey through five hundred years of Mediterranean art history with some reflections of a general kind.

I take my cue from the manner in which the Hellenistic tradition reasserted itself – and was developed further – in the seventh century. Undoubtedly in that reassertion conscious and deliberate revival efforts were involved. We need only recall the clear references to Theodosian court art in the Cypriot David plates or the Justinianic revival in the last part of the century so particularly manifest in coins. In these cases one has good reason to assume deliberate policy moves undertaken with a programmatic intent by persons in authority. They are, in other words, examples of essentially 'other-directed' stylistic changes. But these changes are based on movements that are far broader and far deeper. We saw in the mythological silver plates of the early seventh century a seedbed for the style of the David plates; and long before the end of the century we saw Hellenistic impressionism in painting developing in a direction that prepared the way for a Justinianic revival. Most clearly observable at S.Maria Antiqua, this latter development has every appearance of a gradual 'inner-directed' change.

Modal conventions were a factor of great importance in this entire complex interplay of currents and traditions. It was primarily the habitual and natural use of a Hellenistic style for secular subjects and contexts which kept that style alive at a critical stage. Within the religious sphere there were certain subjects which provided particular scope for this style and encouraged its use. Modal differentiations leap to the eye in a survey of the art of this period. This may well in itself be a symptom of crisis, of conflicts and indecision in the aesthetic field and of a search for form adequate to the expression of new concerns. But the wide adoption of the Hellenistic style for religious images and the transformation we saw this style undergo in the course of the seventh century cannot be explained adequately in terms of conventions. This was a slow and broadly based process of formal evolution with a powerful impetus of its own.

We have encountered such processes frequently in earlier periods. Suffice it to recall the gradual decomposition of classical form in Roman sculpture of the Antonine and Severan periods, the regenerative development in fourth-century sarcophagi, the new abstraction (springing from the principle of

affirming rather than dissembling basic surfaces and shapes) in fifth-century floor mosaics and capitals, or the dematerialization and reductionism in paintings and mosaics of the late and post-Justinianic period. All these are morphological changes traceable within a given medium and often within definable geographic areas. The transformation in seventh-century paintings rooted in the Hellenistic tradition is just such a process.

On the other hand, we have also encountered throughout our entire period innovative moves comparable to the Theodosian revival under Heraclius and the Justinianic revival in the late seventh century – moves that appeared to be deliberate, purposeful and inspired from above. The clearest earlier examples of such 'other-direction' were in Constantinople at the court of Theodosius and in Rome during the same period when the pagan senatorial aristocracy made its last stand. Other instances where this factor seemed at least to have played a part were the strongly 'sub-antique' art of the Tetrarchy, papal art in Rome in the fifth century, and the great artistic effort of the early Justinianic period. In all these cases a programmatic intent originating with a particular patron or a particular 'interest group' is more or less clearly in evidence, and always this programme is expressed visually by an open and insistent reference to a pre-existent style that is being quoted, so to speak, for the sake of its mental associations. The aggressively classicist style of the ivory carvings commissioned by the die-hard Roman aristocrats in the late fourth century is the most obvious example. But – and this is one of the principal conclusions we may draw in retrospect – these wholly or partially 'other-directed' efforts are in the nature of catalysts. They do not revolutionize but rather accentuate, reinforce and bring into focus existing trends by introducing a clear reference to an earlier style.

'Inner-direction' and 'other-direction', therefore, are inextricably interlocked. Indeed, the terms must not be understood in any rigid or absolute sense. Both factors may be involved in shaping the style of a given work of art, and often it is not possible to distinguish between features attributable respectively to the one and to the other. The antithesis certainly can help us to gain a better understanding of the historical process and the forces which shaped it. But it must not lead to a schematic or mechanical bisection of what actually happened.

In order to see the historical process in its wholeness and indivisibility I have in this book taken a macroscopic view. The third, fourth and fifth centuries – and, needless to say, these chronological terms are to be understood loosely – each proved to possess a distinct overall physiognomy. In each of these periods we found a convergence or congruence of major initiatives, trends and movements. Again, the art of the Justinianic era has pronounced characteristics of its own. The period which follows, down to the beginning of Iconoclasm, is

stylistically less coherent. But here, too, an evolutionary pattern emerges from the multiplicity of currents and cross-currents, a pattern which in effect continues a dialectical process that had begun with the breakdown of classical art in the late second century.

The existence of these interlocking and interweaving trends is hardly open to question. The art historian's most difficult task is to identify the forces that set these developments in motion, the intent behind changes in form. He can do so with relative assurance in the case of those movements that are essentially 'other-directed'. In these cases the style is part of a programme, and the patron who in effect imposes the style represents in his person the social, political, intellectual or religious interests of which the style is an expression. The problem is far more intractable and elusive in the case of those broad, gradual and largely anonymous developments generated and brought to fruition within the artist's own sphere. There can be no doubt that these 'inner-directed' movements, too, are intimately related to and expressive of social and spiritual concerns and aspirations. But in most cases we lack reliable clues which would enable us to identify these motivating forces, and, quite naturally, the darkness deepens as general historical documentation becomes increasingly scanty with the progressing centuries. We can with some confidence interpret the breakdown of classical forms in the late second and third century in terms of an 'age of anxiety'. My attempts to interpret historically the renewed assaults on the classical tradition in the fifth century and in the late and post-Justinianic age were far more problematic; to say nothing of the new Hellenism in religious art of the seventh century, which so far can be explained only in an essentially intuitive way.

It must suffice to have drawn attention to these difficulties, which to a greater or lesser degree beset the path of any scholar who would view the history of art – and of artistic form in particular – as a history of the human mind. For the student of style there is always the temptation simply to relate forms to antecedent forms and leave it at that. The pursuit is wholly legitimate and indeed necessary. Form in art is never a direct transcript of extra-artistic concerns – political, religious or whatever. It is always a reaction to antecedent forms, either in the sense of building up on them – taking up a cue and pursuing it further – or in the sense of a (conscious or subconscious) differentiation, opposition or even protest. But the manner of this reaction and the direction it takes are determined by the forces that have shaped the artist's mind. Hence in these reactions and relationships important clues lie buried for the historian of culture.

In these terms our understanding of the five centuries of Mediterranean art

surveyed in this book is still very incomplete. What we can perhaps say in a final look backward is that their greatest achievement lies not in their innovations – important as these are – but in having preserved, in the face of vast and cataclysmic changes, basic and essential elements of the Graeco-Roman heritage. Tempered in crisis after crisis and progressively adapted to new needs and concerns, much of that heritage still proved important and meaningful in a totally changed world.

The Monochrome Plates

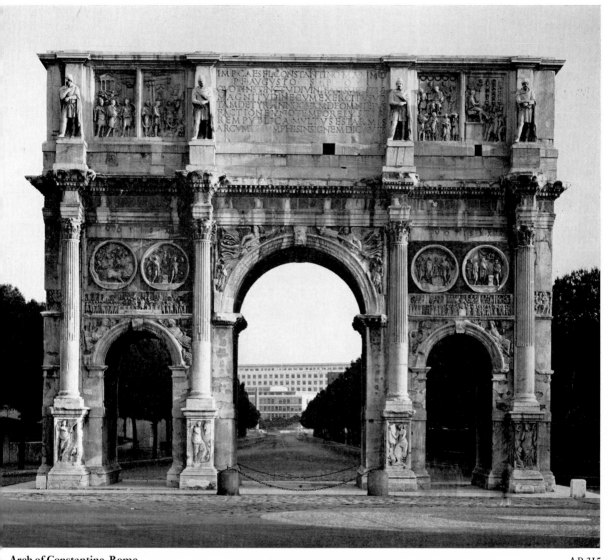

Arch of Constantine, Rome
iew from north

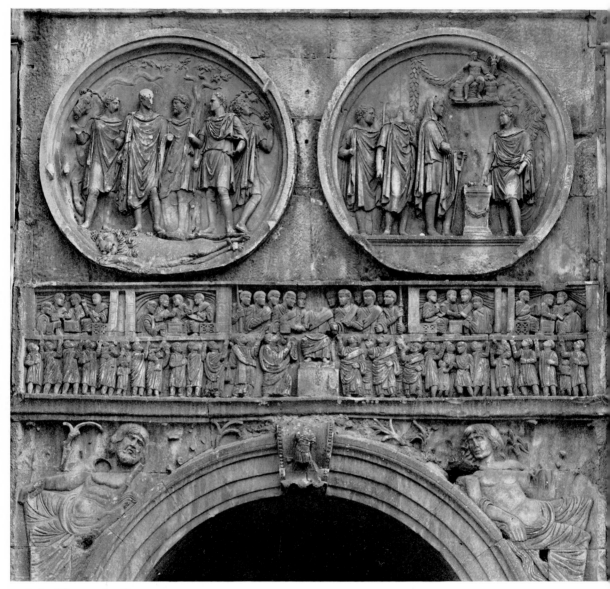

2. Arch of Constantine, Rome
Medallions and frieze on north side

A.D. 31

page

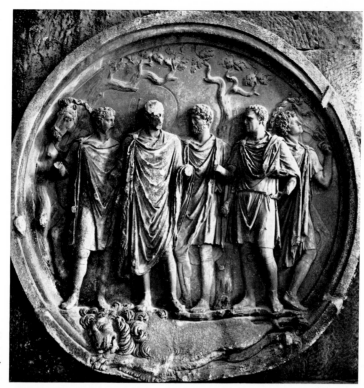

3. **Imperial lion hunt**
Medallion (from a
monument of Hadrian)
on north side of Arch of
Constantine, Rome

Second century
page 7

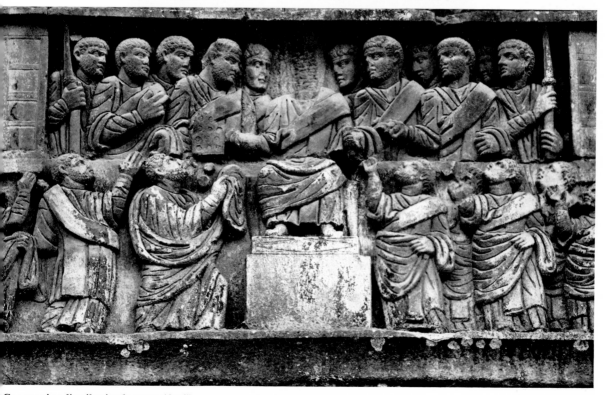

Constantine distributing largesse (detail)
eze on north side of Arch of Constantine, Rome

A.D.315
page 7

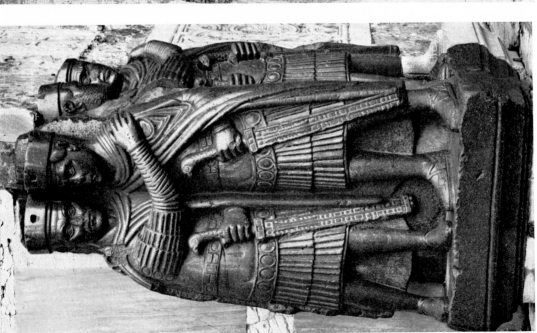

5. **Porphyry group of the Tetrarchs**
Venice, S.Marco

c. A.D.300
page 9

6. **Hunting scene** (detail)
Floor mosaic in great corridor of Roman villa, Piazza Armerina, Sicily

Early fourth century
page 9

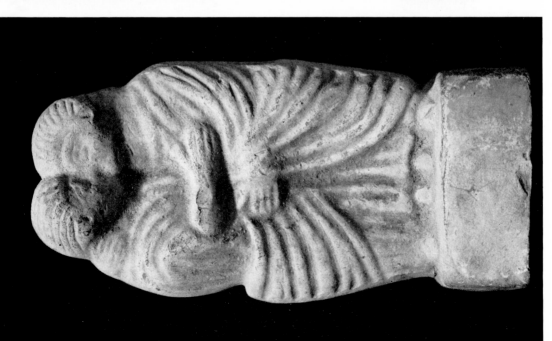

7. Couple embracing
Terracotta from the Altbachtal
Trier, Landesmuseum

Third to fourth century
page 12

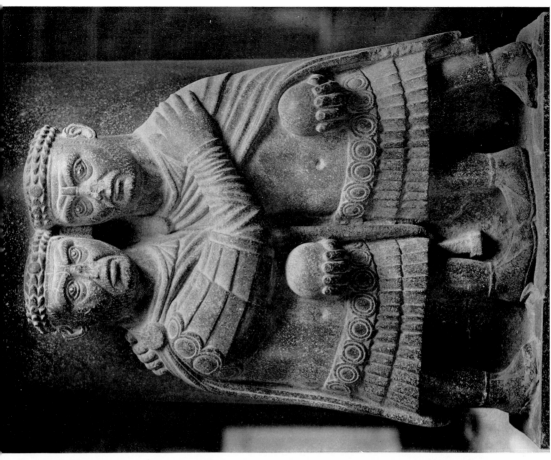

8. Porphyry sculpture of two Tetrarchs
Vatican Library

c. A.D. 300
page 12

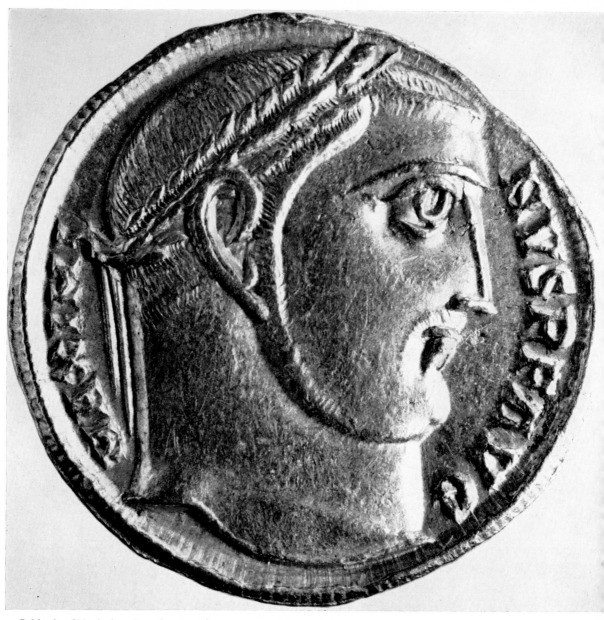

9. Gold coin of Maximinus Daza (A.D.305–13)
(enlarged 8·7 times)

c. A.D.310, Antioch
pages 9, 14

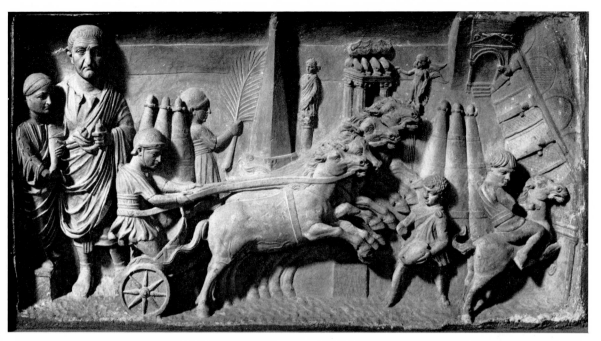

10. Tomb relief with circus scene First half of second century
Vatican Museum (formerly Lateran) *page 11*

11. Tomb relief from Palmyra Second century
Malkou, son of Zabdibol, and his daughter *page 10*
Copenhagen, Ny Carlsberg Glyptotek

12. Tomb relief of a couple, from Weisenau First century
Mainz, Mittelrheinisches Landesmuseum *page 10*

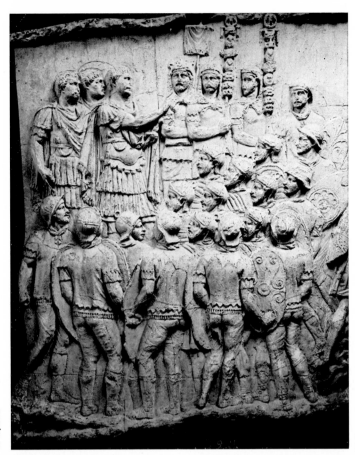

**13. Trajan addressing
his troops**
Detail from Column of
Trajan, Rome

A.D.113
page 14

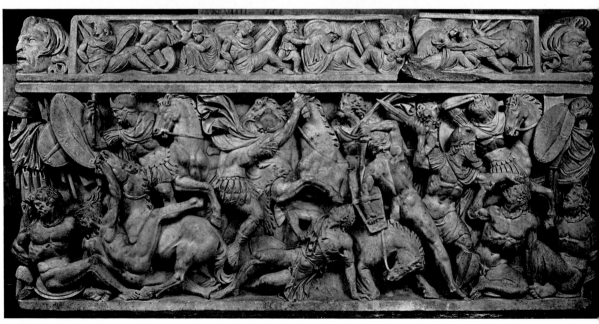

15. Sarcophagus with battle scene
Rome, Capitoline Museum

c. A.D. 160-7
page 1

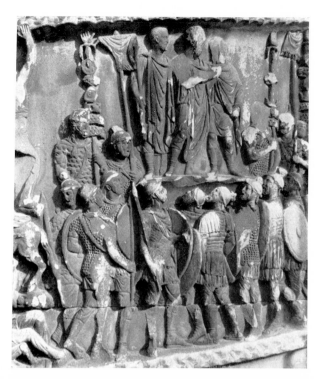

**14. Marcus Aurelius
addressing his troops**
Detail from Column of Marcus
Aurelius, Rome

A.D. 180–93
page 14

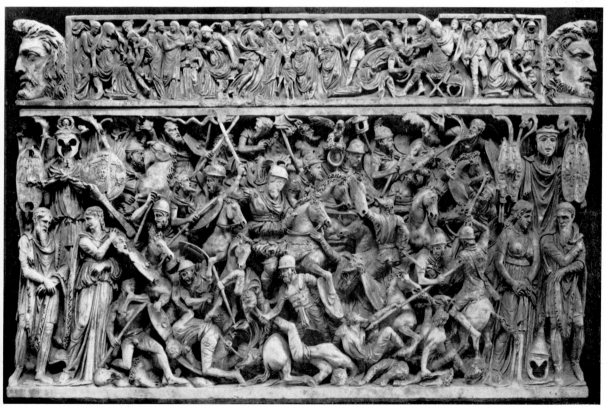

16. Sarcophagus with battle scene
Rome, National Museum

c. A.D. 180–90
page 15

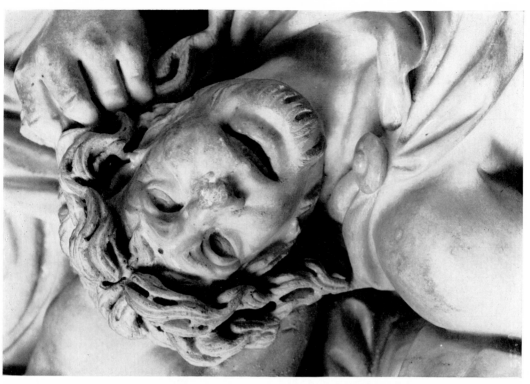

18. Dying barbarian
Detail of battle scene on Ludovisi sarcophagus
Rome, National Museum

17. Detail of fig. 16
Dying barbarian

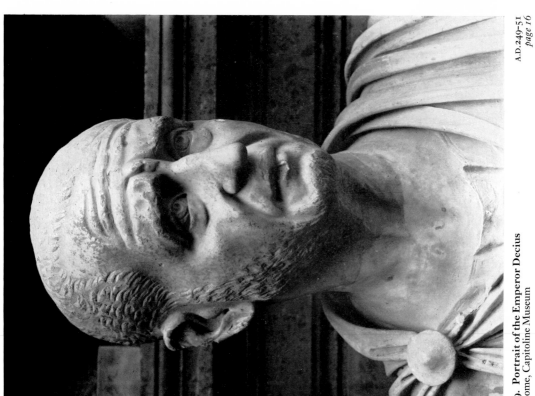

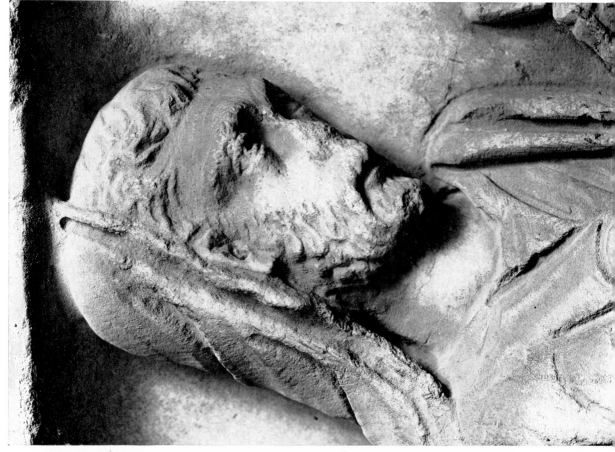

21. Portrait, so-called Plotinus
Ostia, Museum

c. A.D. 260-70
page 16

22. The Emperor Claudius II Gothicus
Detail of scene of sacrifice
A.D. 268-70
Rome, National Museum

page 16

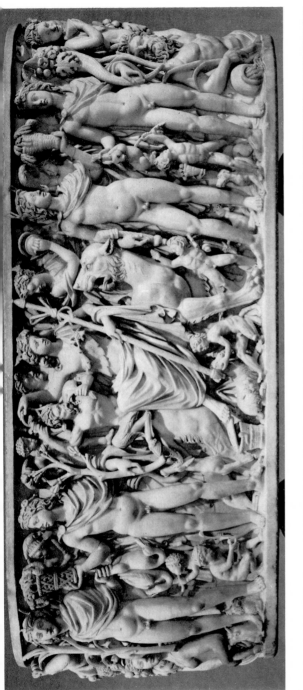

23. Sarcophagus
Dionysiac procession
and Seasons
Early third century
New York,
Metropolitan Museum
page 18

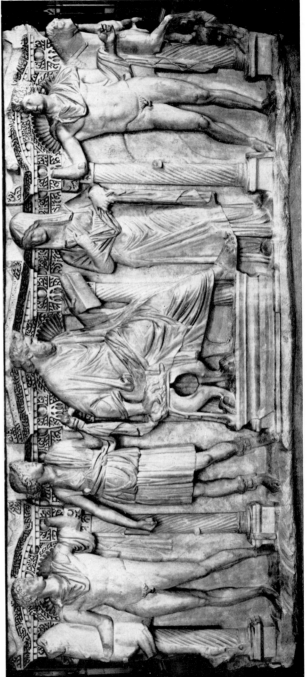

**24. Asiatic
sarcophagus from
Sidamara**
c. A.D.250
Istanbul,
Archaeological
Museum
page 18

25. Attic sarcophagus with scene of Achilles on Skyros
Rome, Capitoline Museum

27. Male portrait
From lid of sarcophagus, fig. 25

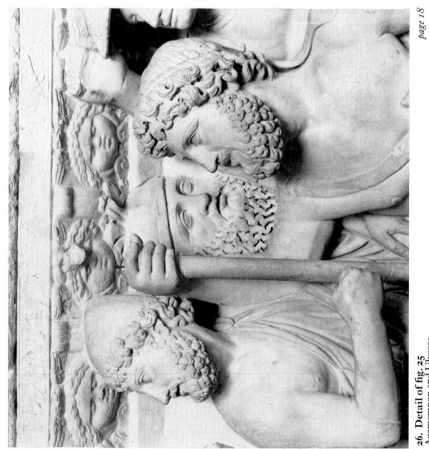

26. Detail of fig. 25
Agamemnon and Ulysses

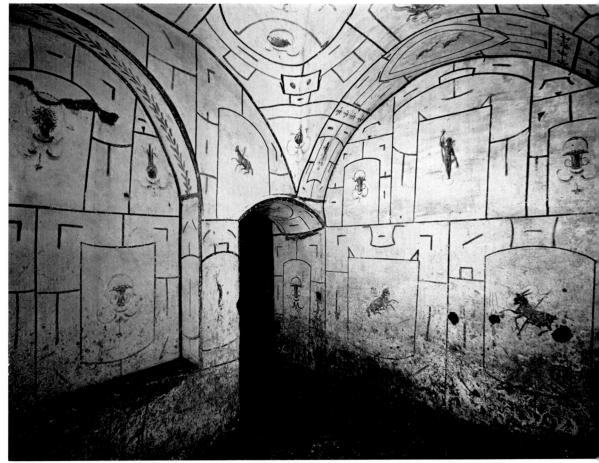

28. Painted interior
House beneath
S.Sebastiano, Rome

First half of th
cent
page

**29. So-called
Chapel of the
Sacraments ('A3')**
Catacomb of
S.Callisto, Rome

First half of third
century
page 20

o. Jonah cast up
Marble group
Cleveland, Ohio, The Cleveland Museum of Art

32. Male portrait bust
Cleveland, Ohio. The Cleveland Museum of Art

Second half of third century

page 21

31. Orpheus taming the animals
Marble group

Third century

page 21

33. **Sarcophagus with Jonah story**
Copenhagen, Ny Carlsberg Glyptotek

Late third century
page 21

34. **Sarcophagus with myth of Endymion**
New York, Metropolitan Museum

Second century
page 21

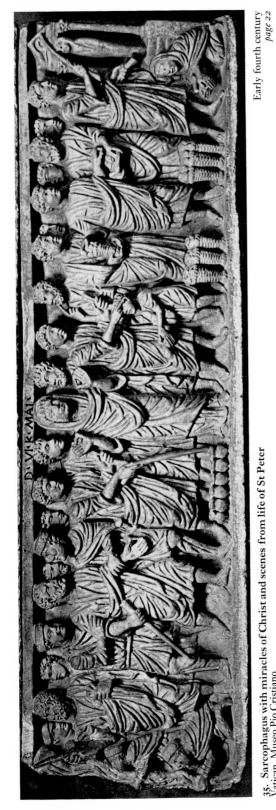

35. Sarcophagus with miracles of Christ and scenes from life of St Peter
Vatican, Museo Pio Cristiano

Early fourth century
page 22

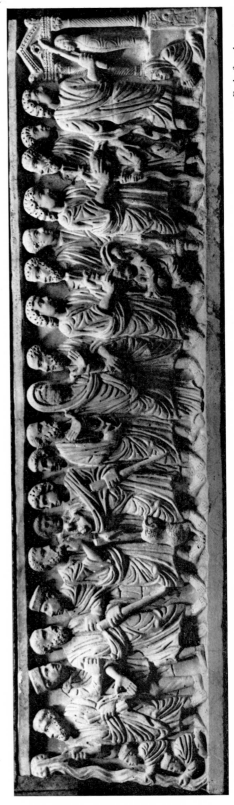

36. Sarcophagus with miracles of Christ and scenes from life of St Peter
Rome, National Museum

Early fourth century
page 22

page 22

37. Detail of fig. 35
St Peter and soldiers

A.D. 315
page 22

38. Roman soldier
Detail of frieze on west side of
Arch of Constantine, Rome

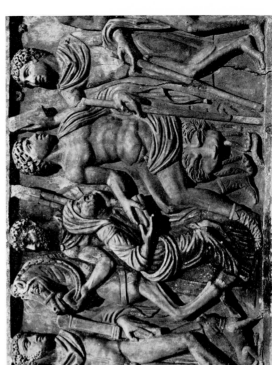

Early fourth century
page 25

40. Hippolytus with Phaedra's Nurse
Detail of sarcophagus
Rome, Villa Albani

page 25

39. Detail of fig. 42
Raising of Lazarus

41. 'Dogmatic' sarcophagus
Scenes from the Old Testament, the Gospels and the life of St Peter
Vatican, Museo Pio Cristiano

c. A.D. 320–30
page 24

42. Sarcophagus of the 'Two Brothers'
Scenes from the Old Testament, the Gospels and the life of St Peter
Vatican, Museo Pio Cristiano

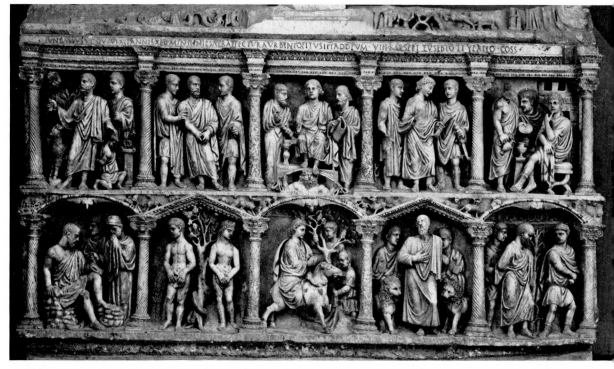

43. Sarcophagus of Junius Bassus
Vatican, Grottoes of St Peter

A.D.359
page 26

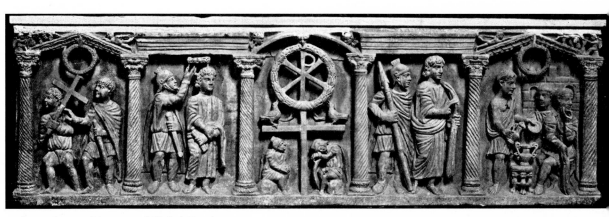

44. Sarcophagus with scenes of Christ's Passion
Vatican, Museo Pio Cristiano

c. A.D.340
page 26

45. Detail of fig. 44. Pilate *page 26*

46. Detail of fig. 43. Pilate *page 26*

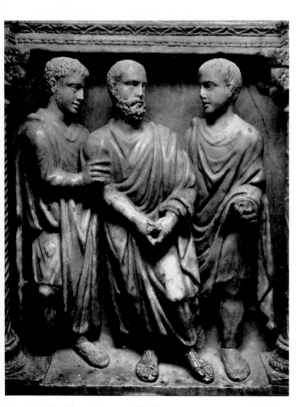

47. Detail of fig. 43. Arrest of St Peter *page 27*

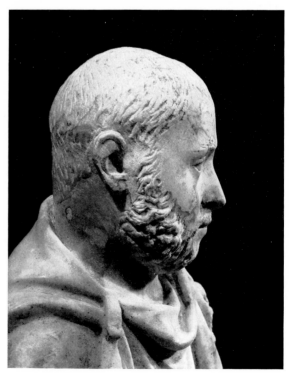

48. Male portrait Second half of third century
From same series of busts as fig. 32 *page 27*
Cleveland, Ohio, The Cleveland Museum of Art

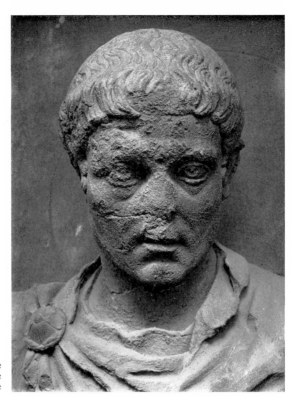

49. Head of Constantine
Detail of medallion on north side
of Arch of Constantine, Rome

A.D.315
page 29

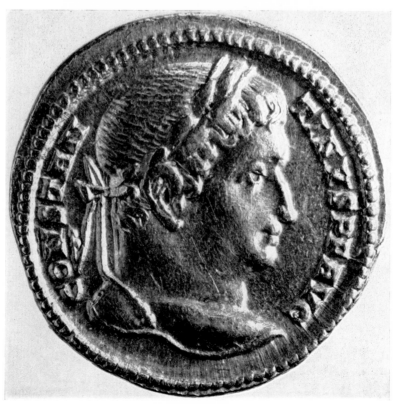

**50. Gold coin of
Constantine**
(enlarged 6·1 times)

A.D.309-13, Trier
page 29

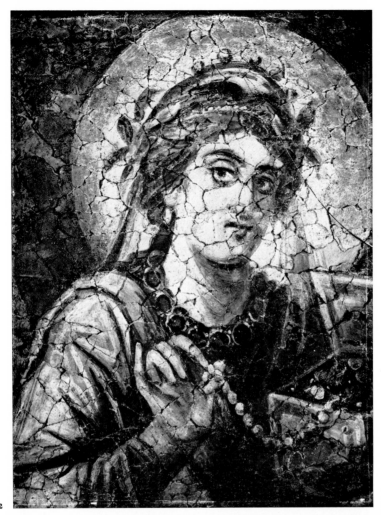

51. Detail of fig. 52

page 29

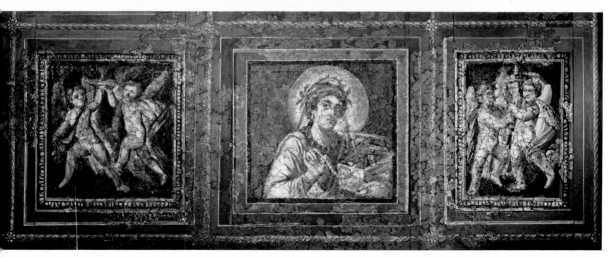

2. Lady with jewel box, flanked by cupids
ection of ceiling fresco from imperial palace, Trier
rier, Bischöfliches Museum

c. A.D.315-25
page 29

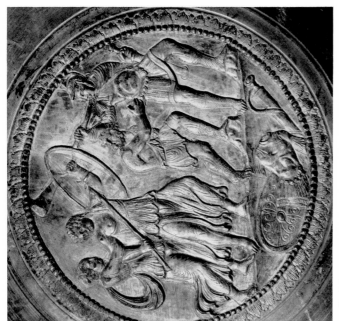

page 30

54. Detail of fig. 55
Achilles on Skyros

**55. Silver plate with
scenes of Achilles**
From Kaiseraugst Treasure
c. A.D. 350
Augst, Museum
page 29

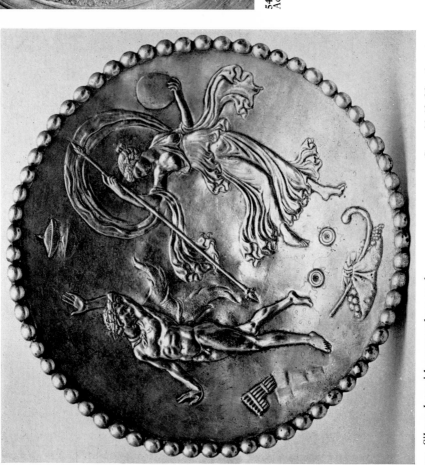

Second half of fourth century
pages 30, 108

53. Silver plate with satyr and maenad
From Mildenhall Treasure
London, British Museum

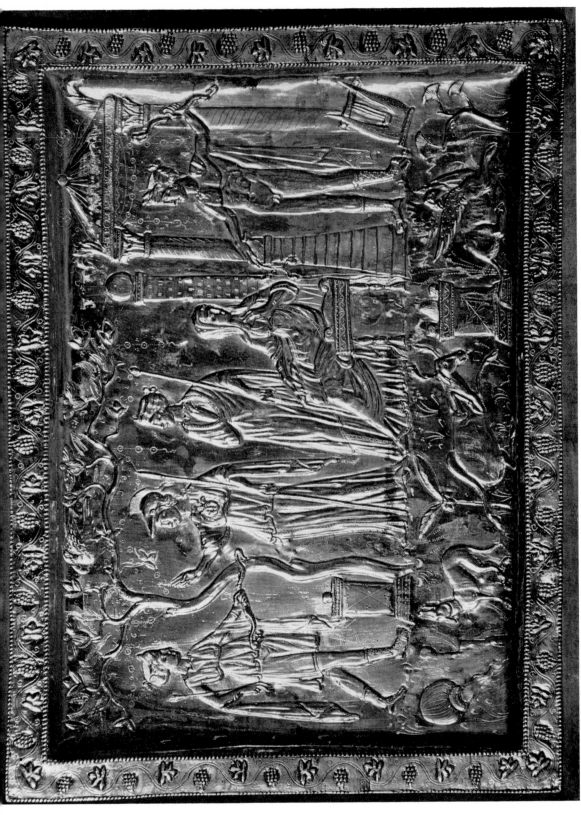

56. Silver tray with pagan divinities (Corbridge *lanx*)
Alnwick Castle, Collection of the Duke of Northumberland

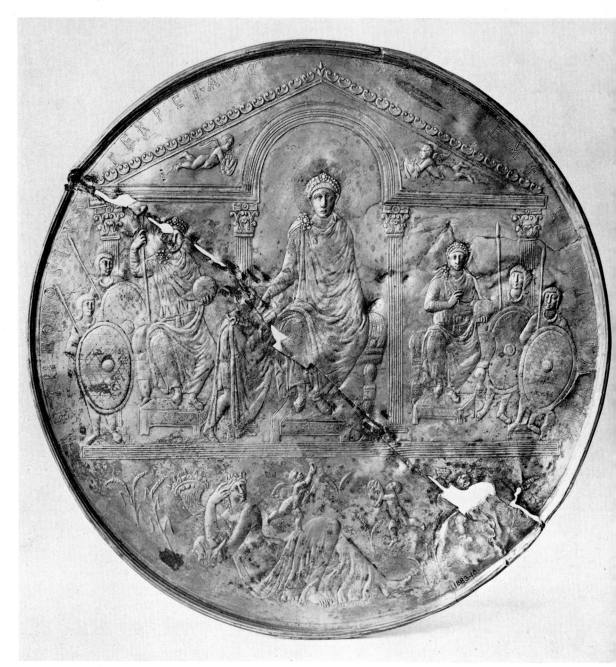

57. Silver Missorium of the Emperor Theodosius
Madrid, Academia de la Historia

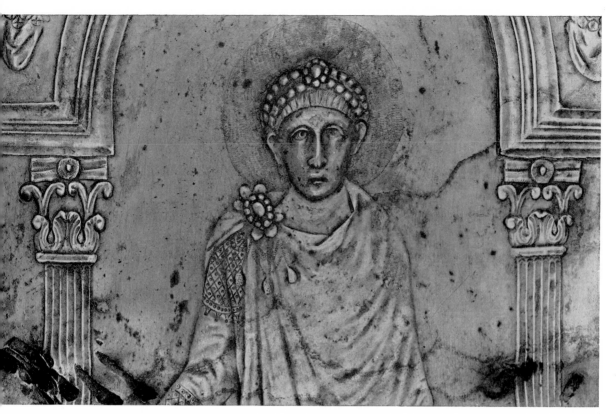

38. Detail of fig. 57. The Emperor Theodosius

page 31

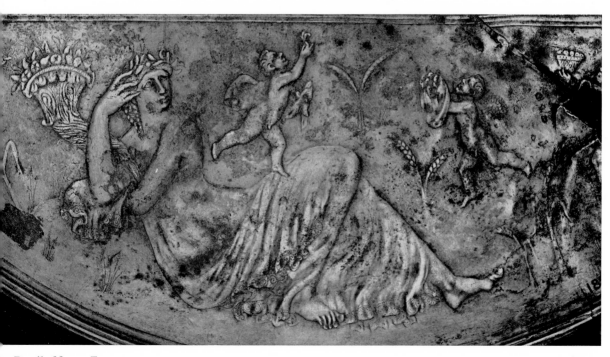

39. Detail of fig. 57. *Terra*

page 32

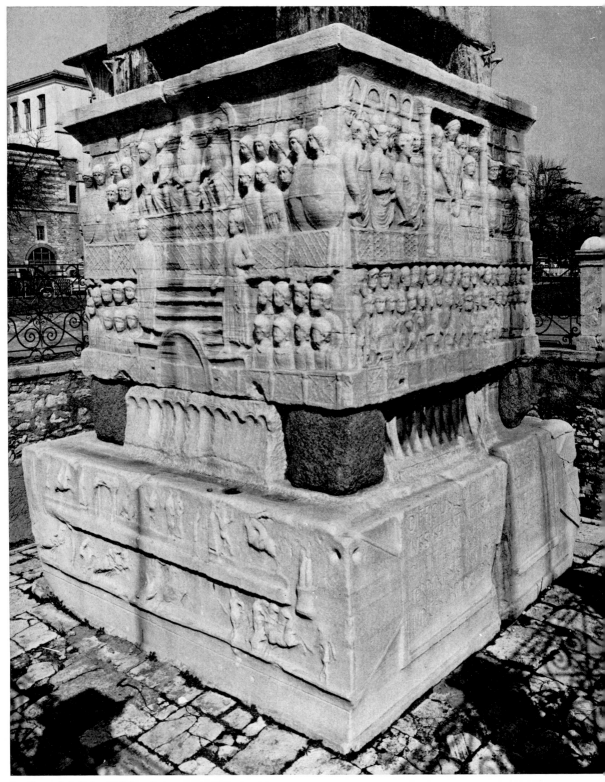

60. Base of obelisk with hippodrome scenes
Istanbul, Atmeydani

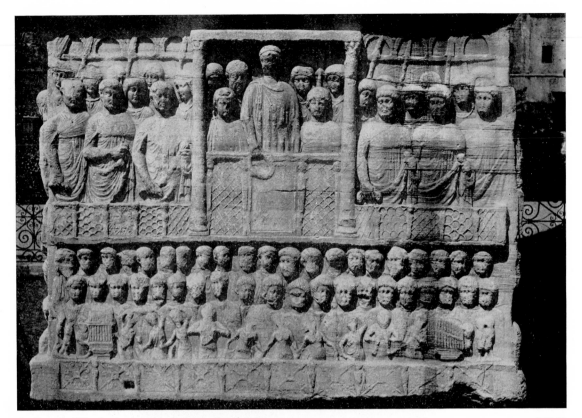

61. Detail of fig. 60
The Emperor Theodosius
with entourage, musicians
and dancers

page 32

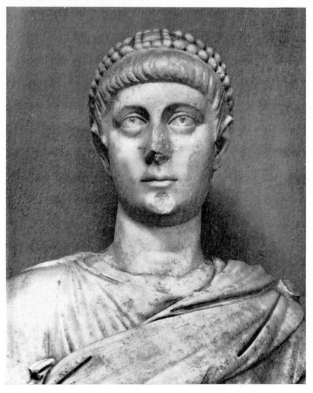

**62. The Emperor
Valentinian II**
(A.D.375–92)
Head of portrait statue
from Aphrodisias
Archaeological Museum,
Istanbul

c. A.D.390
page 33

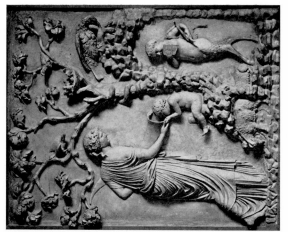

64. 'Amalthea' relief
Vatican Museum (formerly Lateran)
Second century
page 34

63. Ivory diptych
Priestesses performing pagan rites
Late fourth century
Paris, Musée Cluny (*left*)
London, Victoria and Albert Museum (*right*)
page 34

65. Ivory diptych
Asclepius and Hygieia
Liverpool,
County Museum

66. Silver plate with procession of Cybele and Attis
From Parabiago
Milan, Pinacoteca di Brera

Late fourth century
page 35

67. Ivory diptych of Probianus
Berlin, Staatsbibliothek, Stiftung Preussischer Kulturbesitz

68. Leaf of ivory diptych of Lampadii
Circus scene
Brescia, Museo Civico Cristiano

c. A.D.400
page 37

69. Leaf of ivory diptych
Stag hunt in amphitheatre
Liverpool, County Museum

c. A.D.400
page 37

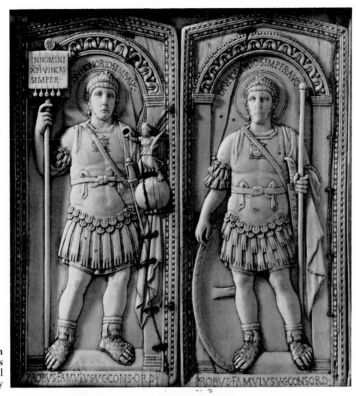

**70. Ivory diptych
of Probus**
Aosta, Cathedral
Treasury

A.D.406
page 37

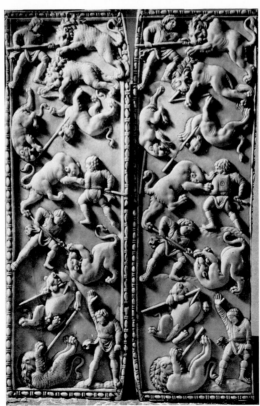

71. Ivory diptych
Animal combats in amphitheatre
Leningrad, Hermitage Museum

c. A.D.400
page 38

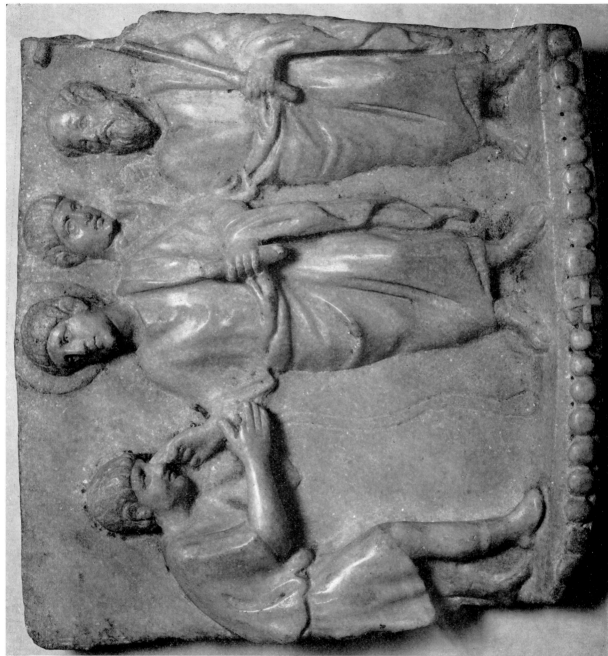

**72. Christ
healing the
blind man**
Washington, D.C.
Dumbarton Oaks
Collection

73. Detail of fig. 72. Christ *page 39*

74. Two heads from base of obelisk (fig. 60) *page 39*

75. **Child's sarcophagus**
Istanbul, Archaeological Museum

Late fourth century
page 39

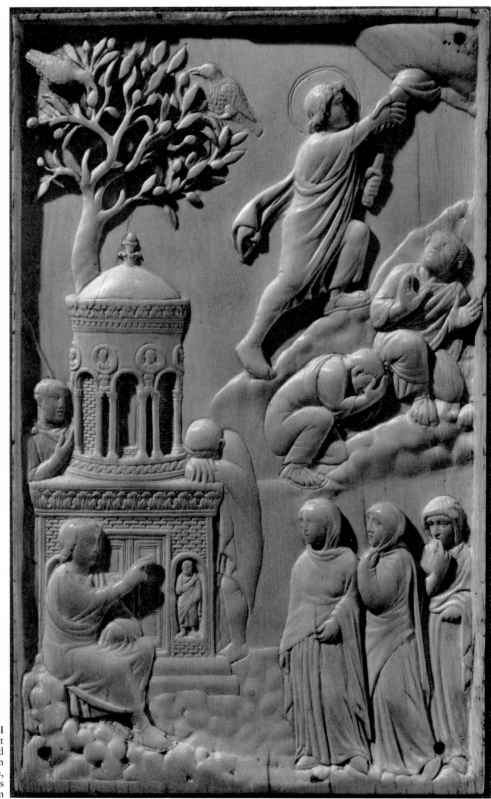

76. Ivory panel
Holy Women at
the Tomb and
Ascension
Munich,
Bayerisches
Nationalmuseum

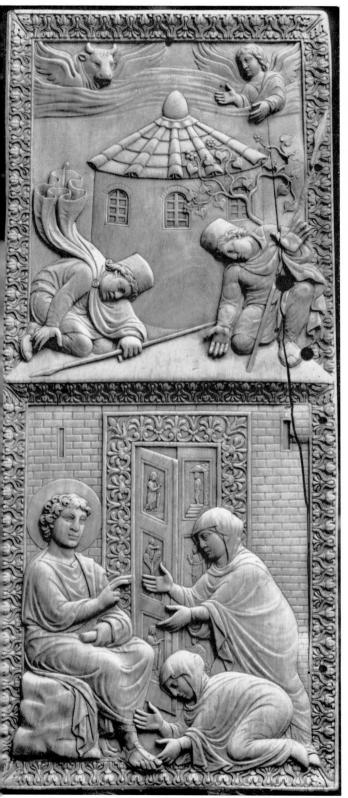

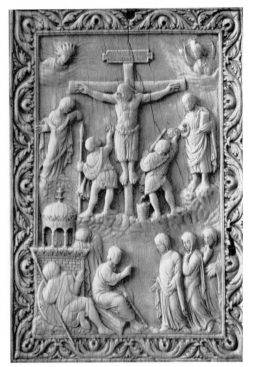

78. Carolingian ivory panel Ninth century
Crucifixion and Holy Women at the Tomb *page 41*
Liverpool, County Museum

77. Ivory panel
Holy Women at the Tomb
c. A.D.400
Milan, Civico Museo d'Arte, Castello Sforzesco
page 40

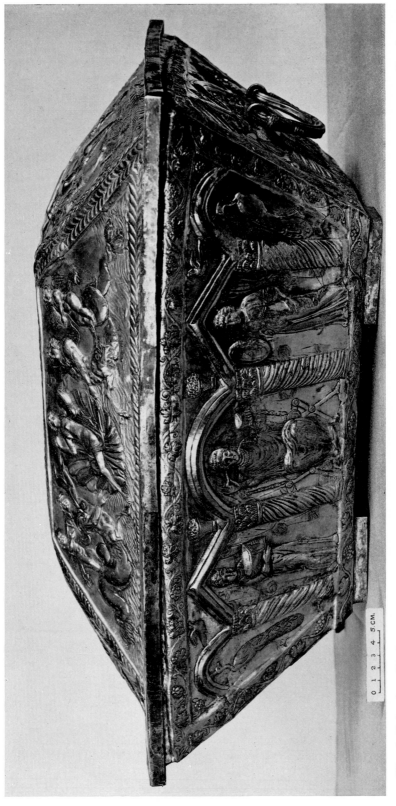

79. Silver bridal casket of Projecta
London, British Museum

Fourth century
page 40

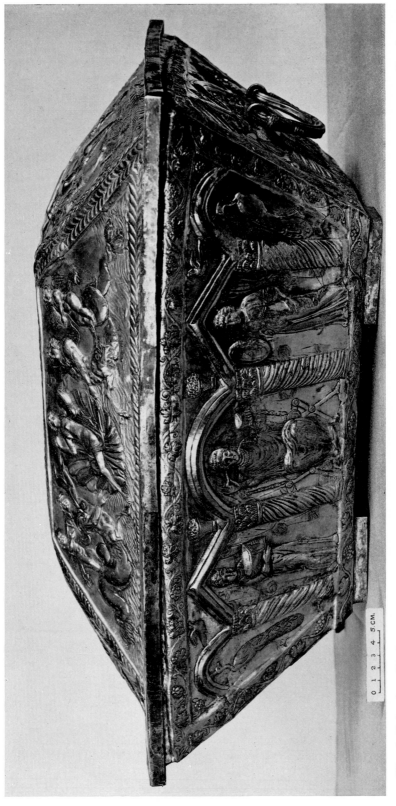

0 1 2 3 4 5 CM.

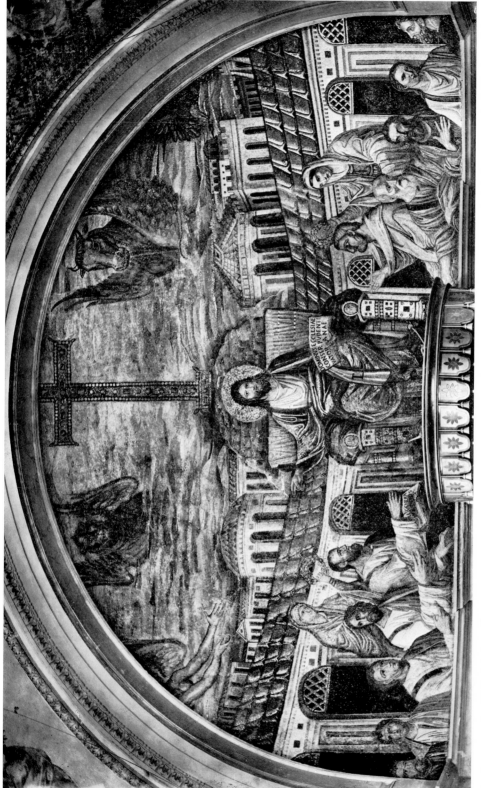

80. Apse mosaic of S. Pudenziana, Rome

A.D. 402–17
page 41

81. Ivory diptych of Boethius
Brescia, Museo Civico Cristiano

82. Ivory diptych of high official
Novara, Cathedral Treasury

Mid-fifth century
page 47

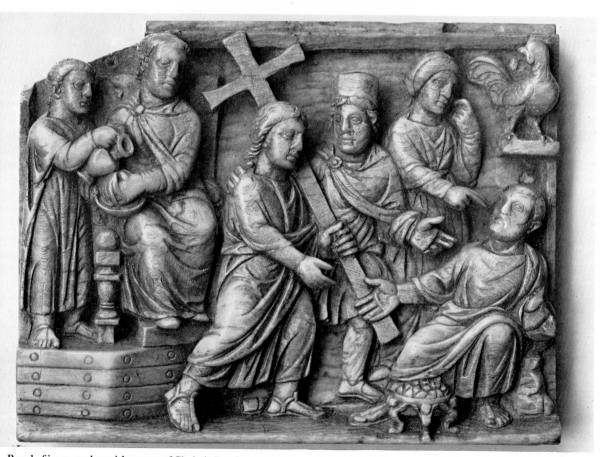

3. Panel of ivory casket with scenes of Christ's Passion
ilate, Christ carrying cross, Denial of St Peter
ondon, British Museum

First half of fifth century
page 47

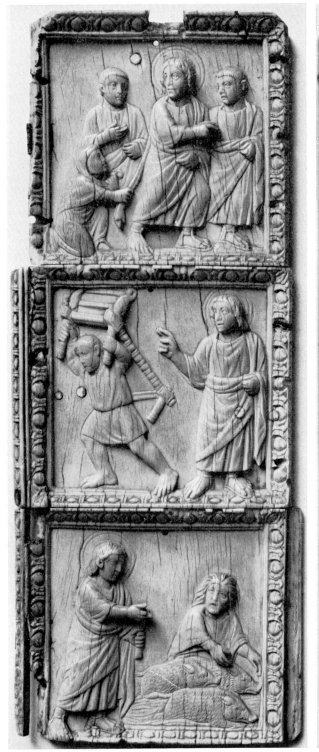
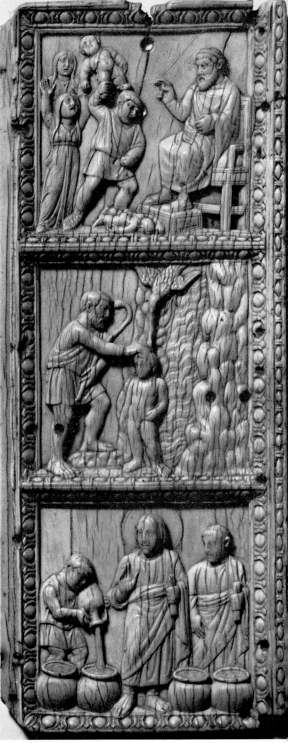

84. Ivory panels with scenes from Christ's life and miracles
Paris, Louvre (*left*); Berlin-Dahlem, Staatliche Museen, Preussischer Kulturbesitz (*right*)

First half of fifth centur
page

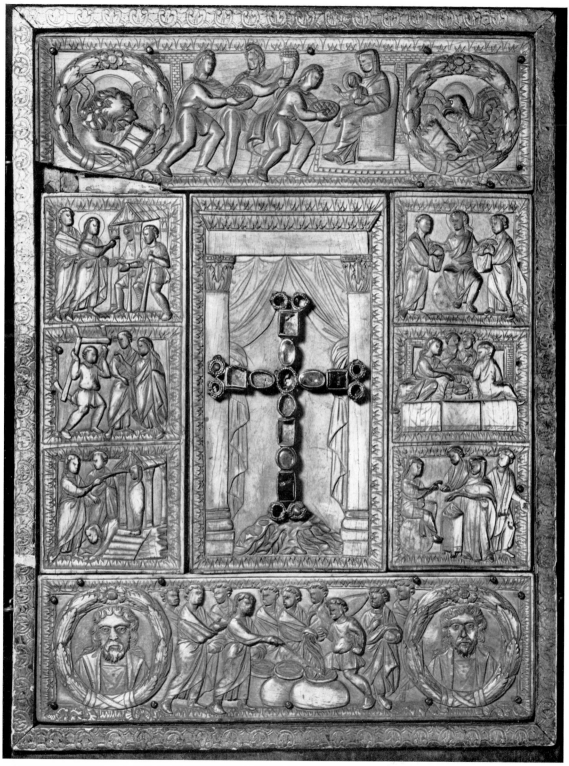

85. Ivory book cover
Scenes from life of Christ and portraits and symbols of evangelists
Milan, Cathedral Treasury

Late fifth century
page 47

86. Ivory diptych of the Consul Anastasius
Paris, Bibliothèque Nationale

A.D.517
page 48

87. Detail of fig. 88. Drinking contest between Hercules and Dionysus
Princeton University, Art Museum

page 50

88. Floor mosaic
House of the
Drinking Contest,
Antioch (*in situ*)

Third
century
page 50

89. **Seasons and hunting scenes**
Floor mosaic from Antioch
Paris, Louvre

90. Hunting scenes
Floor mosaic from Antioch
Worcester, Massachusetts, Art Museum

91. Floor mosaic of geometric design
North arm of Church of Kaoussie, Antioch

A.D. 387
page 52

92. Floor mosaic with Nilotic landscape
Church of the Multiplying of the Loaves and Fishes, Tabgha, Sea of Galilee

Fifth century
page 51

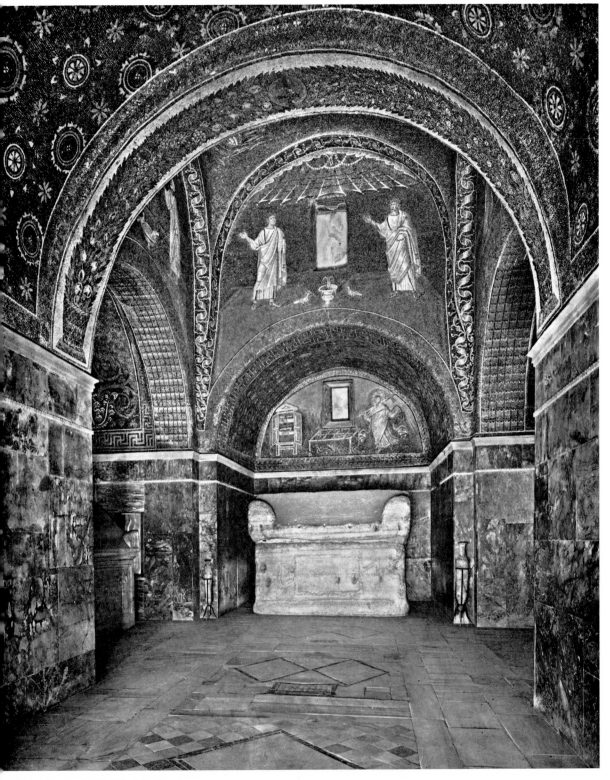

3. Mausoleum of Galla Placidia, Ravenna
interior, view to south

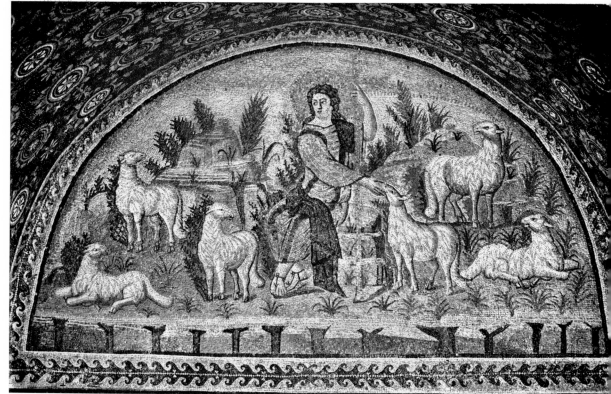

94. The Good Shepherd
Lunette in north arm of Mausoleum of
Galla Placidia, Ravenna

A.D.424-5
page 5

96. Painted tomb chamber
Palmyra, Tomb of Three Brothers

Second century
page 56

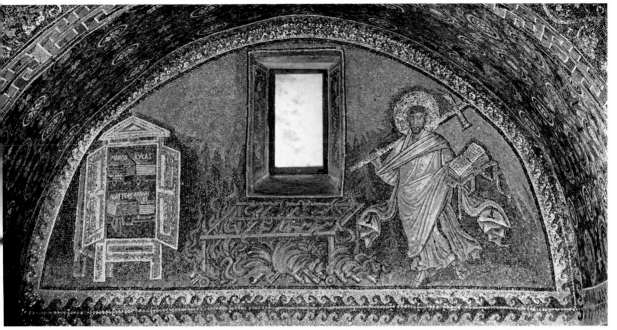

95. St Lawrence
Lunette in south arm of
Mausoleum of Galla
Placidia, Ravenna

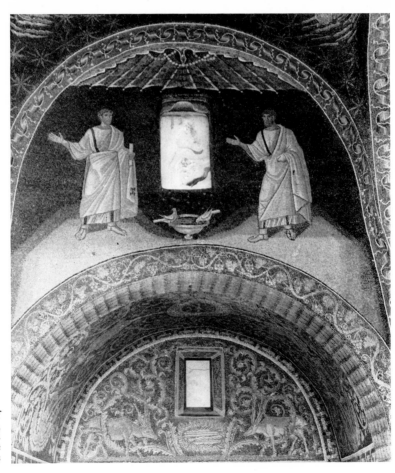

**97. Mausoleum of
Galla Placidia,
Ravenna**
West arm and lunette
with apostles

98. Mausoleum of Galla Placidia, Ravenna
View into vault

99. Church of St George, Thessaloniki
View into dome showing fifth-century mosaics

100. Detail of fig. 99
Medallion, originally with figure of Christ, carried by flying angels

Fifth century
page 57

101. St Cosmas
Detail of dome mosaic, St George, Thessaloniki

Fifth century
page 58

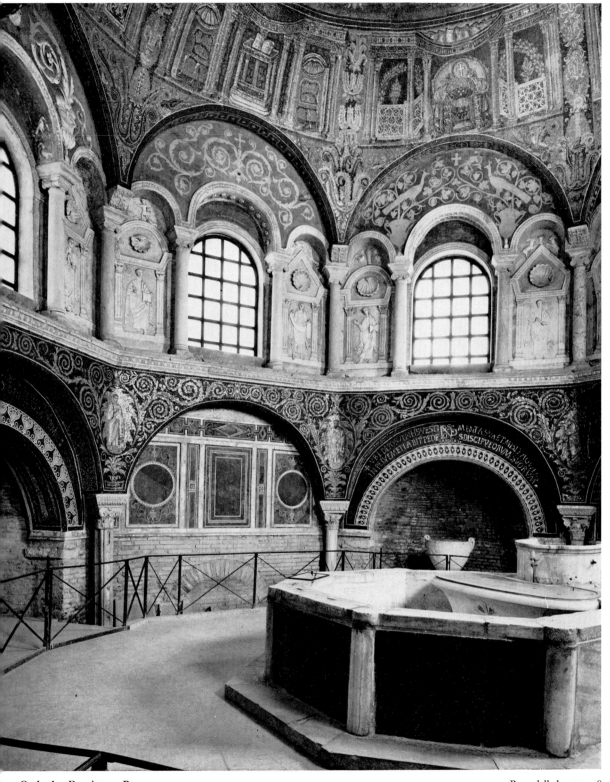

02. Orthodox Baptistery, Ravenna
Interior, view to north-east

Remodelled *c.* A.D.458
page 58

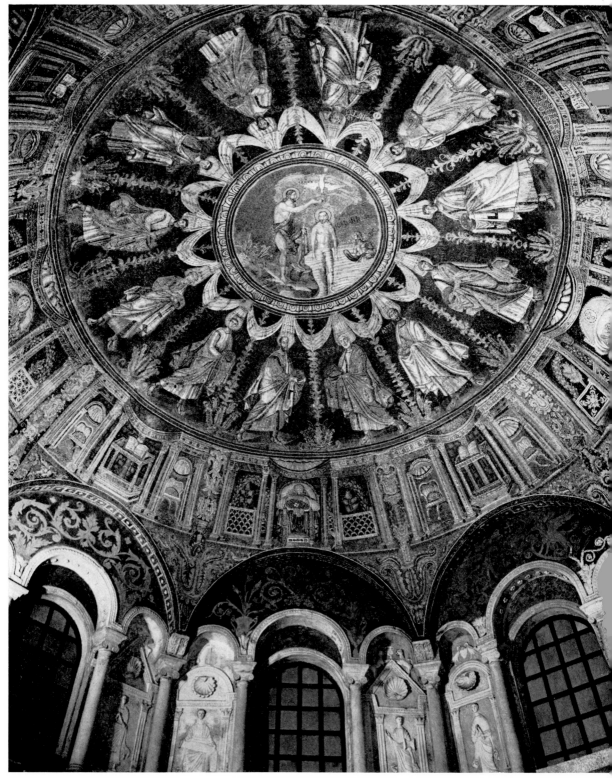

103. Orthodox Baptistery, Ravenna
View into dome

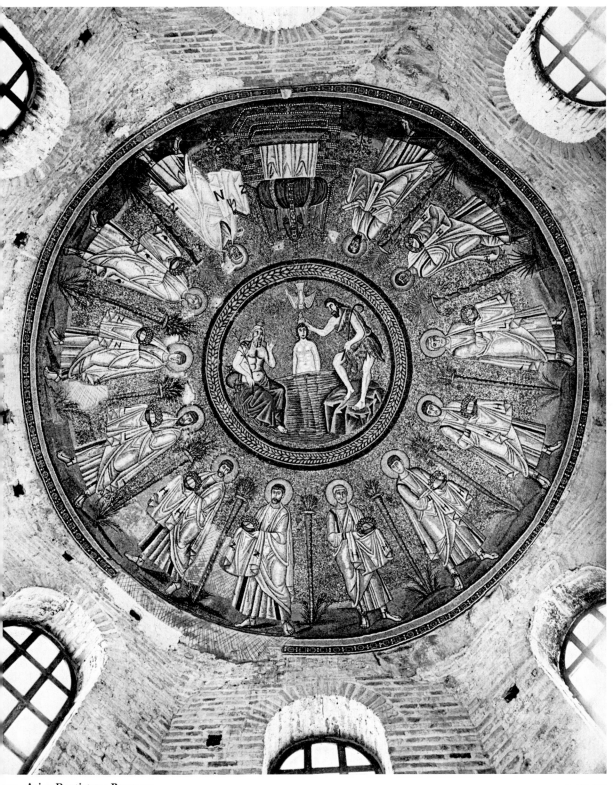

104. Arian Baptistery, Ravenna
View into dome

105. Chapel of S. Vittore in Ciel d'Oro, S. Ambrogio, Milan
View into dome

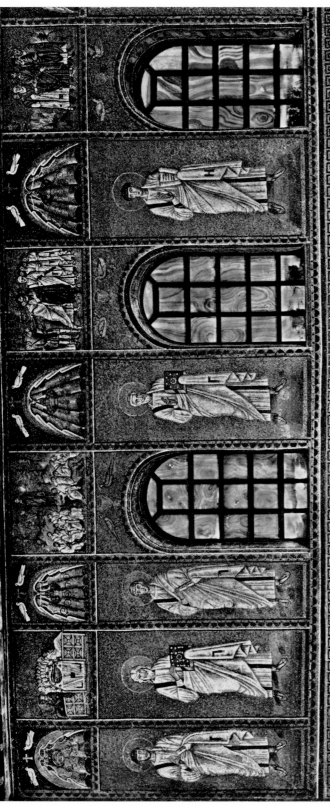

106. **S. Apollinare Nuovo, Ravenna**
East end of south wall with mosaics of Christ enthroned, biblical figures and Gospel scenes

c. A.D. 500 (procession of saints *c.* A.D. 560)
page 62

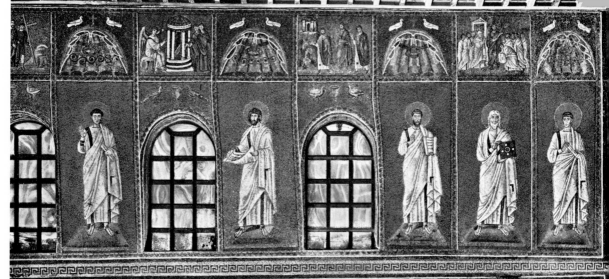

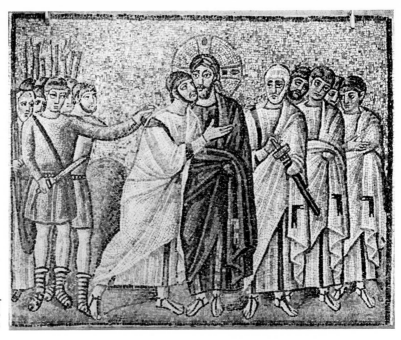

107. S.Apollinare Nuovo, Ravenna
West end of south wall with mosaics of Theoderic's Palace, biblical figures and Gospel scenes

c. A.D.5(
page 6

108. Detail of fig. 106
The Kiss of Judas

page 64

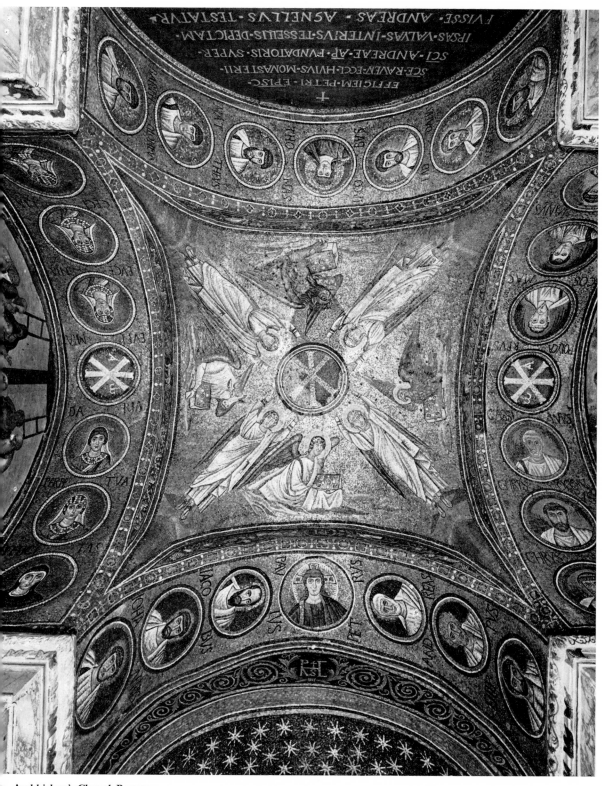

9. Archbishop's Chapel, Ravenna

View into vault

110. **Detail of fig. 109**
St Philip

page 65

111. **Detail of fig. 109**
St Cecilia

page

112. **St Mark**
Detail of apse mosaic,
Panagia Kanakaria, Lythrankomi, Cyprus

First quarter of sixth century
page 65

113. **Detail of fig. 86**
Head of the Consul Anastasius

page

114. S.Maria Maggiore, Rome
Interior, view towards apse

A.D.432-40
page 66

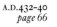

115, 116. S.Maria Maggiore, Rome
Reconstruction of original appearance of nave, apse, and system of clerestory walls (after Krautheimer)

page 66

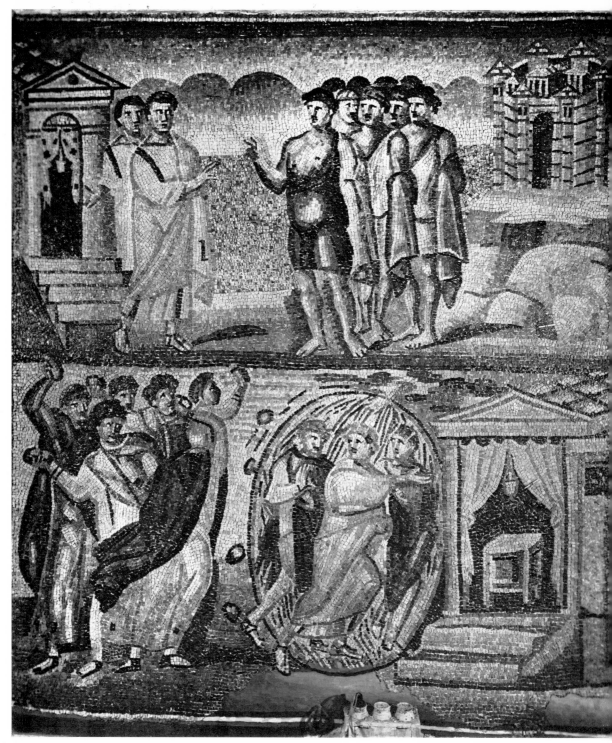

117. Israelites threatening revolt; Stoning of Moses
Mosaic in nave of S.Maria Maggiore, Rome

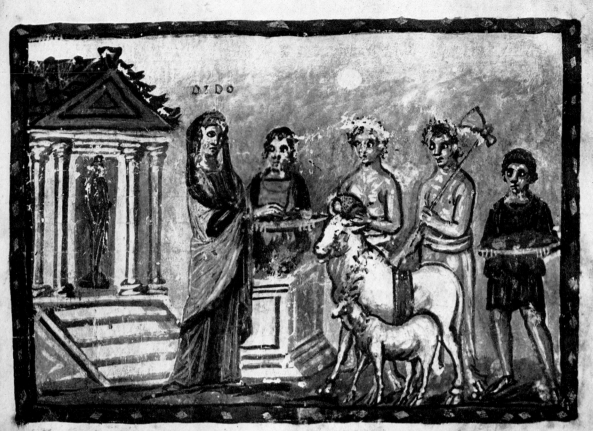

DIDO

PRINCIPIODELVBRAADEVNTPACEMQVEPERARAS
EXQVIRVNTMACTANTLECTASDEMORELIDENTES
IVCITERAICERERIPHOEBOQVEPATRIQVELYAEO
IVNONIANTEOMNISCVIVINCLAIVGALIACVRAE
LESTINENSDEXTRAPATERAMPVLCHERRIMADIDO
CANDENTISVACCAEMEDIAINTERCORNVAFVNDIT

8. **Dido sacrificing**
Illustration to Virgil's *Aeneid*, IV, 76ff.
Vatican Library, Ms. lat. 3225, f.33v

Early fifth century
page 67

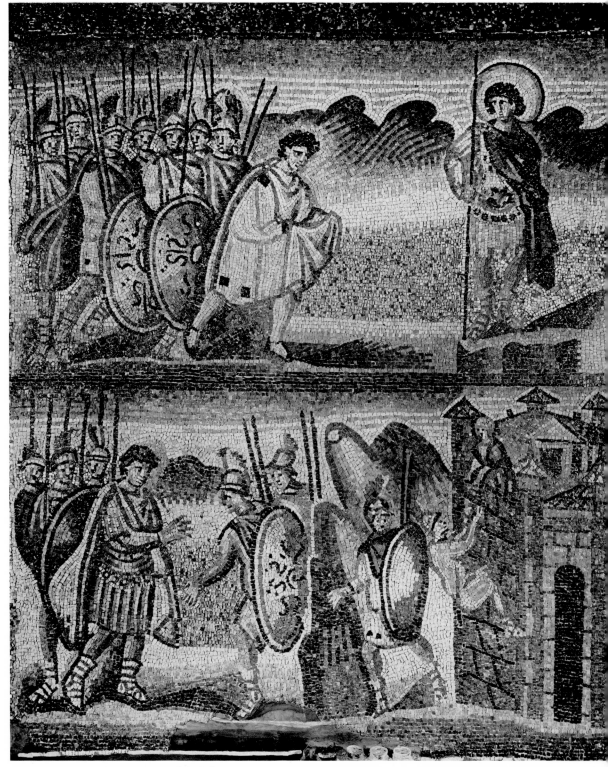

119. Joshua and the Angel; Return of the Spies
Mosaic in nave of S.Maria Maggiore, Rome

A.D.432-4

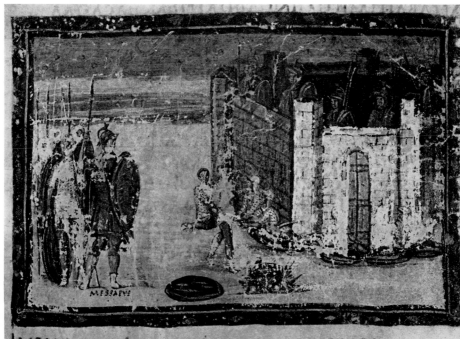

120. The
Trojans
blockaded by
Messapus
Illustration to
Virgil's *Aeneid*,
IX, 211ff.
Vatican
Library,
Ms. lat. 3225,
f.72v

Early
fifth
century
page 67

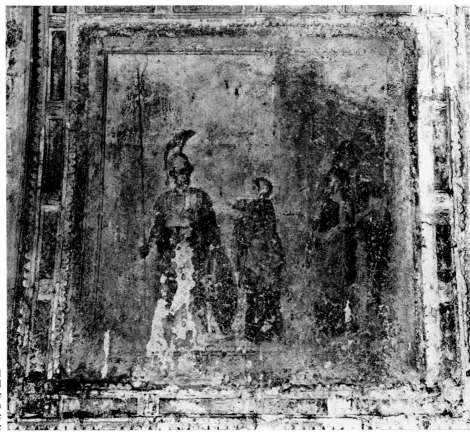

121. Farewell
of Hector and
Andromache
Wall painting in
Golden House
of Nero, Rome

First
century
page 67

122. Illustrations to First Book of Samuel, ch. 10
Berlin, Staatsbibliothek Ms. theol. lat. fol. 485 (Quedlinburg *Itala*)

Early fifth century
page 68

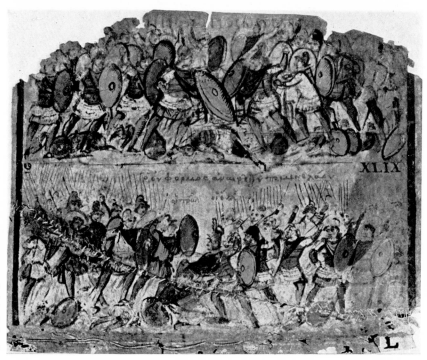

123. Battle scene of the Trojan War
Milan, Biblioteca Ambrosiana Ms. F. 205 P. Inf. (*Iliad*) f.44v

Fifth century
page 68

124. Heads of Israelites
(detail of Crossing of
Red Sea)
Mosaic in nave of S.Maria
Maggiore, Rome

A.D.432–40
page 70

125. Heads of elders
(detail of Presentation
scene, fig. 128)

page 70

**126. Heads from
Massacre of the
Innocents** (detail of
fig. 127)

page 70

127. Annunciation; Adoration of Magi; Massacre of Innocents
Mosaics on arch of S.Maria Maggiore, Rome

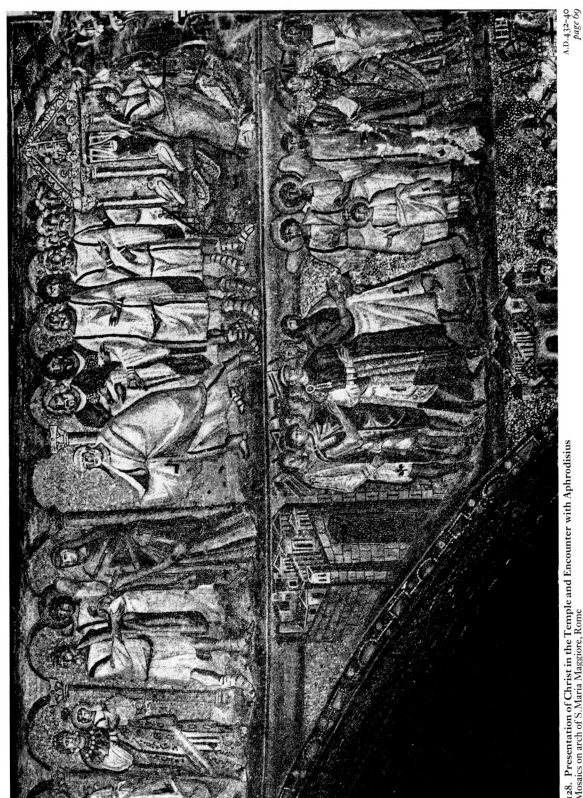

128. **Presentation of Christ in the Temple and Encounter with Aphrodisius**
Mosaics on arch of S. Maria Maggiore, Rome

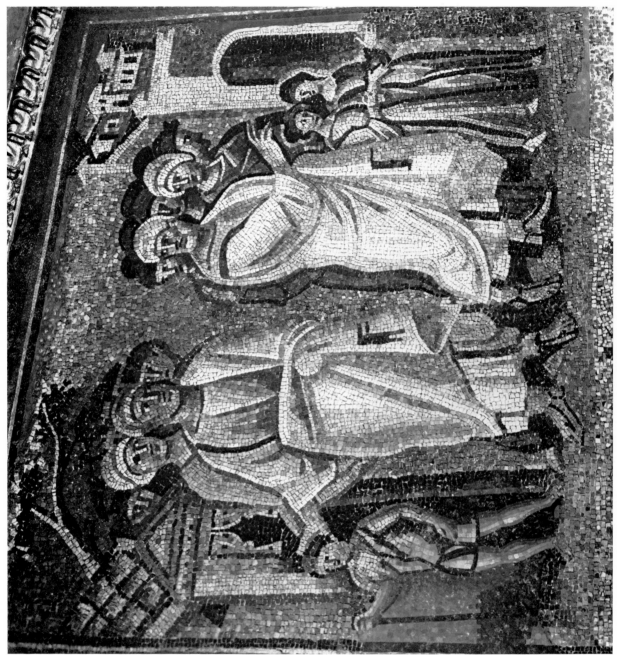

129. Separation
of Abraham
and Lot
Mosaic in nave
of S. Maria
Maggiore, Rome

131. **Marriage of Moses**
Mosaic in nave of S.Maria Maggiore, Rome

A.D.432-40
page 72

130. **Detail of fig. 127. Angels**

page 71

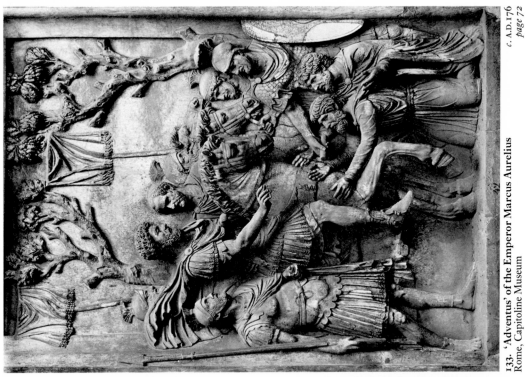

133. 'Adventus' of the Emperor Marcus Aurelius
Rome, Capitoline Museum

c. A.D.176
page 72

132. Abraham and Melchizedek
Mosaic in nave of S. Maria Maggiore, Rome

A.D. 432–40
page 72

134. Jacob being blessed by
Isaac
Detail of mosaic in nave of
S.Maria Maggiore, Rome
A.D.432–40
page 75

136. Men of Shechem before
Jacob
Detail of mosaic in nave of
S.Maria Maggiore, Rome
A.D.432–40
page 75

137. Detail of floor
mosaic with port scene
Apamea, 'Triclinos' Villa
Fourth century (?)
page 75

135. Detail of floor
mosaic with port
scene
Apamea, 'Triclinos' Villa
Fourth century (?)
page 75

**138. Corinthian
capital**
From Pergamon

Second century
page 76

139. Corinthian capital
Salamis, Cyprus
Fourth century
page 76

140. Corinthian capital
Jerusalem, Islamic Museum
Fourth century
page 79

141. Capital and impost
S. Apollinare Nuovo, Ravenna

c. A.D. 500
pages 77, 79

142. Impost
Delphi

Fifth century
page 78

143. Impost
Perge

Fifth century
page 78

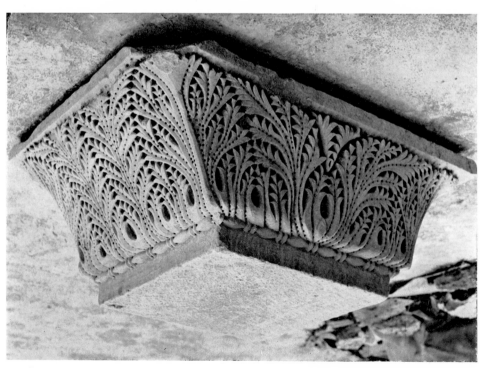

144. Impost
Nea Anchialos

Second half of fifth century
pages 78, 80

145. Ionic impost capital
Vravron (Brauron), Attica

Fifth century
page 78

148. Impost capital
Sts Sergius and Bacchus, Istanbul

c. A.D.53
page 7

146. Ionic impost capital
St Demetrius, Thessaloniki

Late fifth century
page 78

147. Ionic impost capital
Sardis

Late fifth century
page 78

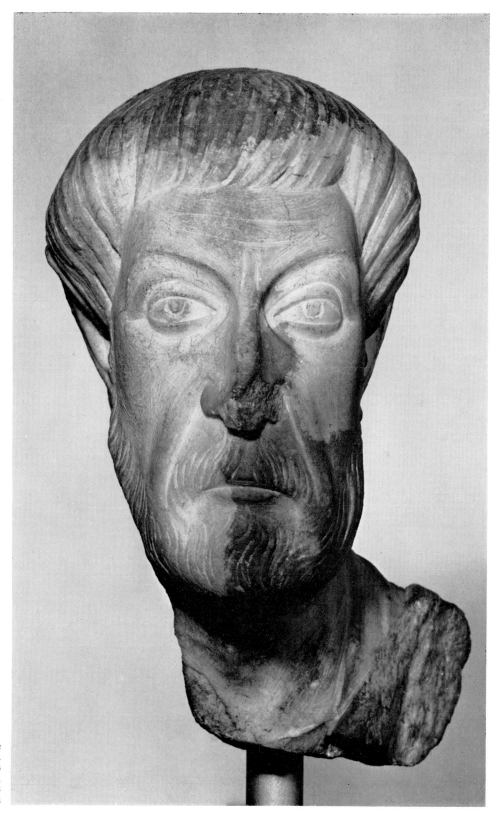

149. Male
portrait from
Ephesus
Vienna,
Kunsthistorisches
Museum

Fifth
century
page 80

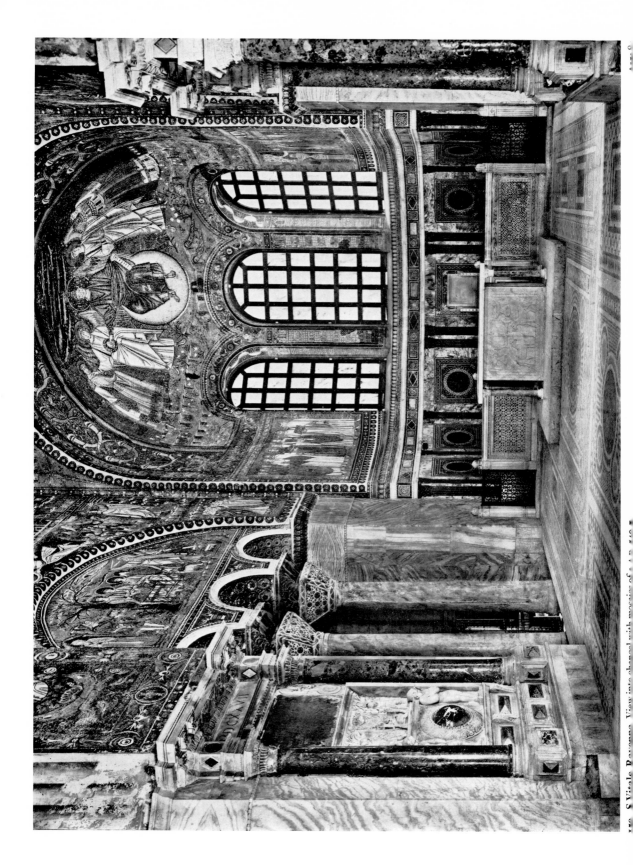

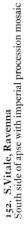

c. A.D. 547
page 81

152. S.Vitale, Ravenna
South side of apse with imperial procession mosaic

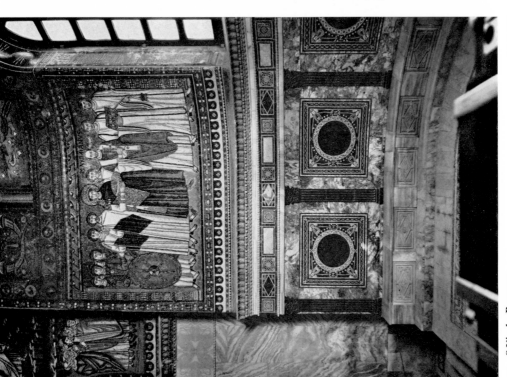

c. A.D. 547
page 81

151. S.Vitale, Ravenna
North side of apse with imperial procession mosaic

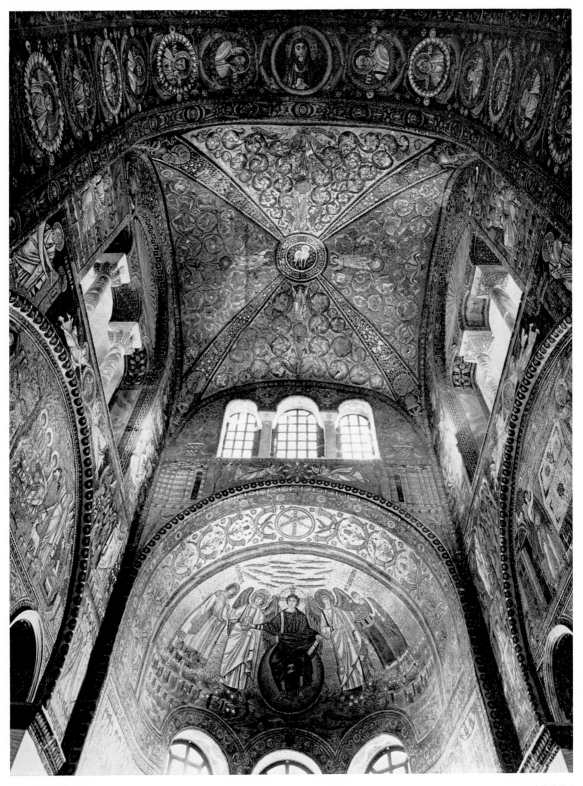

153. S.Vitale, Ravenna
View into chancel vault

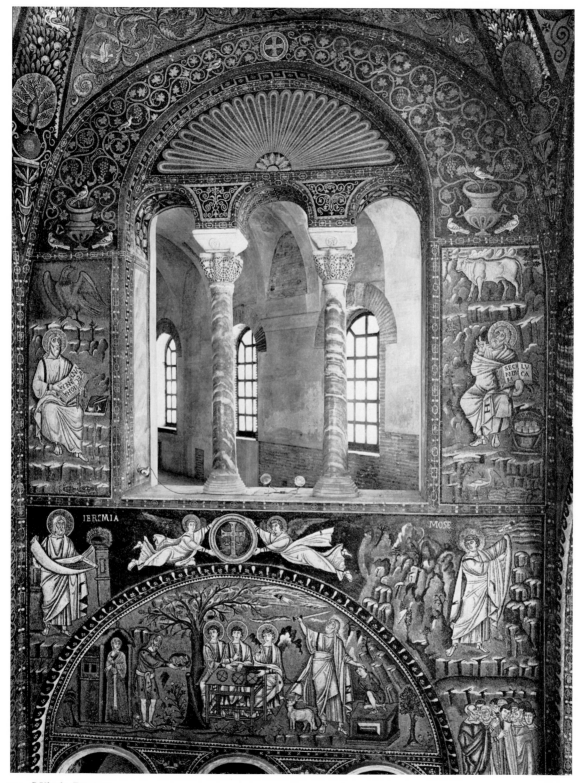

154. S.Vitale, Ravenna
North wall of chancel

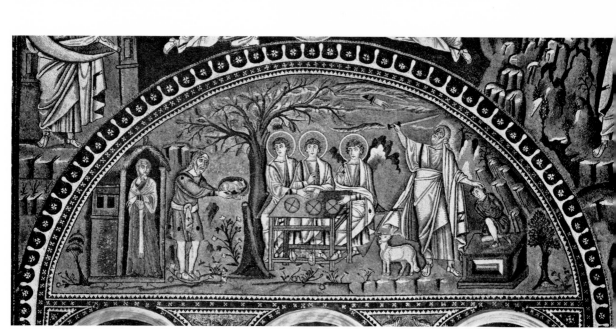

155. **Detail of fig. 154.** Hospitality of Abraham and Sacrifice of Isaac

page 84

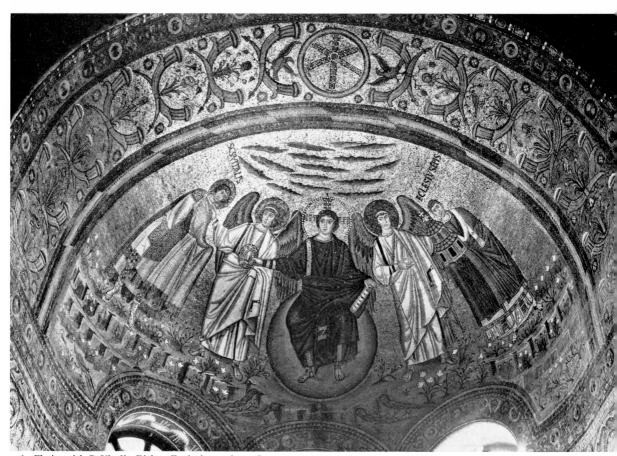

156. **Christ with St Vitalis, Bishop Ecclesius and angels**
Mosaic in apse of S. Vitale, Ravenna

c. A.D.540–7
page 85

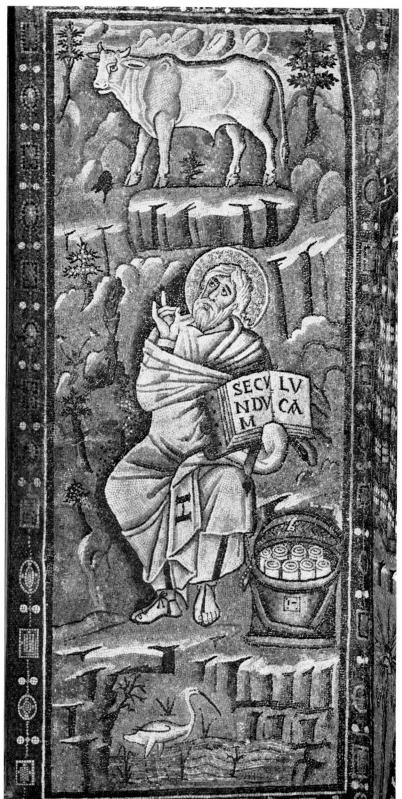

157. Detail of
fig. 154
St Luke

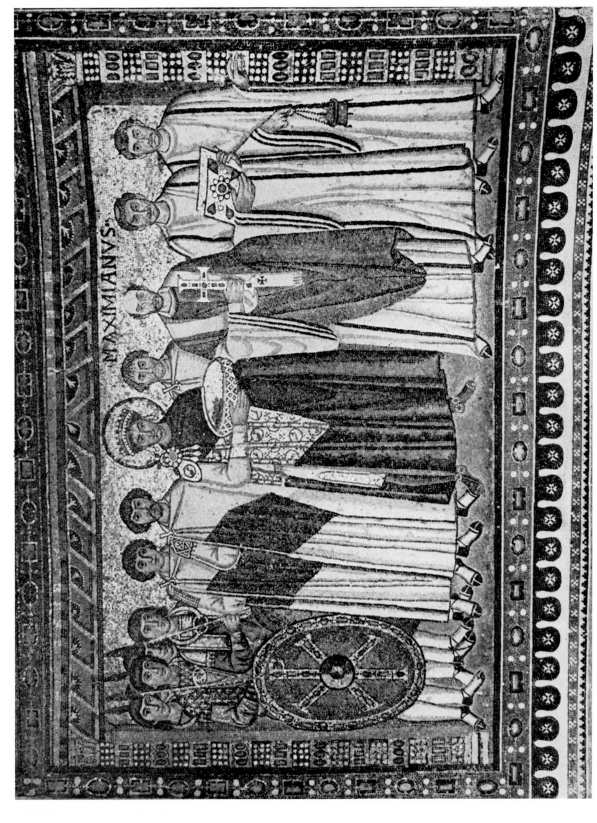

158. Justinian and his retinue
Mosaic in apse of S. Vitale, Ravenna

page 93

160. **Detail of fig. 169**
Head of St Peter

page 93

159. **Detail of fig. 158**
Head of Justinian

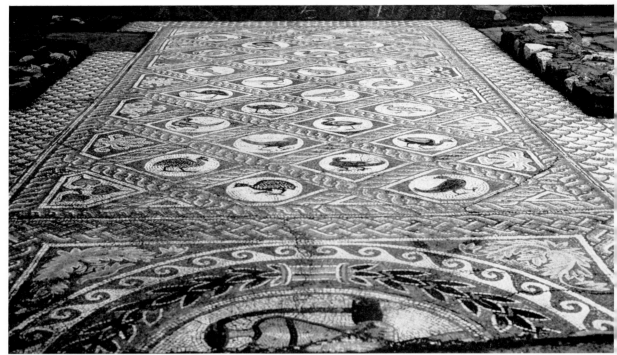

161. Floor mosaic from narthex of a church
Delphi, Museum

c. A.D.500
page 89

162. Floor mosaic from Antioch ('Green Carpet')
Washington, D.C., Dumbarton Oaks Collection

Fifth century
page 89

163. Floor mosaic from Antioch ('Striding Lion')
Baltimore, Maryland, Baltimore Museum of Art

c. A.D. 500
page 89

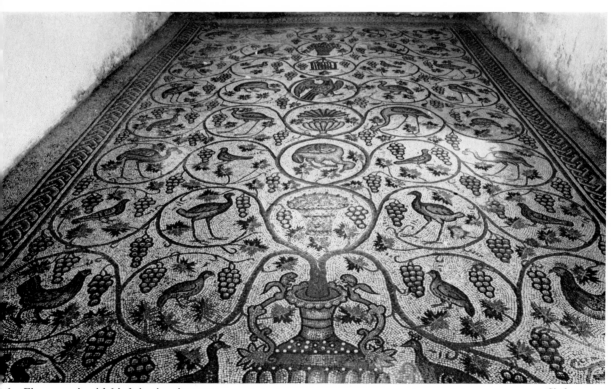

164. Floor mosaic with birds in vine rinceau
Jerusalem, outside Damascus Gate

Sixth century
page 89

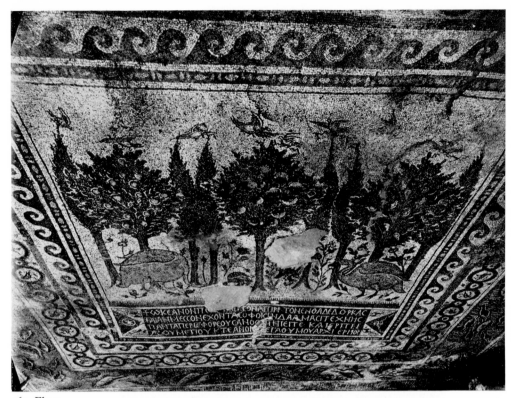

165. Floor mosaic ('Earth and Ocean') Church of St Demetrius, Nikopolis, Epirus

c. A.D. 525-50 *page 90*

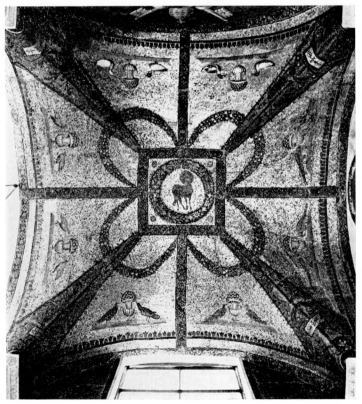

166. Mosaic in vault Chapel of St John the Evangelist, Lateran Baptistery, Rome

A.D. 461-8 *page 91*

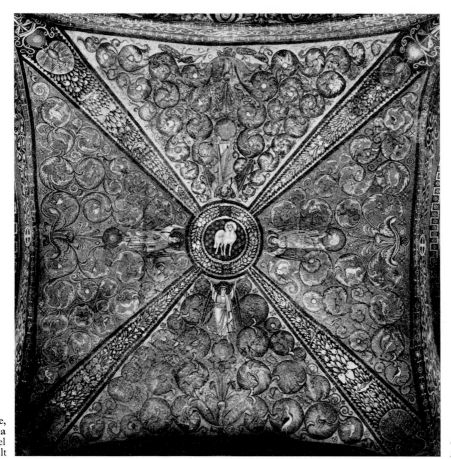

167. S.Vitale,
Ravenna
Mosaic in chancel
vault

c. A.D.540-7
page 91

168. **Mosaic in**
vault
Matrona Chapel,
S.Prisco, Capua
Vetere

Fifth century
page 92

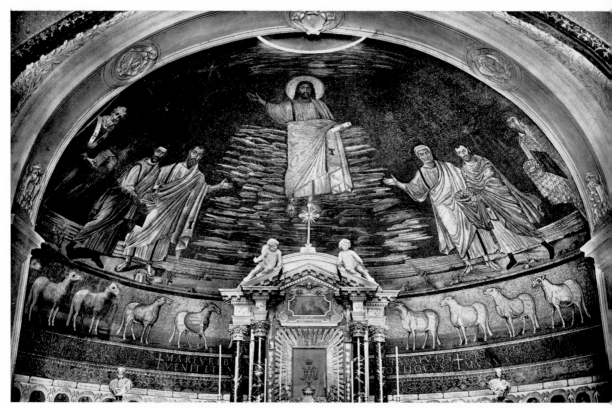

**169. SS.Cosma
e Damiano,
Rome**
Apse mosaic

A.D 526–
page

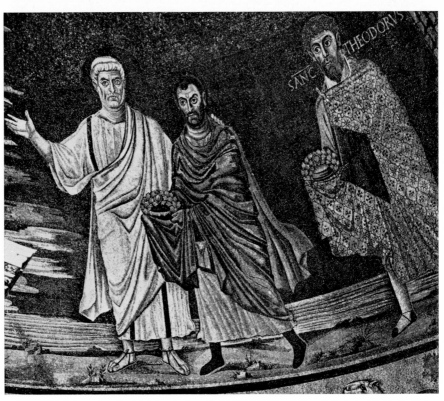

**170. Detail of
fig. 169**
St Peter with
titular saint and
St Theodore

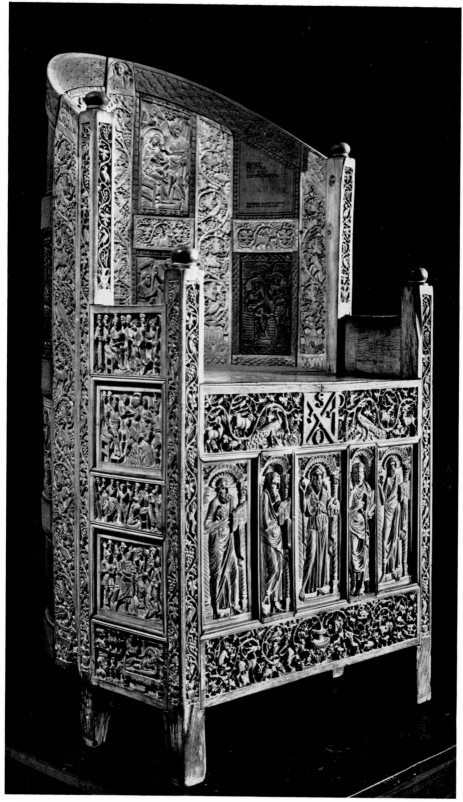

. Ivory chair
of Maximian
Ravenna,
Archiepiscopal
Museum

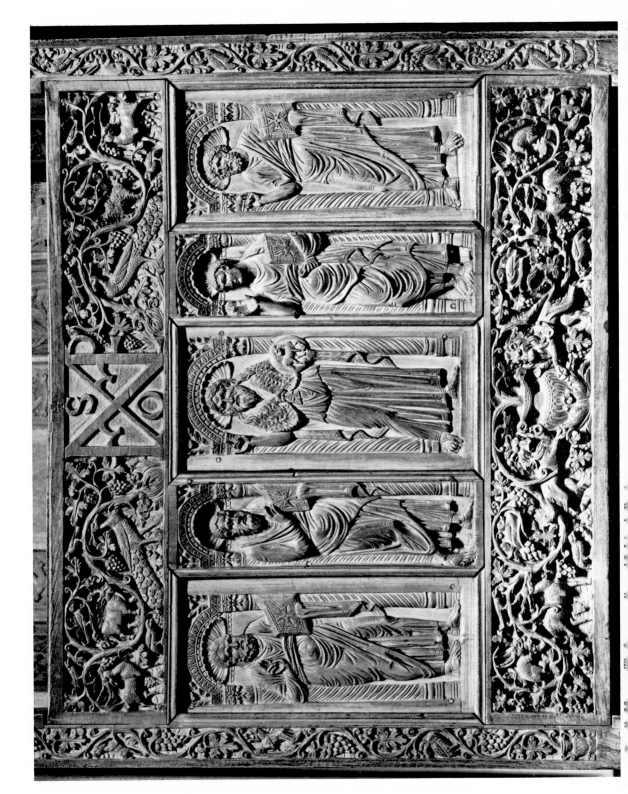

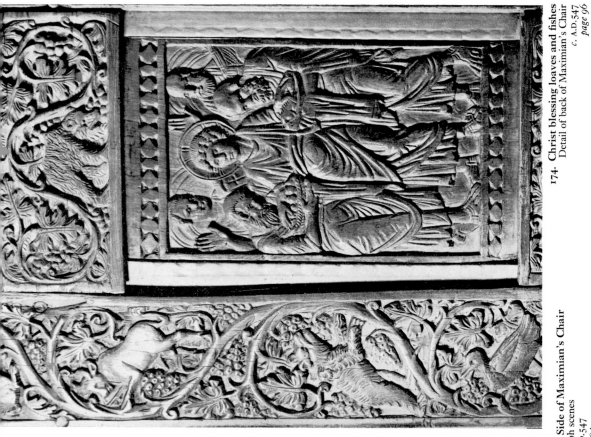

174. Christ blessing loaves and fishes
Detail of back of Maximian's Chair
c. A.D. 547
page 96

173. Side of Maximian's Chair
Joseph scenes
c. A.D. 547
page 94

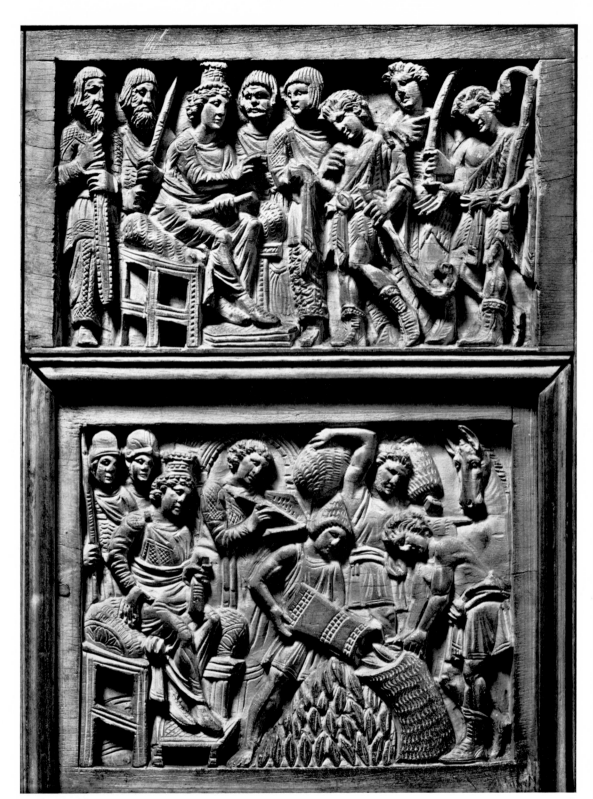

175. Detail of fig. 171
Joseph scenes: His brothers before Joseph; Filling the sacks

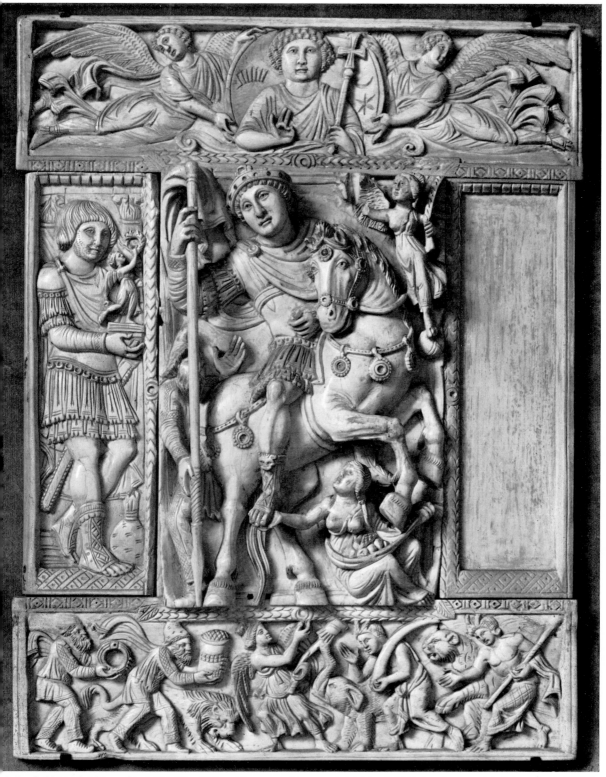

6. Leaf of imperial ivory diptych ('Barberini Diptych')
ris, Louvre

177. The Transfiguration
Apse mosaic in Church of Monastery of St Catherine, Mount Sinai

c. A.D. 550–65
page 99

179. Detail of fig. 177. Apostle James

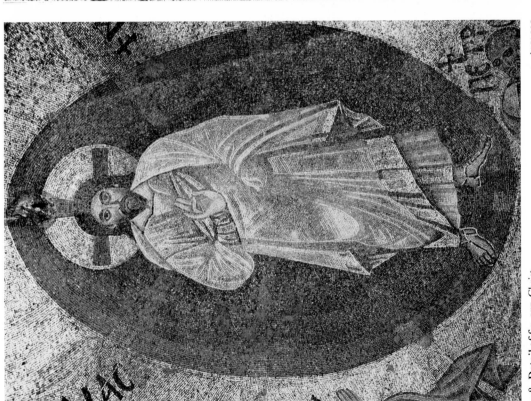

178. Detail of fig. 177. Christ

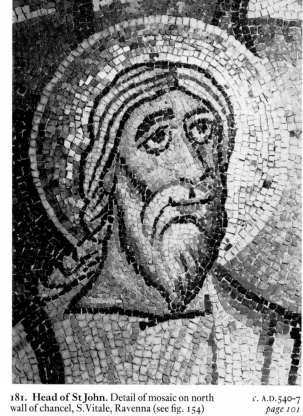

180. Detail of fig. 177
Head of Elijah

page 100

181. Head of St John. Detail of mosaic on north
wall of chancel, S. Vitale, Ravenna (see fig. 154)

c. A.D. 540-7
page 101

182. Head of angel
Detail of mosaic on apse wall,
Church of Monastery of St Catherine, Mount Sinai

c. A.D. 550-65
page 101

183. Head of Angel of St Matthew
Detail of mosaic on south wall of chancel,
S. Vitale, Ravenna (see pl. V)

c. A.D. 540-7
page 101

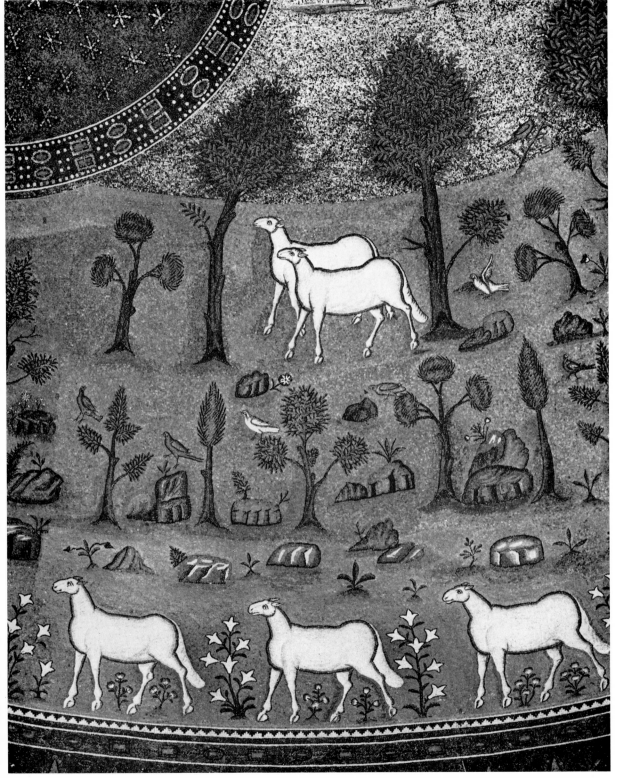

184. Detail of fig. 186

185. S. Apollinare
in Classe, Ravenna
View towards apse

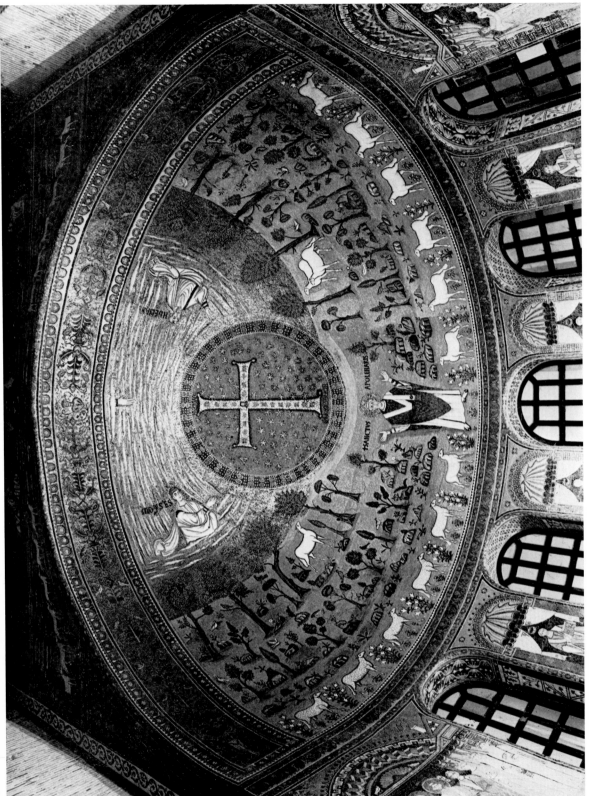

186. S. Apollinare in Classe, Ravenna
Apse mosaic

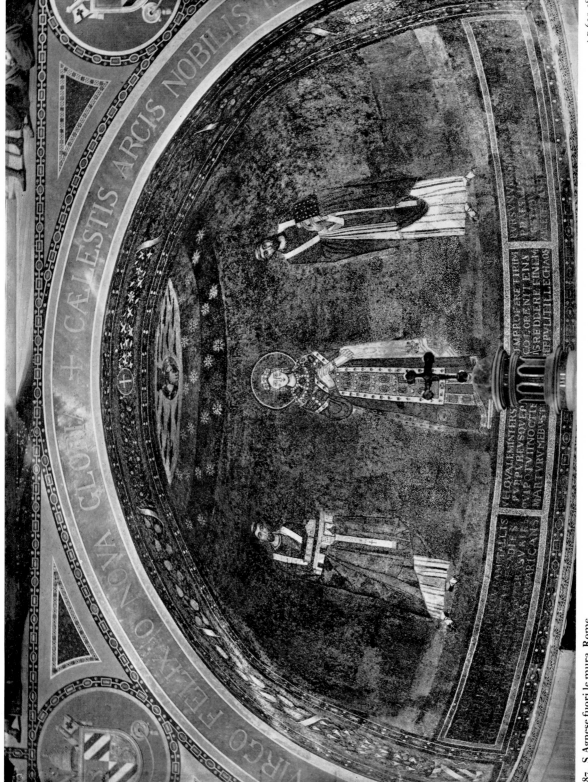

187. S. Agnese fuori le mura, Rome
Apse mosaic

188. Virgin and Child
Ninth-century restoration of seventh-century
mosaic in apse of Church of the Dormition, Nicaea

page 104

189. St Demetrius and donors
Mosaic on chancel pier, Church of St Demetrius, Thessaloniki

c. A.D. 650
page 105

190. Saint and children
Mosaic on chancel pier,
Church of St Demetrius, Thessaloniki

c. A.D. 650
page 105

191. Silver plate with Meleager and Atalante
Leningrad, Hermitage Museum

A.D. 613-29
page 107

195. Detail of fig. 197
David

page 11

196. Detail of fig. 191
Meleager

pages 110, 114

97. Combat of David and Goliath
Silver plate from Cyprus
New York, Metropolitan Museum

A.D. 613-29
page 110

198. David before Saul
Silver plate from Cyprus
New York, Metropolitan Museum

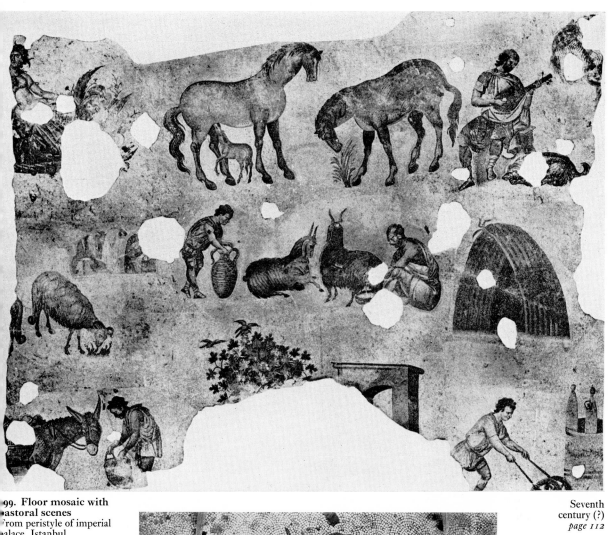

**99. Floor mosaic with
pastoral scenes**
From peristyle of imperial
palace, Istanbul

Seventh
century (?)
page 112

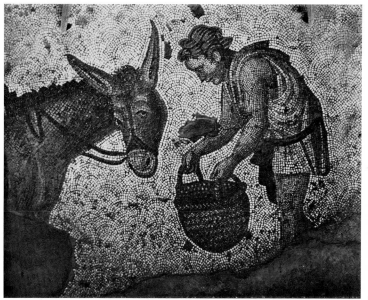

200. Detail of fig. 199
Boy with donkey

page 112

201. S.Maria Antiqua, Rome
Superposed frescoes to right of apse ('Palimpsest Wall')

Sixth to early eighth century
page 114

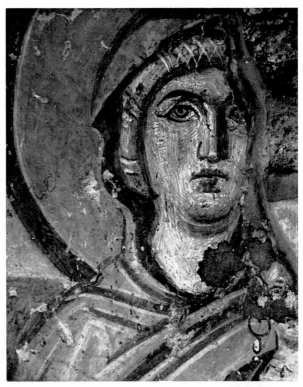

02. **Detail of fig. 201**
ngel of the Annunciation

First half of seventh century
pages 114, 117

203. **Detail of fig. 207**

page 116

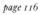

4. **Detail of pl. VII**
.ead of the Mother of the Maccabees

page 113

205. **Detail of pl. VII**
One of the Maccabees

page 113

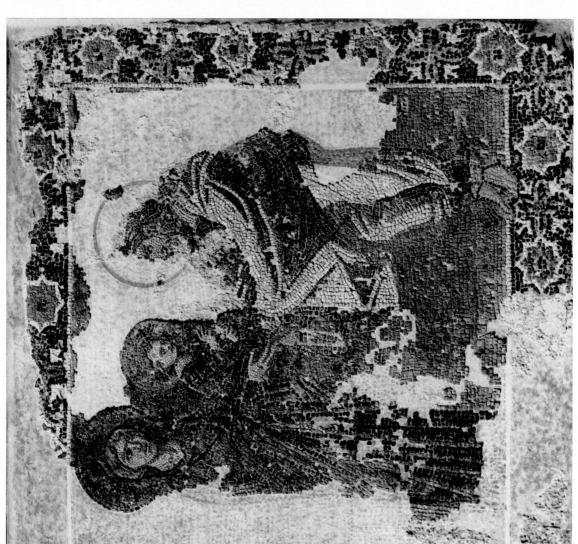

206. **Presentation of Christ in the Temple**
Mosaic in Kalenderhane Djami, Istanbul

Seventh century
page 115

207. **St Anne** First half of seventh century
Fresco in S.Maria Antiqua, Rome
page 116

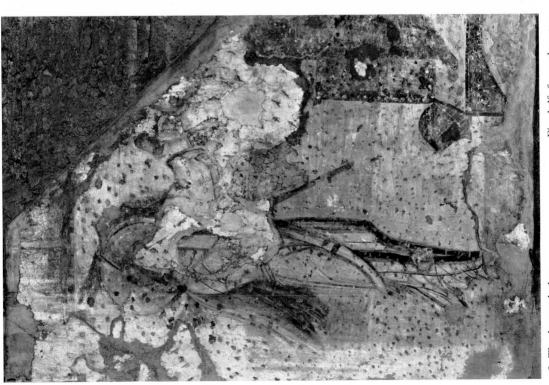

208. The Annunciation
Fresco in S.Maria Antiqua, Rome

First half of seventh century
pages 116, 118

209. The Annunciation
Fresco in S.Maria Antiqua, Rome

c. A.D. 700
page 118

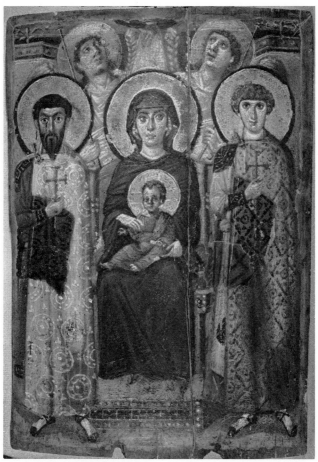

**210. Virgin and Child with
angels and saints**
Icon in Monastery of
St Catherine, Mount Sinai

First half of seventh century
page 117

212. Detail of fig. 210
Angel

page 117

**213. Achilles being
taught by Chiron** (detail)
Fresco from Herculaneum
Naples, National Museum

First century A.D.
page 117

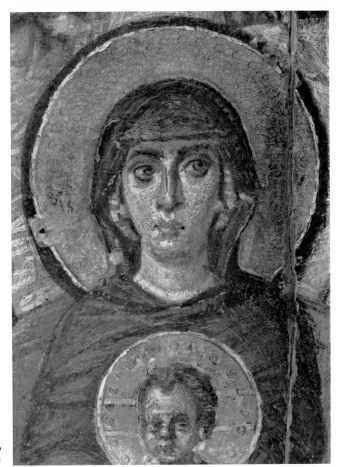

211. Detail of fig. 210
Head of Virgin

page 117

214. St Barbara (detail)　　First half of seventh century
Fresco in S.Maria Antiqua, Rome
page 117

215. Detail of fig. 210
St Theodore

page 118

216. St Andrew
Fresco in S.Maria Antiqua, Rome

217. St Paul
Fresco in S.Maria Antiqua, Rome

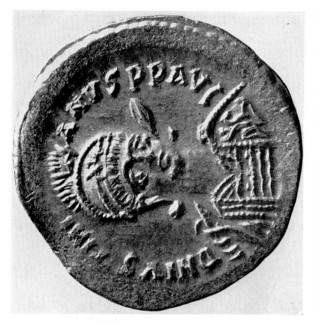

218. **Gold coin of Justinian II**
Obverse, with head of Christ
A.D. 692–5, Constantinople
(enlarged 6·3 times)
page 121

219. **Gold coin of Justinian I**
A.D. 527–38, Constantinople
(enlarged 3·7 times)
page 121

220. **Gold coin of Constantine IV**
A.D. 681–5, Constantinople
(enlarged 4·2 times)
page 121

222. Zeus
Marble head from Mylasa
Boston, Massachusetts, Museum of Fine Arts

Fourth century B.C.
page 121

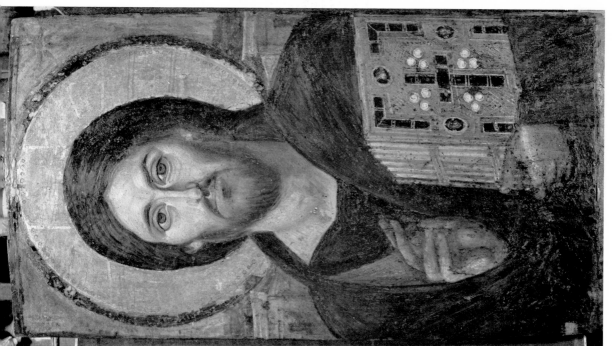

221. Christ
Icon in Monastery of St Catherine, Mount Sinai
Here attributed to *c.* A.D.700
page 120

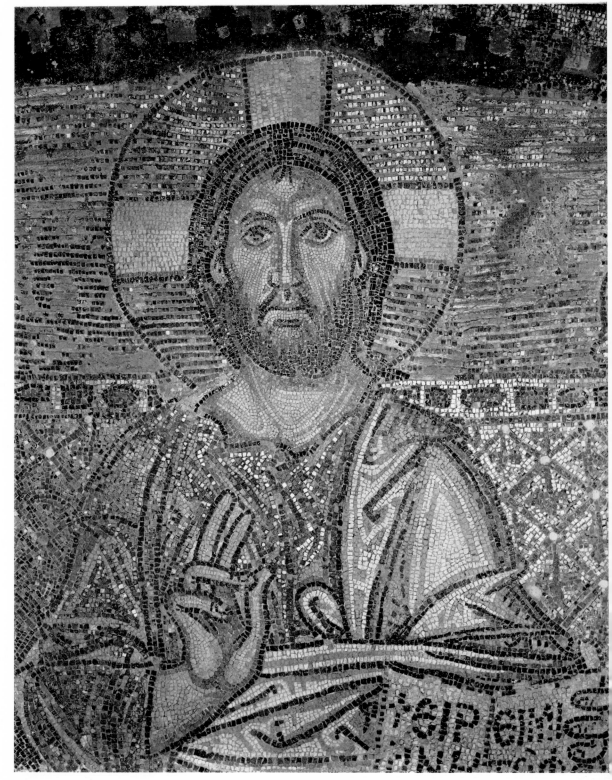

223. Christ
Detail of mosaic in narthex of St Sophia, Istanbul

NOTES

INTRODUCTION

1. G. Rodenwaldt, 'Zur Begrenzung und Gliederung der Spätantike', *Jahrbuch des Deutschen Archäologischen Instituts*, 59/60, 1944/5, pp.81ff.; A. Rumpf, *Stilphasen der spätantiken Kunst*, Arbeitsgemeinschaft für Forschung des Landes Nordrhein-Westfalen, Abhandlung, Heft 44, Cologne and Opladen, 1957; and, in the general sphere of social and cultural history, P. Brown, *The World of Late Antiquity: A.D. 150–750*, London, 1971.

2. K. M. Swoboda, 'Über die Stilkontinuität vom 4. zum 11. Jahrhundert', *Forschungen zur Kunstgeschichte und christlichen Archäologie*, I, 1: *Spätantike und Byzanz*, Baden-Baden, 1952, pp.21ff.

3. This term, or rather its German equivalent, was used by R. Kömstedt in the title of his book *Vormittelalterliche Malerei* (Augsburg, 1929), which deals essentially with the same period as the present study.

4. C. R. Morey, *Early Christian Art*, Princeton, New Jersey, 1942, *passim*; cf. *infra*, VII, n.5.

5. E. Kitzinger, *Early Medieval Art in the British Museum*, London, 1940, pp.17ff.

6. Rumpf, *Stilphasen* (*supra*, n.1).

7. For a comprehensive study see A. Grabar, *Christian Iconography*, Princeton, New Jersey, 1968.

CHAPTER ONE

1. H. P. L'Orange and A. von Gerkan, *Der spätantike Bildschmuck des Konstantinsbogens*, Berlin, 1939.

2. *Ibid.*, p.28. It has been argued by J. Ruysschaert that the arch, erected to celebrate Constantine's decennalia in 315, may not have been planned until A.D. 314 ('Essai d'interprétation synthétique de l'arc de Constantin', *Atti della Pontificia Accademia Romana di Archeologia, Rendiconti*, 35, 1962–3, pp.79ff., especially p.82.)

3. B. Berenson, *The Arch of Constantine or the Decline of Form*, London, 1954, pp.31f.; cf., more generally, L'Orange and von Gerkan, *op.cit.*, pp.218f.

4. R. Delbrueck, *Antike Porphyrwerke*, Berlin and Leipzig, 1932, pp.84ff. and pls. 31–4. For a review of more recent literature see R. Calza, *Iconografia romana imperiale*

da Carausio a Giuliano (287–363 d.C.), Rome, 1972, pp.98ff. I find the various attempts to attribute the Venice group – or the related group in the Vatican (fig.8; cf. *supra*, p.12) – to a period later than the Tetrarchy unconvincing.

5. R. Naumann, 'Der antike Rundbau beim Myrelaion und der Palast Romanos I. Lekapenos', *Istanbuler Mitteilungen*, 16, 1966, pp.199ff., especially pp.209ff.

6. A. R. Bellinger, P. Bruun, J. P. C. Kent, C. H. V. Sutherland, 'Late Roman Gold and Silver Coins at Dumbarton Oaks: Diocletian to Eugenius', *Dumbarton Oaks Papers*, 18, 1964, pp.161ff., especially pp.173f., no.29.

7. G. V. Gentili, *La Villa Erculia di Piazza Armerina: I mosaici figurati*, Milan, 1959; for the mosaic of the Great Hunt, of which our fig. 6 shows a detail, see pp.21ff., with fig.5 and pls.24–35. For the chronology cf. C. Ampolo, A. Carandini, G. Pucci, P. Pensabene, 'La Villa del Casale a Piazza Armerina', *Mélanges de l'École française de Rome*, 83, 1971, 1, pp.141ff., especially p.179; J. Polzer, 'The Villa at Piazza Armerina and the Numismatic Evidence', *American Journal of Archaeology*, 77, 1973, pp.139ff.

8. Berenson, *The Arch of Constantine* (*supra*, n.3).

9. J. Strzygowski, 'Die Schicksale des Hellenismus in der bildenden Kunst', *Neue Jahrbücher für das klassische Altertum, Geschichte und deutsche Literatur*, 8, 1905, pp.19ff., especially p.23.

10. D. Simonsen, *Sculptures et inscriptions de Palmyre à la Glyptothèque de Ny Carlsberg*, Copenhagen, 1889, pp.12f. and pl.4. For Palmyrene sculpture in general see H. Ingholt, *Studier over Palmyrensk Skulptur*, Copenhagen, 1928.

11. Tomb relief, attributed to the first century A.D.; cf. R. Bianchi Bandinelli, *Rome: The Late Empire*, New York, 1971, p.156, fig.145, and p. 431.

12. G. Rodenwaldt, 'Römische Reliefs Vorstufen zur Spätantike', *Jahrbuch des Deutschen Archäologischen Instituts*, 55, 1940, pp.12ff.; R. Bianchi Bandinelli, *Rome: The Center of Power*, New York, 1970, pp.58ff. with figs.58ff.

13. Rodenwaldt, 'Römische Reliefs', *passim*.

14. Kitzinger, *Early Medieval Art* (*supra*, Introduction, n.5), pp.7ff.; cf. *idem*, 'Notes on Early Coptic Sculpture', *Archaeologia*, 87, 1938, pp.181ff., especially pp.202ff.

15. Delbrueck, *Antike Porphyrwerke*, pp.91ff. with fig.34; pls.35–7; Calza, *Iconografia romana imperiale*, pp.104f.; cf. *supra*, n.4.

16. E. Gose, *Der gallo-römische Tempelbezirk im Altbachtal zu Trier*, Mainz, 1972, fig.387, nos.2–8, 25–31; text, p.203; cf. N. Kyll, 'Heidnische Weihe-und Votivgaben aus der Römerzeit des Trierer Landes', *Trierer Zeitschrift*, 29, 1966, pp.5ff., especially pp.53f. and n.554.

17. H. P. L'Orange, *Art Forms and Civic Life in the Late Roman Empire*, Princeton, New Jersey, 1965, pp.62ff.

18. E. Kitzinger, 'On the Interpretation of Stylistic Changes in Late Antique Art', *Bucknell Review*, 15, 3, December 1967, pp.1ff.; reprinted in E. Kitzinger, *The Art of Byzantium and the Medieval West*, Bloomington, Indiana, 1976, pp.32ff.

19. L'Orange, *Art Forms and Civic Life*, pp.103f. and figs.50f.

20. M. Wegner, 'Die kunstgeschichtliche Stellung der Marcussäule', *Jahrbuch des Deutschen Archäologischen Instituts*, 46, 1931, pp.61ff.; P. G. Hamberg, *Studies in Roman Imperial Art with Special Reference to the State Reliefs of the Second Century*, Copenhagen, 1945, pp.135ff.

21. Wegner, *op.cit.*, pp.116f., 120, 135f.; cf. Kitzinger, 'On the Interpretation of Stylistic Changes' (*supra*, n.18), p.9 and figs.8f.

22. Hamberg, *Studies in Roman Imperial Art* (*supra*, n.20), pp.173ff. with pl.38 and pp.176ff. with pl.40; cf. also G. M. A. Hanfmann, *Roman Art*, Greenwich, Connecticut, n.d., pp.114, 205, no.121.

23. A Riegl, *Spätrömische Kunstindustrie*, Vienna, 1927 (reprint), p.35 *et passim*; for sculpture see pp.85ff.

24. Hamberg, *Studies in Roman Imperial Art*, pp.181ff. with pl.44; cf. Hanfmann, *Roman Art*, pp.120f., 214f., nos.134f.

25. E. R. Dodds, *Pagan and Christian in an Age of Anxiety: Some Aspects of Religious Experience from Marcus Aurelius to Constantine*, Cambridge, 1968; cf. Bianchi Bandinelli, *Rome : The Late Empire* (*supra*, n. 11), pp.1ff.

26. For figs. 19, 20, 22 see B. M. Felletti Maj, *Iconografia romana imperiale da Severo Alessandro a M. Aurelio Carino (222–285 d.C.)*, Rome, 1958, p.189, no.235, with pl.29, fig.95; p.203, no.260, with pl.36, fig.113; p.261, no.350, with pl.50, fig.170. For the portrait interpreted as that of the philosopher Plotinus (our fig. 21) see H. P. L'Orange, 'I ritratti di Plotino ed il tipo di San Paolo nell'arte tardo-antica', *Atti del Settimo Congresso Internazionale di Archeologia Classica*, II, Rome, 1961, pp.475ff. For third-century portraiture in general see L'Orange, *Art Forms and Civic Life* (*supra*, n.17), pp.105ff.

27. G. Rodenwaldt, 'Zur Kunstgeschichte der Jahre 220 bis 270', *Jahrbuch des Deutschen Archäologischen Instituts*, 51, 1936, pp.82ff., especially pp.99ff.

28. For the Attic sarcophagus, fig. 25, see H. Stuart Jones, *A Catalogue of the Ancient Sculptures preserved in the Municipal Collections of Rome: The Sculptures of the Museo Capitolino*, Oxford, 1912, pp.77ff. and pl.16; for Attic sarcophagi generally, A. Giuliano, *Il commercio dei sarcofagi attici*, Rome, 1962. For the Asiatic sarcophagus, fig. 24, see G. Mendel, *Musées impériaux ottomans. Catalogue des sculptures grecques, romaines et byzantines*, I, Constantinople, 1912, pp.288ff. For this type of sarcophagus generally, H. Wiegartz, *Kleinasiatische Säulensarkophage*, Berlin, 1965.

29. F. Matz, *Ein römisches Meisterwerk: Der Jahreszeitensarkophag Badminton-New York*, Jahrbuch des Deutschen Archäologischen Instituts, Ergänzungsheft 19, Berlin, 1958.

30. For this portrait see H. P. L'Orange, *Studien zur Geschichte des spätantiken Porträts*, Oslo, 1933, pp.9ff., 107f. and figs.12, 14.

31. Th. Klauser, 'Studien zur Entstehungsgeschichte der christlichen Kunst I', *Jahrbuch für Antike und Christentum*, 1, 1958, pp.20f. H. Brandenburg, *Überlegungen zum Ursprung der frühchristlichen Bildkunst*, IX Congresso Internazionale di Archeologia Cristiana, Rome, 1975, pp.3f.

32. Brandenburg, *op.cit.*, *passim*, especially pp.8f.

33. The writings of Clement of Alexandria and Tertullian are the principal witnesses to this change. Although both authors were hostile to images, we learn from Tertullian about chalices with representations of the Good Shepherd being in use in his time, while Clement lists symbolic subjects which he considers suitable for representation on seal rings. What is perhaps most significant is the fact that both writers put the case against images on a broader basis than earlier apologists had done. This suggests that the issue was becoming urgent within the fold; cf. H. Koch, *Die altchristliche Bilderfrage nach den literarischen Quellen*, Göttingen, 1917, especially pp.3ff., 14ff.

34. F. Wirth, *Römische Wandmalerei vom Untergang Pompejis bis ans Ende des dritten Jahrhunderts*, Berlin, 1934, pp.165ff.; Bianchi Bandinelli, *Rome: The Late Empire* (*supra*, n.11), pp.86ff.

35. Klauser, 'Studien . . . IV', *Jahrbuch für Antike und Christentum*, 4, 1961, pp.128ff. Brandenburg, *Überlegungen*, pp.5ff.

36. W. Weidlé, *The Baptism of Art*, London, n.d., pp.10f.

37. The stucco decoration of the basilica under Porta Maggiore (first century A.D.) with its abridged representations of a variety of classical myths which seem to have been selected to convey an esoteric message, is an example; cf. Hanfmann, *Roman Art* (*supra*, n.22), pp.107, 195, no.107.

38. W. D. Wixom, 'Early Christian Sculptures at Cleveland', *The Bulletin of the Cleveland Museum of Art*, 54, no.3, March 1967, pp.67ff. A paper on these sculptures which I read at the Ninth International Congress of Christian Archaeology (Rome, 1975), is due to be published in the Acts of that congress.

39. For the Jonah sarcophagus in Copenhagen (our fig.33) and its relatives see F. Gerke, *Die christlichen Sarkophage der vorkonstantinischen Zeit*, Berlin, 1940, pp.38ff. For an additional example, acquired some years ago by the British Museum, see M. Lawrence, 'Three Pagan Themes in Christian Art', *De artibus opuscula XL: Essays in Honor of Erwin Panofsky*, New York, 1961, pp.323ff., especially pp.325f. and pls.100f., figs.4f.

CHAPTER TWO

1. For a list of the sarcophagi in question see Gerke, *Die christlichen Sarkophage*, pp.351f.; cf. also L'Orange and von Gerkan, *Der spätantike Bildschmuck* (*supra*, I, n.1), pp.225ff. For the sarcophagi illustrated in our figs. 35 and 36 see F. W. Deichmann (ed.), *Repertorium der christlich-antiken Sarkophage*, I, Wiesbaden, 1967, pp.6f., no.6; pp.316f., no.770; pls.2, 121.

2. For sarcophagi with the Labours of Hercules see C. Robert, *Die antiken Sarkophagreliefs*, III, 1, Berlin, 1897, pp.115ff. and pls.28ff. For a third-century sarcophagus relief in Naples with scenes from the life of an official represented by a series of stand-

ing figures in tight alignment see V. M. Strocka, 'Zum Neapler Konsulsarkophag', *Jahrbuch des Deutschen Archäologischen Instituts*, 83, 1968, pp.221ff. and figs.1–4; note the author's comments pp.232ff.

3. Cf. *supra*, p.20.

4. E. Stommel, *Beiträge zur Ikonographie der konstantinischen Sarkophagplastik* (Theophaneia, 10), Bonn, 1954, pp.27f., 64ff. *et passim*.

5. For possible antecedents see Gerke, *Die christlichen Sarkophage*, p.8 and the references *ibid.*, n.3; cf. also his index, p.392, *s.v.* 'Zweizonigkeit'. A most unusual pagan sarcophagus of the second century discovered at Velletri some twenty years ago is relevant in this connection, as was pointed out by M. Lawrence, 'The Velletri Sarcophagus', *American Journal of Archaeology*, 69, 1965, pp.207ff., especially p.209.

6. Deichmann, *Repertorium* (*supra*, n.1), pp.39ff., no.43; pl.14.

7. *Ibid.*, pp.43ff., no.45; pl.15.

8. For this comparison see Gerke, *Die christlichen Sarkophage*, p.21.

9. Deichmann, *Repertorium*, pp.48f., no.49; pl.16.

10. *Ibid.*, pp.279ff., no.680; pls.104f.

11. A. H. M. Jones, J. R. Martindale, J. Morris, *The Prosopography of the Later Roman Empire*, I, Cambridge, 1971, p.155.

12. Cf. *supra*, p.13.

13. G. M. A. Hanfmann, *The Season Sarcophagus in Dumbarton Oaks*, Cambridge, Massachusetts, 1951, I, pp.66ff.; A. Rumpf, *Stilphasen* (*supra*, Introduction, n.1), pp.12ff.; I. Lavin, 'The Ceiling Frescoes in Trier and Illusionism in Constantinian Painting', *Dumbarton Oaks Papers*, 21, 1967, pp.97ff., especially pp.110ff. (see also *idem*, in *Art Bulletin*, 49, 1967, p.58).

14. L'Orange and von Gerkan, *Der spätantike Bildschmuck* (*supra*, I, n.1), pp.165ff. and pls.43–5.

15. E. B. Harrison, 'The Constantinian Portrait', *Dumbarton Oaks Papers*, 21, 1967, pp.79ff., especially pp.82f., 90; figs.6, 34–6.

16. T. K. Kempf in W. Reusch (ed.), *Frühchristliche Zeugnisse im Einzugsgebiet von Rhein und Mosel*, Trier, 1965, pp.235ff. Lavin, *op.cit.* (*supra*, n.13).

17. For the Esquiline Treasure see O. M. Dalton, *Catalogue of Early Christian Antiquities*, British Museum, London, 1901, pp.61ff. (cf. also *infra*, n.48); for the Traprain Law Treasure, A. O. Curle, *The Treasure of Traprain*, Glasgow, 1923.

18. *The Mildenhall Treasure: A Handbook*, British Museum, London, 1955; cf. T. Dohrn, 'Spätantikes Silber aus Britannien', *Mitteilungen des Deutschen Archäologischen Instituts*, 2, 1949, pp.67ff. For the Kaiseraugst Treasure see the report by R. Steiger and H. Cahn in *Jahrbuch der Schweizerischen Gesellschaft für Urgeschichte*, 51, 1964, pp.112ff. and pls.23–35; also H. U. Instinsky, *Der spätrömische Silberschatzfund von Kaiseraugst*, Akademie der Wissenschaften und der Literatur, Mainz, Abhandlungen der geistes- und sozialwissenschaftlichen Klasse, 1971, no.5.

19. Instinsky, *op.cit.*, p.13.

20. O. Brendel, 'The Corbridge Lanx', *Journal of Roman Studies*, 31, 1941, pp.100ff.; cf. J. M. C. Toynbee, *Art in Britain under the Romans*, Oxford, 1964, pp.306ff.

21. A. Momigliano (ed.), *The Conflict between Paganism and Christianity in the Fourth Century*, Oxford, 1963; see especially pp.17ff. (A. H. M. Jones); pp.193ff. (H. Bloch).

22. Cf., e.g., Dohrn, 'Spätantikes Silber' (*supra*, n.18), pp.126f.

23. R. Delbrueck, *Die Consulardiptychen und verwandte Denkmäler*, Berlin and Leipzig, 1929, pp.235ff., no.62.

24. G. Bruns, *Der Obelisk und seine Basis auf dem Hippodrom zu Konstantinopel*, Istanbul, 1935; J. Kollwitz, *Oströmische Plastik der theodosianischen Zeit*, Berlin, 1941, pp.115ff. *et passim*; H. Wrede, 'Zur Errichtung des Theodosiusobelisken in Istanbul', *Istanbuler Mitteilungen*, 16, 1966, pp.178ff.; H. Kähler, 'Der Sockel des Theodosiusobelisken in Konstantinopel als Denkmal der Spätantike', *Institutum Romanum Norvegiae: Acta ad archaeologiam et artium historiam pertinentia*, 6, 1975, pp.45ff.

25. Kollwitz, *Oströmische Plastik*, pp.81ff. with pls.16, 34 and Beilage 13; H.-G. Severin, *Zur Portraitplastik des 5. Jahrhunderts n. Chr.*, Miscellanea Byzantina Monacensia, 13, Munich, 1972, pp.11ff., 152ff.

26. On this problem see B. Brenk, 'Zwei Reliefs des späten 4. Jahrhunderts', *Institutum Romanum Norvegiae: Acta ad archaeologiam et artium historiam pertinentia*, 4, 1969, pp.51ff., especially pp.54ff.; H.-G. Severin, 'Oströmische Plastik unter Valens und Theodosius I.', *Jahrbuch der Berliner Museen*, 12, 1970, pp.211ff., especially pp.226ff.

27. Kollwitz, *Oströmische Plastik*, pp.3ff., with pls.1–9 and Beilagen 1, 3–10; G. Becatti, *La colonna coclide istoriata*, Rome, 1960.

28. Severin, 'Oströmische Plastik' (*supra*, n.26), pp.230f.

29. H. Bloch, 'The Pagan Revival in the West at the End of the Fourth Century', in Momigliano, *The Conflict* (*supra*, n.21), pp.193ff. See now J. Matthews, *Western Aristocracies and Imperial Court A.D. 364–425*, Oxford, 1975; especially pp.203ff., 238ff.

30. W. F. Volbach, *Elfenbeinarbeiten der Spätantike und des frühen Mittelalters*, 3rd edn., Mainz, 1976, p.51, no.55; pl.29.

31. The term was aptly used by A. Alföldi, 'Die Spätantike in der Ausstellung "Kunstschätze der Lombardei" in Zürich', *Atlantis*, 21, 1949, pp.61ff. (see p.68).

32. W. Helbig, *Führer durch die öffentlichen Sammlungen klassischer Altertümer in Rom*, I, *Die Päpstlichen Sammlungen im Vatikan und Lateran*, Tübingen, 1963, pp.726f., no.1012; cf. H. Graeven, 'Heidnische Diptychen', *Römische Mitteilungen*, 28, 1913, pp.198ff., especially p.270.

33. Volbach, *Elfenbeinarbeiten*, pp.52f., no.57; pl.30.

34. For statuary models see Graeven, 'Heidnische Diptychen' (*supra*, n.32), pp.227ff.

35. A. Levi, *La patera d'argento di Parabiago*, R. Istituto d'Archeologia e Storia dell'Arte, Opere d'arte, V, Rome, 1935. The attribution to the late fourth century is due to A. Alföldi, 'Die Spätantike' (*supra*, n.31), pp.68ff.

36. Kitzinger, 'On the Interpretation of Stylistic Changes' (*supra*, I, n.18), pp.2f. See *supra*, p.13.

37. Volbach, *Elfenbeinarbeiten*, pp.54f., no.62; pl.34.

38. For this problem see E. Garger, 'Zur spätantiken Renaissance', *Jahrbuch der kunsthistorischen Sammlungen in Wien*, n.s., 8, 1934, pp.1ff., especially pp.23ff. (à propos of the related interior views in the Virgil Ms., Vat. lat. 3225).

39. Volbach, *Elfenbeinarbeiten*, pp.29f., no.1; pl.1.

40. *Ibid.*, pp.50f., 53, nos.54, 59; pls.28, 32. For the Western – and very probably Roman – origin of these diptychs see the important observations by J. W. Salomonson, 'Kunstgeschichtliche und ikonographische Untersuchungen zu einem Tonfragment der Sammlung Benaki in Athen', *Bulletin Antieke Beschaving*, 48, 1973, pp.3ff., especially pp.14ff.

41. C. Formis, 'Il dittico eburneo della cattedrale di Novara', *Pubblicazioni dell'Università Cattolica del Sacro Cuore, Milan, Contributi dell'Istituto di Archeologia*, 1, 1967, pp.171ff., especially pp.187ff. For the Lampadii see Jones, Martindale, Morris, *The Prosopography*, I (*supra*, n.11), pp.493f.; for the Rufii, *ibid.*, Stemma 13 on p.1138. At least two members of the latter family also bore the name Lampadius; cf. *ibid.*, pp.978ff.; Bloch, 'The Pagan Revival' (*supra*, n.29), pp.204ff.; A. Chastagnol, *Le sénat romain sous le règne d'Odoacre*, Bonn, 1966, p.6.

42. Volbach, *Elfenbeinarbeiten*, pp.53f., no.60; pl.32. The Leningrad diptych bears a stylistic relationship to a panel in the British Museum representing the apotheosis of an emperor (Volbach, *Elfenbeinarbeiten*, p.52, no.56; pl.28). The two reliefs may well come from the same atelier. On the evidence both of its subject matter and of the monogram inscribed in its frame, which has been plausibly read as 'Symmachorum', the British Museum ivory appears to have been made for a member of the pagan aristocracy. But its style, while distinctive, does not come under the heading of refined, retrospective classicism. One must conclude that patronage by the Symmachi and their class did not automatically lead to the adoption of a classicist manner. For the type of composition exemplified by these reliefs see *infra*, pp.50ff.

43. E. Kitzinger, 'A Marble Relief of the Theodosian Period', *Dumbarton Oaks Papers*, 14, 1960, pp.17ff.; reprinted in Kitzinger, *The Art of Byzantium* (*supra*, I, n.18), pp.1ff.; cf. Severin, 'Oströmische Plastik' (*supra*, n.26), pp.232ff. and fig.14.

44. Grabar, *Christian Iconography* (*supra*, Introduction, n.7), pp.37ff.

45. Kollwitz, *Oströmische Plastik* (*supra*, n.24), pp.132ff. and pls.45ff.

46. Volbach, *Elfenbeinarbeiten*, pp.79f., no.110; pl.59.

47. *Ibid.*, p.80, no.111; pl.60.

48. Dalton, *Catalogue* (*supra*, n.17), pp.61ff., no.304, and pls.13ff. For Projecta see Jones, Martindale, Morris, *The Prosopography*, I (*supra*, n.11), p.750. In a Columbia University thesis currently being prepared by Kathleen J. Shelton an attempt will be made to attribute Projecta's Casket, and with it the Esquiline Treasure as a whole, to a somewhat earlier date (middle of the fourth century).

49. R. Klein, *Der Streit um den Victoriaaltar*, Darmstadt, 1972, pp.55ff. For the literary activities of the pagan aristocrats see Bloch, 'The Pagan Revival' (*supra*, n.29), pp.213ff.; also *infra*, IV, n.4.

50. *Ibid.*, pp.216f.; L. D. Reynolds and N. G. Wilson, *Scribes and Scholars*, Oxford, 1974, pp.33ff.

51. A. Goldschmidt, *Die Elfenbeinskulpturen*, I, 1914, pp.68f., no.139; pl.59. For Ottonian art I cite the miniatures by the Gregory Master in the Codex Egberti (Trier, Stadtbibliothek, Ms. 24), which are heavily indebted to the art of our period; cf. C. R. Dodwell, *Painting in Europe 800–1200*, The Pelican History of Art, 1971, pp.58f.

52. J. Wilpert, *Die römischen Mosaiken und Malereien der kirchlichen Bauten vom IV. bis XIII. Jahrhundert*, III, Freiburg i. Br., 1917, pls.42–6. G. Matthiae, *Mosaici medioevali delle chiese di Roma*, Rome, 1967, pp.55ff. with pls.12f. and figs.36, 38ff.; for the date see pp.68f.; for the condition, the diagram on an unnumbered page at the end of the plate volume.

53. A. Boëthius and J. B. Ward-Perkins, *Etruscan and Roman Architecture*, The Pelican History of Art, 1970, pp.245ff., 512ff.

54. W. Köhler, 'Das Apsismosaik von Sta. Pudenziana in Rom als Stildokument', *Forschungen zur Kirchengeschichte und zur christlichen Kunst* (Festschrift J. Ficker), Leipzig, 1931, pp.167ff., especially pp.173f.

55. On this feature see R. Krautheimer, S. Corbett, W. Frankl, *Corpus basilicarum christianarum Romae*, III, Vatican City, 1967, pp.293, 297.

56. Reliefs: M. Bieber, *The Sculpture of the Hellenistic Age*, New York, 1961, figs. 656–8; cf. pp.153ff. Second Pompeian Style: see, for instance, the well-known paintings in the Metropolitan Museum in New York from a Villa at Boscoreale (Ph. W. Lehmann, *Roman Wall Paintings from Boscoreale in the Metropolitan Museum of Art*, Cambridge, Massachusetts, 1953, pls.10ff.; J. Engemann, *Architekturdarstellungen des frühen zweiten Stils*, Heidelberg, 1967, pp.102ff. and pls.36ff.).

57. See, e.g., I. Scott Ryberg, *Panel Reliefs of Marcus Aurelius*, New York, 1967, pls.9, 14f., 17, 22f., 26, 32f., 48.

58. For this much debated question see Matthiae, *Mosaici medioevali*, pp.58f.; also E. Dassmann, 'Das Apsismosaik von S. Pudentiana in Rom', *Römische Quartalschrift*, 65, 1970, pp.67ff., especially p.74. A special problem is posed by the jewelled cross which it is tempting to relate to the cross erected on Golgotha by Theodosius II in A.D.420 (Ph. Grierson, *Catalogue of the Byzantine Coins in the Dumbarton Oaks Collection and in the Whittemore Collection*, II, Washington, D.C., 1968, pp.95f.). Implicit in this identification is a *terminus post quem* for the mosaic that would be incompatible with a date in the period of Innocent I. But there was a cross on Golgotha already in the fourth century (Chr. Ihm, *Die Programme der christlichen Apsismalerei vom vierten Jahrhundert bis zur Mitte des achten Jahrhunderts*, Wiesbaden, 1960, p.14, n.8; Ch. Coüasnon, *The Church of the Holy Sepulchre in Jerusalem*, London, 1974, pp.50f.).

59. For early representations of 'councils' see Chr. Walter, *L'iconographie des conciles dans la tradition byzantine*, Paris, 1970, pp.165ff.; *ibid.*, pp.190f. for assemblies of Christ and the apostles in fourth-century art.

60. Köhler, 'Das Apsismosaik' (*supra*, n.54), p.179.

61. There must have been other works of painting or mosaic of similar character, some of them slightly earlier. They in turn found a reflection in relief sculpture of the late fourth century, of which the sarcophagus of S.Ambrogio in Milan provides the most outstanding example; see F. Gerke, 'Das Verhältnis von Malerei und Plastik in der theodosianisch-honorianischen Zeit', *Rivista di Archeologia Cristiana*, 12, 1935, pp.119ff., especially pp.146f. and fig.8.

CHAPTER THREE

1. Swoboda, 'Über die Stilkontinuität' (*supra*, Introduction, n.2), p.26.

2. Volbach, *Elfenbeinarbeiten* (*supra*, II, n. 30), p.32, no.6; pl.3.

3. Successive stages in this development are exemplified, within the category of diptychs with single standing figures, by the diptych of the consul Felix of A.D.428 (*ibid.*, p.30, no.2; pl.2); the diptych of a high official in Novara (*ibid.*, p.56, no.64; pl.36; our fig.82); the diptych in Vienna – not necessarily official – with personifications of Rome and Constantinople (*ibid.*, pp.43f., no.38; pl.21); and the diptych of the consul Basilius of A.D.480 (*ibid.*, p.31, no.5; pl.3). Although the Novara diptych appears to be substantially later than that of Felix, the date proposed by C. Formis (second half of fifth or early sixth century) is probably too late ('Il dittico eburneo' [*supra*, II, n.41], p.177). The style of the Vienna figures has Eastern affinities, but I agree with Volbach and others that the diptych is a Western work. Finally, the diptych of Basilius bears a close stylistic resemblance to that of Boethius (our fig. 81).

4. Volbach, *Elfenbeinarbeiten*, pp.82f., no.116; pl.61.

5. *Ibid.*, pp.80f., nos.112f.; pl.60. H. Schnitzler has reiterated and refined the argument that these panels once formed part of a 'five-part' diptych similar to, but substantially earlier than, that in Milan Cathedral to be cited presently and, like the latter, destined for a book cover ('Kästchen oder fünfteiliges Buchdeckelpaar?', *Festschrift für Gert von der Osten*, Cologne, 1970, pp.24ff.); see also *infra*, p.96.

6. Volbach, *Elfenbeinarbeiten*, pp.84f., no.119; pl.63.

7. See the literature cited by Volbach, *ibid.*, under the individual entries.

8. *Ibid.*, pp.32ff., nos.8–11; pls.4f.

9. *Ibid.*, pp.35ff., nos.17–21; pls.8f.

10. *Enciclopedia dell'arte antica, classica e orientale*, V, 1963, s.v. 'Mosaico' (D. Levi); H. Stern, 'La funzione del mosaico nella casa antica', *Antichità Altoadriatiche*, 8, 1975, pp.39ff.

11. D. Levi, *Antioch Mosaic Pavements*, Princeton, London and The Hague, 1947.

12. See the series *Fouilles d'Apamée de Syrie* and *Fouilles d'Apamée de Syrie Miscellanea*, in progress of publication by the Centre Belge de Recherches Archéologiques à Apamée de Syrie since 1969 and 1968 respectively; see also *infra*, IV, n.30.

13. Levi, *Antioch Mosaic Pavements*, pp.363ff. and pls.86b, 90, 170ff., 176f. For the rinceau border, not exhibited at Worcester, see *ibid.*, p.363, fig. 150; pl.144b,c.

14. *Ibid.*, pp.156ff. and pl.30.

15. *Ibid.*, pp.226ff. and pls.52ff.

16. A. M. Schneider, *The Church of the Multiplying of the Loaves and Fishes*, London, 1937, pls.A, B, 2–17.

17. For what follows see I. Lavin, 'The Hunting Mosaics of Antioch and their Sources', *Dumbarton Oaks Papers*, 17, 1963, pp.179ff.; E. Kitzinger, 'Stylistic Developments in Pavement Mosaics in the Greek East from the Age of Constantine to the Age of Justinian', *La mosaique gréco-romaine*, I, Paris, 1965, pp.341ff. (reprinted in Kitzinger, *The Art of Byzantium* [*supra*, I, n.18], pp.64ff.). For critical observations see A. Carandini, 'La villa di Piazza Armerina, la circolazione della cultura figurativa africana nel tardo impero ed altre precisazioni', *Dialoghi di Archeologia*, 1, 1967, pp.93ff., especially pp.108ff.; Salomonson, 'Kunstgeschichtliche und ikonographische Untersuchungen' (*supra*, II, n.40), pp.38ff.

18. More often than in the East, *emblemata* in these Western countries are panels separately set on marble or ceramic trays and subsequently inserted into the pavement. The *emblema* thus tends to be quite literally more of a foreign body in relation to the overall design of the floor than it is in the East. For a recent survey of such 'true' *emblemata* see A. Balil, 'Emblemata', *Universidad de Valladolid, Boletin del Seminario de Estudios de Arte y Arqueologia*, 60–1, 1975, pp.67ff.

19. Volbach, *Elfenbeinarbeiten*, nos. 56, 60, 61, 108; cf. *supra*, p.38 with n.42.

20. Levi, *Antioch Mosaic Pavements* (*supra*, n.11), pp.283ff. and pls.113ff.

21. F. W. Deichmann, *Ravenna, Hauptstadt des spätantiken Abendlandes*, I, *Geschichte und Monumente*, Wiesbaden, 1969, pp.158ff.; II, 1, *Kommentar*, Wiesbaden, 1974, pp.61ff.; III, *Frühchristliche Bauten und Mosaiken von Ravenna*, 2nd edn., Wiesbaden, n.d., pls.I, 1–31.

22. *Ibid.*, I, p.158; II, 1, pp.51f., 63ff.

23. *Ibid.*, II, 1, p.75. An *emblema* with a pastoral scene on the floor of one of the rooms of a Roman villa at Corinth provides a particularly good example; see T. L. Shear, *The Roman Villa, Corinth*, Cambridge, Massachusetts, 1930, pls.3ff. and pp.21f.

24. Deichmann, *Ravenna*, II, 1, p.88. It is true that no precisely similar examples have survived, but the affiliation with textiles can hardly be doubted; see now also the fabrics (admittedly of somewhat later date) recovered in Chinese excavations in Central Asia (M. W. Meister, 'The Pearl Roundel in Chinese Textile Design', *Ars Orientalis*, 8, 1970, pp.255ff.; especially fig.41 with p.260, n.16).

25. J. Strzygowski, *Orient oder Rom*, Leipzig, 1901, pp.11ff. C. H. Kraeling, 'Color Photographs of the Paintings in the Tomb of the Three Brothers at Palmyra', *Les Annales Archéologiques de Syrie*, 11–12, 1961–2, pp.13ff., especially p.16 and pls.2f.,

13. The subject of the painting in the lunette was identified by Strzygowski as Achilles on Skyros (*op.cit.*, pp.13f., 24f.). For this scene cf. the central medallion of the Augst plate (our fig.54). The Mausoleum of Galla Placidia was cited by Strzygowski à propos of the architecture of the Palmyra tomb (*op.cit.*, p.19). His dating of the paintings was revised by Kraeling (*op.cit.*, pp.14ff.).

26. Full publication by H. Torp is being awaited; meanwhile see his preliminary article cited *infra*, n.29, and his monograph *Mosaikkene i St Georg-Rotunden i Thessaloniki*, Oslo, 1963; also the colour photographs by M. Hirmer in W. F. Volbach, *Early Christian Art*, New York, n.d., pls.123–7. Since the mosaics were cleaned – and fragmentary remains of those above the lowest zone of the dome discovered – in 1952–3, discussion of their date has focused mainly on two alternatives, namely, the period of Theodosius I (*c.* A.D.380–90) and the decades around A.D.450. The weight of the evidence is very much against the first of these alternatives; see W. E. Kleinbauer, 'The Iconography and the Date of the Mosaics of the Rotunda of Hagios Georgios, Thessaloniki', *Viator*, 3, 1972, pp.27ff., especially pp.68ff. On the basis of evidence derived from brick stamps M. Vickers has proposed a precise dating in the 440s, but his argument relies heavily on the still hypothetical identification of Hormisdas, the builder of the city walls of Thessaloniki, with an official of that period ('Fifth Century Brick Stamps from Thessaloniki', *The Annual of the British School at Athens*, 68, 1973, pp.285ff., with references to his earlier articles on the subject). Even so, I think it is most likely that the mosaics were made in the decade or decades just before the middle of the fifth century. The arguments recently advanced by B. Brenk in favour of the sixth-century date originally proposed by E. Weigand in 1939 do not appear to me strong enough to make it necessary to revert to that opinion (see p.154, n.168 of the monograph on the mosaics of S.Maria Maggiore cited *infra*, IV, n.1).

27. A. Grabar, 'À propos des mosaïques de la coupole de Saint-Georges à Salonique', *Cahiers Archéologiques*, 17, 1967, pp.59ff., especially pp.64ff.; Kleinbauer, 'The Iconography and the Date', pp.29ff.

28. Cf. especially the painted decoration of the 'dome' of a small circular tomb chamber of the early Hellenistic period discovered in 1944 at Kazanlak in Bulgaria (L. Zhivkova, *Kazanlushkata grobnitsa*, Sofia, 1974, pls.1, 12, 20, 26; *Enciclopedia dell'arte antica, classica e orientale*, IV, 1961, s.v. Kazanlǎk).

29. H. Torp, 'Quelques remarques sur les mosaïques de l'église Saint-Georges à Thessalonique', *Acts of the Ninth International Congress of Byzantine Studies, Thessaloniki, 12–19 August 1953* (title in Greek), I, Athens, 1955, pp.489ff., especially p.498: 'le palais céleste des athlètes du Christ'.

30. Reconstruction drawings by M. Corres, published by Maria G. Sotiriou ('Sur quelques problèmes de l'iconographie de la coupole de Saint-Georges de Thessalonique', *In Memoriam Panayotis A. Michelis*, Athens, 1971, pp.218ff., especially pls.10f., figs.1f.), show a – purely hypothetical – ring of terrain inserted between the chorus of acclaiming figures and the angels carrying the central medallion, thus confining the former to a disproportionately narrow band and severing their connection with the latter.

31. The late Hellenistic and Roman antecedents that are specifically relevant here are not the views of upper parts of distant buildings behind screen walls, which I cited à propos of the architectural scenery of the mosaic of S.Pudenziana (*supra*, II, n.56), but rather instances in which a pictorial representation *complete in itself* and with a greater or lesser amount of spatial implications is placed above a zone of simulated wainscoting. The room to which the famous Odyssey landscapes in the Vatican belonged provided an outstanding example of a painted decoration of this latter kind. Although this decoration, which can be reconstructed at least in its broad outlines, entailed a framework of simulated full-length pilasters, within this framework the upper parts of the walls were played off against the lower parts in the manner indicated (see P. H. von Blanckenhagen, 'The Odyssey Frieze', *Römische Mitteilungen*, 70, 1963, pp.100ff., especially pp.102f., with further references; also Engemann, *Architekturdarstellungen* [*supra*, II, n.56], pp.141ff., especially p.143). In a more restrained and not always consistent form the concept is present in certain interiors of the Roman period in Eastern Mediterranean lands; for instance, in the painted decorations of some of the tomb chambers of the second century A.D. in the Crimea (M. I. Rostovtsev, *Ancient Decorative Painting in South Russia* [in Russian], St Petersburg, 1913–14, pp.283ff. and pls.73–5; pp.293ff., figs. 59f. and pls.76–81) and in the third-century decoration of the Christian Baptistery at Dura-Europos (C. H. Kraeling, *The Christian Building*, The Excavations at Dura-Europos, Final Report, VIII, Part II, New Haven, 1967, pp.160ff. and pls.24, 33, 44, 46). In these Eastern interiors the decoration is organized in terms of horizontal zones entirely as it is in the dome of St George.

32. Deichmann, *Ravenna* (*supra*, n.21), I, pp.130ff.; II, 1, pp.15ff.; III, pls.IIf., 37–95. S. K. Kostof, *The Orthodox Baptistery of Ravenna*, New Haven and London, 1965.

33. H. Stern, 'Les mosaïques de l'église de Sainte-Constance à Rome', *Dumbarton Oaks Papers*, 12, 1958, pp.157ff., especially pp.166ff. and figs.1ff., 22, 23. The mosaic in the dome of the Baptistery of S.Giovanni in Fonte in Naples is another example; see Wilpert, *Die römischen Mosaiken und Malereien* (*supra*, II, n.52), I, p.216, fig.68; III, pls.29ff.

34. Kostof's analysis of the compositional system of the dome fails to bring out this duality of sources (*The Orthodox Baptistery*, pp.112ff.). Deichmann clearly recognizes it but he places the phenomenon of conflation in an art-historical perspective somewhat different from the one offered here (*Ravenna*, I, pp.138ff.; cf. also II, 1, pp.31f.).

35. *Ibid.*, I, pp.209ff.; II, 1, pp.251ff.; III, pls.249–73.

36. G. Bovini, 'I mosaici di S.Vittore "in ciel d'oro" di Milano', *Corsi di cultura sull'arte ravennate e bizantina*, 1969, pp.71ff.

37. Deichmann, *Ravenna*, I, pp.171ff.; II, 1, pp.125ff.; III, pls.IV–VII, 98–213.

38. *Ibid.*, I, pp.201ff.; II, 1, pp.191ff.; III, pls.216–45.

39. One might also recall here once more the little chapel in Milan whose decoration comprises, in addition to the bust of St Victor in the dome, six single standing figures of local bishops on the lateral walls; see *supra*, n.36 and fig. 105.

40. M. Sacopoulo, *La Theotokos à la mandorle de Lythrankomi*, Paris, 1975. An exhaustive monograph by A. H. S. Megaw is in the press. Miss Sacopoulo attributes the mosaic to the second quarter of the sixth century (*op.cit.*, p.107), Mr Megaw to a date in or about the third decade of the century.

41. This is true also of some mosaics in Thessaloniki whose dates have been much debated and in which the relatively loose technique characteristic of the Lythrankomi mosaic is accentuated, at times to the point of fuzziness. The most important is the apse mosaic of the little church of Hosios David, which has been attributed to dates ranging from the fifth to the seventh century. For reproductions see Volbach, *Early Christian Art* (*supra*, n.26), pls.133–5; for the earlier literature, V. Lazarev, *Storia della pittura bizantina*, Turin, 1967, p.61, n.61. The debate concerning the date continues. R. S. Cormack advocates the late fifth century ('The Mosaic Decoration of S.Demetrios, Thessaloniki', *The Annual of the British School at Athens*, 64, 1969, pp.17ff., especially p.49); W. E. Kleinbauer a date later than that of the mosaics of St George but prior to Justinian (*op. cit.* [*supra*, n.26], p.85, n.215). There is similar uncertainty about the chronology of the first group of *ex voto* mosaics in the Church of St Demetrius, only a few of which have survived the fire of 1917. These mosaics are not stylistically uniform and need not all be of one date. But a panel still to be seen on the west wall of the south aisle exhibits characteristics which seem to have been shared also by many of the lost mosaics; and for work such as this the late fifth-century date advocated by Cormack (*op.cit.*, pp.49f.) seems to me too early (see *infra*, VI, n.10). I still believe that the curiously elusive style of these Thessalonikan mosaics should be understood in terms of a local tradition continued over a fairly long stretch of time in the wake of the great example set by the mosaics of St George; cf. E. Kitzinger, *Byzantine Art in the Period between Justinian and Iconoclasm*, Berichte zum XI. Internationalen Byzantinisten-Kongress, IV, 1, Munich, 1958 (reprinted in Kitzinger, *The Art of Byzantium* [*supra*, I, n.18], pp.157ff.), pp.20ff.

CHAPTER FOUR

1. H. Karpp (ed.), *Die frühchristlichen und mittelalterlichen Mosaiken in Santa Maria Maggiore zu Rom*, Baden-Baden, 1966. See now the comprehensive study (intended as a companion volume to Karpp's plates) by B. Brenk, *Die frühchristlichen Mosaiken in S.Maria Maggiore zu Rom*, Wiesbaden, 1975. The pages which follow recapitulate in large part observations I put forward in a recently published paper read at a Princeton symposium in 1973 ('The Role of Miniature Painting in Mural Decoration', *The Place of Book Illumination in Byzantine Art*, Princeton, New Jersey, 1975, pp.99ff., especially pp.121ff.). On most questions I find myself in substantial agreement with Brenk, and in my notes specific references to his text will be limited to major points.

2. On this question see Brenk, *Die frühchristlichen Mosaiken*, pp.3f.

3. R. Krautheimer, 'The Architecture of Sixtus III: A Fifth Century Renascence?', *De artibus opuscula XL: Essays in Honor of Erwin Panofsky*, New York, 1961, pp.291ff.; reprinted, with a *Postscript*, in R. Krautheimer, *Studies in Early Christian, Medieval, and Renaissance Art*, New York and London, 1969, pp.181ff.

4. J. de Wit, *Die Miniaturen des Vergilius Vaticanus*, Amsterdam, 1959; see especially pp.207f.

5. Compare the mythological scenes incorporated in the decoration of a ceiling in Nero's Golden House (our fig. 121; colour reproductions in *Enciclopedia dell'arte antica, classica e orientale*, VI, 1965, facing p.960; cf. Bianchi Bandinelli, *Rome: The Center of Power* [*supra*, I, n.12], pp.132ff.).

6. H. Buchthal, 'A Note on the Miniatures of the Vatican Virgil Manuscript', *Mélanges Eugène Tisserant*, VI (Studi e Testi, 236), Vatican City, 1964, pp.167ff. Brenk, *Die frühchristlichen Mosaiken*, p.128.

7. H. Degering and A. Boeckler, *Die Quedlinburger Italafragmente*, Berlin, 1932.

8. *Ilias Ambrosiana*, Fontes Ambrosiani, 28, Bern and Olten, 1953; R. Bianchi Bandinelli, *Hellenistic-Byzantine Miniatures of the Iliad*, Olten, 1955; cf. Kitzinger, 'The Role of Miniature Painting' (*supra*, n.1), pp.123, 134.

9. Brenk, *Die frühchristlichen Mosaiken*, pp.135f.

10. For the inscription of Sixtus III see *infra*, p.73. I agree with Brenk and others that the inscription is an integral part of the decoration of the arch (*Die frühchristlichen Mosaiken*, pp.15, 52, n.16). For the view that the nave mosaics are of substantially earlier date see the references *ibid.*, p.151, n.163.

11. *Ibid.*, pp.134ff.

12. *Ibid.*, pp.151ff.

13. J. J. Tikkanen, *Die Genesismosaiken von S.Marco in Venedig und ihr Verhältniss zu den Miniaturen der Cottonbibel*, Acta Societatis Scientiarum Fennicae, 17, 1889; cf. Kitzinger, 'The Role of Miniature Painting', pp.99ff.

14. Kömstedt, *Vormittelalterliche Malerei* (*supra*, Introduction, n.3), pp.14ff.; M. Schapiro, in *The Review of Religion*, 8, 1943–4, pp.165ff. (review of Morey, *Early Christian Art*), especially p.182; F. W. Deichmann, *Frühchristliche Kirchen in Rom*, Basle, 1948, p.65; Brenk, *Die frühchristlichen Mosaiken*, pp.62, 108, 110, 152.

15. It was P. Künzle who first drew this important conclusion ('Per una visione organica dei mosaici antichi di S.Maria Maggiore', *Atti della Pontificia Accademia Romana di Archeologia, Rendiconti*, 34, 1961–2, pp.153ff., especially p.162); cf. also Kitzinger, 'The Role of Miniature Painting', pp.128ff.; Brenk, *Die frühchristlichen Mosaiken*, pp.128, 180.

16. *Supra*, pp.18f.; cf. Brenk, *Die frühchristlichen Mosaiken*, p.152.

17. Degering and Boeckler, *Die Quedlinburger Italafragmente* (*supra*, n.7), pp.65ff.; for disposition sketches, *ibid.*, pp.72, 154 and pl.8; cf. Kitzinger, 'The Role of Miniature Painting', p.135 with n.76.

18. See our fig. 122, lower right hand panel (Saul); cf., in general, Brenk, *Die frühchristlichen Mosaiken*, pp.147ff. and figs.42ff.

19. *Ibid.*, p.8 and figs.2–4.

20. A. Grabar, *L'empéreur dans l'art byzantin*, Paris, 1936, pp.209ff.; *idem*, *Christian Iconography* (*supra*, Introduction, n.7), pp.46ff.; E. H. Kantorowicz, 'Puer exoriens', *Perennitas* (Festschrift Thomas Michels), Münster, 1963, pp.118ff.; Brenk, *Die frühchristlichen Mosaiken*, pp.178ff. *et passim*.

21. Grabar, *L'empéreur*, pp.216ff.; Kantorowicz, 'Puer exoriens', pp.118ff.; cf. also U. Schubert, 'Der politische Primatanspruch des Papstes dargestellt am Triumphbogen von Santa Maria Maggiore in Rom', *Kairos*, n.s. 13, 1971, pp.194ff., especially pp.205ff. Brenk, *Die frühchristlichen Mosaiken*, pp.21f., rejects this interpretation, which, however, receives important support from representations on fourth-century contorniates; cf. Kantorowicz, *op.cit.*, p.121 with n.13; Schubert, *op.cit.*, p.205 with n.46 and fig.12.

22. Kitzinger, 'The Role of Miniature Painting', p.134 and figs. 25, 27; cf. Brenk, *Die frühchristlichen Mosaiken*, p.151.

23. Grabar, *L'empéreur*, pp.221ff.; Krautheimer, 'The Architecture of Sixtus III' (*supra*, n.3), pp.301f.; Kantorowicz, 'Puer exoriens', pp.121f.; Schubert, 'Der politische Primatanspruch', pp.222ff.

24. S. Waetzoldt, *Die Kopien des 17. Jahrhunderts nach Mosaiken und Wandmalereien in Rom*, Vienna and Munich, 1964, pp.56ff.

25. Cf. Brenk, *Die frühchristlichen Mosaiken*, pp.56, 108f.

26. *Ibid.*, pp.47ff. Brenk sees a possible reference to the Council of Ephesus primarily in the scenes in the second zone of the arch.

27. An important clue to the understanding of the iconography of the mosaics of the arch lies in the transposition of biblical chronology in the three zones depicting scenes from Christ's infancy; cf. Grabar's classical interpretation in *L'empéreur* (*supra*, n.20), pp.209ff.; also Brenk, *Die frühchristlichen Mosaiken*, pp.39ff.

28. Kömstedt (see *supra*, n.14).

29. Köhler, 'Das Apsismosaik' (*supra*, II, n.54), p.179. Brenk takes a less negative view of the relationship of the mosaics of S.Maria Maggiore to earlier Roman mosaics and believes that in all probability the artists were Roman (*Die frühchristlichen Mosaiken*, pp.154ff.).

30. At Antioch see especially the Topographical Border in the Yakto complex, a work of about the middle of the fifth century (Levi, *Antioch Mosaic Pavements* [*supra*, III, n.11], pp.323ff. and pls.79f.; see *ibid.*, p.582 for comparisons with figures in Old Testament scenes in S.Maria Maggiore). For the Apamea mosaic illustrated in our figs. 135 and 137, which is known to me only in black and white photographs, see J. Balty, 'Une nouvelle mosaïque du IVe s. dans l'édifice dit "au triclinos" à Apamée', *Annales Archéologiques Arabes Syriennes*, 1970, pp.1ff., especially pp.4ff., and figs. 5–10. The fourth-century date proposed for this mosaic by Mme Balty is based on comparisons with mosaics at Antioch. Brenk, it should be noted, finds in certain

heads at S.Maria Maggiore an influence of Theodosian portraiture, but sees no reason for assuming a collaboration of artists from the East (*Die frühchristlichen Mosaiken*, pp.139f.).

31. *Ibid.*, p.153.

32. *Supra*, pp.50ff.

33. R. Kautzsch, *Kapitellstudien*, Berlin and Leipzig, 1936. There has been extensive research in this field during the forty years since Kautzsch's book was published. Much new material has come to light and some of his datings have been – or may yet have to be – revised. But in its main lines his concept of stylistic developments is still valid.

34. *Ibid.*, pp.115ff., 140ff., 152ff. For the 'Theodosian' type see also F. W. Deichmann, *Studien zur Architektur Konstantinopels*, Baden-Baden, 1956, pp.59ff.; for capitals with animal protomes, E. Kitzinger, 'The Horse and Lion Tapestry at Dumbarton Oaks', *Dumbarton Oaks Papers*, 3, 1946, pp.1ff., especially pp.17ff. The existence in Asia Minor of a continuous tradition for capitals of the latter type throughout late antiquity is hypothetical (F. W. Deichmann, 'Zur Entstehung der spätantiken Zweizonen-Tierkapitelle', *Charisterion eis Anastasion K. Orlandon*, I, Athens, 1965, pp.136ff., especially p.142).

35. For the capital from Pergamon (fig.138) see Boëthius and Ward-Perkins, *Etruscan and Roman Architecture* (*supra*, II, n.53), pl.215. The capital from Cyprus (fig.139) may be compared with examples such as Kautzsch, *Kapitellstudien*, pl.5, no.69 (*ibid.*, pp.28, 39: 'second quarter of fourth century').

36. Deichmann, *Ravenna* (*supra*, III, n.21), I, pp.64f. and fig.30; II, 1, p.128 and figs.85ff.

37. Kautzsch, *Kapitellstudien*, pp.5–115 with pls.1–23.

38. Deichmann, *Studien zur Architektur Konstantinopels* (*supra*, n.34), pp.41ff.

39. For this development see *ibid.*, p.45. I am indebted to Dr Alison Frantz and the late Professor Arif Müfid Mansel for photographs of the examples illustrated in figs. 142 and 143 respectively. For the splendid example from Basilica A in Nea Anchialos (fig.144) see G. A. Sotiriou, 'Hai christianikai Thebai tes Thessalias', *Archaiologike Ephemeris*, 1929, pp.1ff., especially p.62 with fig.65.

40. For the capital from the basilica at Vravron in Attica, illustrated in our fig. 145, see the excavation report by E. Stikas in the *Praktika* of the Athens Archaeological Society for the year 1951, pp.53ff., especially pp.65ff. and figs.21f. (for this church cf. R. Krautheimer, *Early Christian and Byzantine Architecture*, The Pelican History of Art, revised edition, 1975, pp.127f.). For the capital from the Church of St Demetrius in Thessaloniki (our fig. 146) see Kautzsch, *Kapitellstudien*, pp.169f., no.548; pl.34. Its probable date is towards the end of the fifth century (*ibid.*, p.172; Krautheimer, *op.cit.*, pp.132ff. with n.49). For the capital from Sardis (our fig. 147), probably of much the same date, see F. K. Yegul, 'Early Byzantine Capitals from Sardis', *Dumbarton Oaks Papers*, 28, 1974, pp.265ff., especially p.272 and figs.8f.; *ibid.*, pp.267ff. (with figs.16ff.), a general survey of the development of the Ionic impost capital, with references to earlier literature.

41. See in general Kautzsch, *Kapitellstudien*, pp.182ff.

42. *Ibid.*, p.188, no.591; pl.37.

43. *Ibid.*, pp.184ff., and pls.37ff. Kautzsch's attribution of examples in the Church of St Sophia in Thessaloniki (*ibid.*, pp.184ff., no.586; pl.37) to a date before the accession of Justinian has been confirmed by the discovery of the architectural decoration of the Church of St Polyeuktos in Constantinople, a building erected by Juliana Anicia probably between A.D.524 and 527. The Thessalonikan capitals, which are in secondary use, bear ornament closely related to the work at St Polyeuktos (cf. M. Kambouri, 'Two Capitals of Hagia Sophia in Thessaloniki' [Greek, with English summary], *Aristoteleion Panepistemion Thessalonikes, Epistomenike Epeteris tes Polytechnikes Scholes*, 6, 1973, pp.67ff.). There were true impost capitals also at St Polyeuktos itself (R. M. Harrison and N. Firatli, 'Excavations at Sarachane in Istanbul: Fourth Preliminary Report', *Dumbarton Oaks Papers*, 21, 1967, pp.273ff., especially p.276 and fig.14; R. M. Harrison, 'A Constantinopolitan Capital at Barcelona', *ibid.*, 27, 1973, pp.297ff.; for the building cf. Krautheimer, *Early Christian and Byzantine Architecture*, pp.230ff.).

44. Kautzsch, *Kapitellstudien*, p.100, no.290; pl.19. For the date see *ibid.*, p.104.

45. *Supra*, pp.61f.

46. J. Inan and E. Rosenbaum, *Roman and Early Byzantine Portrait Sculpture in Asia Minor*, London, 1966, pp.151ff., no.194; pl.181. Severin, *Zur Portraitplastik des 5. Jahrhunderts n. Chr.* (*supra*, II, n.25), pp.108ff., 177ff.

CHAPTER FIVE

1. Deichmann, *Ravenna* (*supra*, III, n.21), I, pp.226ff.; III, pls.285–375. Publication of Part 2 of the *Kommentar* (vol. II), which will cover S.Vitale and also S.Apollinare in Classe (cf. *ibid.*, II, 1, p.ix), was announced for 1976 but was not available to me at the time this book went to press.

2. Cf. R. Krautheimer's analysis of the interior of the church: *Early Christian and Byzantine Architecture* (*supra*, IV, n.40), pp.219ff.

3. For a detailed analysis of this framework see G. Rodenwaldt, 'Bemerkungen zu den Kaisermosaiken in San Vitale', *Jahrbuch des Deutschen Archäologischen Instituts*, 59–60, 1944–5, pp.88ff.

4. See *supra*, pp.57f., and III, n.31 for the antecedents of this design concept.

5. See the colour reproduction in Volbach, *Early Christian Art* (*supra*, III, n.26), pl.164.

6. *Supra*, pp.69ff.

7. Cf. Rodenwaldt, 'Bemerkungen zu den Kaisermosaiken' (*supra*, n.3), pp.101ff.

8. For what follows see Kitzinger, 'Stylistic Developments in Pavement Mosaics in the Greek East' (*supra*, III, n.17), pp.346ff.

9. For references see J.-P. Sodini, 'Mosaïques paléochrétiennes de Grèce', *Bulletin de Correspondance Hellénique*, 94, 1970, II, pp.710f.

10. For the example illustrated in our fig. 162 see Levi, *Antioch Mosaic Pavements* (*supra*, III, n.11), pp.315f. and pl.128b. Attributed by Levi to a date after the middle of the fifth century, this floor is of special interest because of its colour scheme. Both the stylized buds making up the diaper grid and the rosettes filling it are pink, while the ground is green. Such extensive use of green is unusual in the floor mosaics of Antioch. Although the design remains severely abstract, evidently the artist went out of his way to convey a suggestion of a flowering meadow. The floor thus exemplifies particularly well the tendency in this period to reinterpret geometric patterns in organic terms.

11. *Ibid.*, pp.321ff. and pl.74a. For the date see Lavin, 'The Hunting Mosaics of Antioch' (*supra*, III, n.17), p.195 with n.46.

12. M. Avi-Yonah, 'Mosaic Pavements in Palestine', *Quarterly of the Department of Antiquities in Palestine*, 2, 1933, pp.136ff., especially pp.171f., no.132; *idem*, 'Une école de mosaïque à Gaza au sixième siècle', *La mosaïque gréco-romaine*, II, Paris, 1975, pp.377ff.; especially p.379 and pl.180, 1 (with wrong caption).

13. Lavin, 'The Hunting Mosaics of Antioch', pp.217f. and figs. 47–50. The early dating of the floor at Djemila (*ibid.*, fig. 50) has been questioned; see most recently M. Blanchard-Lemée, *Maisons à mosaïques du quartier central de Djemila (Cuicul)*, Aix-en-Provence, 1975, pp.88ff.

14. Avi-Yonah, 'Une école de mosaïque à Gaza' (*supra*, n.12).

15. See, e.g., Levi, *Antioch Mosaic Pavements*, pls.83a, 91.

16. E. Kitzinger, 'Studies in Late Antique and Early Byzantine Floor Mosaics, I: Mosaics at Nikopolis', *Dumbarton Oaks Papers*, 6, 1951, pp.81ff., especially pp.93ff. and figs.18f. For the pendant of this floor – a hunting mosaic whose composition bears witness to the same characteristic development – see *ibid.*, pp.108ff. and figs. 20ff.

17. Bianchi Bandinelli, *Rome: The Center of Power* (*supra*, I, n.12), pp.125f. and figs. 130f., 133.

18. E. Kitzinger, 'Mosaic Pavements in the Greek East and the Question of a "Renaissance" under Justinian', *Actes du VIe congrès international d'études byzantines*, II, Paris, 1951, pp.209ff.; reprinted in Kitzinger, *The Art of Byzantium* (*supra*, I, n.18), pp.49ff.

19. *Supra*, p.51.

20. See, for instance, the splendid floor in the nave of the Justinianic basilica at Sabratha (S.Aurigemma, *I mosaici*, L'Italia in Africa: Tripolitania, I, 1, Rome, 1960, pp.27ff. and pls.19ff.).

21. Matthiae, *Mosaici medioevali* (*supra*, II, n.52), p.85 and fig.77.

22. R. O. Farioli, 'La decorazione musiva della capella di S.Matrona nella chiesa di S.Prisco presso Capua', *Corsi di cultura sull'arte ravennate e bizantina*, 1967, pp.267ff.; cf. also the mosaic decoration of the year A.D.512 in the barrel vault of the chancel of the monastic church near Kartmin (Tur Abdin); the decoration consists of a vine trellis issuing from vases in the four corners and surrounding a central medallion with a cross (E. J. W. Hawkins and M. Mundell, 'The Mosaics of the Monastery of Mār Samuel, Mār Simeon, and Mār Gabriel near Kartmin', *Dumbarton Oaks Papers*, 27, 1973, pp.279ff.).

23. K. Lehmann, 'The Dome of Heaven', *Art Bulletin*, 27, 1945, pp.1ff., especially p.5. Stern, 'La funzione del mosaico nella casa antica' (*supra*, III, n.10), pp.47f., 51ff. See also *supra*, p.51.

24. Matthiae, *Mosaici medioevali*, pp.135ff., with pls.16–18 and figs.78, 80–5; for restorations see the diagram on an unnumbered plate at end of volume.

25. R. Brilliant, *Gesture and Rank in Roman Art*, Memoirs of the Connecticut Academy of Arts and Sciences, 14, New Haven, 1963, pp.173ff. *et passim*.

26. For the mutilated mosaic on the wall surrounding the apse, which represented the adoration of the Lamb by the twenty-four elders (Rev. 4 and 5), see Waetzoldt, *Die Kopien des 17. Jahrhunderts* (*supra*, IV, n.24), p.32 and fig.39. This mosaic has been attributed to the period of Pope Sergius I (A.D.687–701) by Matthiae (*Mosaici medioevali*, pp.203ff. with pl.26 and figs.126–31).

27. C. Davis-Weyer, 'Das Traditio-Legis-Bild und seine Nachfolge', *Münchner Jahrbuch der bildenden Kunst*, 3rd series, 12, 1961, pp.7ff., especially pp.17f.

28. Volbach, *Elfenbeinarbeiten* (*supra*, II, n.30), pp.93f., no.140; pls.72ff. Add to the bibliography S. Bettini's discussion in the introduction to the exhibition catalogue *Venezia e Bisanzio*, Venice, 1974 (pp.18ff.).

29. Kitzinger, 'Notes on Early Coptic Sculpture' (*supra*, I, n.14), pp.210ff.; *idem*, 'A Marble Relief of the Theodosian Period' (*supra*, II, n.43), pp.38, 42.

30. Oddly enough, the sequence is not strictly chronological in terms of the biblical text (cf. C. Cecchelli, *La Cattedra di Massimiano ed altri avori romano-orientali*, Rome, 1936, p.46 with n.14). The most striking anomalies occur on the right-hand side, in the second part of the cycle (figs.171, 175). They could be explained by assuming that on this side the scenes on the framing panels and those on the framed ones were thought of as distinct sequences, the latter to be read from top to bottom, the former from bottom to top.

31. Volbach, *Elfenbeinarbeiten*, pp.47f., no.48; pl.26.

32. Delbrueck, *Die Consulardiptychen* (*supra*, II, n.23), pp.12ff.

33. The case for the attribution of the diptych to the period of Justinian has been stated most cogently by K. Wessel, 'Das Diptychon Barberini', *Akten des XI. Internationalen Byzantinistenkongresses*, Munich, 1960, pp.665ff.

34. For Roman *adventus* iconography see the study by Brilliant cited *supra*, n.25 (with further references).

35. See *supra*, especially p.90 with nn.16f.; also *infra*, p.109 with n.31.

36. See in general G. Ostrogorsky, *History of the Byzantine State*, New Brunswick, New Jersey, 1957, pp.63ff. For the classicizing tendency in Justinianic law see K.-H. Schindler, *Justinians Haltung zur Klassik*, Cologne and Graz, 1966.

37. O. Demus, *Byzantine Mosaic Decoration*, London, 1948, pp.14ff.

CHAPTER SIX

1. G. H. Forsyth and K. Weitzmann, *The Monastery of Saint Catherine at Mount Sinai: The Church and Fortress of Justinian*, Ann Arbor, n.d., pp.11ff. and pls.103ff.

2. *Ibid.*, pp.11f., 19.

3. *Supra*, pp.85f.

4. Forsyth and Weitzmann, *The Monastery: The Church and Fortress*, p.14.

5. *Ibid.*, p.16.

6. *Supra*, pp.88ff.

7. Deichmann, *Ravenna* (*supra*, III, n.21), I, pp.257ff.; III, pls.383–413. Concerning the relevant part of Deichmann's *Kommentar*, see *supra*, V, n.1.

8. J. Engemann, 'Zu den Apsis-Tituli des Paulinus von Nola', *Jahrbuch für Antike und Christentum*, 17, 1974, pp.21ff., especially pp.36ff. *Sinopie* which have come to light on the brickwork of the conch show that a different iconography was planned at first. But it appears that all essential elements of the mosaic as actually executed form a single unit; cf. M. Mazzotti, 'Sinopie Classensi', *Felix Ravenna*, 4th series, III–IV, 1972, pp.211ff., especially pp.219, 221.

9. Deichmann, *Ravenna*, I, pp.259f., 276f.; cf. O. Demus, 'Zu den Apsismosaiken von Sant' Apollinare in Classe', *Jahrbuch der österreichischen Byzantinistik*, 18, 1969, pp.229ff.

10. Ravenna: Deichmann, *Ravenna*, I, pp.199f.; II, 1, p.150; III, pls.120–35 (processions of saints in S.Apollinare Nuovo; for the date – *c.* A.D.561 – see *ibid.*, II, 1, p.129). Rome: Matthiae, *Mosaici medioevali* (*supra*, II, n.52), pp.143ff., 149ff. with pls.19f. and figs.79, 86–9, 91–7, 101–2 (S.Teodoro; S.Lorenzo f. l. m.). At Thessaloniki I would cite an *ex voto* mosaic on the west wall of the south aisle of the Church of St Demetrius; cf. Kitzinger, *Byzantine Art in the Period between Justinian and Iconoclasm* (*supra*, III, n.41), pp.21f. and fig.22. The group of donors in this panel has been compared with the group of Abraham and Isaac in one of the mosaics in the window zone of the apse of S.Apollinare in Classe (Demus, 'Zu den Apsismosaiken von Sant'Apollinare in Classe', p.238, n.18). The comparison certainly suggests a fairly advanced date for the St Demetrius panel and other related mosaics in the same church. For this question see *supra*, III, n.41. The stylistic development in mosaics is strikingly paralleled in the renderings of the imperial portrait on Byzantine coins of the second half of the sixth century and the early seventh. Here, too, there was a drastic loss of volume, while linearism and abstraction increased correspondingly.

See my study cited earlier in this note, p.20 and fig.20; also M. Restle, *Kunst und byzantinische Münzprägung von Justinian I. bis zum Bilderstreit*, Athens, 1964, pp.65ff.

11. Matthiae, *Mosaici medioevali*, pp.169ff. with pls.21f. and figs.90, 98–100.

12. The portraits of the two papal donors are heavily restored; cf. *ibid.*, p.169.

13. See in general A. Grabar, *Martyrium*, Paris, 1946, II, chapters 1–3. The catacombs of Naples are particularly rich in commemorative portraits on tombs; cf. H. Achelis, *Die Katakomben von Neapel*, Leipzig, 1936, pls.25–33; also the important mosaic portraits recently discovered in the catacomb of S.Gennaro (U. M. Fasola, *Le catacombe di S.Gennaro a Capodimonte*, Rome, 1975, pp.133ff., with figs. 92, 98, and pls.11–13). I would stress, more than Grabar did, the importance of the fact that a simple portrait bust devoid of all action appears in complete isolation as a central feature of the decoration of a martyr's shrine as early as the fifth century (our fig. 105).

14. *Supra*, pp.20, 23.

15. Demus, *Byzantine Mosaic Decoration* (*supra*, V, n.37), pl.2.

16. T. Schmit, *Die Koimesis-Kirche von Nikaia*, Berlin and Leipzig, 1927, pls.20ff.

17. P. A. Underwood, 'The Evidence of Restorations in the Sanctuary Mosaics of the Church of the Dormition at Nicaea', *Dumbarton Oaks Papers*, 13, 1959, pp.235ff.

18. E. Kitzinger, 'The Cult of Images in the Age before Iconoclasm', *Dumbarton Oaks Papers*, 8, 1954, pp.83ff.; reprinted in Kitzinger, *The Art of Byzantium* (*supra*, I, n.18), pp.90ff.

19. G. A. and M. G. Sotiriou, *He basilike tou hagiou Demetriou Thessalonikes*, Athens, 1952, pp.193ff. and pls.61b, 63–5, 67, 68, 71a. For the date see my study cited *supra*, n.10, especially pp.25f. For the earlier *ex voto* mosaics in St Demetrius, whose dates are more controversial, see *ibid.*, pp.20ff. and *supra*, III, n.41; VI, n.10.

20. Matthiae, *Mosaici medioevali* (*supra*, n.10), pp.191ff.; figs.104–24.

21. E. Kitzinger, 'On Some Icons of the Seventh Century', *Late Classical and Mediaeval Studies in Honor of Albert Mathias Friend, Jr.*, Princeton, New Jersey, 1955, pp.132ff., especially pp.145f. (reprinted in Kitzinger, *The Art of Byzantium* [*supra*, I, n.18], pp.233ff.). See also my study cited *supra*, n.10, especially pp.45f.

22. See my study cited *supra*, n.18, especially pp.139ff.

23. *Ibid.*, pp.144f.

24. E. H. Gombrich, *Meditations on a Hobby Horse*, Greenwich, Connecticut, 1963, p.8.

25. E. Gibbon, *The History of the Decline and Fall of the Roman Empire*, ed. J. B. Bury, V, London, 1929, p.267, n.14.

26. E. C. Dodd, *Byzantine Silver Stamps*, Washington, D.C., 1961; for the earlier literature see *ibid.*, pp.vii and 279f.

27. *Ibid.*, pp.176f., no.57; pp.202f., no.70.

28. L. Matzulewitsch, *Byzantinische Antike*, Berlin and Leipzig, 1929.

29. *Supra*, pp.29f.

30. A plate at Dumbarton Oaks with a hunting scene of mythological character is considered to be of fifth-century date but is not likely to have been made long after A.D.400 (M. C. Ross, *Catalogue of the Byzantine and Early Mediaeval Antiquities in the Dumbarton Oaks Collection*, I, Washington, D.C., 1962, pp.3f., no.4; pls.2f.); while a fragmentary bowl with a Dionysiac procession in the same collection probably is not much (if at all) earlier than A.D.500 (*ibid.*, pp.5ff., no.6; pls.6f.). For other categories of fifth-century silver objects see, e.g., *ibid.*, pp.5f., no.5 and pl.4; Volbach, *Early Christian Art* (*supra*, III, n.26), pls.120f.; Delbrueck, *Die Consulardiptychen* (*supra*, II, n.23), pp.154ff., no.35; J. Heurgon, *Le trésor de Ténès*, Paris, 1958, pp.51ff. and pl.6. At least some of the objects in the treasures from Canoscio and Canicattini Bagni, which are composed solely of pieces of Christian or neutral character, also appear to be of the fifth century, though these treasures in their entirety have been attributed to the sixth century (W. F. Volbach, 'Il tesoro di Canoscio', *Ricerche sull' Umbria Tardo-antica e Preromanica. Atti del II Convegno di Studi Umbri*, Gubbio, 1965, pp.303ff.).

31. *Supra*, p.98.

32. Dodd, *Byzantine Silver Stamps* (*supra*, n.26), pp.70ff., nos.9 and 10; cf. also pp.80f., no.14; pp.84f., no.16; pp.256f., no.93.

33. *Ibid.*, pp.174ff., nos.56 and 57; pp.202f., no.70; pp.214f., no.75; pp.218f., no.77.

34. *Ibid.*, pp.94ff., nos.20–36; cf. also the same author's *Supplements in Dumbarton Oaks Papers*, 18, 1964, pp.237ff. (especially pp.240f., no.19.1), and 22, 1968, pp.141ff.; and her monograph *Byzantine Silver Treasures*, Abegg Stiftung, Bern, 1973, *passim*. The only 'mythological' subject in this entire group is the 'Euthenia' relief (Dodd, *Byzantine Silver Stamps*, pp.106f., no.26).

35. See my study cited *supra*, n.10, especially p.7.

36. Dodd, *Byzantine Silver Stamps*, pp.178ff., nos.58–66. For what follows see my study cited *supra*, n.10, pp.4ff.

37. See the introduction to A. Pertusi's critical edition: *Giorgio di Pisidia, Poemi*, Ettal, 1959, pp.11ff.

38. See my study cited *supra*, n.10, especially pp.6f.

39. The thesis that the cycle of David scenes on the Cyprus plates has direct reference to Heraclius is now widely accepted. See I. Shahid, 'The Iranian Factor in Byzantium during the Reign of Heraclius', *Dumbarton Oaks Papers*, 26, 1972, pp.293ff., especially p.303, n.35; M. van Grunsven-Eygenraam, 'Heraclius and the David Plates', *Bulletin Antieke Beschaving*, 48, 1973, pp.158ff., especially pp.170ff.; S. H. Wander, 'The Cyprus Plates: The Story of David and Goliath', *Metropolitan Museum Journal*, 8, 1973, pp.89ff., especially pp.103f. There is, however, disagreement as to whether the reference is to the early part of Heraclius' career (as I prefer to assume) or to events during and after his Persian victory (A.D.627–9). It is not suggested, of course, that every event depicted on the plates has a precise counterpart in the emperor's life.

40. *Supra*, pp.33f.

41. See, in general, E. Kitzinger, 'Byzantium in the Seventh Century', *Dumbarton Oaks Papers*, 13, 1959, pp.271ff.

42. *The Great Palace of the Byzantine Emperors* (Walker Trust, University of St Andrews): *First Report*, Oxford, 1947, pp.64ff. and pls.28ff.; *Second Report*, Edinburgh, 1958, pp.121ff., pls.44ff., and colour plates.

43. For a summary of the state of the question see D. Talbot Rice, 'On the Date of the Mosaic Floor of the Great Palace of the Byzantine Emperors at Constantinople', *Charisterion eis Anastasion K. Orlandon*, I, Athens, 1965, pp.1ff. For the evidence of the pottery finds, cited by Talbot Rice, see now J. W. Hayes, *Late Roman Pottery*, London, 1972, p.418.

CHAPTER SEVEN

1. P. Romanelli and P. J. Nordhagen, *S.Maria Antiqua*, Rome, 1964.

2. *Ibid.*, pl.II and p.53. For the chronology see *infra*, n.4.

3. *Ibid.*, pp.32ff., 56f., and pls.I, 14–17.

4. In attributing dates to the paintings of Hellenistic style in S.Maria Antiqua, I am adhering to the chronology I worked out in 1934 (*Römische Malerei vom Beginn des 7. bis zur Mitte des 8. Jahrhunderts*, diss., Munich). In recent years two revisions have been proposed which, however, would entail moving in opposite directions. P. J. Nordhagen has attributed a large number of paintings (including those illustrated in our pl.VII and figs. 203–5, 207, 208, 214) to a comprehensive decoration supposedly undertaken by Pope Martin I in A.D.650 ('The Earliest Decorations in Santa Maria Antiqua and their Date', *Institutum Romanum Norvegiae: Acta ad archaeologiam et artium historiam pertinentia*, 1, 1962, pp.53ff., especially pp.58ff.; cf. Romanelli and Nordhagen, *S.Maria Antiqua*, p.34). The arguments for crediting Martin I with such a decoration – additional to four figures of Church Fathers on the walls flanking the apse, which certainly were painted during his pontificate – do not seem cogent to me. I continue to believe that the paintings in question, while undoubtedly of the first half of the seventh century, were done earlier than A.D.650. A more drastic chronological revision is implicit in the thesis that the apse of S.Maria Antiqua was installed between A.D.565 and 578 (Krautheimer *et al.*, *Corpus basilicarum* [*supra*, II, n.55], II, 1959, pp.254f., 263f.; cf. C. Bertelli, 'Stato degli studi sulla miniatura fra il VII e il IX secolo in Italia', *Studi medioevali*, 3rd series, 9, 1968, pp.379ff., especially pp.415ff.). Since the Annunciation on the Palimpsest Wall (our figs. 201f.) must have been painted in conjunction with, or, at any rate, very shortly after that operation, a substantially earlier dating would result for the first appearance of the Hellenistic style in Roman painting. But the alleged discovery of coins of Justin II, on which the argument is based, is at present so poorly documented as to be in effect unusable as evidence; and even if it were corroborated it could not prove conclusively the date of the apse. From a stylistic point of view – and not only in Roman terms but in

Byzantine terms as well – the 570s are an unlikely period for a work such as the Annunciation angel (see *supra*, pp.108ff.). I continue to believe that the heyday of Hellenism in Roman religious painting was in the 630s.

5. Morey, *Early Christian Art* (*supra*, Introduction, n.4); cf. the critical review by Schapiro cited *supra*, IV, n.14.

6. For the fourth and early fifth centuries see *supra*, Chapter Two (especially pp.38ff.). For the Macedonian period see K. Weitzmann, *Studies in Classical and Byzantine Manuscript Illumination*, Chicago and London, 1971, pp.199ff.

7. C. L. Striker and Y. D. Kuban, 'Work at Kalenderhane Camii in Istanbul: Third and Fourth Preliminary Reports', *Dumbarton Oaks Papers*, 25, 1971, pp.251ff., especially pp.255f. and fig.11.

8. *Supra*, pp.106f.

9. Romanelli and Nordhagen, *S.Maria Antiqua* (*supra*, n.1), pl.20 and p.58.

10. Kitzinger, *Byzantine Art in the Period between Justinian and Iconoclasm* (*supra*, III, n.41), pp.47f.

11. Romanelli and Nordhagen, *S.Maria Antiqua*, pls.18f. and pp.57f.

12. *Ibid.*, p.34.

13. G. and M. Sotiriou, *Icones du Mont Sinai*, Athens, 1956–8, pp.21f. and pls.4–7. K. Weitzmann, M. Chatzidakis, K. Miatev, S. Radojčić, *Icons from South Eastern Europe and Sinai*, London, 1968, pp.ixf., lxxix; pls.1–3. K. Weitzmann's new publication of the early icons of the Sinai Monastery (1976) did not become available to me in time to be consulted before this book went to press.

14. K. Schefold, *Pompejanische Malerei*, Basle, 1952, pp.136ff., 199 and pl.46.

15. For this problem see my study cited *supra*, n.10; especially p.30 with nn.113f.

16. Romanelli and Nordhagen, *S.Maria Antiqua*, pl.21 and pp.36, 58.

17. *Ibid.*, pp.34ff., 58ff.; pls.III–V, 22–8, 29B. P. J. Nordhagen, *The Frescoes of John VII (A.D. 705–707) in S.Maria Antiqua in Rome*, Institutum Romanum Norvegiae, Acta ad archaeologiam et artium historiam pertinentia, 3, Rome, 1968.

18. *Ibid.*, pp.78f., 107.

19. See my study cited *supra*, n.10; especially pp.32f. For a discussion of the problem see C. Bertelli, *La Madonna di Santa Maria in Trastevere*, Rome, 1961, pp.86ff. Nordhagen in his most recent statement on the subject agrees that the frescoes of John VII in S.Maria Antiqua 'are the signs of the penetration of a completely new phase of the "Hellenistic style" into Italy'. He also speaks of a 'Renaissance-like movement' in Byzantium under Heraclius and his dynasty – and I agree with him about the special importance of that movement for Byzantine *religious* art in the first half of the seventh century (see *supra*, pp.114f.) –, but he does not recognize in the 'new phase' of the end of the century a specific reattachment to the art of Justinian I ('"Hellenism" and the Frescoes in Santa Maria Antiqua', *Konsthistorisk Tidskrift*, 41, 1972, pp.73ff., especially pp.76f., 79).

20. Sotiriou, *Icones du Mont Sinai* (*supra*, n.13), pp.19ff. and pls.1–3; also colour plate. Weitzmann *et al.*, *Icons from South Eastern Europe and Sinai* (*supra*, n.13), pp.x, lxxix; pl.5.

21. M. Chatzidakis, 'An Encaustic Icon of Christ at Sinai', *Art Bulletin*, 49, 1967, pp.197ff.

22. *Ibid.*, figs. 3–7.

23. Grierson, *Catalogue of the Byzantine Coins in the Dumbarton Oaks Collection* (*supra*, II, n.58), II, p.568. For what follows see *ibid.*, pp.514ff. and pl.32.

24. Cf. *supra*, VI, n.10.

25. Grierson, *Catalogue*, II, pp.568ff. and pl.37.

26. J. D. Breckenridge, *The Numismatic Iconography of Justinian II*, New York, 1959, pp.56ff.

27. Grierson, *Catalogue*, III, Washington, D.C., 1973, pp.146ff. with Table 16 (pp.152f.); pp.164f., 454f. and pl.28. Justinian II in his second reign (A.D.705–11) had introduced on his coins a totally different, far less 'Grecian' image of Christ (*ibid.*, II, pp.569, 648 and pl.43); and it is worth noting that this second type was never revived after Iconoclasm (*ibid.*, III, pp.153, 164f., 454). The die-sinkers of the ninth and subsequent centuries reverted to the image of the father god exclusively. I have commented on this phenomenon in an article entitled 'Some Reflections on Portraiture in Byzantine Art', *Recueil de travaux de l'Institut d'Études byzantines* (Belgrade), 8, 1963, pp.185ff., especially pp.190ff. (reprinted in *The Art of Byzantium* [*supra*, I, n.18], pp.256ff.).

28. E. J. W. Hawkins, 'Further Observations on the Narthex Mosaic in St Sophia at Istanbul', *Dumbarton Oaks Papers*, 22, 1968, pp.151ff.; see also a forthcoming article by N. Oikonomides, *ibid.*, 30, 1976.

LIST OF ILLUSTRATIONS

I. Mausoleum of Galla Placidia, Ravenna. North arm with Good Shepherd lunette. Photo: von Matt (*Facing p.52*)

II. Church of St George, Thessaloniki. Detail of dome mosaic with Sts Onesiphorus and Porphyrius. Photo: Lykides (*Facing p.53*)

III. Orthodox Baptistery, Ravenna. Detail of dome mosaic with Sts James and Matthew. Photo: von Matt (*Facing p.68*)

IV. S.Apollinare Nuovo, Ravenna. North wall. Photo: Scala (*Facing p.69*)

V. S.Vitale, Ravenna. South wall of chancel. Photo: von Matt (*Facing p.84*)

VI. Two saints. Mosaic on apse wall of Chapel of S.Venanzio, Lateran Baptistery, Rome. Photo: Scala (*Facing p.85*)

VII. The Maccabees. Fresco in S.Maria Antiqua, Rome. Photo: P. J. Nordhagen (*Facing p.100*)

VIII. St Peter. Icon in Monastery of St Catherine, Mount Sinai. Photo reproduced through the courtesy of the Michigan-Princeton-Alexandria Expedition to Mount Sinai (*Facing p. 101*)

1. Arch of Constantine, Rome. View from north. Photo: German Archaeological Institute, Rome

2. Arch of Constantine, Rome. Medallions and frieze on north side. Photo: Alinari

3. Imperial lion hunt. Medallion (from a monument of Hadrian) on north side of Arch of Constantine, Rome. Photo: Anderson

4. Constantine distributing largesse (detail). Frieze on north side of Arch of Constantine, Rome. Photo: German Archaeological Institute, Rome

5. Porphyry group of the Tetrarchs. Venice, S.Marco. Photo: Hirmer

6. Hunting scene (detail). Floor mosaic in great corridor of Roman villa, Piazza Armerina, Sicily. Photo: Alinari

7. Couple embracing. Terracotta from the Altbachtal. Trier, Landesmuseum. Photo: museum

8. Porphyry sculpture of two Tetrarchs. Vatican Library. Photo: German Archaeological Institute, Rome

9. Gold coin of Maximinus Daza. Photo: Dumbarton Oaks

10. Tomb relief with circus scene. Vatican Museum (formerly Lateran). Photo: Alinari

75. Child's sarcophagus. Istanbul, Archaeological Museum. Photo: Hirmer

76. Ivory panel with the Holy Women at the Tomb and Ascension. Munich, Bayerisches Nationalmuseum. Photo: museum

77. Ivory panel with Holy Women at the Tomb. Milan, Civico Museo d'Arte, Castello Sforzesco. Photo: Hirmer

78. Carolingian ivory panel with Crucifixion and the Holy Women at the Tomb. Liverpool, County Museum. Photo: museum

79. Silver bridal casket of Projecta. London, The British Museum. Photo reproduced by courtesy of the Trustees of The British Museum

80. Apse mosaic of S.Pudenziana, Rome. Photo: Anderson

81. Ivory diptych of Boethius. Brescia, Museo Civico Cristiano. Photo: museum

82. Ivory diptych of high official. Novara, Cathedral Treasury. Photo: Alinari

83. Panel of ivory casket with scenes of Christ's Passion. Pilate, Christ carrying cross, Denial of St Peter. London, The British Museum. Photo: Hirmer

84. Ivory panels with scenes from Christ's life and miracles. *Left*, Paris, Louvre. Photo: museum. *Right*, Berlin-Dahlem, Staatliche Museen, Preussischer Kulturbesitz. Photo: Hirmer

85. Ivory book cover with scenes from life of Christ and portraits and symbols of evangelists. Milan, Cathedral Treasury. Photo: Hirmer

86. Ivory diptych of the Consul Anastasius. Paris, Bibliothèque Nationale. Photo: Hirmer

87. Drinking contest between Hercules and Dionysus. Detail of fig. 88. Princeton University, Art Museum. Photo courtesy Princeton University

88. Floor mosaic, House of the Drinking Contest, Antioch (*in situ*). Photo courtesy Princeton University

89. Floor mosaic with Seasons and hunting scenes, from Antioch. Paris, Louvre. Photo: museum

90. Floor mosaic with hunting scenes, from Antioch. Worcester, Massachusetts, Art Museum. Photo: museum

91. Floor mosaic of geometric design. North arm of Church of Kaoussie, Antioch. Photo courtesy Princeton University

92. Floor mosaic with Nilotic landscape. Church of the Multiplying of the Loaves and Fishes, Tabgha, Sea of Galilee. Photo: Schweig

93. Mausoleum of Galla Placidia, Ravenna. Interior, view to south. Photo: Anderson

94. The Good Shepherd. Lunette in north arm of Mausoleum of Galla Placidia, Ravenna. Photo: Anderson

95. St Lawrence. Lunette in south arm of Mausoleum of Galla Placidia, Ravenna. Photo: German Archaeological Institute, Rome

96. Painted tomb chamber. Palmyra, Tomb of Three Brothers. Photo: Institut Français d'Archéologie, Beirut

INDEX OF MODERN AUTHORS CITED

Here and throughout, reference to the notes (pp. 129–53)
is made in the form, e.g., III, n.36 (Chapter three, note 36)

GENERAL INDEX